Outlaws!

To Cécile, my daughter,
Calamity Jane's naughty little sister

I am one of those who have a strong liking for bandits—
Not that I have any desire to meet them on my travels;
But, in spite of myself, the energy of these men,
At war with the whole of society,
Wrings from me an admiration of which I'm ashamed.[1]

Prosper Mérimée

[1] P. Merimee, *Carmen and Other Stories*, trans. by Nicholas Jotcham
(Oxford and New York: Oxford University Press, 1989).

LAURENT MARÉCHAUX

Outlaws!

Adventures of Pirates, Scoundrels,
and Other Rebels

Flammarion

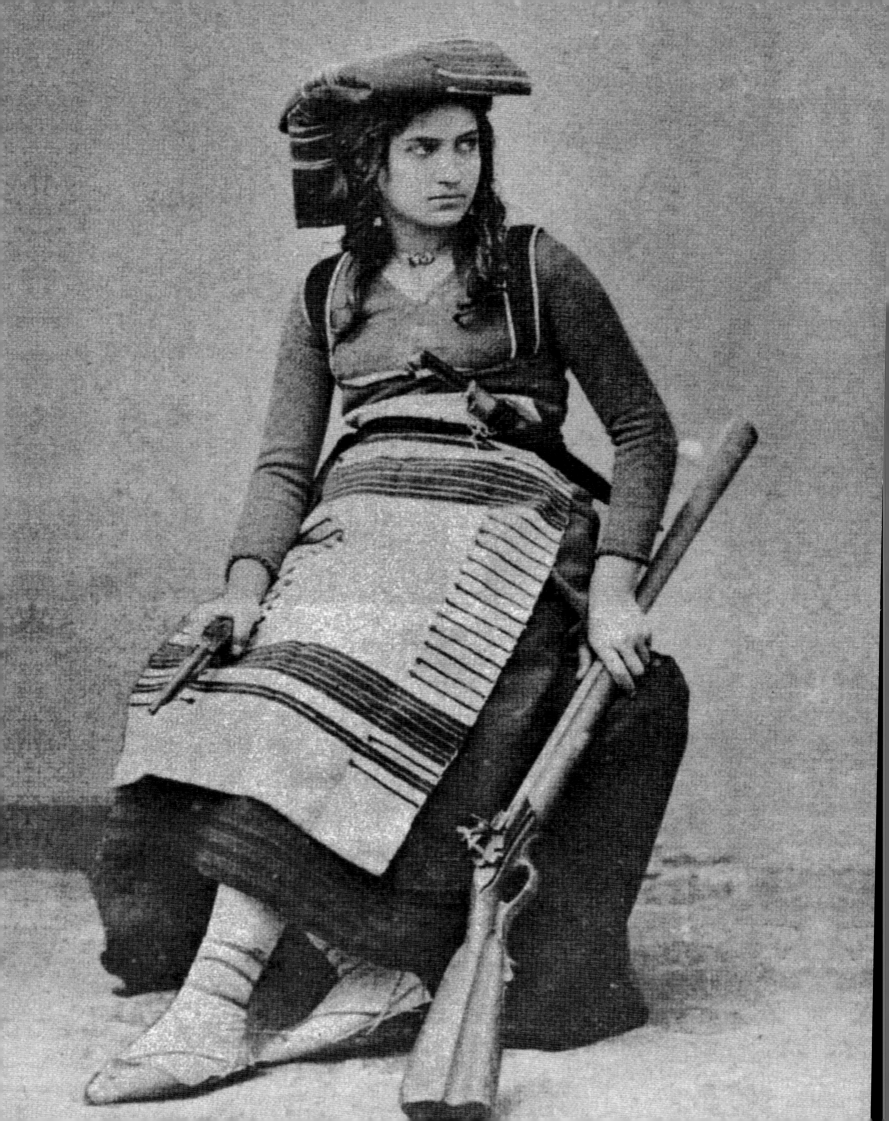

Contents

Sharp Shooters and the Call of Wide Open Spaces

Desert Devils, from the Arabian Peninsula to the Horn of Africa

Illegalists, Anarchists, and Revolutionaries

City Hoodlums and Urban Gangs

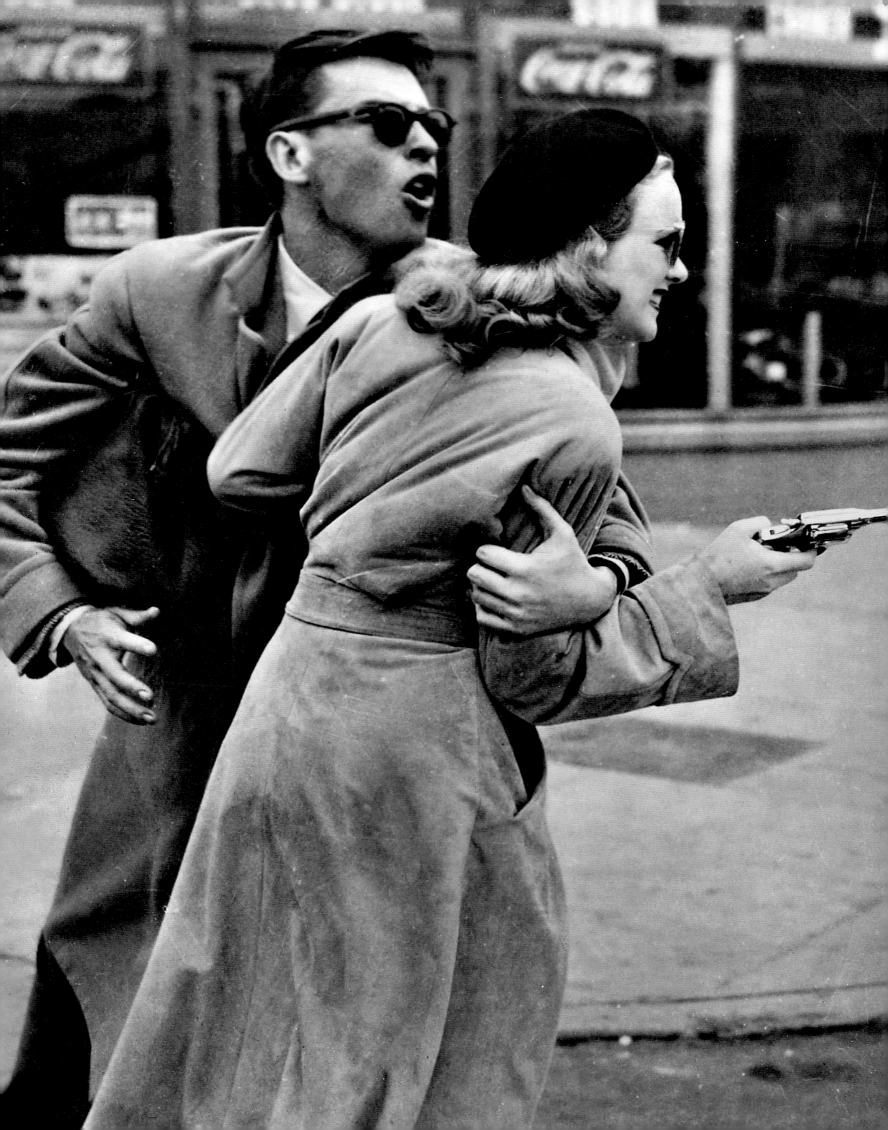

Live Free or Die

Outlaws are not born, but made.

Before hiding out in the forests, taking to the high seas, losing themselves in the immensity of the desert, or melting into the urban jungle, most of our future illegalists or rebels knew the tenderness of a mother's love, the firm hand of paternal authority. The untimely death of a parent or an upset destiny is what will push these *enfants terribles*, at the age of adolescence, into a life of perpetual revolt.

If by "outlaw" we mean those who choose to live outside society's laws and conventions, opposing (generally with force) every conceivable manifestation of authority—be it moral, political, economic, or religious—then it soon becomes clear that true outlaw status is a privilege granted to few of the many who aspire to it. He (or she) who embraces a life outside the law is first and foremost a rebel driven by high ideals: a desire to change the world, escape poverty, and experience ultimate, boundless freedom of the kind that gets your fingers burnt.

These tormented, fiery souls confront their overwhelming sense of injustice by taking up arms: against unfair, crushing taxes that despoil and starve the poor; against the Roman Catholic church's onetime monopoly of distant seas and lands; against the conquest and ruination of the vast, virgin wildernesses of the world that have so often been the theater of their all-consuming quest; against religious sectarianism, harsh morality, arbitrary justice, and the enrichment of the few; against the rise of an industrialized world that leaves the poor by the wayside, struggling for survival on a pittance.

Their sense of revolt is summarized in the letter written by the conquistador Lope de Aguirre "the Mad" to his sovereign, Felipe II of Spain:

This, the sole reason for our conduct: we can endure no longer the crushing taxes, edicts, and mistreatment inflicted upon us by your ministers who, to favor their families and their creatures, snatch from us our glory, our life, and our honor. Your thankless disregard has made me a rebel unto death.

Defiance of the established order is the outlaw's watchword. For al-Kahina, Mandrin, Captain Misson (the pirate philosopher), Calamity Jane, Wyatt Earp, Lawrence of Arabia, Marius Jacob, Victor Serge, Mikhail Bakunin, or Emmett Grogan, and so many others who hungered and thirsted for freedom's sake, the advent of a fairer, more egalitarian society justified their use of violence.

But it is not enough merely to declare oneself the spiritual heir of Robin Hood, the big-hearted righter of wrongs. All too often, an outlaw's determination to take from the rich to give to the poor remains no more than a pious wish when it comes to sharing out the spoils. Rage and despair quickly muddy the clear waters of reason, annihilating any inclination to generosity. With but a few exceptions, the long march to a better world becomes a murderous rampage. One bullet stains the legend, streaking the high ideals with blood. The proud outlaw and righter of wrongs

becomes a lost soldier with no way back to an honest, peaceful life. Faced with a choice between death or an end to hard-won freedom, better by far to die a free man than rot in prison. The history of outlaws down the ages is an endless repetition of the inevitable countdown to a death widely foretold or a long-expected suicide.

And so our new pariahs embark on a life of wandering and suffering. Theft, life on the run, and solitude are the outlaw's daily bread. Defiance of the established order seldom goes unpunished, and the judgment is final: the wheel, the gallows, the gibbet, the guillotine, the anonymous bullet of the firing squad. The price of freedom is paid up front. Death is the ticket to the realm of legend and embellishing a dark, murky life.

"This is the West, sir. When the legend becomes fact, print the legend..."[1] We are not fooled by distorted truths and embroidered facts. We welcome them, and we know them for what they are: they shore up our dreams, magnify our heroes' courage, fuel our new utopias.

Our intellectual connivance with these master thieves, our fascination for these doomed heroes, will not take us to the scaffold. At best they bring excitement, and the frisson of imaginary fear. Too cowardly or reasonable to follow in their footsteps, we are left standing on the shore, secretly sharing their thirst for rebellion, knowingly contemplating their quest for some improbable other place—the fairer, more humane society of their childlike imaginings.

We should not, then, rush to judge the errant ways of these idealistic vagabonds. They deserve our recognition. Without them, the maps of this world would be less colorful, our taxes and rights would be less human, democracy—experimented in the "pirate republics" of Libertalia and Tortuga—would be lacking in imagination, and our eternal quest for a better world would be nothing but an outmoded fancy.

Now, more than ever, as the flames of revolt flicker and die, as despair stalks our every move, we have a duty to uphold their legend, and honor their memory. We shall gallop after them full tilt, sabers a-rattlin'!

Page 4: Micheline de Cesare, the mistress of an outlaw, 1865.
Page 8: John Doll and Peggy Cummins in Gun Crazy, 1949.
Right: Giuseppe Nicola Summa, known as Ninco-Nanco,
killed in a skirmish in Frusci, March 13, 1864.

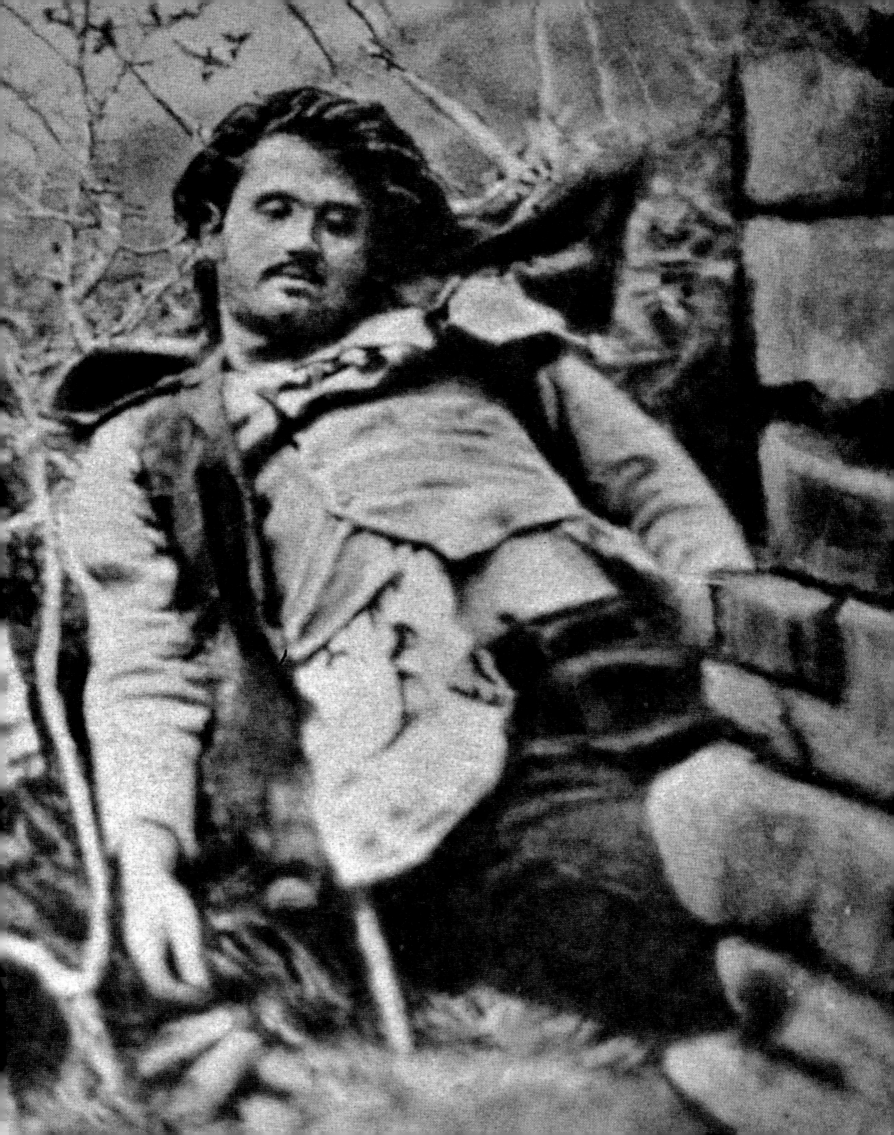

From the depths of the forests, they rebelled against political, military, and religious injustice

What can a seventh-century Berber queen of southeastern Algeria possibly have in common with a mid-fifteenth-century French poet-cum-brigand slaking his excessive thirst for women and alcohol, two vigilante French bandits of the eighteenth century (one plying his trade in the Dauphiné, the other in Provence), an American natural philosopher of the late nineteenth century, a gang leader from the Sertão blazing a trail across the Brazilian Nordeste in the early twentieth century, and Robin Hood, the prince of thieves immortalized by Sir Walter Scott and Alexandre Dumas?

All were outlaws. All stood firm in the name of justice and freedom, against the political, military, or religious powers-that-be. But the similarity does not end there: all chose, at some point in their career, to melt into the depths of their native woods or forests—for safety, to rally their comrades, to savor a fleeting moment of peace, or to gather their strength and courage for the fight.

Before ending up dead, usually killed, nothing predisposed these adepts of the natural world to heroic destinies. Time, poetry, and popular ballads transformed them into the stuff of legend. Almost all suffered family tragedy at a very young age, leading to irreconcilable rifts that catapulted them into adulthood, opened their eyes, and awoke in them an almost animal instinct for survival. Dahia al-Kahina lost her mother at the age of seventeen; Gaspard de Besse lost his mother at the age of two, and his father at the age of three. François Villon was just seven years old when his father was hanged; and the murder of Lampião's father by the Brazilian police when he was just eighteen sealed the boy's fate as an outlaw, forever: "From this day forward, the gun and dagger shall be all our mourning, we shall seek vengeance unto death!"

Without the premature death of a parent, these rebels might have led quiet, respectable lives; remarkable lives, no doubt, given their powerful personalities, and peaceful ones, too, given their generosity of heart. We should not judge these "lost children" as natural-born outlaws, then, but try to understand the nature of their revolt. Al-Kahina would never have taken up arms as the leader of the Imazighen tribes if their Arab aggressors had not forced her people to convert to Islam, and she herself to wear the veil. Robin Hood, the father of all thieves, would never have gathered his skilled archers in Sherwood Forest if the Catholic Church and the conquering Norman lords had not seized their property and land. Mandrin would never have cultivated the fine art of smuggling if French taxes on tobacco and salt had not risen beyond all reason. The same is true of Gaspard de Besse, who waged war against usurers and the collectors of France's hated salt tax, the *gabelle*. Henry Thoreau's call to civil disobedience was driven by his refusal to pay taxes to a government that accepted slavery. Even those wild hotheads, François Villon and Lampião, were driven by a similar desire for revenge, a similar sense of honor. Friendship, and the codes of the *cangaceiros*, were never betrayed.

Few outlaws died at home in their beds. With the exception of Thoreau (who spent just one uneventful night in prison for tax resistance) and Villon (who disappeared without trace after being branded on the forehead as an exiled criminal), every one of these outlaws paid for their quest for justice with their lives: al-Kahina, and Lampião and his companion Maria Bonita were killed and beheaded, Mandrin and Gaspard de Besse were tortured on the wheel, and tradition has it that Robin Hood was felled by a treacherous prioress, who slashed his radial artery while pretending to administer a bloodletting treatment.

Robbing from the rich to give to the poor is easier said than done. These spiritual heirs of Robin Hood may have aspired to his celebrated maxim, but not all of them were capable of carrying it out.

Robin Hood and the Outlaws of the Forest

"They call me the poor man's friend,
for I take from the rich to give to the poor."
Roger Lancelyn Green, *The Adventures of Robin Hood*

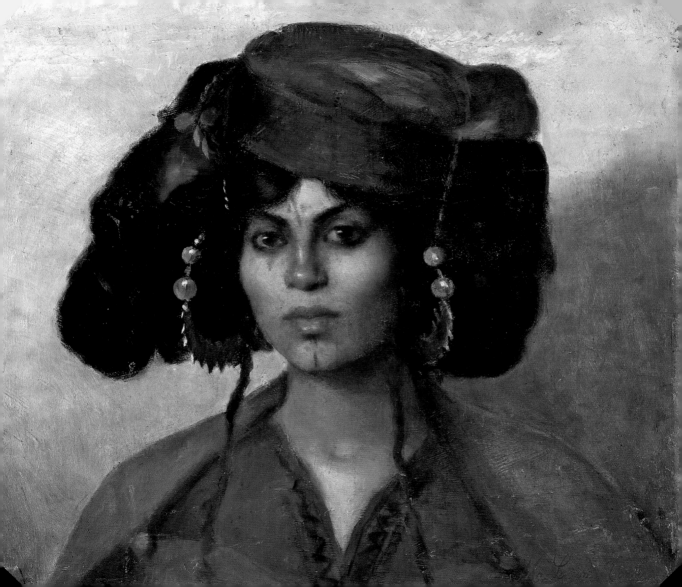

Al-Kahina *(late seventh century)*
The Rebel Queen

Al-Kahina's life story, her fate, even her name, should be approached with circumspection, just like those of her male counterpart Robin Hood. From Antigone to Joan of Arc, women outlaws are few. Yet a wealth of detail testifies to her very real existence. We shall choose to believe in this female rebel.

Al-Kahina—a title with religious connotations, meaning "prophetess" or "witch" in Arabic, and "priestess" in Hebrew—was also known as Dahia, or Dihia (Beauty) in Berber, while several of her hagiographers use the name Damia, meaning "soothsayer" in Tamazight.

This rebel queen, whose exact date of birth is unknown, lived at the end of the seventh century, in the Aurès, a mountainous forest region of south-eastern Algeria. Fifty years after the death of Mohammed, his followers were pursuing a policy of evangelical expansionism. Three groups were locked in confrontation: the Byzantine Christians, who occupied the city of Carthage, the desert Arabs under the formidable Hassan Ibn al Nu'man, and the Imazighen (or Berbers), semi-nomadic tribes including that of al-Kahina. Beyond their territorial ambitions, the Arabs pursued a merciless war of religion, conquering entire peoples and sparing only those who were prepared to renounce their religion and join the ranks of Islam. All others were first tortured then exterminated. Caught up in these conflicts, the Imazighen tribes faced a vital, strategic choice: by attacking the Arabs, they would be playing into the hands of their old enemies, the Christians. If they spared the Arabs, however, they would be forced to relinquish their fierce independence, and their mysterious belief systems.

Little is known about al-Kahina's childhood and youth. Dihia seems to have been the child of a liaison between a female tribal "elder" and a distant descendant of Eliezer, a *kohan* (servant of Yahweh), come to the region several centuries earlier to convert the Berber tribes to Judaism.

Exhausted and hungry, Eliezer is said to have been taken in and accepted by the Djerawa people, who adopted some of his beliefs. Believed to be Jewish by some, and to be Christian by others, al-Kahina was most probably an animist, the high priestess of a hybrid religion involving the god of the wind (referred to, under the influence of her paternal ancestor, as "the holy blessed one may he remain unnamed") and an assortment of angels, archangels, djinns, and devils. In our own time of religious strife, the question of al-Kahina's identity takes on a new significance: she rebelled in the face of the rise of a new religious order, the enforced wearing of the veil, and taxes imposed by the conquering powers.

Al-Kahina's mother died in childbirth, while delivering her thirteenth infant. Aged seventeen, al-Kahina was the firstborn, and now became the head of the family. The adolescent girl was renowned for her wild character and stunning beauty—troubling, pale blue eyes, a mane of copper-colored hair that shone brightly in the sun, falling in waves about her shoulders, a piercing gaze that forced people to look away. Al-Kahina was a solitary figure. She loved to hide among the topmost branches of the ancient cedar trees that grew in abundance in the forests circling her village, losing herself in song and prophecy.

The Imazighen tribes were governed by a female council of elders. The women debated the issues of the day, and the men complied with their decisions, taking arms when their partners and spouses dictated. As the descendant of a *kohan*, al-Kahina established herself as their "queen-prophetess" as soon as she was admitted to the council.

As the Arab threat became more powerful, al-Kahina's isolated tribe was defeated. Her oratory rallied the other Imazighen tribes to the cause, however, and she became president and warlord of a short-lived alliance. The Zenata tribes (a division of the medieval Imazighen) were inferior

in number, but achieved victory through cunning. Al-Kahina greeted outriders from the advancing Arab armies with offers of dates and camel's milk, convincing them that their progress would be unhindered. But, during the night, al-Kahina concealed her troops along the heights of a narrow pass through which Hassan Ibn al-Nu'man's cavalry were due to pass. When the enemy appeared at dawn, men and horses perished under a hail of arrows. Galvanized by her first victory, the warrior queen attacked the main body of Ibn al-Nu'man's troops, engaging with them at Meskiana, between Tbessa and Aïn Beïda. Al-Kahina led her troops into battle, scattering al-Nu'man's army and chasing them back to Gabès. A fragile peace was established, but Ibn al-Nu'man, having been humiliated by a woman, dreamed of revenge, and asked the caliph Ibn Marwan to send reinforcements to put down the unexpected uprising. Anticipating inevitable reprisals, al-Kahina ordered the burning of lands bordering her realm. In doing so, she had hoped to dissuade the invaders, but in fact she drew down the wrath of her own people.

Legend tells how, at the battle of Oued Nini, she became infatuated with a young Arab prisoner, known as Khalid, whom she spared, adopted, and took as her lover, despite his tender age. This consuming passion was her downfall. This time, the soothsayer knew her enemy was the greater. Her co-religionists were ready to surrender and convert: they questioned her leadership and hesitated to return to the fight.

Al-Kahina wanted just three things—never to deny her beliefs, never to submit to foreign rule, and to spare her children from vengeance. To save them from an otherwise certain death, she ordered her two sons to enlist in the Muslim army.

The final battle took place around 700 C.E. at Tabarka in modern-day Tunisia. According to some versions, al-Kahina was betrayed by her lover and assassinated by one of her own people. Others say she showed exceptional courage but was captured, decapitated, and her head taken before the caliph. Her defeat spared her the ordeal of witnessing the surrender of her people, and their allegiance to a religion she had fought against her entire life. She lived as an outlaw and died unbroken, transforming her life and death into the perfect legend.

Page 14: A woman from Biskra, portrait by Marie Caire, 19th century.
Below: A caravan of camels near Biskra, Algeria, painting by Jean-Baptiste Lazerges, 1892.
Facing page: Bab Darb in old Biskra, painting by Gaston-Ernest Marché, 1907.

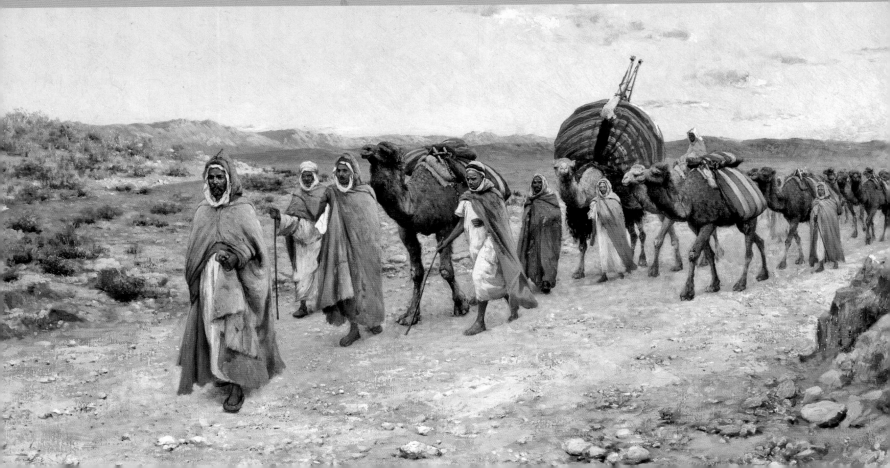

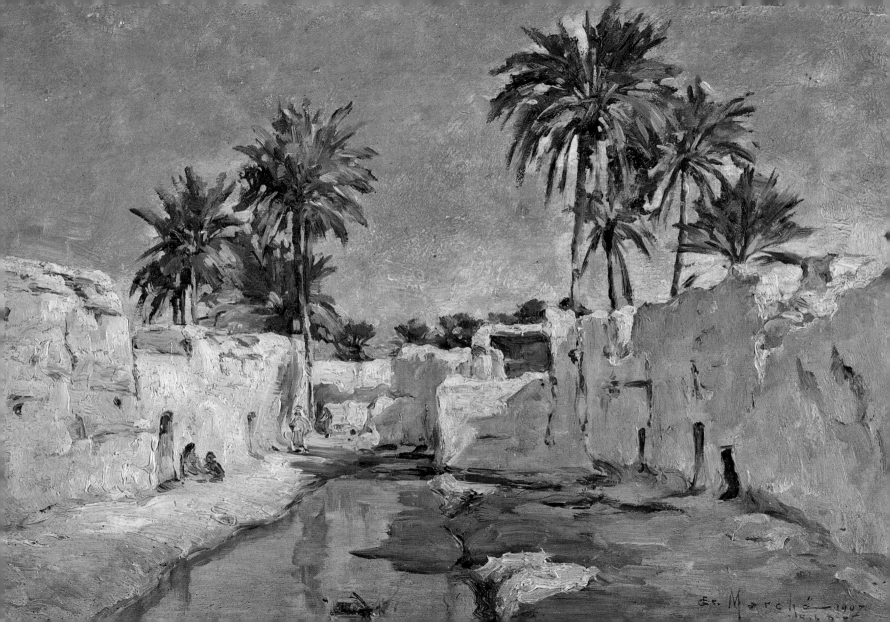

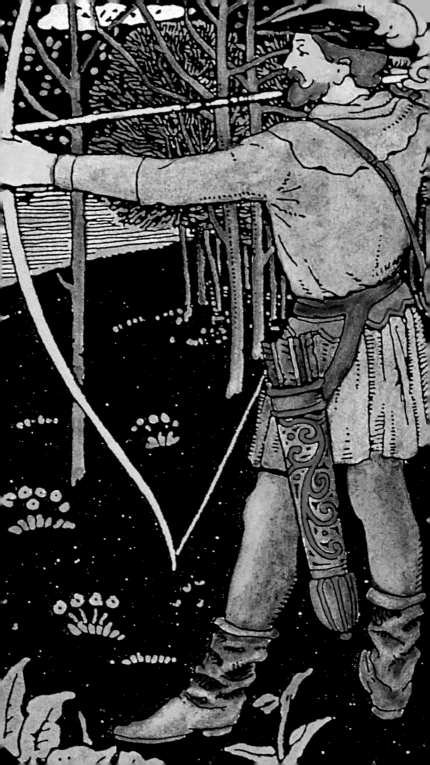

Robin Hood (late twelfth century)
The Prince of Thieves

What if Robin Hood—the subject of so many flattering portraits, from early English ballads to the novels of Sir Walter Scott, Alexandre Dumas, and others—never existed? Even his name is open to controversy: Robin Hood to some (a reference to his costume), Robin Wood (for his forest hideout) to others. But quibbles over his real identity are unimportant. The legend is the thing, and Robin's is particularly fine, establishing him as the quintessential outlaw, a model for aspiring brigands everywhere. Robin stands in their eyes as a universal hero, a spiritual father, an idolized older brother, a master to emulate. Let us step with him into the deep shade of Sherwood Forest, open our childhood hearts, and dream on.

> —Is it permissible to ask the name of one whose eye is so penetrating as to judge by a single shot the difference betwixt the action of a soldier and that of a forester?
> —My name boots little in the question before us, Sir Stranger, but I can tell you my qualifications. I am one of the chief keepers of this Forest.... I am chief of a band of men, stout-hearted, clear-witted, and well skilled in all the exercises of their trade. You seem to me a good fellow: if your heart be honest, if you be of a calm and conciliatory spirit, I shall be happy to enroll you in my company. [2]

So begins the story of *Robin Hood, the Outlaw,* as told by Alexandre Dumas. As Robin himself admits to a gentleman ruined by punitive taxes, who has come to petition him for help, he is an unusual outlaw, indeed:. "I am what men call a robber, a thief so be it! But if I extort money from the rich, I take naught from the poor. I detest violence, and I shed no blood. Nay, never thank me; I have done but my duty; you had naught, and I gave to you. 'Tis only just."[3]

The legend of Robin Hood began with minstrel ballads of the thirteenth century. It was printed in popular leaflets in the sixteenth century, and performed in street pageants of the seventeenth and eighteenth centuries. The story was taken up and embellished by the great nineteenth-century writers Sir Walter Scott and Alexandre Dumas, and adapted for the cinema in the twentieth century, with the role of Robin taken by Douglas Fairbanks (1922), Errol Flynn (1938), and Kevin Costner (1991). In every adaptation, the essential story remains the same: a revolt in the late twelfth-century England, in the county of Nottinghamshire, led by an "outlaw with a social conscience" rebelling against the abuses of the civil and religious authorities. Over time, these favored ranks of society became the favorite targets of the arrows shot by Robin and his companions: the hated Norman lords, who had stripped the Saxons of their titles and nobility, and the men of the Church, who were getting rich at the expense of ordinary people.

As with every fine story, there is a pretty tale of romance, too: Robin loves the beautiful Maid Marian, his fellow outlaw Will (in Dumas's version) loves a certain Maude, Allan-a-Dale pines for Christabel, and Barbara nurses a passion for Much the Miller's Son. No epic adventure without fraternal comradeship, either. Robin's Merry Men are united in staunch friendship: a trickster monk, a miller, a military deserter, a woodcutter, a yeoman[4], and a knight. Attracted by Robin's charisma, cunning, and courage, all choose the path of rebellion, much as others at the time might choose to enter the Church.

Let us follow in their footsteps, to the castle of the Sheriff of Nottingham, where Will Scarlett is held prisoner for the murder of his captain. Let us hide with the outlaws in Sherwood Forest, as they plan Scarlett's rescue. Let us draw back our bows and read again the finest pages of Dumas's legend. Will's execution for murder is about to take place,

ROBIN HOOD
AND HIS MERRY MEN BY BARRY PAIN

when the prince of thieves himself arrives on the scene, disguised in a hooded monk's habit.

"Soldiers, stand back a little," said the old pilgrim, "The prayers of a dying man must not fall upon profane ears."

At a sign from the Baron the soldiers fell back a little way from the prisoner, and William was left alone with the pilgrim at the foot of the gallows. "Do not move, Will," said the pilgrim, leaning towards the young man, "I am Robin Hood, and I am going to cut the cords which fetter your movements. Then we will dash into the midst of the soldiers, and sheer surprise will rob them of their wits. Now take the sword which hangs beneath my gown. Can you feel it?" [5]

Throwing off his disguise, Robin appears in his famous green forester's costume. His companions join the fray with cries of "The forest and Robin Hood!" The Merry Men free the prisoner and repulse their soldier enemies before returning to the depths of Sherwood Forest, singing as they go. The legend of Robin as a forester and a righter of wrongs is encapsulated in this heroic episode: the challenge to authority, the use of cunning and disguise, Robin's quiet strength and good humor.

His is a complete "philosophy of the forest,"as illustrated in this robust exchange between Little John and the Bishop of Hereford, surrounded by Robin's companions in the heart of Sherwood Forest, at the so-called Trysting Tree.

"This treasure," stammered the Bishop, "shall we not divide it? You dare not utterly despoil me, rob me of so large a sum?"

"Rob you!" repeated Little John, disdainfully. "What do you mean by such a word?

You have obtained this money on false pretences; you took it from those who needed it, and I shall return it to them. Thus you see, my Lord, I do not rob you."

"Do you not comprehend the difference between robbing and taking from a man what is not his?"

—"We call our way the woodland philosophy," said Robin, with a laugh. [6]

"Take from the rich to give to the poor," Robin's famous motto is the key to his legend, a leitmotif that was to inspire many an outlaw vocation.

Sadly, Robin's spiritual heirs have not always been motivated by such disinterest. Reality and legend are not easy bedfellows. Not everyone can be an outlaw with honor.

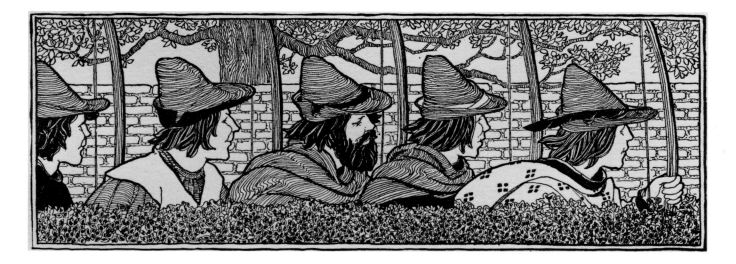

Page 18: Robin Hood, *illustration, c. 1905.*
Facing page: Illustration taken from Robin Hood *by Barry Pain, 1898.*

Above: Robin Hood, his Deeds and Adventures *by Lucy Fitch Perkins, author's illustration, 1906.*

VILLON

François Villon (1431–1463?)
The Brigand and Balladeer

Can one be both a poet and an outlaw? Are the rhymester's inspirations—romance, hedonism, or despair—compatible with the bloodthirsty atrocities of the brigand, even if that brigand is an impressionable youth, and no man of honor?

The eventful life of the French poet François Villon would seem to plead in favor of this difficult cohabitation. The young François de Montcorbier (his father's name) endured a tough upbringing at the hands of his uncle Guillaume de Villon, the parish priest of Saint-Benoît-le-Bétourné. He grew up shy and thin, hollow-cheeked and pale, remarkable as a schoolboy more for his poverty and ragged clothes than for his application to his studies. At seventeen years of age, he was a dreamer who preferred bad company to regular attendance in the schoolroom.

His solitary wanderings along the embankments of the Seine led to a chance meeting by the Pont au Change: a pair of young rascals with whom he quickly became infatuated. The first, Régnier de Montigny, came from a noble family from Bourges. This handsome son of a royal squire was a kept man, living off the earnings of a Parisian trollop. His stocky, ham-fisted sidekick Colin de Cayeux was the son of a locksmith, and a skilled lock-picker in his own right. Flattered by their show of friendship, and powerless to resist the call of criminality, François de Montcorbier threw in his meager lot with this pair of ne'er-do-wells. Permanently broke, he readily agreed to steal all he lacked. François was fearful and lacked experience: his two friends taught him how to live like *goliards*,[7] tricksters, and highway robbers.[8]

Orphaned at the age of seven when his father was sentenced to hang, abandoned by his mother, and subject to his uncle's rigid authority, François's craving for affection was plain to see: he wanted nothing more than friendship. He was still a student at university when his cronies pushed him, for a dare, into the arms of a girl of ill repute—a gentle soul known as *la belle Marion*, who taught him the ways of the world. François fell instantly madly in love with her, mistaking his first experience of sex (paid for by friends) for love. He regarded himself not as a pimp but a gigolo once he began exacting from Marion some of the money she received from her bourgeois admirers in exchange for her favors.

Marion was a spirited, attractive girl; François adored her and made no secret of his misery when a more persistent lover insinuated his way into her affections and had him thrown out onto the street. Disillusionment, and a liking for women, led to an irreversible downward spiral. He was weak and craven, and admitted as much: "I know am worth little, but it does me good to hear it."[9] Now a confirmed ladies' man, François enjoyed numerous liaisons and conducted several affairs. His first conquest, Margot, ran the cloister at Nôtre-Dame, with her husband. François dedicated his early verses to her. His *Ballade de la grosse Margot* (The Ballad of Fat Margot) was a quick-fire success in the taverns of Paris, under his pen name, Villon, borrowed from his uncle:

> Wind, hail, frost, my bread's all baked
> I'm a lecher, she's a lecher to match.
> Like one of us better. We're a pair
> Like unto like, bad rat bad cat
> On filth we dote, filth is our lot
> Now we run from honor and honor runs from us
> In this whorehouse where we hold our state.[10]

Villon's mistress took offence at his "vulgar" verses. The two quarreled, depriving him of the generous allowance of twenty *pistoles* paid him by the lovely landlady.

Villon's second conquest was Catherine de Vauselles, a capricious demimondaine whom he met at a soirée hosted by the wife of the provost marshal of Paris, who admired the young poet's verses. His new fiancée was a manipulative character, taking advantage of Villon's blind love and

leading him to commit his first murder—a priest by the name of Sermoise, who mocked his poems and courted De Vauselles with ardor and persistence.

One evening in May 1453, Villon was strolling along the banks of the Seine, with a compliant young girl on his arm, when he encountered Sermoise. The priest slit his lip with a thrust of his dagger. Fearing for his life, Villon fought back. He was arrested and thrown into the fetid, straw-strewn cells of Paris's Châtelet prison, escaping the noose by nothing but a few well-turned verses addressed to Robert d'Estouteville who, upon reading them, commuted his sentence to exile.

Together with Colin, who had become his mentor, Villon began the life of a wandering brigand, in the forests of France. He excelled at—but took no pleasure in—armed robbery, and soon began to pine for Paris. Far from his beloved city, Villon sank into a perilous decline but eventually returned to the capital, and his ill-starred penchants for alcohol and women. While Villon caroused and went to pieces, his old friends fell in with the Coquillards, a gang of con men and forgers operating mainly in Burgundy. Their ringleader was a dubious character, physically repugnant and fluent in *gourd* (the hoodlums' dialect), answering to the name of Piez-Blancs. From pimping, they progressed to stealing ritual objects from churches and living off the proceeds of their sale. On Christmas Eve 1456, the two vagabonds took Villon along to the sacristy of the Collège de Navarre. The trio broke

open the chest housing the chapel's treasure and shared a booty of five hundred écus between them.

Staying in Paris became too risky. Loaded with cash, Villon returned to a wandering life along the Loire, disguised as a peddler, sleeping in woods and ditches, and ending up in Angers. Money slipped through his fingers; he squandered his bounty on drinking and prostitutes. Warned that he and his companions had been betrayed, he was seized with paranoia. Penniless, he fled to the town of Blois, the home of the aristocratic poet Charles d'Orléans, hoping to earn his living from poetry. Villon charmed the duke with a few skilled rhymes, but his talents provoked irritation and jealousy among the latter's entourage. Surrounded by fakes and poseurs, he felt a deep nostalgia for Paris, and his friends. Adventure beckoned once more. As he declared to the Duke: "Nothing is truer to me than uncertainty."

Villon wandered the highways all winter, downcast when hungry, full of gusto when drunk, thieving and earning a frugal living writing poetry and selling fabrics. Four lost years, wandering and waking each morning to the fear of arrest— filled with self-loathing, he longed to return to Paris. Passing through Orléans, he was betrayed by a prostitute, subjected to questioning, and thrown into the city jail on June 19, 1460, but released thanks to the intervention of Charles d'Orléans. The long shadow of the scaffold drew ever nearer.

The vagabond poet joined his old friend Colin at

Montpipeau, where he learned of Regnier's death by hanging, three years earlier, at Montigny. He committed a handful of felonies, broke into the church at Baccon, and was chased as far as Meung-sur-Loire, where he discovered Colin's bloated, strangled corpse. Seized by two guards, Villon offered no resistance, and was imprisoned and tortured on the orders of Monseigneur d'Aussigny. Once again, he escaped execution, this time thanks to the general amnesty granted by Louis XI in honor of his coronation.

Dazed, toothless, and in rags, Villon made his way to Paris. The robbery at the Collège de Navarre caught up with him, however, and he languished once again in the city jail, until his uncle agreed to repay the one-hundred-and-twenty écus he had stolen. Villon dared not return to his now-ruined benefactor, and went to live in his mother's garret at the Cordeliers, sleeping on straw and eating dry bread. The rigors of writing day after day, returning home night after night to an illiterate woman indifferent to his poetry, were too much for him. He took up with his old associates, and followed them once more to the city's taverns.

Wandering drunk one night along the Rue Saint-Jacques, the gang broke into the home of Maître Ferrebouc, a papal notary, who was killed in the ensuing fight before Villon's innocent eyes. Villon was arrested and thrown into prison at Châtelet once again, before being questioned and sentenced to be "hung and strangled at the Paris gibbet." On January 5, 1463, the court overruled the sentence but banished Villon from the capital for ten years.

With Colin and Regnier dead, Villon had no one and nothing. Without his friends, he saw no prospect of pleasure, no reason to live. On January 8, Villon set out for Bourg-la-Reine, on the road he had taken once before with Colin. Like every criminal banished from the capital, the letter "P" for Paris had been branded on his forehead. The outlaw poet wandered deep into the woods and vanished forever, taking with him the secret of a death that remains a mystery to this day. His turbulent life has left us a handful of immortal poems that have become his epitaph, the testament of a humble wordsmith:

> Rest eternal grant him
> Lord and everlasting light…
> Here lies and sleeps in this garret
> One love's arrow struck down
> A poor obscure scholar
> Who was known as François Villon…[11]

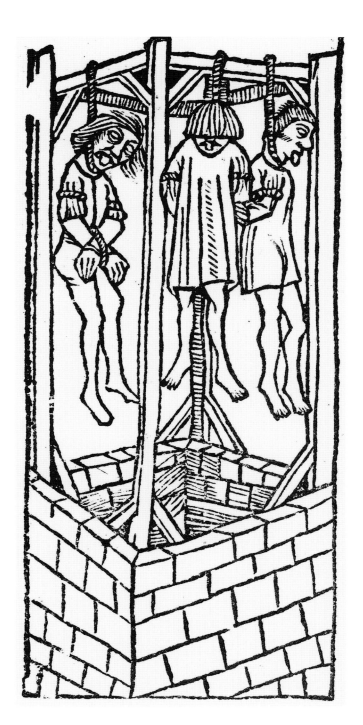

Page 22: François Villon, 19th–century print.
Facing page: Hôtel de ville and place de Grève, drawing by Théodore Hoffbauer, 19th century.
Above: La Ballade des pendus, *wood engraving, 1497.*

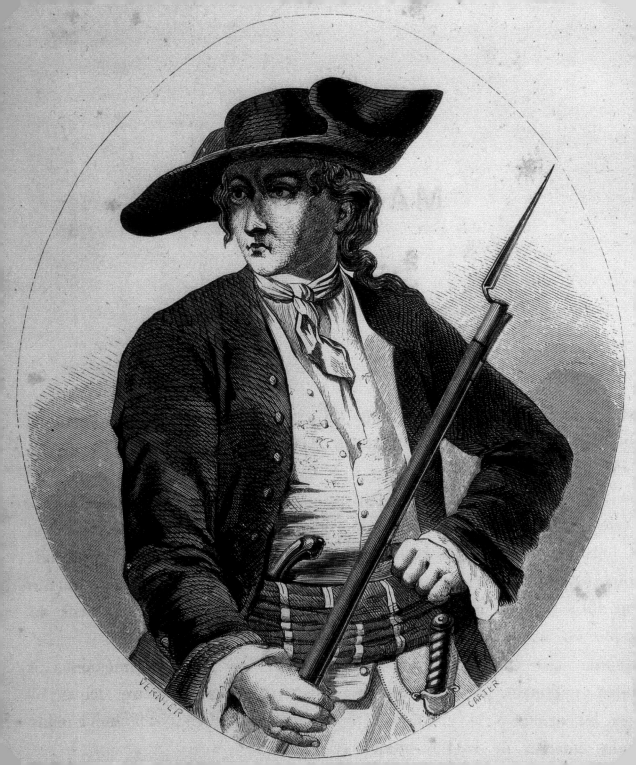

VERNIER CARTER

Louis Mandrin (1725–1755)
The Smuggler with a Heart of Gold

What's a young man of courage, moderate talent, and good looks to do at sixteen years of age? Louis Mandrin began by deserting from the army and forging coins with his brother, biding time until they could earn or steal some of their own. At eighteen, Mandrin was an outlaw who had escaped the scaffold—where his brother had already perished—by running for his life. He cut an imposing figure: a lively, piercing gaze, brilliant blue eyes, a mop of red hair above a long face and lean physique, and a sharp flair for repartee. Nicknamed The Fox by his friends at Saint-Étienne-de-Saint-Geoirs in the Dauphiné, where he was born in 1725, Mandrin was a crafty, resourceful child. Remembering his late father's career as a horse-dealer, he dressed as a fairground roustabout and made a living "selling old nags to honest folk, passing them off as Spanish thoroughbreds."[12] The young swindler soon tired of these comparatively unrewarding deals, however.

Mandrin was blessed with charisma, ambition, and a visionary spirit. Styling himself as the "tax collectors' tax collector" he went into business as the leader and strategist of his own smuggling organization, in January 1754. Young girls swooned, and agents of the king trembled at the sound of his name. He quickly found himself at the head of a federation that numbered every smuggler, crooked employee, military deserter, outlaw, and swindler in France, all the way from the Rhine to the Mediterranean, each one of them eager:

1—to avenge with arms the deaths of their vigilante comrades in Valence
2—to recover the sums seized from the convoys of the *Ferme Générale de la Contrebande* [Mandrin's "Federation of Contraband Agents"]
3—to shake off, without fear of retribution, the unbearable, blood-stained yoke of the King's tolls, customs houses, commissioners and brigades who so unjustly intercept the precious imports of the finest merchandise
4—to get rich, and delight the public.[13]

Mandrin had a brilliant mind, a tough spirit, and an innate flair for illicit trade. He began "trading by force" on a grand scale all over Europe. Like their leader, his merchant-mercenary lieutenants knew all of the continent's highways and byways; they "confiscated" tobacco, fine muslins, fabrics, and Indian spices in Holland, England, Switzerland, and Savoy, sneaking their booty back to France for sale on the open market at bargain prices. When their path was blocked by the King's soldiers and agents—which was often—they would take out their weapons and attack, with cries of "Hurrah for glory, contraband, and fine wine! Hurrah for Mandrin!"

Mandrin was a pragmatist. Rather than waste time over delicate negotiations with ladies and demoiselles in palaces and fine houses, he preferred to sell wholesale to shopkeepers, tobacconists, and officials in charge of the bonded warehouses at toll barriers. Mandrin's sales tactics were soon firmly established and irresistible: escorted by a handful of comrades, the smuggler chief would present himself at the home of a toll official or warehouse keeper, and negotiate the exchange of tobacco and fine printed Indian cottons for a sum of money. If the toll official or warehouse keeper seemed reluctant or unreceptive, tougher forms of persuasion replaced the veneer of politesse. No one argued with Mandrin, and everyone paid up—if they wanted to escape with their life.

The big-hearted brigand swelled the ranks of his troops by freeing prisoners in the towns through which he passed—with the exception of thieves, whom he abhorred. "Prejudice," he said, "will accuse my deeds as criminal. Fie on prejudice, it will not deter me from acts of justice and mercy on behalf of the innocent."[14] And to new recruits he would

say: "You are our true comrades. It is you who deserve to eat more bread, and not those murderous officials and agents."[15]

Mandrin's travels took him to his home village, where he sought revenge against the peasant responsible for his brother's death by hanging. He found the informer standing on the edge of his field, an eighteen-month-old child in his arms.

"Were you not bought?" the brigand called out to him, "and was it not you who placed the rope around the neck of my brother, Pierre?"

On his knees, the man begged for his life in the name of the child, whom he held against him as a shield. Mandrin answered with a shot from his gun, killing both father and son."[16]

Mandrin's repeated acts of brutality began to tarnish the charm and renown of the "Smuggler King." The very name of Mandrin became a deeply wounding insult. Numerous traps were laid to try and catch him. At Autun, Mandrin and his gang narrowly escaped ambush by a certain Captain de Fitscher of the grenadier guards. Seized with fury, the outlaw escaped death thanks only to his determination and military prowess. Of the ninety smugglers involved in the incident, thirty were killed.

In January 1755, Mandrin's loyal followers, worried by the persistent mounting threats to their leader's life, urged him to call a halt and leave the kingdom of France for a time. Mandrin was now a rich man, they argued. It was time to end his life as a smuggler. But Mandrin refused. Henceforth, the bandit chief traveled everywhere with an escort of his toughest men. On the night of May 10, 1755, Mandrin took refuge over the border in Savoy, at the castle of Rochefort, just a few miles away from the French frontier.

The toll officials of the Dauphiné were well informed. Accompanied by a host of volunteers, they determined to kidnap Mandrin. The plan worked. Mandrin was taken by surprise in his sleep. He opted for cunning rather than open resistance, and hid in a pile of firewood. A servant was subjected to questioning and led the armed officials to the hiding-place. Alas, one of Mandrin's feet could be seen sticking out from beneath the logs. The smuggler was discovered, arrested, and taken to Valence under escort, to face the French judge Fredet. Eager to satisfy their morbid curiosity, the local people filed past his cell all day and all night long. Mandrin denied nothing, admitted all of his shootings, spared his comrades, and exonerated the weak.

One important problem remained: Mandrin's complicated relationship with the Almighty. Mandrin disliked men

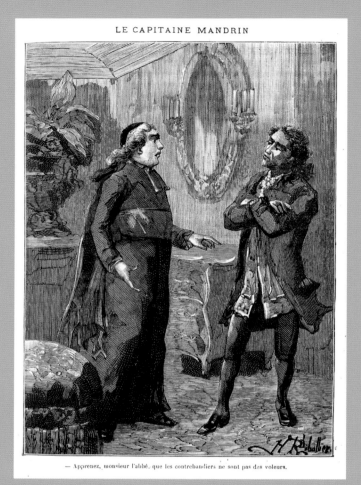

LE CAPITAINE MANDRIN

— Apprenez, monsieur l'abbé, que les contrebandiers ne sont pas des voleurs.

"Fie on prejudice, it will not deter me from acts of justice and mercy on behalf of the innocent."

Page 26: Louis Mandrin, print taken from a portrait of the period, 1863.
Above: Captain Mandrin, *by Jules de Grandpré, illustration by H. Riballier, 1885.*
Facing page: The tale of Mandrin, the famous bandit, *drawn by Epinal, 19th–century.*
Page 30: Mandrin in prison just before his execution, 18th–century print.
Page 31: Public petition following the capture of Louis Mandrin, 1755.

HISTOIRE DU CÉLÈBRE BRIGAND LOUIS MANDRIN,

Né à Saint-Etienne-de-Saint-Geoire, en Dauphiné, le 30 mai 1724.

Mandrin ayant déserté se mit chef de contrebandiers; son premier crime fut l'assassinat de son capitaine qui voulait lui faire rejoindre son régiment.

Mandrin pour former son quartier-général dans un vieux château dont le maître venait de mourir, met le reste des habitants en fuite en y faisant le revenant.

Un des gens de Mandrin, couvert d'une peau d'ours, gardait l'entrée du château, un officier, qui n'était pas peureux, lui brûle la cervelle.

Des affidés de Mandrin substituent dans les poches de l'officier un morceau de bois aux objets de conviction qu'il a prises au château.

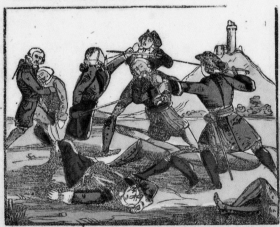

Forcée dans ses retranchements, la troupe de Mandrin combat à outrance contre les soldats et les paysans.

Mandrin, qui voulait réparer ses pertes immenses par un mariage avantageux, est arrêté chez Isaure qu'il devait épouser sous peu.

Mandrin ayant obtenu dans sa prison même de dîner avec ses complices, enivre le geôlier et s'évade avec eux.

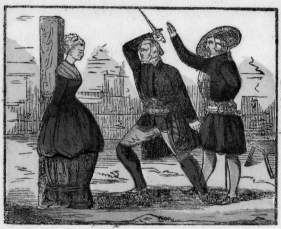

Mandrin fait assassiner une malheureuse mère de famille qui refuse de se livrer à lui, et qui avait découvert un trésor qu'il avait caché.

Déguisé en ermite, il trompe, par ses apparences de piété, plusieurs femmes honnêtes de la contrée.

Mandrin, arrêté et condamné à la peine de mort, parvient à s'échapper en marchant au supplice.

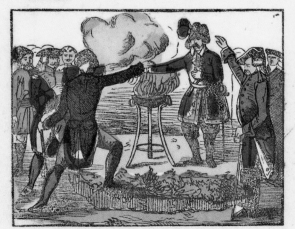

Mandrin ayant de nouveau recomposé sa troupe, fait jurer à chacun d'eux, la main sur un brasier ardent, de lui être fidèle jusqu'à la mort.

Mandrin, pour punition de ses crimes, est condamné à être roué vif, et fut exécuté le 26 mai 1763, à Valence en Dauphiné.

Propriété de l'éditeur. (Déposé.) Fabrique de PELLERIN, Imprimeur-Libraire, à ÉPINAL.

of the Church, especially when he was drunk. His judge and visitors urged him to make his peace with God and beg forgiveness for his sins. Before agreeing to confess, Mandrin joked: "Tell me instead how many inns there are on the road to Paradise. I only have six *livres* left to spend on the way."[17]

The dread sentence was pronounced on May 24, 1755:

"In payment for his crimes, Louis Mandrin—the smugglers' leader, guilty of the crime of lèse-majesté, murderer, thief, and public nuisance—is condemned to have his arms, legs, thighs, and back broken alive on the scaffold, thence to be placed upon the wheel, his face turned toward Heaven, there to end his days."

To all those who mourned his imminent death, Mandrin responded with characteristic gusto: "Weep not for me, but for the crimes that have resulted in my sentence, which truly deserve your tears."

The last word on this epic life goes to Stendhal, "This brave smuggler lacked neither courage nor spirit. Mandrin may have been immoral, but his military talent was a hundred times that of the generals of his day, and he ended his life nobly on the scaffold at Valence."[18]

Mandrin died on May 26, 1755, at half past five in the afternoon, aged twenty-nine years and two months. The weeping crowd mourned the death of a true and generous spirit, and the end of his uncontested two-year reign over the contraband of the kingdom of France.

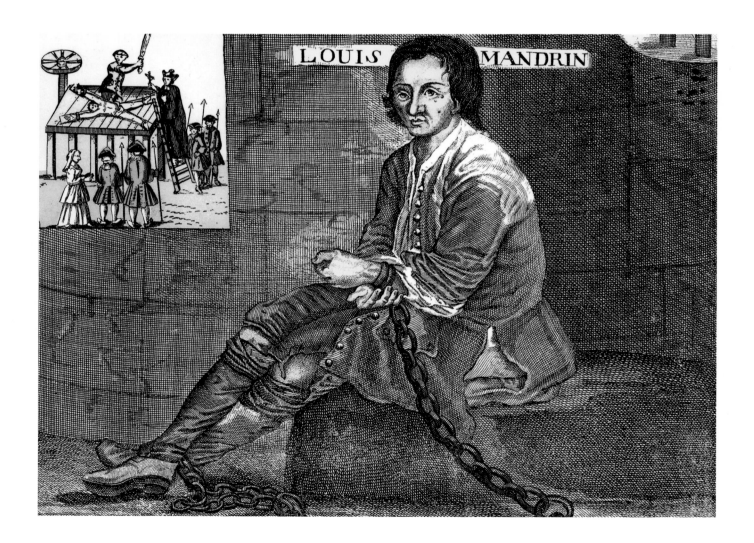

COMPLAINTE NOUVELLE
SUR LA PRISE
DE LOUIS MANDRIN,

Natif de Saint-Étienne, de Saint-Geoirs en Dauphiné, pris au Château de
Rochefort, le 12 Mai 1755.

Sur l'Air : *Il est vrai, je le confesse.*

Ne doutez pas de ma peine,
Et de mon cuisant chagrin ;
Moi pauvre Louis *Mandrin*,
Je me vois chargé de chaînes,
Mes forces si redoutées,
Sont mises en captivité.

Mon malheur inconsolable,
Me fait gémir en ce lieu,
Sont les larmes de mes yeux
Qui me rendent inconsolable,
Parce que mon funeste sort
Me menace de la mort.

Écoutez, je vous en prie,
Ce que je vais réciter,
Je veux bien vous annoncer,
Tous les forfaits de ma vie ;
Faites bien réflexion
A tant de noires actions.

Je suis né de Saint-Étienne,
De Saint-Geoirs en Dauphiné,
Que maudit soit la journée,
Qui m'a causé tant de peine,
Je voudrois en vérité,
N'avoir pas été créé.

Je menois dans mon jeune âge,
La vie d'un vrai libertin ;
Je n'avois autre dessein,
Que pour le libertinage,
Enfin dedans mon endroit,
Chacun se plaignoit de moi.

Mes père et mère commandent
D'abandonner la maison,
Mais moi comme un vagabond,
J'entrepris la contrebande,
Et j'ai commencé par là,
La vie d'un vrai scélérat.

Ma malice fut si grande,
Que je fus en peu de temps,
Choisi de plusieurs brigands,
Pour le chef de leur bande,
Nous étions certainement,
Tous armés bien fortement.

Nous ne craignons point les gardes,
Ni à cheval ni à pied,
Mais comme des meurtriers,
Nous attaquions des brigades,
Nous faisions tous nos efforts,
Pour les mettre à la mort.

J'ai eu plusieurs rencontres
De différens employés,
Tous mes complices animés,
Sur eux s'efforçoient de fondre,
Ils les tuoient ou blessoient,
Les voloient ou désarmoient.

J'ai sommé plusieurs personnes
A me produire de l'argent,
Des cinq à six mille francs,
Il falloit que l'on me donne,
Sinon je les menaçois
Que je les égorgerois.

J'ai fait périr sur ma route
Plusieurs maisons par le feu ;
Mes délits les plus affreux
Étoient pour qu'on me redoute,
En effet où je passois,
Le plus fort m'appréhendoit.

J'ai assassiné sans crainte,
Plusieurs personnes en chemin
J'ai égorgé de mes mains
Une pauvre femme enceinte,
Et plusieurs que j'ai violé,
Après les avoir volé.

J'ai roulé dans la Provence,
Et dans tout le Dauphiné,
La Bourgogne et la Comté
Appréhendoient ma présence,
Ils seront bien réjouis,
De savoir que je suis pris.

Un jour j'appris des nouvelles
Qui me firent trembler de peur ;
Un de mes frères par malheur
Fut pris auprès des Echelles,
Et reconnu de plusieurs
Pour être faux monnoyeur.

Il fut conduit à Valence,
C'est là où il fut pendu,
Aussitôt que je le sus,
Je me sauvai en Provence,
Et pris ma troupe avec moi,
Pour entrer dans la Savoye.

Je fis là des connoissances,
De qui je fus bien aimé,
Je venois faire des tournées,
De temps en temps dans la France,
Mais cela certainement,
Pour moi dura peu de temps.

Dans mes dernières entreprises,
Ah ! que j'ai eu de malheurs,
Je pense en versant des pleurs,
A ma cruelle surprise,
Non je n'aurois jamais cru,
Être pris comme je fus.

J'avois pris pour assurance,
Le château de Rochefort,
Comme étant un endroit fort,
Et de très-bonne défense,
Mais mes ennemis jurés
Malgré moi y sont entrés.

Les soldats de la Morlière,
Pour accomplir leur dessein,
Sortirent du pont Beauvoisin,
Deux compagnies tout entières,
Tant à cheval qu'à pied,
Pour me prendre prisonnier.

Il y avoit à leur suite
Des cavaliers déguisés,
Ils ont fort bien su trouver,
L'endroit où étoit mon gîte,
Ils étoient dans cette action,
Plus hardis que des lions.

Dedans l'eau jusqu'aux aisselles,
Ces intrépides ont passé,
Je n'aurois jamais pensé,
Que personne sans nacelle,
Auroit bravé le hasard,
Comme ont fait ces vrais Césars.

Ils ont forcé à coups d'hache,
Les portes de mon château,
Moi m'éveillant en sursaut,
J'entendis crier, courage,
Mes enfans, dépêchons-nous,
Mandrin est bientôt à nous.

Je n'eus que le temps de mettre,
Mes culottes et mes souliers,
Je me sauvai au grenier,
Pour sauter par les fenêtres,
Mais craignant de me tuer,
Je n'ai osé m'hasarder.

Je crus d'être en assurance,
Dans un gros tas de fagots,
Mais mes pieds passoient par trop,
Ce qui donna connoissance
A tous ceux qui me cherchoient,
Que c'étoit là où j'étois.

Par plusieurs coups de bourrade,
Ils m'ont tiré de ce lieu,
Je jetois des cris affreux,
Appellant mes camarades,
Mais cinq à six bons grivois,
M'ont saisi de par le Roi.

Ces foudroyantes paroles
M'ont tout affoibli le cœur,
Espérant quelque faveur ;
Je leur offris cent pistoles,
Leur disant, je vous en prie,
Messieurs, sauvez-moi la vie.

La colère qui les transporte,
Les rend encor plus méchans,
Deux cavaliers m'approchant,
Aux mains me mirent les menotes,
Et d'un air par trop brutal,
Me lièrent sur un cheval.

Ne doutez pas de ma honte
Et de ma confusion,
Par-tout là où nous passions,
J'entendois crier le monde :
Te voilà donc malheureux,
Tu dois être bien honteux.

Mon arrivée dans Grenoble,
Fit bien du dérangement.
Je fus vu certainement,
Des personnes les plus nobles,
Chacun disoit le voilà,
Mandrin ce grand scélérat.

Quand je fus près de Valence,
Je fus bien épouvanté,
J'aperçus des roues plantées,
Aux environs des potences,
C'étoit pour placer les corps
De six de mes consors.

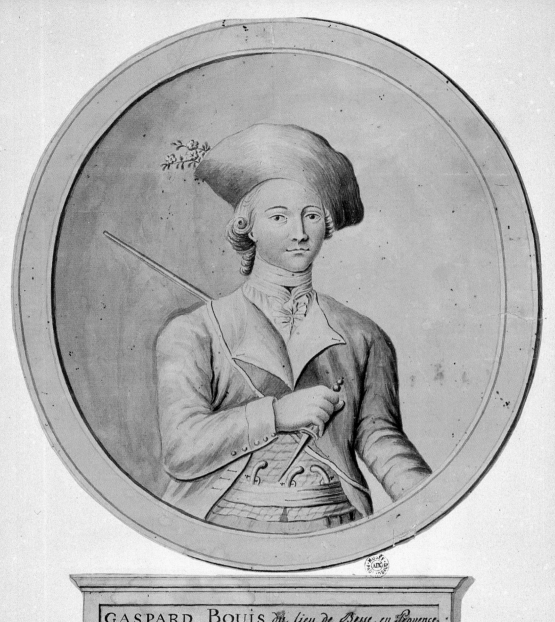

GASPARD BOUIS du lieu de Besse en Provence
Chef de Bande de Voleurs agé d'environ 25 ans, Condamné
a etre rompu vif par arret du Parlement du dit Pays du 25
Octobre 1781.

Gaspard de Besse (1757–1781)
The Highwayman of Provence

"Frighten but never kill" ran the motto of Gaspard Bouis, better known as Gaspard de Besse, the "Provençal Robin Hood."

The Bouis were an honest, hard-working family, respectful of other people and their property. Little Gaspard entered the world on February 9, 1757, in Besse-sur-Issole, in the very best of circumstances, born to a close-knit family with loving parents. But fate had other plans for him. His father died when Gaspard was two years old, his mother when he was three. At the age of seven, he became a runaway and a thief. Solitary, and with a deep loathing of authority in all its forms, Gaspard learned how to poach, live rough in the forest, and shoot with a pistol. A natural idealist, he sided with the weakest and poorest in society. As an adolescent, he fell in with an ex-convict by the name of Sanplan, who had been sentenced to the galleys for selling the revolutionary writings of Voltaire and Diderot illicitly. The two became friends. Sanplan schooled his young apprentice in the subtle art of cards and games of chance (bluffing and cheating), fencing and kick-boxing, and how to handle a saber and a knife. Gaspard was soon his master's equal, and the old revolutionary's utopian ideals fired the young adolescent's imagination. The world must change, happiness was a universal right, privilege had prevailed for far too long, and noblemen and clerics were the true enemies of the people.

Biding their time and fomenting revolution, the pair took over Gaspard's family forge, borrowing two thousand écus from Mâitre Lentier, a Draguignan notary and moneylender, to finance the venture. Their humanism and philanthropy undermined the business, however, further sharpening their hatred of usurers, moneylenders, and tax collectors.

One euphoric night, lured by alcohol and the promise of tobacco, Gaspard enlisted in the King's army. Waking the next day with a stale mouth and bad headache, he realized that he had been duped by the recruiting sergeant's fine words and fled to the *maquis* (the wild scrubland of his native Provence) with other recruits. At eighteen years of age, he found himself at the head of a gang of brigands, thieving and pillaging to feed their bellies. Captain Gaspard—as he was known to his men—was a fervent admirer of Mandrin and the notorious French highwayman called Cartouche, and their accompanying legends. He decided to raise an army of brigands to seize control of Provence and take from the wealthy that which belonged to the people, restoring to them what was rightfully theirs.

Toulon became the nerve-center of the gang's illicit activities. Gaspard settled there under the name of Gaspard de Besse, operating as an occasional swindler and perfecting his skills as a highway robber. Always impeccably dressed, and with great personal charm, he emerged as a leader among the city's criminal fraternity, and was widely respected for his discretion and daring. Gaspard soon became well-known, holding court on the city's café terraces (in particular the Grand Commerce), where he would receive information, secrets, and grievances in preparation for his next robberies.

Among his petitioners one morning was Claire Augias, the beautiful wife of an inn-keeper in La-Valette-du-Var. Claire's husband had stolen two-and-a-half pounds of salt from the salt merchants of Hyères, for which he had been sentenced to fifteen years imprisonment and now languished in the city dungeons. Intoxicated by Augias's curvaceous figure and flashing eyes, the young braggart decided to free her husband. The break-out—executed with exemplary efficiency with the help of the fortress's undertaker, named La Joie—gave the young Gaspard the support he needed to carry out his grand dreams. Joseph Augias and Jacques Bouilly became his loyal lieutenants.

The rocky uplands overlooking the bay of Toulon are full of caves and dug-outs. The three brigands established their hideout in the Grotte du Garou, from where they

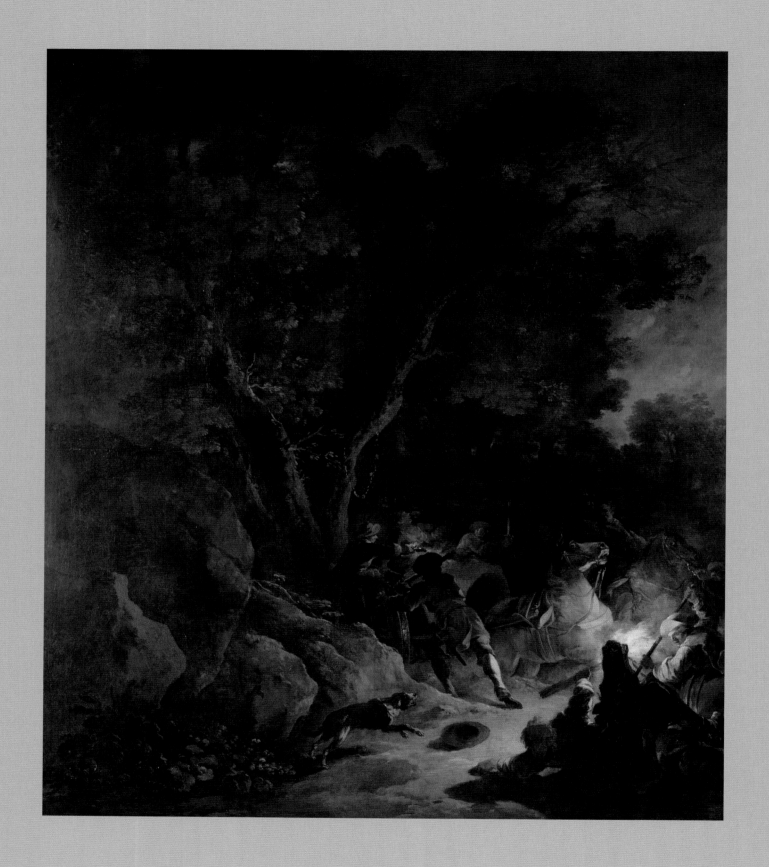

launched successful attacks on passing stagecoaches, relieving travelers of their purses and possessions. Personal gain was out of the question! The aim was to strip passengers of their riches, without violence, to distribute to the poor. Gaspard was an impassioned revolutionary, who issued and enforced the implacable rules of his risky business:

> We will steal only from the rich, nobility, usurers, major beneficiaries of the clergy, prelates, as well as tax officials, bailiffs, and agents of the *gabelle* [France's hated salt tax]. Never will we molest or steal from peasant farmers or the poor. The booty will be divided into two parts: the larger part will be used to constitute a war chest, to be deployed wherever we see the worst extremes of poverty; the other to be divided scrupulously between the participants in each operation.[19]

To swell their numbers and carry out simultaneous strikes throughout Provence, Gaspard's vigilantes recruited deserters and peasants victimized by social inequality and injustice. The gang was quickly joined by Gaspard's godfather, tutor, and great-uncle Gaspard Bouis, his cousin Louis-Germain Bouis, and the irrepressible undertaker La Joie. Members of the fraternity all adhered to Gaspard's philosophy, and none was permitted to challenge their leader's authority. The gang carried out an array of dazzling feats and bold operations, from stagecoach attacks to ambushes, beginning in the Gorge d'Ollioules and extending to the four corners of the region. Gaspard covered the gang's tracks by splitting the company into three divisions, targeting tax collectors and royal military escorts taking convicts to prison and labor camps. A favorite target of the agents of the King's treasury were charcoal-makers—social outcasts who earned a meager living turning pine logs into charcoal.

One day, as Gaspard made his way across the Plateau de Signes, he was alerted to the sound of a woman sobbing. A beautiful, dark-skinned, comely young girl in rags told him her tale of woe: "My father is sick and we have no money to pay for his care. What little savings we had have been seized by the tax collector and his escort. Unless we pay two hundred livres in taxes, we will be driven from our home."

Horrified by her despairing story, Gaspard de Besse promised to kill the tyrants, there and then.

The next day, Gaspard and a courageous band of men posted themselves at first light around the Col de l'Ange pass, ready to seize the open carriage and its lounging passengers—the bailiff and the tax collector in question. They recovered the taxes and stripped the men of their horses, clothes, purses, and pocket watches. Gaspard returned that which belonged to them to the poor family and fell madly in love with the beautiful girl, Clarisse. She eagerly reciprocated his attentions, becoming his mistress. The digression was to prove fatal.

A few days later, six dragoons on horseback, escorting twenty condemned souls for non-payment of taxes, were the victims of a lightning attack by Gaspard and his gang. Surrounded in a clearing (the Clairière des Faremberts), where they had paused to drink from a spring, the soldiers were disarmed and tied up while the convicts, unable to believe their good luck, were freed of their leg-irons and invited to join Gaspard's troops. "Do you want all this to continue? No! Then be my soldiers. Follow me: we shall defend the lambs from the ravening wolves. We shall be the scourge of the evil rich, and the succor of the poor."[20]

The response was immediate. Humiliated by Gaspard's dazzling exploits, the region's tax collectors, magistrates, soldiers, and gendarmes reacted with violence. In autumn 1779, the gentleman brigand decided to call a halt to his activities for the time being, and retreated to the hills above Fréjus, taking up residence at the Auberge des Adrets. Here Gaspard, an enthusiastic womanizer, embarked on a series of one-night affairs and doomed infatuations. Jealous of his escapades, the neglected Clarisse took her revenge, betraying him to the gendarmes of Fréjus. Gaspard was arrested in his bed and taken to Draguignan under armed escort, languishing on the putrid straw of the Observance prison throughout the spring of 1780.

As with any self-respecting bandit, escape became an obsession. Gaspard called for a confessor. Clad in a monk's habit, salvation presented itself in the person of none other than his old associate La Joie. The prisoner bribed his jailer without difficulty and breathed the fresh air of freedom once more. Far from daunting his spirit, Gaspard's brief spell in prison had galvanized his ardor and strengthened his beliefs. Henceforth, he concentrated his attacks on official convoys, carrying out a series of punitive expeditions in the course of which he crossed paths with his old enemy, the notary Lentier and his son Théodore—who had tried to ruin him in his early venture

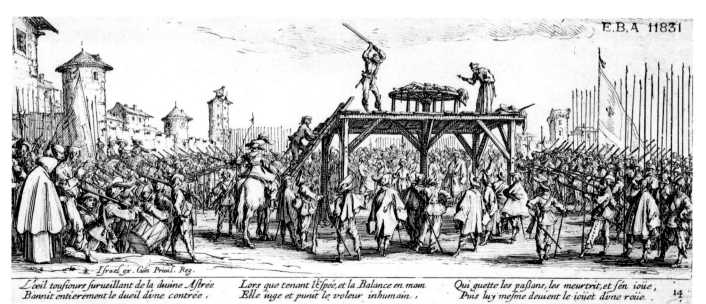

L'œil touſiours ſurueillant de la duine Aſtrée *Lors que tenant l'Eſpeé, et la Balance en main* *Qui guette les paſſans, les meurtrit, et ſen ioüe,*
Bannit entierement le dueil d'vne contrée, *Elle iuge et punit le voleur inhumain,* *Puis luy meſme deuient le ioüet d'vne roüe.* 14

Page 32: Gaspard de Besse, 1781.

Page 34: Bandits Attacking at Night *by Francesco Giuseppe Casanova, 18th century.*

Above: A Highwayman Robbing a Traveler, *print after S. E. Walker, 18th century.*

Below: The Wheel, *print by Jacques Callot, 1633.*

Facing page: Third View of Toulon, *view of the old port, taken next to the food shops, picture by Joseph Vernet, 1756.*

as a blacksmith. Faithful to his personal motto: "I punish, but never kill," Gaspard robbed the father of his possessions and ran his rapier through the son's leg, sparing both their lives.

Louis XVI's tax revenues melted like snow in the Provençal sun. The King took umbrage and dispatched his naval commissioner, Hyacinthe de Possel, to put an end to the insolent brigand's ruinous exactions. De Possel was a wily operator: he recruited a handful of convicts to form a vigilante force, charged to search every inn and tavern in the region. His tactics paid off. Gaspard had anticipated the danger and taken refuge with his old accomplice Jacques Bouilly in the inn at La Valette-du-Var (and in the arms of his old mistress, Claire Augias). Bouilly was recognized by one of de Possel's convicts; an ambush was planned for the morning of October 23, 1780. Possel seized Gaspard and took him to the prison in Aix-en-Provence. At the age of twenty-four, the young gang leader had come to the end of his road.

He eschewed all thoughts of escape, and chose to face his judges. The trial lasted an entire year. Gaspard denied nothing and received unexpected support from the prosecution witnesses, who praised his goodness and charity. Denouncing the one-sided nature of the proceedings, two leading Aixois personalities—the Marquis of Vauvenargues and the lawyer Jean-Etienne Portalis—put their support for Gaspard in writing: "The accused's intelligence, his vision of society, politics, and institutions are a source of unprecedented hope! This travesty of justice threatens to smother a nascent utopia, from which the future, and progress, may blossom forth."[21]

Gaspard had never killed a man, but his fate was sealed. He had challenged the King's authority and dreamed of offering his peers a better existence. He would pay with his life. He had grown up with the exploits of Louis Mandrin; the judgement that condemned him to death on October 14, 1781 was a strange echo of that handed down to his hero: "Convicted of crimes and armed robbery on the King's highway, Gaspard Bouis is condemned to make honorable amends and to beg mercy of God, the King, and Justice. It is ordered that he be taken to the scaffold, there to have his arms, legs, thighs, and back broken, and thence to be exposed upon a wheel, his face turned to Heaven, until death."

Gaspard de Besse was tortured and killed in public on October 25, 1781 at eleven o'clock in the morning. Mandrin had been mercifully strangled by his executioner, to avoid unnecessary suffering, but Gaspard was not granted the same ultimate relief. That very evening, his name went down in legend as one of the truly great outlaws, "the Provençal brigand with a heart of gold."

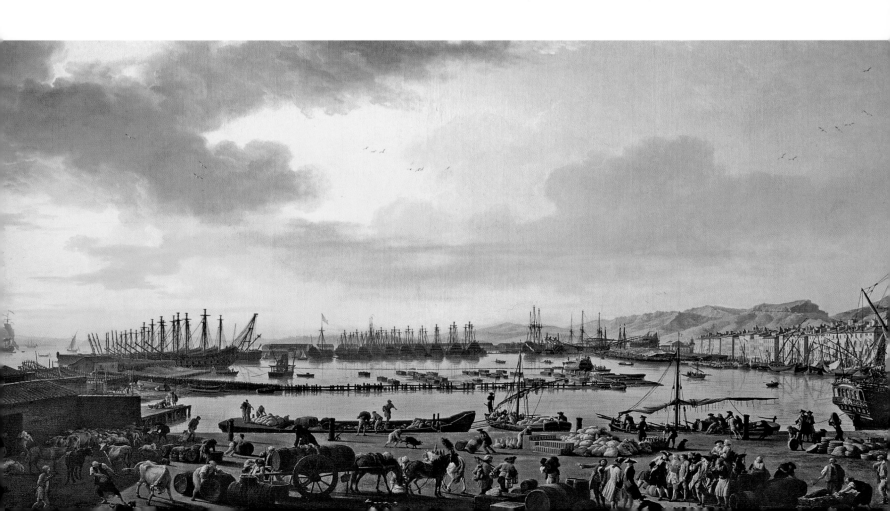

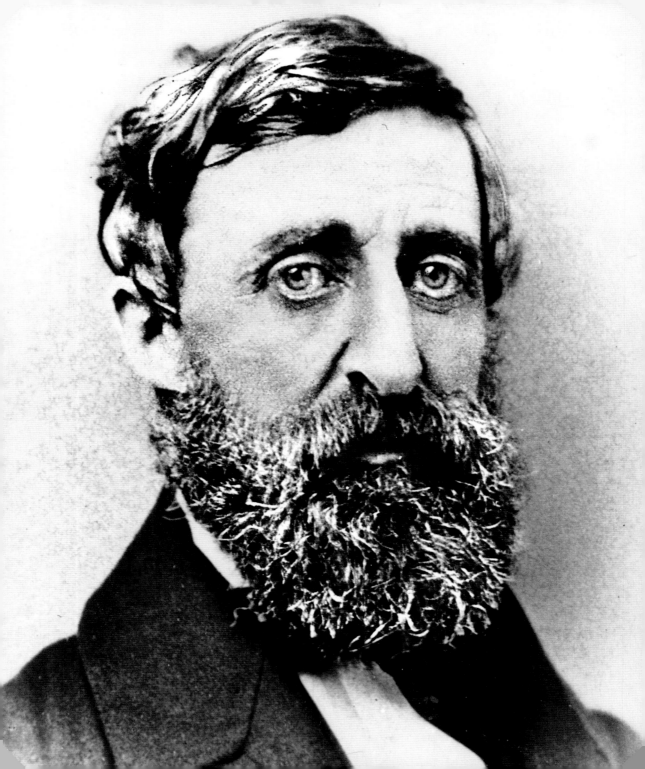

Henry David Thoreau (1817–1862)
The Woodland Revolutionary

Can one be an outlaw, and at the same time proclaim that the State itself is outside the law? Henry David Thoreau saw no contradiction in retreating to the woods and living outside the laws and society of his day, while at the same time maintaining an active campaign of opposition and non-recognition of a state whose politicians "even postpone the question of freedom to the question of free-trade."[22] Throughout his life, the American essayist strove to live in accordance with his ideals and to make his utopian beliefs a reality.

Born on July 12, 1817, in Concord, Massachusetts, Thoreau was an intellectual who defined himself as "a mystic, a transcendentalist, and a natural philosopher."

He was the son of a grocer, a graduate of Harvard, and a close associate of the celebrated philosopher Ralph Waldo Emerson. From his adolescence onward he deliberately positioned himself on the margins of conventional, authoritarian, materialistic society, challenging it not with arms and violence, but in his writings and with his bucolic lifestyle.

Thoreau's first official act of "revolt" took place in 1837, when he was twenty years of age and working as a teacher at Concord's state-run school. Thoreau chose to resign rather than comply with what was the current practice of the time and inflict corporal punishment upon his pupils. He practiced non-violence in every aspect of his daily life and subsequently founded a private school with his brother, based on progressive educational principles and propounding the revolutionary ideals that were to dominate the rest of his life: non-violence, the condemnation of corporal punishment, and a combination of woodland hikes and conventional classroom teaching.

Thoreau tried to launch a literary career in New York but soon returned to Concord and Emerson's circle, where he continued to write, and to work occasionally as a private tutor and in his family's pencil-making business. On July 4, 1845, he broke away from the conventional Protestant society in which he had grown up and built himself a simple log cabin on the shores of Walden Pond. He lived a hermit-like existence here for two years, gathering material for his second major essay, *Walden*, published nine years later.

This foundational work was preceded by *Civil Disobedience*, a short text published in 1849, in which the man of the woods justified his refusal to pay the poll tax imposed by a government of (in his view) questionable legitimacy, particularly as long as it continued to tolerate slavery, and called upon all citizens worthy of the name to disobey in the same way. Starting from the precept that "That government is best which governs least," and looking ahead to a government that "governs not at all,"[23] Thoreau invited his fellow citizens to rebel and join a peaceful revolution, by refusing to pay their poll tax as well. He practiced what he preached: starting in 1846, he refused to pay taxes that he believed would help finance the American government's continued support of slavery and its senseless expenditure on a professional army sent off to wage war in Mexico. His obstinate refusal to pay landed him behind bars. Outraged, an anonymous local supporter paid the tax on his behalf (unknown to Thoreau), in exchange for his release the very same day. Thoreau was uncomfortable with this friendly gesture, however, and spent a token night in prison, walking free early the next morning.

The rise of capitalism, thriving in the northeastern United States thanks to the slave labor of his fellow human beings, was a source of endless indignation for Thoreau. His great political struggle was against slavery, and he called ceaselessly for its abolition. Beginning in 1854, Thoreau presented lectures throughout New England, preaching civil disobedience to a nation state that refused to break off dealings with slave-owners. Thoreau was an indefatigable supporter of the Rights of Man, believing that "the law

will never make men free; it is men that have to make the law free." The death sentence handed down to the abolitionist John Brown reinforced Thoreau's convictions, and his calls became still more strident and uncompromising: slavery in all its forms must stop immediately. Determined as always to practice what he preached, Thoreau became a committed activist, carrying out numerous high-risk operations to help escaped slaves flee to Canada.

Thoreau did not consider himself a militant, however. He was a free thinker who eschewed political parties and reformers, believing that evil lay within the individual, and not out in the external world. Thoreau believed that each individual's spiritual struggle was an inner combat to separate the diabolical from the divine in human nature. His skepticism extended to the very word "democracy." Rather than the voices of the greatest number, he favored of the single voice speaking for justice and truth.

Natural observation lay at the heart of Thoreau's life and political thought. Nature was both his chief source of inspiration, and his favorite sphere of reference: "If a plant cannot live according to its nature, it dies; and so a human being."[24] A hymn to the dawn of a new world, *Walden* is a double tribute: to a personal awakening, and to Nature. To be alive should mean, above all, to be alive and awake to the world. Beauty should be in the eye of the beholder of Nature—preferably at dawn, "when there is least somnolence in us." By choosing to retreat far from the madding crowd, on the banks of a quiet lake, Thoreau planned to rid himself of "the luxuries and [...] comforts of life [which] are not only not indispensable, but positive hindrances to the elevation of mankind."[25]

When Thoreau died, on May 6, 1862, at the age of forty-four, his dreamed-of world of justice and individual respect seemed more utopian than ever—especially the right to live beyond the boundaries of conventional society, a right which this quiet outlaw never ceased to uphold. But was Thoreau preaching in the desert?

Politicians and writers have followed in his footsteps, becoming devotees of Nature, civil disobedience, and nonviolence in their turn. We might say that the utterances of this "forest philosopher" have never been more relevant.

As the poet Kenneth White—one of Thoreau's spiritual heirs—has observed, Thoreau was an anarchist of the dawn, committed to living outside the accepted order, and filled not with nihilistic despair, but a rising sense of hope.[26]

Page 38: Henry David Thoreau, 1879.
Above: Next to Walden pond, 1981.
Facing: Walden, or Life in the Woods, *first edition, 1854.*

41

WALDEN;
OR,
LIFE IN THE WOODS.

By HENRY D. THOREAU,
AUTHOR OF "A WEEK ON THE CONCORD AND MERRIMACK RIVERS."

I do not propose to write an ode to dejection, but to brag as lustily as chanticleer in **the** morning, standing on his roost, if only to wake my neighbors up. — Page 92.

BOSTON:
TICKNOR AND FIELDS.
M DCCC LIV.

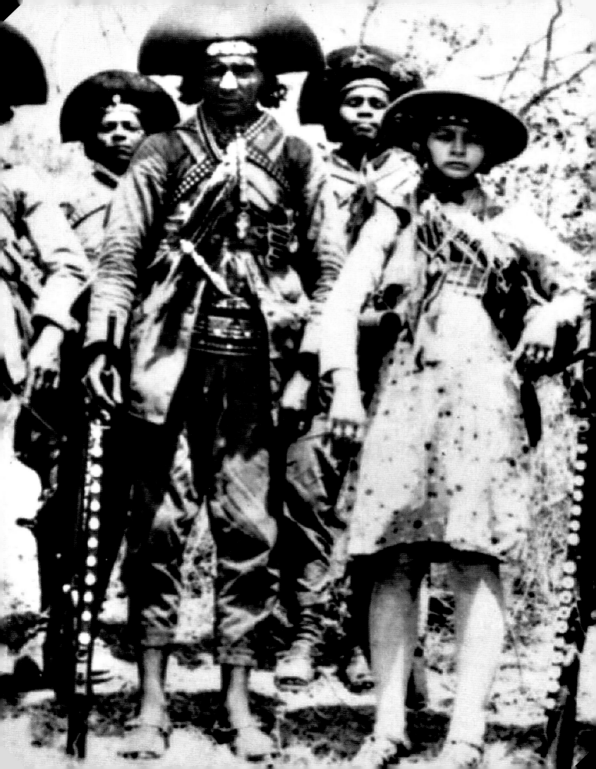

Lampião *(?–1938)* and Maria Bonita *(1897?–1938)*
The Bandit Lovers of the Sertão

Few outlaws have sparked such controversy. To some, Virgulino Ferreira da Silva, known as Lampião, was "a bandit who spread misery, a maker of widows and orphans, a scourge of virgins, a man who violated hearth and home, and whose psychological make-up gave the world the very picture of an exceptional individualist, capable of the very worst." To others he was, on the contrary, "a hero who took arms against a system of justice based on class, against the established military order and colonial society, to build a new counter-society, the *cangaço*."[27] Bloodthirsty bandit or legendary hero? Should we believe Lampião's detractors or his praise-singers?

At the beginning of the twentieth century, the Sertão was a hostile region of the Brazilian Nordeste, covering a million square kilometers, dotted with thorn bushes and twisted trees, and ruled by the *fazendeiros*. Far from the coast and central government, these vast landowners exercised unlimited power over their stock hands and laborers, through a mix of prestige, domination, cultivated dependency, and solidarity. Rivalries were fierce and perpetual; chattels and honor were defended with endless skirmishing. For these hardened souls, killing a neighbor was a lesser offence than stealing his cattle. Two armed powers confronted one another: the *cangaceiros* (those who carry their weapons on their shoulders like a yoke), who were mercenaries who sold their murderous services to the *fazendeiros* and local political chiefs, on the one side; and the "flying squads" who combated these outlaws in the name of the distant, much-despised government, on the other.

The third son of a family of nine children, Virgulino was born with violence, robbery, and crime in his blood; his grandfather and father had fled their native region of Ceara and changed the family name to escape justice and the police. Virgulino entered the world between 1893 and 1900 (the accounts of his life vary), in Vila Bela, in Pernambuco. He dreamed of an honest life, becoming a *vaqueiro* and living by his work, but at the age of seventeen he seems to have beaten to death a farm laborer employed by his family's neighbor, José Saturnino, following the theft of a cattle bell. The incident marked the start of a hellish downward spiral for Virgulino and his brothers, during which they were frequently forced to flee the vengeance of the Saturninos, spending periods in exile.

October 1917. The blood feud had become increasingly bitter, with both sides hiring *cangaceiros* with connections to their respective family clans. The police became caught up in the affair. What had begun as a private family quarrel was now an open conflict of regional and political importance. Lampião's father was killed by the members of a police flying squad, paying for his sons' misdeeds with his life. It was said in the Sertão that the "corpse of a victim continues to bleed until the assassin is punished." Virgulino's fate was sealed: "From this day forward, the gun and dagger shall be all our mourning! We shall seek revenge unto death." And speaking over his father's tomb, he added, "Henceforth, I am the *lampião* (lantern, in Portuguese)."

The new firebrand blazed a trail across the whole of the Sertão and the Brazilian Nordeste. Virgulino sought honor as a *cangaceiro*, enlisting in the gang of one Sinhô Pereira and eventually becoming its chief. From 1922 onward, popular songs published in cheap pamphlets (known as *cordels*) glorified Lampião's heroism and epic adventures, establishing him as a notorious public enemy. Intoxicated by violence, power, and wealth, Lampião preferred to establish a bloodthirsty reign over the whole of the Nordeste rather than acquit his debt of honor. He never avenged his father's death and routinely spared the lives of José Saturnino and José Lucena, his two worst enemies. The reason was simple. The rule of the Sertão stated that: "Once a bandit has secured his vengeance, he must relinquish the life of arms and leave the *cangaço*."

Sporting tortoiseshell spectacles, Lampião was a slightly built figure with the air of an overgrown college boy, fond of fancy clothes and military get-ups. The inhabitants of Juazeiro called him the "operetta Captain," a reference to his penchant for parading in the uniforms of the national guard. Photographs of Lampião by Lauro Cabral were widely distributed, showing him in a leather hat embroidered and decorated on both sides with pieces of gold, a military jacket, canvas trousers, puttees, and leather sandals, sporting a carbine, cartridge belts, and the distinctive attributes of the *cangaço*: the green neck scarf fastened with a gold ring, a broad dagger worn on the belt, a traveler's satchel over one shoulder, and fingers full of rings.

Beginning in 1929, Lampião's risky direct attacks on towns and large estates made way for simpler operations: extortion, and the kidnapping of leading figures and wealthy landowners for ransom. His name and reputation, founded on pillaging, arson, and murder, were enough to terrorize his victims, and he had no need to resort to further violence, as seen in a ransom note sent to a military colonel, Aristides Simoes de Freitas, in 1932:

> I am sending you this letter because I know that you can do [what I ask] and that as you know, I cannot work and am asking you for money… I hope that you will not fail to do [what I ask] because I would remind you that until now I have never touched your *fazenda,* nor those who belong to you. I trust that you will not disobey me…. [Signed: Captain Ferreira, *alias* Lampião.]

A significant change now occurred in the *cangaceiros'* way of life, encouraging them to settle: on Lampião's initiative, women were allowed to join each of the various gangs, as permanent members. In February 1930, Virgulino fell in love with Maria Déa, alias Maria Bonita, a former seller of fruit jellies (a traditional candy in the region). She was already married, and exceptionally beautiful and courageous. Maria Bonita had the "symmetry, grace, and charm of a precious gem, but her heart was as hard as she was beautiful." Bonita became Lampião's constant companion, and his second-in-command, never leaving his side until they were both killed, eight years later. Together, they have entered the legend of the Sertão.

Their deaths on July 28, 1938, mirrored the lives they led: theatrical, violent, and spectacular. The couple had

Autor: Alexandre José Felipe Cavalcanti d'Albuquerque Saboia Dilla - 445 D 17.
'MARECHAL do Cordel de Cangaço'
LAMPIÃO E MARIA BONITA
DILLA

"From this day forward, the gun and dagger shall be all our mourning! We shall seek revenge unto death."

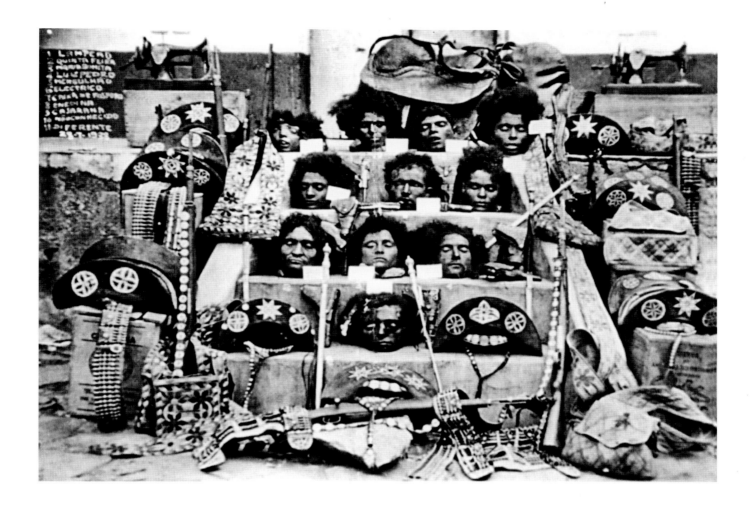

taken refuge in a cave with a single entrance, on the arid banks of the Angico River but was betrayed by a trusted collaborator, who brought supplies of poisoned food. Surrounded by the flying squad of Lieutenant Joao Bezerra, Lampião and Maria perished (according to an article in the periodical *A Noite Ilustrada*) in a hail of bullets. Woken from a deep sleep by the surprise attack, Lampião sprang to his feet like a wild demon, dagger in hand, but was strafed with machine-gun fire. The bandit dropped his weapon, spun around on the spot, and died instantly. When the soldiers made their victorious entry into the gang's hideout, they found nine bodies including that of a woman, her hair loose, a dagger in her hand. Maria Bonita had joined the love of her life in death. As an ultimate act of vengeance, the *cangaceiros* were decapitated, and their heads transported to Maceio, where they were exhibited as proof of the government's victory over their repressive reign of terror.

Today, they are preserved in formaldehyde at the Instituto Nina Rodrigues in the Brazilian city of Salvador.

Angel or demon, victim or murderer? The writer Rubem Braga has no doubt as to the verdict on Lampião's life: "For all his moral poverty, lack of conscience, and cruelty, Lampião is a hero, the one true, faultless hero. [...] The people do not love him just because he is brave and bad. [...] What he did reflects a certain instinct of the people. Behind Lampião's spectacles there was a thinker. His rough sandals trod sacred ground."[28]

Page 42: Lampião and his partner Maria Bonita, 1938.
Facing page: Lampião and Maria Bonita, Cordel, 1938.
Above: Heads of the Cangaceiros displayed as an exemplary warning.

They rebelled against hegemony over the seas

Corsairs one day, pirates the next, known as freebooters by some, buccaneers by others. But all members of the great family of global adventurers. All suffered terrors and hardships, all pursued the same quest for riches and the freedom of the world's wild places, all stood firm against injustice and the established social order. In the name of liberty, these maritime rebels fought with loathing and desperation in equal measure, against a common enemy: the Catholic and Iberian hegemony of the high seas.

The history of these denizens of the ocean is intimately linked with the Old World's insatiable appetite for seasoned food. From the thirteenth century onward, maritime expeditions set out from Europe to bring pepper, cloves, ginger, camphor, cinnamon, and nutmeg from India and China, to discover new sea routes, and to harvest gold and exotic fruit from unexplored lands.

At the dawn of the fifteenth century, a series of papal bulls led to the drawing of a line running north-south between the poles, splitting the world into two: Portugal was granted rule over colonies and new lands discovered in India, southeast Asia, and China; Spain was given the Americas (with the exception of Brazil) and the Pacific. The other crowned heads of Europe got nothing, although Spain and Portugal were not to claim any territory already in the hands of a Christian ruler by 1492, the date of Columbus's arrival in the New World. This breathtakingly arrogant ruling, known as the Treaty of Tordesillas, after the city where the Iberian ambassadors met in 1494 to affirm the division, provoked the fury of François I of France: "The sun shines for me as for the others; I should like to see the Old Testament clause that excludes me from this sharing out of the world." And so the great history of piracy was launched bringing violence, swashbuckling ship captures, high ideals, and blood in its wake.

Excluded from the papal settlement of the high seas and lacking funds for the establishment of significant royal fleets, the French, English, and Dutch monarchies of the day turned to the owners of private armed ships (known as privateers or corsairs), issuing them with letters of commission authorizing them to attack enemy vessels and seize their cargos by force or cunning.

Ordinary seamen operating out of Europe's major western ports (Dieppe, Honfleur, La Rochelle, Bristol, Plymouth, or Amsterdam) were quickly overwhelmed by the task, recruiting in turn crews of hard-boiled sailors, men with no family ties who were ready to fight for rich, if uncertain, rewards. This new class of mariner included Dutch and English freebooters (from the Dutch term, *vrijbuiter*, meaning "plunderer"—literally "he who takes free booty"); buccaneers (from the French term, *boucanier*, because they came from among the former slaves based on the Caribbean islands of Saint-Domingue (Haiti) and Tortuga who earned their living selling beef and wild pig meat smoked on wooden grills, known as *boucans*); and finally pirates, true outlaws operating for personal gain. All declared open season on the Spanish. The promise of booty and the notion of "every man for himself" glorified their harsh lives (in reality little better than the condition of galley slaves), transforming every man into a hero fighting injustice. Initially confined to the chilly waters of Europe's Atlantic coast, the struggle soon extended to the turquoise waters of the Caribbean, and later the dark reaches of the Indian Ocean. Consumed by their burning desire for independence and freedom, some were inspired to establish their own utopian states on land, founded on absolute equality, with no distinction of nationality, color or class—fledgling republics where freed slaves were granted the same rights as their pirate brethren.

The pirates' reign was brief, however. Established order and the emerging colonial powers soon forced the surrender of their saber-rattling adversaries. Still, a handful of die-hards—those who had escaped the noose or the guillotine—fought on in defense of the principles so dear to the notorious Welsh pirate Bartholomew Roberts: "In an honest service there is thin commons, low wages, and hard labor. In this, plenty and satiety, pleasure and ease, liberty and power.... A merry life and a short one shall be my motto."[29]

The Black Sail and the Call of the High Seas

"Alive today, dead tomorrow, what does it matter whether we hoard or save.
We live for the day and not for the day we may never live."
Alexandre-Olivier Exquemelin, pirate-surgeon, *Histoire des aventuriers filibustiers,* 1686

Jehan Ango (1480–1551)
The Shipowner and Privateer
(The English Channel and the North Sea)

"It is not I who wages war against you, but Ango. Seek a settlement with him!" François I of France's laconic reply to Charles V of Spain encapsulates all the dupery and ambiguity of piracy. The Spanish King had good cause to be furious. Sailing home from the New World, a convoy of three ships—including the flagship commanded by Admiral Alonso de Avila—had been bombarded. Two of the vessels lost their masts off the coast of Cape Saint-Vincent (on Portugal's Algarve coast), tantalizingly close to Seville. Their assailant was the French mariner Jean Fleury, a corsair financed by the Dieppe-based privateer Jehan Ango. Fleury made off with a fabulous booty: 685 pounds of Aztec pearls, 507 pounds of powdered gold, three chests of gold ingots and ten of silver, more chests filled to the brim with gems and jewelry, and above all, the priceless logbooks and maps of the great Cortès, giving Ango access to the sea routes to the West Indies, South America, and the Aztecs.

At the height of his powers, Ango negotiated with kings, but he was eventually brought to ruin by François I, jealous of his power, his magnificent residences and his sumptuous, ostentatious lifestyle. Yet Ango's rise to greatness and riches had been painstaking and slow.

From his birth in Dieppe in 1480, this son of a fishing captain had saltwater in his veins. His father had become wealthy fishing for cod off the coast of Newfoundland before becoming a shipowner in his own right, operating along the sea routes to Africa and Asia. When, in 1494, the Treaty of Tordesillas halted his quest for gold and spices; his young son was appalled at the arbitrary nature of the "settlement." Excluded from the great papal carve-up, the Ango family's ships, sailing under the French flag, were officially banished from the waters of the Atlantic and Indian oceans.

Jehan learned his sea lore at the age of twenty-three, becoming an officer and captain of the *Espoir* before discovering the thrill of the chase and life as a corsair. On the death of his father, he decided to develop his inherited fleet. He settled on the seafront in Dieppe, in a sumptuous mansion renamed *La Pensée* in honor of the first of his ships to reach America, in 1508. His physical appearance was hardly impressive—he was stocky, with a large head and bright red cheeks that were adorned by a beard and angelic curly blond hair—but his strategic brilliance, foresight, and piety made him a prince of the Renaissance.

Deprived of access to the warm southern seas by the papal bull, Ango ordered his renowned corsair captains—Jean Fleury, Jean Fain, Michel Ferré, Sylvestre Bille, Guyon d'Estimauville, and Nicolas de Croismare—to wait off the coast of Spain and Portugal for returning Iberian expeditions loaded with spoils from distant shore, and, armed with letters of commission, to take possession of their cargoes.

Ango was a smart operator whose tactics paid off: his warehouses overflowed with riches, allowing him to act as banker to François I himself. He enjoyed close financial ties to the French monarch and, as the maritime scourge of Charles V of Spain, he found himself drawn into a full-scale private war between the two Catholic kings.

It was a dirty fight. In 1522, Ango's captain Jean Fain—in command of the *Marie*—was captured by four Portuguese ships, after carrying off the cargoes of five Spanish galleons loaded with gold and silver. He narrowly escaped hanging. Five years later, Jean Fleury was less fortunate. After a desperate fight, he was captured by the Spanish and was made to pay for his repeated assaults against the Iberian powers with his life. In 1537, the Portuguese captured Ango's ship the *Petit Lion* off the Azores. Its officers were tortured and "thrown into the sea from the top of masts then subjected to the *strappado* [dipping into the sea from the yard arm] before tasting a special kind of garroting, with

the addition of nails clamped to the head, so that their eyeballs sprang from their sockets."[30]

Obstinate and embittered, Ango had no intention of submitting to the dictates of Rome and renouncing the fabulous riches of Asia and the Caribbean. Gathering about him the finest hydrographers, astronomers, mapmakers, and geographers of the age, he tried to use, with mixed success, his accumulated wealth to poach Spanish and Portuguese adventurers and captains. In 1530, two of Ango's new recruits, the Parmentier brothers, broke through the Iberian blockade aboard the *Sacre* and the *Pensée*, reaching the shores of Sumatra and China.

Ango now headed a fleet of thirty ships, terrorizing the whole of Europe and making enemies of its monarchs. Unable to defeat him on the high seas, John III of Portugal tried to break his invincible adversary with cunning and corruption. He bribed the French high admiral Brion Chabot—with ten thousand écus and a priceless tapestry—to convince François I to withdraw his support for Ango, thereby reducing the venerable corsair to the status of a common pirate, with no royal protection. Unbowed, despite this betrayal, Ango remained loyal to his sovereign,

and accepted an official role helping Jacques Cartier in his conquest of Canada. In 1544, after the signing of the Treaty de Crépy-en-Laonnois with Spain, Ango responded to a request from François I to send his ships into combat against the English fleet of Henry VIII. His loyalty would lead to his downfall.

After a ruinous ten-year war, the English triumphed. François I died in 1547, leaving his son Henri II to repay a colossal debt to Ango—a debt he refused to honor, despite numerous law suits.

Jehan Ango died in 1551, ending his days as a recluse in his manor house at Varengeville, a ruined man, gazing at the sea that had given him everything, and taken it all away.

Page 48: Jehan Ango and François I, print by Jules de Caudin, 1852.
Below: Jehan Ango opposite a corsair, illustration by Zier, taken from the Journal des voyages, 1899.
Facing page: Replica of the letter issued to captains and private ship-owners under the Directoire, 1795–99.
Following pages: Map of South and North America, 1713.

Liberté. *Egalité.*

République Française.

Lettre de Marque.

Le Directoire exécutif permet, par la présente, à de faire armer et équiper en guerre un nommé le du port de tonneaux, avec tel nombre de canons, boulets, et telle quantité de poudre, plomb et autres munitions de guerre et vivres qu'il jugera nécessaire pour le mettre en état de courir sur tous les Ennemis de la République, et sur les Pirates, Forbans, gens sans aveu, en quelque lieu qu'il pourra les rencontrer, de les prendre et amener prisonniers avec leurs Navires, armes et autres objets dont ils seront saisis; à la charge par de se conformer aux Ordonnances et Lois concernant la Marine, et notamment aux Lois des 31 janvier 1793 (v. st.) et 23 thermidor an III, concernant le nombre d'hommes devant former son Équipage; de faire enregistrer la présente Lettre au Bureau de l'Inscription maritime du lieu de son départ; d'y déposer un rôle signé et certifié d et du Capitaine, contenant les noms et surnoms, âges, lieux de naissance et demeure des gens de son Équipage; et à la charge par ledit Capitaine de faire, à son retour ou en cas de relâche, son rapport par-devant l'Administrateur de la Marine.

Le Directoire Exécutif invite toutes les Puissances amies et alliées de la République française, et leurs Agens, à donner audit Capitaine toute assistance, passage et retraite en leurs Ports avec sondit bâtiment et les prises qu'il aura pu faire, offrant d'en user de même en pareilles circonstances. Ordonne aux Commandans des Vaisseaux de l'État, de laisser passer ledit avec son bâtiment et ceux qu'il aura pu prendre sur l'Ennemi, et de lui donner secours et assistance.

Ne pourra la Présente servir que pour mois seulement, à compter de la date de son enregistrement.

En foi de quoi le Directoire Exécutif a fait signer la présente Lettre de Marque par le Ministre de la Marine et des Colonies.

Donné à Paris, le l'an de la République Française.

Mille..lly

Par le Ministre de la Marine et des Colonies,

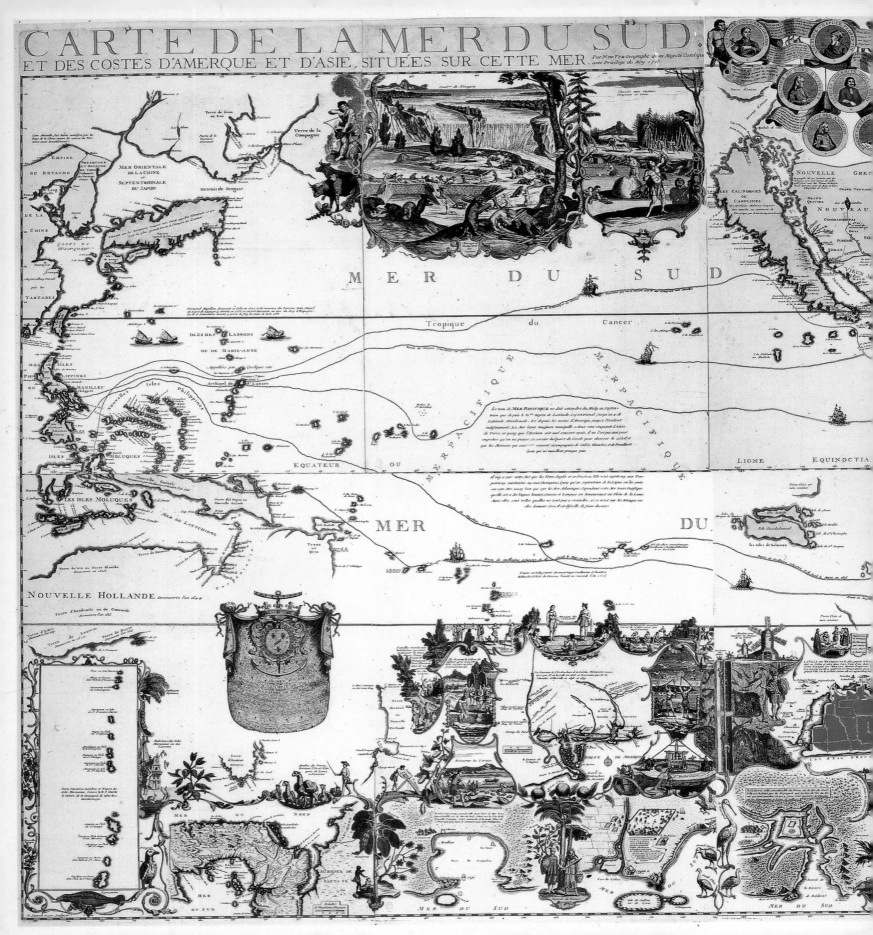

CARTE DE LA MER DU SUD,

ET DES COSTES D'AMERQUE ET D'ASIE, SITUÉES SUR CETTE MER

Par N. de Fer Geographe de sa Majesté Catolique
avec Privilege du Roy 1713.

MER DU SUD

MER DU SUD

Tropique du Cancer

MER PACIFIQUE OU MER PACIFIQUE

EQUATEUR OU LIGNE EQUINOCTIA

MER DU

NOUVELLE HOLLANDE

GOLFE DE MEXIQUE

MER DU NORD

MER DU SUD

MER DU SUD

MER DU SUD

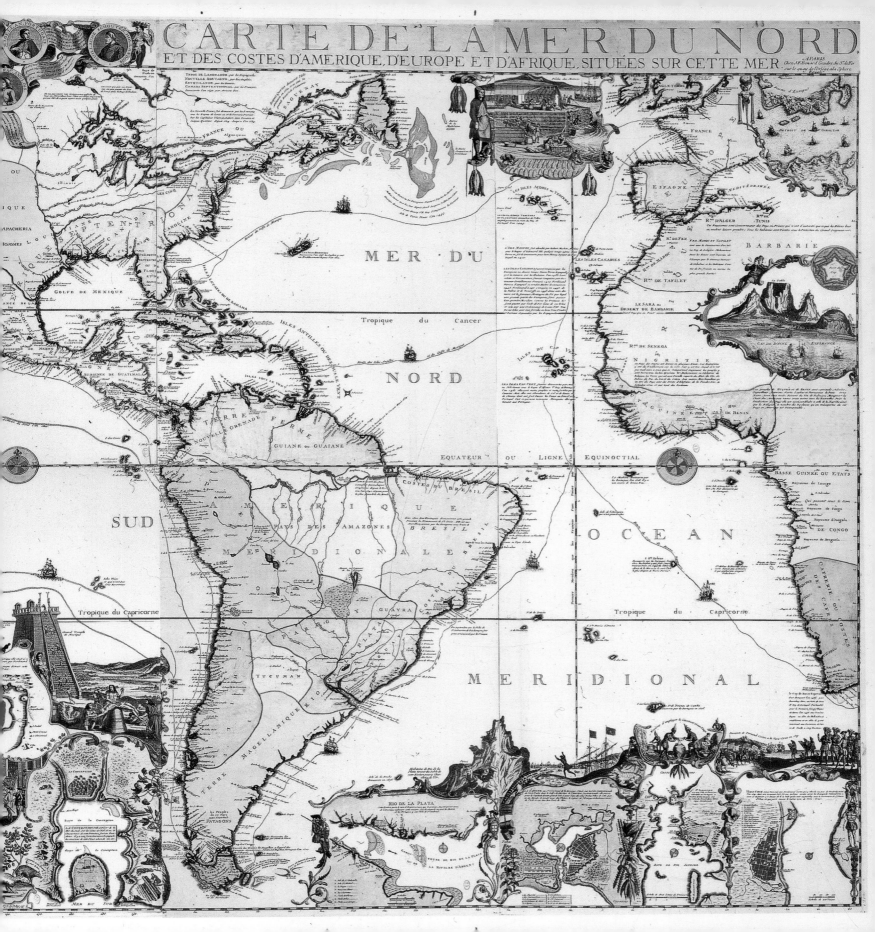

The Barbarossas (1467–1546)
The Pirate Geniuses of the Mediterranean

Spring 1504. Pope Julius II ruled supreme over Rome and the Mediterranean coast, eyed jealously by the Barbary Turk, his new enemy in the wars of religion. Suspicious of his eastern neighbor, His Holiness ordered two powerful galleons to escort a precious convoy of merchant vessels from Genoa to the nearby port of Civitavecchia. The flag-ship lookout signaled a suspicious presence to starboard, and one of the papal galleons sailed out to meet and intimidate it. The stratagem worked: the papal ship, albeit superior in arms, had sailed into a trap. A horde of freebooters burst from between-decks on the enemy boat, clutching scimitars in their fists. Commanded by a stockily built captain with a red beard, they quickly took control of the papal galleon. Stripped of their uniforms, Julius's sailors and soldiers were left naked and bound in the hold, while the pirate crew swapped their turbans and flowing pantaloons for more respectable Christian garb. Towing their own skiff behind them, dressed and acting for all the world like the Pope's own men, the captured ship's pirate masters headed back to its sister galleon, where they received a hero's welcome. The cheers were short-lived: Barbarossa and his companions quickly boarded the second papal ship, and the merchant vessels under its protection.

Through cunning and bloodshed, a master pirate had entered the history books forever. This skill at covering their tracks typified the tactics of the pirate brothers Oruç and Hizir Hayreddin, celebrated for their visionary genius and exemplary courage, and both known to the world as Barbarossa (Redbeard), a name inherited by Hizir from his older brother, after the latter's death. The brothers were born on what is now the Greek island of Lesbos, to a Turkish Balkan refugee by the name of Yaqub Reis. Under Ottoman rule, the family took Turkish nationality and converted to Islam. Driven by their hatred of the Spanish and Portuguese, who had begun to attack North Africa in the early sixteenth

century, the brothers recruited Turks and Muslim Spanish immigrants to their cause: the establishment of a dominion on the North African coast. During one of their forays, Oruç was arrested by the Turks, imprisoned and sentenced to the galleys, before being ransomed by Hizir. To free Oruç from the Turkish janissaries, Hizir gathered a band of die-hards, inspiring them with his acts of bravura to attack Christian ships and steal their cargoes. The Turks demanded an enormous ransom for Oruç, and it was several years before he was freed and able to take the helm of his own ship once more.

Reunited, the brothers plied the Mediterranean, scoring significant victories and even capturing a Spanish galley transporting a governor, ten gentlemen of the royal court, a hundred soldiers, and a sizeable booty. This brilliant operation cost Oruç an arm, however, marring his triumphal return to Tunis with the hoard of prisoners and precious gems. Hizir took the honors, and the prestigious title of Kheir-ad-Din—"protector of the faithful"—while Oruç remained the family strategist. In 1516, the brothers answered a call for help from the inhabitants of Algiers to curb Spanish ambitions in the region. While Oruç marched on the city with an army of five thousand men, Hizir used his fleet to blockade the port against enemy ships. Their victory was total. Oruç slit the throat of the Ottoman emir Selim al-Teuni (while the latter was in his bath) and took control of the city. His endless thirst for power and his determination to conquer only hastened his undoing, however.

Tired of Oruç's excesses and expansionist dreams, the Algerians allied with Charles V of Spain to drive him out. Oruç died fighting with his troops on the banks of the Huerda. The legend tells how, in a final stroke of cunning, he tried to slow down his pursuers by scattering pieces of gold and silver behind him as he fled.

But history and the Spanish emperor had not heard the last of "Barbarossa." Hizir (Kheir-ad-Din) determined

to take back the city of Algiers and rekindle the family flame. He destroyed the Spanish armada, captured the city, and delivered it into the hands of the Turkish sultan Selim I "the Grim." As thanks, he received the title *beyler-bey* (the bey of beys).

In 1841, a French history about life on the high seas described Hizir as follows:

> His eyebrows were bushy, his beard was thick and his nose was fat and coarse. His lower lip was large, protruding, and scornful. Of medium height, he was nonetheless gifted with Herculean strength, so that he was able to hold a two-year-old sheep in one hand, at arm's length. […] Intelligent and bold in attack, farsighted and resolute in defense, inexhaustible at work, impervious to setbacks: so many remarkable qualities, tarnished by his bouts of cold, pitiless cruelty.

For seventeen years, Kheir-ad-Din controlled the western Mediterranean, to the vast displeasure of King Charles V of Spain. Appointed by the Ottoman sultan to the post of admiral-in-chief of the Turkish fleet, Kheir-ad-Din crossed the path of a redoubtable adversary: the Genoan corsaire Andrea Doria, a man who was always ready to sell his services to the highest bidder. Following an initial defeat off the coast of Messina, the Ligurian captain went on to take Tunis for Charles V on July 21, 1535. The Spanish king entered the city in triumph, while Barbarossa slipped away quietly. The two met once again on September 25, 1538, at Preventa on the western Greek coast. Kheir-ad-Din deployed all of his considerable forces in fighting the battle, forcing Doria to flee. The whole of the Mediterranean now lay under Barbarossa's control.

In 1543, François I, the sworn enemy of Charles V, sided with the new Ottoman sultan Suleyman I, called

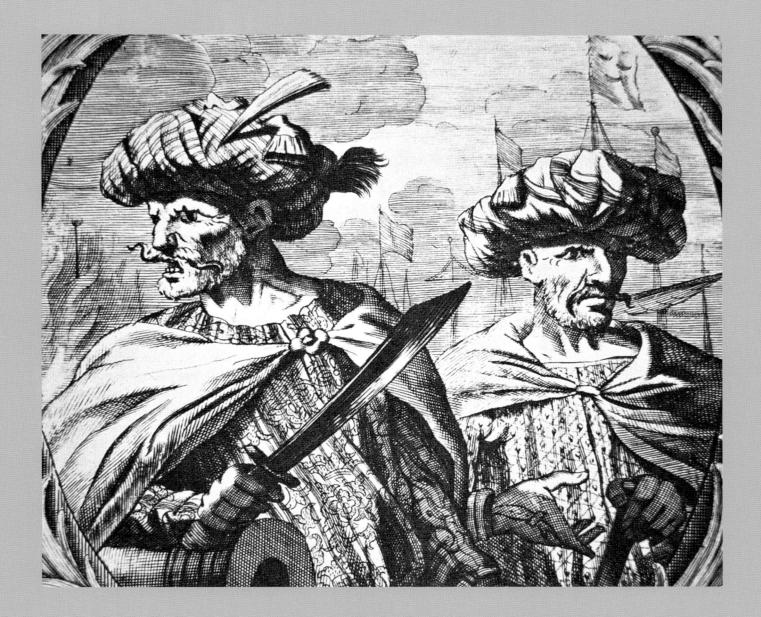

"the Magnificent." Barbarossa's ships blockaded Nice (then a protectorate of the counts of Savoy) on behalf of François I, capturing and pillaging the city. When the French king refused to honor the debt contracted in exchange for this muscular intervention, the aging pirate exacted his own payment, with repeated attacks and raids along the French Mediterranean coast, until François acquitted Suleyman of every last écu of the debt.

When the youngest Barbarossa died in the summer of 1546, his reputation for cruelty was eclipsed by his past history as a maritime hero, and a keen military and political strategist. Together with his elder brother Oruç, he went down in history as a Muslim pirate of genius.

Page 54 : Kheir-ed-Din, known as Barbarossa,
print by Agostino Veneziano, 1535.
Facing page: **Barbariae and Biledulgerid, nova descriptio,**
map of North Africa, 1570.
Above: **The Barbarossa brothers, 17th-century print.**

Sir Francis Drake (1542–1596)
The Dragon of the Atlantic and Pacific Oceans

The scene takes place on the River Thames. Wreathed in glory, Francis Drake has returned to England from his voyage around the world, after pillaging Valaparaiso and losing five of his six ships, his hold full of extraordinary riches. Smarting from his attacks, the Spanish have complained to Elizabeth I of England who, showing her customary flair for diplomacy and double-dealing, has invited the Spanish ambassador Mendoza to accompany her aboard Drake's ship, the *Golden Hind*, ostensibly to demand reparations from her celebrated privateer. Kneeling, Drake greets the Queen on board ship. The Queen draws her sword. Drake, too proud to beg for mercy, awaits his punishment, unflinching. But instead, under the ambassador's astonished gaze, the Queen embraces her servant and dubs him a knight of the realm: "Arise, Sir Francis!" The Queen's spectacular act of ennoblement was Drake's reward for thirty years of bloodthirsty, loyal service to the Crown.

Francis Drake's fabulous destiny was closely linked to his kinship and complicity, sealed on the harborfront at Plymouth, with his cousins, the slave traders William and John Hawkins (ten years his seniors). These intrepid young sea-dogs were unrelenting in pursuit of their prey: the gold, silver, pearls, and spices amassed by the Spanish conquistadors and sent back across the Atlantic in sea convoys under papal escort. Ready to risk all for their Queen, who dispensed honors, finance, and letters of commission, the privateers set out for the New World in a spirit of cunning and cold blood. Their motto, borrowed from another Plymouth privateer, Sir Walter Raleigh, was, "Whosoever commands the sea commands the trade; whosoever commands the trade of the world commands the riches of the world, and consequently the world itself."

The group's first expedition was launched in October of 1562. John Hawkins commanded the fleet; Drake served as an ordinary seaman. Financed by Pedro de Ponte, a Genoese merchant living in Tenerife, the cousins made a first stop in Sierra Leone where they loaded three hundred slaves into the hold, "like spoons in a drawer," for resale in Hispaniola at forty ducats a head, before heading home to Plymouth.

A second, more turbulent voyage took place the following year, with the blessing of Elizabeth I. The two privateers sailed for the island of Margarita off the coast of Venezuela, and from there to the Huguenot settlements in Florida, provoking a violent reaction from the *Casa de Contractation* and Philip II of Spain, furious at the sight of English ships infiltrating their closely guarded territory. A third expedition, launched in 1567 with Hawkins commanding the fleet at the helm of the *Jesus of Lübeck* and Drake as captain of the *Judith*, tested the two men's friendship. Hawkins suspected Drake of abandoning him in dire circumstances during a heroic confrontation between the English ships and the Spanish Golden Fleet in the harbor of San Juan de Ulua; they were reunited, however, by their mutual hatred of the Spanish and their common desire for revenge.

Henceforth, John Hawkins—a more measured, austere figure—took charge of finance and supplies, while his cousin—an unscrupulous, amoral adventurer now nicknamed *El Drague* (the Dragon) by the Spanish—blazed a trail in the Caribbean. No more out-and-out confrontations on the high seas with the powerful Spanish fleet— Drake launched a series of surprise attacks from uninhabited islands, followed by furtive evasion into coves inaccessible to the Sevillan ships with their deep holds.

From 1571 onward, Drake studied the expert methods of French pirates and privateers aboard his ship the *Swan*, a shallow-bottomed 25-ton pinnace. Drake proved a diligent pupil, top of the class for sheer obstinacy. Operating without royal backing, he became an exemplary pirate, always on the look-out, and impervious to danger. With supplies and ship morale at their lowest ebb, Drake

encountered Guillaume Le Testu—a French adventurer and cosmographer—off the island of Cativas. The two joined forces and, with the help of a band of *cimarrons*—"maroons," or escaped slaves on the run—they succeeded in intercepting a jungle convoy of gold, silver, and pearls heading through Panama to Nombre de Dios, where the Sevillan fleet lay waiting to receive it. Le Testu lost his life on the trip, but Drake returned to Plymouth on August 9, 1573, his holds full and his honor intact.

The signing of the Treaty of Bristol between England and Spain, in August 1574, made El Drague an outcast from the New World and the English court. Once again, Drake became a private pirate and pariah. To reinstate his reputation, and perfume himself in the royal odor of sanctity, he embarked on a professional military career in Ireland, earning forty-six shillings a month. His desire for recognition was equaled only by his ferocity. The palace doors—and the Queen's personal coffers—were thrown open to him once more following his conquest of the island of Rathlin.

Drake's new project remained a secret until December 1577: he would cross the Atlantic, sail through the Magellan Strait, head north along the Pacific coast of south America, loot gold and silver from the Indies and Peru (then under Spanish rule), and return to England via the Pacific, the Indian Ocean, and the Cape of Good Hope.

Fortune smiled on Drake as he lay at anchor off the Cape Verde Islands. He succeeded in capturing the *Santa Maria*, commanded by Captain Nuno da Silva, a mariner with detailed knowledge of the South American coastline. But three of Drake's ships—the *Swan*, the *Christopher*, and the *Mary*—were burned or otherwise destroyed as they made their way south along the Brazilian coast. Upon arrival in Port San Juan, Drake tried and executed his associate Thomas Doughty for attempted mutiny, and demoted all of his officers to the rank of common seamen. On August 21, 1578, in the depths of the southern winter, Drake entered the perilous waters of the Magellan Strait with his three remaining ships, the *Pelican* (renamed the *Golden Hind*), the *Marigold*, and the *Elizabeth*. Seventeen days of hell lay ahead, at the entrance to the Pacific Ocean. An apocalyptic storm separated the three boats; the *Marigold* sank with its cargo and all hands, the *Elizabeth* turned back and headed for England under pressure from her crew, but the *Golden Hind* carried on alone.

Drake and his eighty-strong crew pursued their treasure hunt along the coasts of Chile and Peru. Their Spanish enemies were unaccustomed to the presence of an English ship in these distant waters, and the pirates now sprang a series of surprise raids, seizing 3,000 silver ingots on February 2, thirty silver ingots and a cargo of wine on February 5, eighty pounds of gold, a golden crucifix and emeralds as long as a man's finger and 22,000 silver pesos on February 28. On March 1, Drake confiscated the abundant cargo of the *Nuestra Senora*: exotic fruits, preserves, sugar, jewelry and precious gems, thirteen chests of silver coin, 80 gold ingots, and 1,300 bars of silver. Furious at the spoils, the Spanish issued a general alert, while the insatiable Drake seized a merchant ship with

"The master-thief of the unknown world"

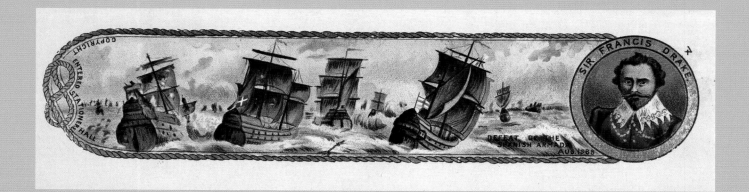

To the weste of this Lande 3. leags of is a lowe pointe and from that pointe you haue 5. leagues to / Nombra de Deos /

one hill. South The other hill.

S.S.E.

A rock

30 or 3 L. of to se.

The marcke of thes too hilles one maie knowe by this representacion, This Lande is parte of the Terafirma. and parte of the necke of the Lande by Nombra de deos / 8. leagues to the westar is Nombra de deos from this place. and to the eastuardes of this place theare are many Jlandes longeste the coaste This Rocke is also a marck unto you to knowe whether ye be yet com to Nombre de Deos or no /

West

W. B. N.

Rock Jland.

S.S.E. 9. degres 30. m. N. N. W. Jland.

Jland.

4. leagues of at see.

This head lande heare representid is the Cape which lies to the westuardes of Nombre de Deos som to leags. or as I saie the westarde Cape of the Baie of Nombre de Deos. by the forme of this Lande or Cape it is a verisoficente marke to knowe wheare you be (Imeane for Nombre de Deos Jlandes Lickwise are a principall marck. The fourme of the baie with some of the easterne coaste theare set doune in platewise /

The toune of Nombra de Deos.

Baie of Nombre de Deos

In this place the Compas varieth 22 Degries or uert nighe 2 pointes of the Compas as it is in the heithe of 8. Degries /

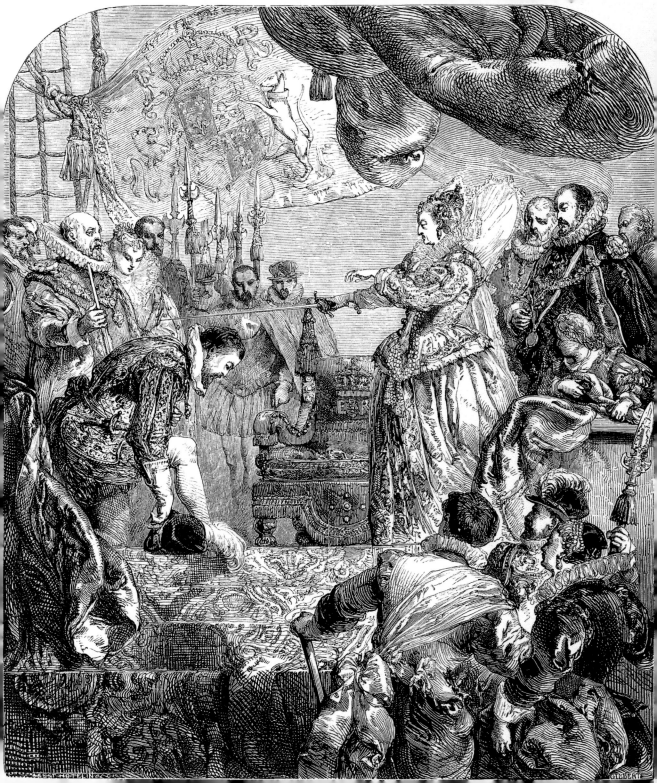

empty holds but a cabin furnished with a rich store of charts and navigational instructions, together with two experienced pilots familiar with the sea route through the Moluccas. Drake watered his ship and took on supplies off the coast of California. Seized with sudden piety and repenting his recent piratical exploits, he set sail for the Spice Islands, negotiating a deal on the spice trade with a friendly local sultan. But on January 8, 1580, the *Golden Hind* struck a reef between two islands in the Celebes; according to some accounts, the event led the ship's chaplain Francis Fletcher to denounce Drake "as one whose crimes of murder and lust had brought down Divine vengeance on all the company."[31] The Indian Ocean is kind to navigators, however: a high tide and a stiff breeze

lifted the ship into open waters. Drake called in at Java then rounded the Cape of Good Hope, anchored for a time at Guinea, and returned to Plymouth, his home port, on September 26, 1580, after a voyage lasting two years, nine months, and thirteen days.

Drake was now the richest man in England, dubbed the "master-thief of the unknown world,"[32] and the first mariner to return home alive from a circumnavigation of the globe. He would cement his unfailing fame with his courageous and triumphant involvement, as captain of the *Revenge*, in the English defeat of the Spanish Armada in 1588. His name lives on in history as the greatest ocean navigator of all time.

Page 58: Sir Francis Drake, c. 1540.
Page 60: The English fleet defeat the Invincible Armada under Sir Francis Drake's command, 1588.
Page 61: Sir Francis Drake's log, 1598.

Facing page: Elizabeth I, Queen of England, knighting Sir Francis Drake, print based on a drawing by Gilbert, 19th century.
Above: Map of the Pacific Ocean by Hessel Gerritz, official cartographer for the Compagnie des Indes orientales, 1622.

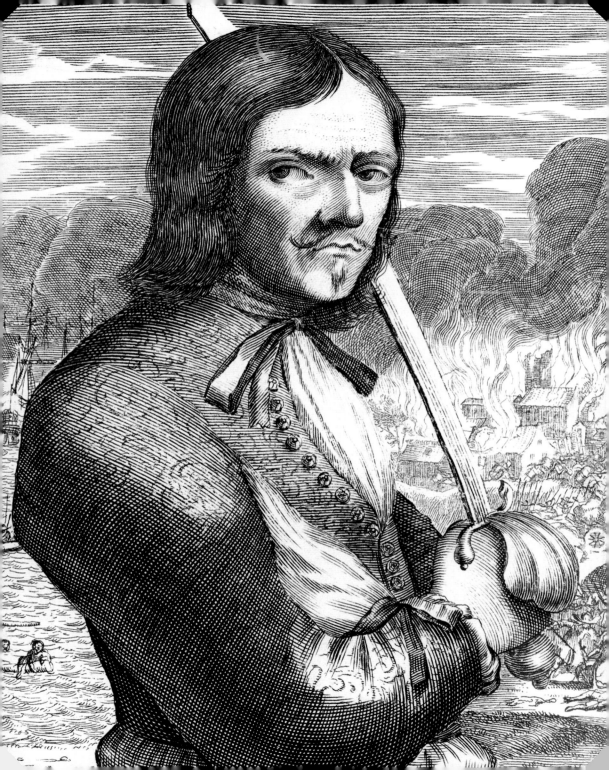

François l'Olonnais (1630–1671)
The Cruel Pirate
(Hispaniola and the West Indies)

Pirates are no saints, but it's a rare adventurer who goes down in history purely for his cruelty. Jean-David Nau—known as François l'Olonnais, for his home town of Les Sables d'Olonne in the French Vendée region—is one such, and the cruelest of his kind. Legend tells how, "possessed of a devil's fury," he once ripped open a prisoner's chest with his cutlass, "tore the living heart out of his body, gnawed at it, then hurled it in the face [of another captive]."[33] Born in 1630, Nau was an unloved, unhappy child. His early tribulations doubtless contributed to his sickening notoriety but in no way excuse his horrific, murderous career.

At the age of twenty, like many other young peasants, Jean-David Nau decided to escape poverty and sail for the West Indies. He endured three years of slavery as a bonded laborer for a plantation owner in Saint-Domingue (now known as Haiti)—the price of his uncomfortable transatlantic crossing—before enjoying a fleeting taste of freedom as a buccaneer. His visceral loathing of the Spanish sprang from this precarious existence, living in the forests hunting wild pigs and hiding from the *lanceros*, who burned their luckless captives alive.

Nau sooned tired of this drab subsistence. The former slave answered the call to adventure, heading for the neighboring island of Tortuga and a life of piracy, eager to exercise his talents as an outlaw on the high seas. A novice in the subtle art of navigation, he lost his first ship as captain in a sudden squall, but his courage and determination persuaded the French interim governor of Tortuga, Frédérick Deschamps de La Place, to give him a new vessel.

His hatred of Spain and his barely contained cruelty now boiled over into an infernal crescendo of violence. L'Olonnais was captured during an attack by the Spanish and survived only by the repulsive strategy of smearing himself in blood and hiding beneath the corpses of his companions, all of whom had been mercilessly exterminated. With the help of a handful of slaves, he returned to Tortuga in a rowing boat, armed a third galleon with the governor's support and headed for Cuba, where he laid waste to the port of Los Cayos, capturing a Spanish frigate sent to assassinate him. In a mad fit of rage, L'Olonnais had every prisoner decapitated, with the exception of one, whom he sent to the governor of Cuba with his comrades' heads, and a letter couched in the clearest of terms, "Rest assured, Governor, that in the future any Spaniard falling into my hands will suffer the same fate. Perhaps even you will experience it yourself; this would be justice, indeed, and a great pleasure for me."

From now on, nothing stood in the way of L'Olonnais's thirst for vengeance and blood. Evil attracts evil. In 1666 he joined forces with Michel d'Artigny—a French outlaw of the same water, nicknamed "the Basque"—and attacked Maracaibo, a Venezuelan town at one end of the lake of the same name, linked to the sea by a narrow channel defended by a small fortress. Together, the pair recruited four hundred and fifty men, and armed a fleet of five ships, including two vessels loaded with arms and cocoa, renaming them with a touch of wry humor, *La Poudrière* and *La Cacaoyère* (The Powder Keg and The Cocoa Keg). L'Olonnais was installed as admiral of the expedition, with the Basque taking charge of operations on land. The expedition, notorious for its savagery and cunning, had multiple repercussions. After neutralizing the fort and entering the town, the pirates realized that it had been deserted by its inhabitants, all of whom had fled with their riches to the neighboring stronghold of Gibraltar, protected by eight hundred Spanish soldiers who were armed with twenty cannon. The two accomplices were twice repulsed but eventually took the fortified bastion by cunning: the pirates sounded the retreat, made a show of disbanding, and hid in the surrounding jungle, pursued by the besieged townspeople, who were now certain of their victory. L'Olonnais engineered a

cunning about turn, capturing them from behind and gaining possession of the citadel, now empty of its military guard. The pillaging and massacres lasted for six weeks. The Spanish lost five hundred men, while the pirates escaped with just forty dead and thirty wounded and gained both 360,000 écus and a ship loaded with tobacco.

Pirate lore dictates that "pirates take with violence, and distribute with generosity." Back on Tortuga, L'Olonnais and his comrades respected the ruling to the letter, spending their booty while it lasted on feasting, drinking, and women.

Nau was soon penniless and set to sea once again on May 3, 1667, at the head of a fleet of six ships with a crew of six hundred freebooters, bound for Spanish Nicaragua. His luck turned with the winds, however, and the pirates found themselves drawn into the inhospitable waters of the Gulf of Honduras. The famished men explored the Zague River in canoes, attacking the huts of the native tribes (referred to as "Big-Ears") and pillaging their supplies of corn. The hatred they engendered soon turned against them. Ravaged with hunger, the pirates sailed on to Puerto Caballo but found empty warehouses and stores everywhere they went. The rest was a bitter succession of failures, bad luck, and desertions. Seized with rage, L'Olonnais massacred anyone who showed resistance and tore out the tongues of those who refused to talk. At last, the long-awaited sails of the *Houque des Honduras* appeared on the horizon; the pirates' frenzy was matched only by their disappointment. Seizing the imposing seven-hundred-ton vessel, they found its hold loaded with twenty thousand bales of paper and a cargo of iron bars.

L'Olonnais wandered from island to island with his last remaining loyal men, before running aground on a reef just below the water at the mouth of the San Juan River in Nicaragua. The survivors spent ten months building a longboat from the debris of their ship, but their hope was short-lived. Harassed by the local tribes, who were allied to the Spanish, the pirates were forced to flee to Costa Rica and, finally, to the gulf of Darién. L'Olonnais went ashore in search of food and fresh water but was captured—in an act of poetic justice—by the local Indians, who "tore him in pieces alive, throwing his body limb by limb into the fire and his ashes into the air; to the intent no trace nor memory might remain of such an infamous, inhuman creature."[34] In his seventeenth-century history of the *Buccaneers of America*, the pirate-surgeon Alexandre Exquemelin delivers a damning verdict: "Thus ends the history of the life and miserable death of that infernal wretch L'Ollonais [sic] who, full

of horrid, execrable and enormous deeds, and also debtor to so much innocent blood, died by cruel and butcherly hands, such as his own were in the course of his life."

In his *General History of the Pyrates* Captain Johnson (alias Daniel Defoe), offers the following item of pirate lore: "In the Commonwealth of Pyrates, he who goes the greatest length of wickedness is looked upon with a kind of envy amongst them, as a person of a more extraordinary gallantry, and is therefore entitled to be distinguished by some post, and if such a one has but courage, he must certainly be a great man."

In the case of L'Olonnais, it seems difficult to agree.

Page 64: François l'Olonnais, print taken from De Americaensche Zee-Rovers ("History of reported East Indian pirate adventures" / Histoire des aventuriers flibustiers qui se sont signalés dans les Indes) by Alexandre-Olivier Exquemelin, 1678.
Below: Prisoner Walking the Plank, *illustration by Howard Pyle, 1887.*
Facing page: Flags and Flame, *illustration taken from* Frères de la Coste, *by Maurice Besson, 1928.*

PAVILLONS ET FLAME

du Navire Forban nommé le Sanspitié
arrivé à la Coste du Pouliguen pres de Nantes, le 20.ᵉ Mars 1729.

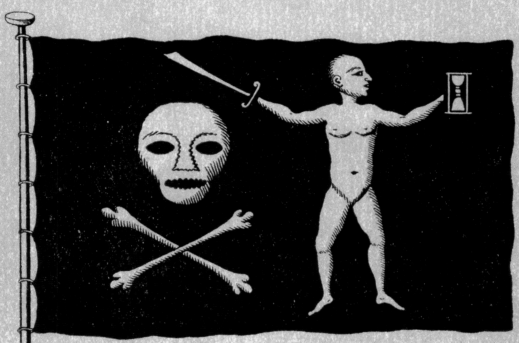

Pavillon de Ras de Sᵗ Maur long de 22 pieds 9 pouces
& large de 14 pieds 9 pouces.

Pavillon, nommé Sansquartier,
de Crespon, long de 14 pieds 8 pouces
& large de 9 pieds 7 pouces

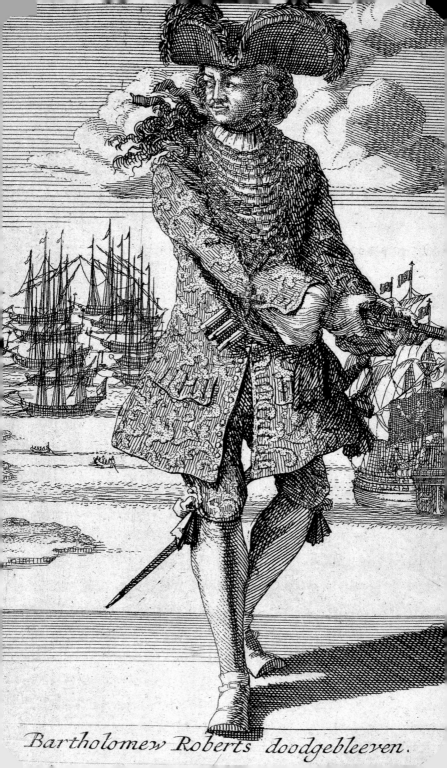

Bartholomew Roberts doodgebleeven.

Bartholomew Roberts (1682–1722)

The Sun King of Caribbean Piracy

It is difficult to imagine the sight of pirates sobbing with grief, yet neither rum nor prayers could staunch the tears of the men who sailed with Bartholomew Roberts, when the death of their beloved captain was discovered off the coast of Cape Lopez. If Roberts's biographers are to be believed, he was a good, chaste, pious man, and an accomplished musician. His benevolent disposition is reflected in the Articles of the social contract—a set of rules governing life on board ship—which this unusual pirate submitted to his fellow-adventurers for their unanimous approval, before every expedition:

1. Every man shall have an equal vote in affairs of moment. He shall have an equal title to the fresh provisions or strong liquors at any time seized, and shall use them at pleasure unless a scarcity may make it necessary for the common good that a retrenchment may be voted.
2. Every man shall be called fairly in turn by the list on board of prizes, because over and above their proper share, they are allowed a shift of clothes. But if they defraud the company to the value of even one dollar in plate, jewels or money, they shall be marooned. If any man rob another he shall have his nose and ears slit, and be put ashore where he shall be sure to encounter hardships.
3. None shall game for money either with dice or cards.
4. The lights and candles should be put out at eight at night, and if any of the crew desire to drink after that hour they shall sit upon the open deck without lights. […]
8. None shall strike another on board the ship, but every man's quarrel shall be ended on shore by sword or pistol in this manner. At the word of command from the quartermaster, each man being previously placed back to back, shall turn and fire immediately. If any man do not, the quartermaster shall knock the piece out of his hand. If both miss their aim they shall take to their cutlasses, and he that draweth first blood shall be declared the victor.
9. No man shall talk of breaking up their way of living till each has a share of 1,000. Every man who shall become a cripple or lose a limb in the service shall have 800 pieces of eight from the common stock and for lesser hurts proportionately.[35]

Roberts was a non-smoker and tea-drinker, who impressed everyone around him with his studied elegance and distinguished demeanor. His tall, lean figure, kindly face, and long brown hair earned him the nickname, "the Sun King of Piracy." On the ill-fated day of his death (he was shot by a musket), his hagiographers describe him as having been: "dressed in a rich crimson damask waistcoat and breeches, a red feather in his hat, a gold chain round his neck, with a diamond cross hanging to it, a sword in his hand, and two pairs of pistols slung over his shoulders."[36]

Roberts's pirate career was short—from 1719 to 1722—but he commands respect and admiration for his astonishing tactical brilliance and humanity, so far from the cruel, murderous methods of his fellow Brethren of the Coast (the general name adopted by the pirates of Tortuga). Weary of life as a privateer in the service of the English Crown, Roberts opted for a less regimented existence as a free pirate, under a certain Captain Davis, who was killed in combat just six weeks after Roberts enlisted aboard his ship. Impressed by the new recruit's natural authority and fine manners, the crew voted unanimously to instate Roberts as their next captain.

Roberts's first armed encounter as captain perfectly reflects his bold, exemplary image. Preparing to lay anchor in the bay of Todos los Santos, the pirate encountered a fleet of forty-two Portuguese merchant vessels waiting for an escort of warships to take them across the Atlantic. Roberts headed straight for the first boat, coming alongside so that he could call out to the captain and persuade him—with threats—to come aboard his own ship. Roberts's prisoner pointed out the most richly stocked ship of the fleet, armed with forty cannon and one hundred and fifty men. Roberts then ordered him to invite its captain to join them. In so doing, the prisoner managed to raise the alarm, but not before Roberts had fired his cannons, damaging the ship's broadside and rigging. His pirates boarded, and before the

firing a shot, he swapped his two dilapidated sloops for the proud sailing ship, which he renamed the *Kings Happy*. Sailing under the French flag, Roberts delighted in deceiving his enemies, with a tried and tested strategy: whenever a likely prey was spotted, he would approach in a way that inspired trust and confidence. As soon as he was within range, he would hoist the black flag and take advantage of the element of surprise to fire and unleash his men onto the rigging and bridge of his adversary's ship. With the business concluded, scenes of drunkenness and debauchery invariably followed.

On February 9, 1722, the English Captain Chaloner Ogle was pursued by a vessel from Roberts's pirate fleet aboard his own ship, *H.M.S. Swallow*. Ogle fired at the

"In an honest service there is thin commons, low wages and hard labor; in [piracy], plenty and satiety, pleasure and ease, liberty and power."

rest of the fleet could enter the fray, Roberts weighed anchor and hoisted his sails, making off with a smile and a fabulous booty: gold, jewelry, precious gems, and a cross set with diamonds destined for the Catholic king of Portugal.

The dashing operation provoked the jealousy of Roberts's second-in-command and a handful of mutineers. While their captain was away in the ship's sloop, the group made off with his ship and treasure.

Roberts had to start all over again, capturing two sloops and persuading their crews, with characteristic bravado, to enlist under the black flag. Declared "enemy number one" by the governors of Barbados and Martinique, the Welsh pirate used all his considerable imagination and agility to escape their fleets and pursue his quest for treasure. Caution prevailed, however, and Roberts eventually left the increasingly hazardous waters of the Caribbean to ply his illicit trade along the West African coast.

On the high seas, he encountered a sizeable French ship, armed with forty cannon but commanded by a timorous captain. Roberts seized the opportunity: without

pirate boat, destroying it. In the ensuing chase, he came upon Roberts and his drunken crew, carousing at anchor in a sheltered cove off Cap Lopez. Resistance was, plainly, useless. In a final burst of pride, Roberts ordered those of his men who were still sober to set the ships' powder reserves alight and blast themselves sky-high, all together. A well-aimed bullet put an end to this suicidal scheme, dispatching Roberts to meet his maker at just forty years of age.

Long after his death, his former comrades liked to comfort themselves, and justify their decision, by repeating the celebrated maxim of their good captain, languishing in his early, watery grave: "In an honest service there is thin commons, low wages and hard labor; in [piracy], plenty and satiety, pleasure and ease, liberty and power."

Page 68: Bartholomew Roberts, etched engraving, 1725.
Facing page: Brazilian coastline by a Portugese cartographer, c.1515.

73

Edward Teach (1680–1718)
Blackbeard, the Black-hearted Pirate of the Americas

[His] Beard was Black, which he suffered to grow of an extravagant length; as to breadth it came up to his eyes; he was accustomed to twist it with ribbons, in small tails [...] and to turn them about his ears. In time of action he wore a sling over his shoulders with three brace of pistols hanging in holsters like bandoliers, and struck lighted matches under his hat, which appearing on each side of his face, his eyes naturally looking fierce and wild made him altogether such a figure that imagination cannot form an idea of a Fury from Hell to look more frightful.

The colorful portrait of Edward Teach painted by Daniel Defoe (alias Captain Charles Johnson) in his *General History of the Pyrates* leaves us in little doubt as the terror struck by this diabolical pirate in the heart of the English and Spanish captains unlucky enough to cross his path.

The life of Edward Teach, better known as Blackbeard, is full of the spice and color we expect from the epic adventures of the hardened sea-dogs of his day. Born in the western English port of Bristol in 1680, the young Teach followed the well-worn path of many a lost boy before him, wandering the waterfront in search of adventure and easy money. He enlisted as a privateer and distinguished himself by capturing French ships waging war against the rest of Europe in alliance with Phillip V of Spain—the grandson of the French king Louis XIV.

But Teach's rebellious nature chafed at the discipline and lack of personal glory aboard English ships sailing under royal protection. His fighting spirit led him to enlist, at the age of twenty-three, with the celebrated pirate captain Hornigold. Teach was a gifted pupil, blazing his way through the ranks. Scarcely a year after joining the so-called Brethren of the Coast, he raided a sloop and seized command, asserting his authority with a combination

of alcohol and brutality. Teach's log, as recorded by Captain Johnson, contains the following entry: "Such a day—rum all out—Our company somewhat sober—A damn'd confusion amongst us!—Rogues a-plotting—great talk of Separation—So I look'd sharp for a prize—Such a day took one, with a great deal of liquor on board, so kept the company hot, damn'd hot—then all went well again." Teach's allegiance to Hornigold ended in 1718, with the seizure of a French merchant vessel, the *Queen Anne's Revenge*, armed with forty cannon. While his mentor sought amnesty, Blackbeard refused clemency and proudly declared his intention to continue life as a pirate, on his own account. After some early successes, he crossed paths off the South American coast with an ex-major by the name of Stede Bonnet, who had also turned to piracy. Preferring to "live a life of ease, according to his own desires and fancies, aboard a larger ship,"[37] Bonnet abandoned his sloop and enlisted aboard Blackbeard's ship—a profitable choice, as it turned out. The ship's bounty grew, and the wily pirates decided to dispose of their merchandise in North Carolina, a state noted for its blind eye to the origins of goods coming ashore.

En route, the two freebooters seized an English merchant ship sailing for London, with a sizeable cargo of cotton and a company of wealthy passengers, including a group of leading citizens from Charleston, South Carolina. Unabashed, Teach headed for the port of Charleston, where he demanded a significant ransom and medical supplies in exchange for the prisoners from the South Carolina governor. Blackbeard made it clear he would cut off his prisoners' heads and send them to the governor in person, should he refuse.

The city council gave in to Blackbeard's demands, paid the tribute he demanded, and turned a blind eye to the pillaging of ships at anchor in the harbor. Teach was free

to set sail once again, with booty estimated at around one thousand five hundred pounds sterling. A dramatic series of events followed: the cunning pirate was allergic to the concept of sharing, and had no intention of dividing the proceeds of his raids amongst his crew.

Teach landed his ship and two other sloops on a secluded beach on the island of Topsail, ostensibly so that the sloops could be upturned and cleaned. He then set off in one of the sloops, supposedly on a reconnaissance mission to the nearby islands. Instead, he slipped away with the treasure and a small band of his most loyal men. Never short of a cunning plot, Blackbeard finally presented himself to Charles Eden, the governor of North Carolina,

Twenty-five injuries were found on his body, including five bullet wounds. His head was severed and displayed at the top of the mast.

hoping for a royal amnesty (which was duly granted) and the legitimate command of a Spanish galleon that he had recently captured. The plan worked. Equipped with his new ship, Blackbeard carried out a succession of attacks and tricks, telling the governor that he had recovered the wreck of an abandoned French ship (which he had in fact seized, massacring the crew and confiscating its cargo of sugar and cocoa).

Blackbeard was by now a rich man, free to indulge his immoderate taste for carousing, women, and idiotic games played according to his own invented rules:

One day at sea, and a little flushed for drink: come says he, let us make a Hell of our own, and try how long we can bear it. Accordingly he, with two or three others, went down into the hold, and closing up all the hatches filled several pots full of brimstone and other combustible matter, and set it

on fire, and so continued till they were almost suffocated, when some of the men cried out for air; at length he opened the hatches, not a little pleased that he held out the longest.[38]

Defoe also relates that Teach married what was apparently his fourteenth wife, a girl of sixteen, while twelve of the others were still alive. When visiting her at the plantation where she lived, Teach would insist that, after pleasuring him, she submit to five or six of his drunken companions, in his presence.

On November 14, 1718, outraged at Teach's excesses and violence, Alexander Spotswood, the governor of Virginia, offered a reward of one hundred pounds for anyone who could capture Edward Teach. Lieutenant Maynard, the captain of the English warship the _Pearl_, at anchor in the James River, hunted Teach down and trapped him at dawn on November 22, returning from a drunken escapade, in the bay of Ocracoke.

Blackbeard's last stand was titanic: Teach and fourteen of his men hurled a last grenade and leapt into the midst of the smoke, aboard their adversary's ship. Maynard and Teach confronted one another, dueling with pistols. Teach was wounded but still managed to seize a saber and challenge the English officer, whose weapon was broken in the fight. As the pirate threw himself on Maynard, preparing to kill him, an enemy seaman delivered a blow to the nape of his neck. Blackbeard staggered but carried on fighting. Struck with a fatal shot from the Englishman's pistol, the invincible pirate collapsed. Twenty-five injuries were found on his body, including five bullet wounds. His head was severed and displayed at the top of the mast.

On the eve of his death, Teach was questioned by a drinking companion, anxious to find out where his personal hoard of treasure was hidden. Teach replied that "no Body but himself and the Devil knew where it was, and the longest liver should take all."[39]

Page 72: Edward Teach, known as Black Beard, print, 1724.
Facing page: **The Capture of the Pirate Black Beard,** _painting by Jean Leon Gerome Ferris, 1718._
Following pages: **Scenes From the Cabaret,** _paintings by Gustave Alaux, 20th century._

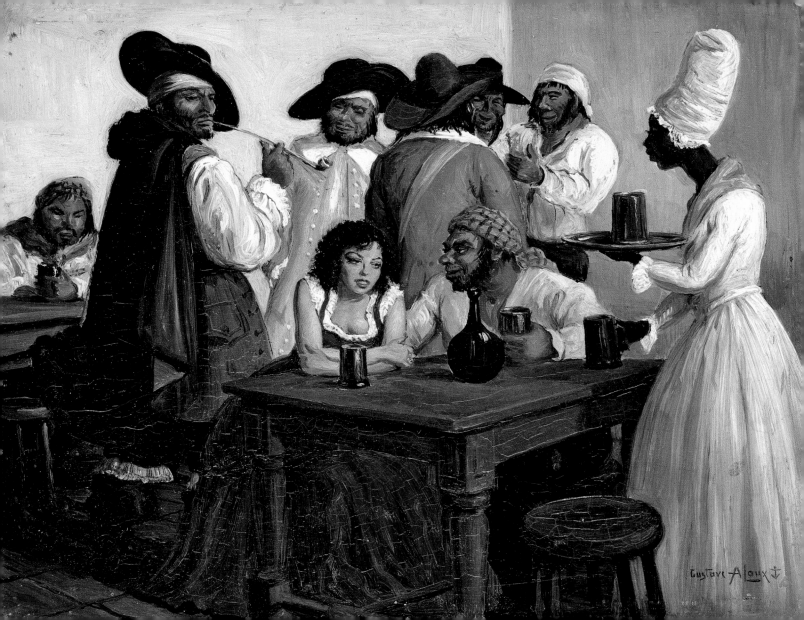

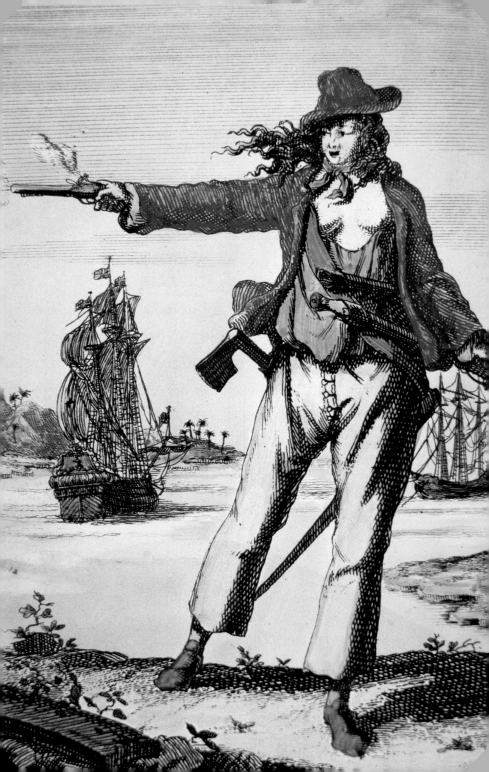

Anne Bonny (1695–1720), Calico Jack Rackham (?–1720), and Mary Read (1677–1720)

The Hell-fire Trio (Bahamas and New Providence)

Bartholomew Roberts's Articles of Piracy were categorical: "No woman to be allowed amongst them. If any man shall be found seducing any of the latter sex and carrying her to sea in disguise he shall suffer death." The *odor di femina* could never be allowed to disrupt the fragile order on board ship or distract the pirates in their pursuit of the Spanish galleons.

Anne Cormac was born in Cork, Ireland, in 1695, the child of an adulterous liaison between a respectable lawyer and one of his serving women. Her father was banished for his wanton transgression, and Anne traveled with him to the New World. Her beauty was equaled only by her fiery temperament; Anne's biographers tell how, as an adolescent, she stabbed her English maid for daring to reprimand her. William Cormac set about earning his fortune, while his daughter—aged just fifteen—frequented the waterfront and the disreputable taverns around the port of Charleston, in South Carolina. Dreaming of adventure, Anne longed to take to the high seas. But none of the young sailors she enticed was prepared to face her father's wrath or risk hanging from the yardarm of the tallest mast for infringing one of the most important laws of piracy. Anne was determined, though, and finally persuaded a weak-willed young man by the name of James Bonny to marry her. Sometimes a sailor, sometimes a pirate, Bonny had just enlisted with a new ship, and the pair eloped on board.

Anne stowed away among the rats and stench in the furthest depths of the hold, and finally arrived one fine morning in Nassau, the headquarters of the flower of English piracy. The young girl marveled at everything she saw—the comings and goings of ships in the harbor, the drunken debauchery of the pirates on shore between expeditions, the heaps of écus and precious stones—but above all, she fell prey to the charms of an extravagant pirate by the name of John Rackham, better known as "Calico Jack." While her husband set sail once more, she fell wildly in love with the glamorous rogue and began a torrid, highly public liaison. Anne soon fell pregnant, and Rackham took her to Cuba to give birth to their child, of whom all trace is lost.

In May 1718, the amnesty offered to Caribbean pirates by George I of England settled matters for Anne, her husband, and Calico Jack. Tormented by his wife's deception, James Bonny decided to turn himself in. Anne, now operating as Calico Jack's henchwoman, encouraged her lover to refuse the hand of mercy extended by the governor of New Providence. When Charles Vane (the captain of Calico Jack's ship) decided to raise anchor, Anne and Jack's fate was sealed. Anne donned her former husband's clothes and blended into the crew. In 1718, her courage during the capture of an English ship attracted the attention of the captain, to whom she was introduced as a new recruit. Soon after, the ship crossed the route of a Dutch merchant vessel whose crew, disinclined to risk their lives over their cargo of calico sheets, chose to surrender without a struggle. In an outburst of unusual goodwill, Vane decided to spare the Dutch captain, his crew, and their ship, which he renamed the *Dragon*. On November 24, 1718, a powerful French warship appeared to starboard, heavily armed. Vane preferred to beat a retreat rather than confront it, provoking a furious reaction from Anne Bonny, now known simply as "Bonn." Mad with rage at her captain's cowardice, she incited the crew to rebellion, overthrew Vane, and set him adrift in an open sloop in the middle of the ocean. Her lover now became the ship's captain, but she became entangled with one of the passengers from the Dutch merchant vessel—a youth with delicate features and long black hair that was tied with a ribbon—who had eagerly joined the crew of the pirates. As their attraction advanced, she discovered that the young sailor was also a woman. Mary Read's life was every bit as turbulent as that of her pirate sister. Born in England in 1677, she had a

chaotic childhood. Her mother's husband had been a sailor who went off to see and never returned, leaving her pregnant with a young boy who proved not long for this world. Before his death, however, out of wedlock, she gave birth to Mary. To cover Mary's illegitimacy, she decided to raise her as a boy, known as Mac, successfully passing her off for the son who had died. Treated like a boy, Mary behaved like one. At the age of sixteen, she enlisted as a cabin boy aboard a warship and went on to become an army cadet, and finally a dragoon guard in Flanders, where she fell in love with a cavalryman, Captain Read, who saved her as she lay wounded on the battlefield. When Read undressed the wounded soldier to tend to his injuries, he discovered to his astonishment that the soldier was a ravishing young girl. Read took care of Mary, married her, and left the army. The couple opened an inn in Breda, but he died in 1697, shortly after the Treaty of Ryswick, from a raging fever. Mary closed the inn, dressed herself as a man once again, and enlisted aboard a Dutch ship sailing for the West Indies, soon to be captured at sea by Vane and his pirate crew.

The two women became friends "for life and unto death," throwing themselves into a series of daring operations, captures, and attacks on the high seas, to the great entertainment of Rackham who, to stave off jealousy, had been informed of the new sailor's true gender. To the rest of the ship, however, it remained a secret.

At the end of 1719, the two women pirates captured a French brigantine, taking its crew prisoner and throwing them into the hold along with a handful of Spanish captives. Despite her pirate garb, Mary was a romantic at heart and fell in love with a young French prisoner. To the fury of the other detainees, she tried to improve conditions for her new *amour*. The atmosphere deteriorated on board. Fighting was forbidden at sea, so Rackham decreed that the prisoners should settle their scores with the sword, on land. Mary feared for her lover's life and challenged his Spanish adversary herself, on the beach. A peerless fighter, she not only tumbled the posturing Spaniard but killed him. According to legend, she also, in the course of the fight, revealed a fine pair of breasts, to the amazement all present. Her secret was out.

Anne Bonny and Mary Read now took to wearing women's clothes and asserted their authority on board ship. "Captain Johnson" (Daniel Defoe) describes how they plundered ports and the smaller islands north and west of Jamaica, to no great gain and with considerable loss of life. On November 1, 1720, a Royal Navy ship commanded by Jonathan Barnett rammed the pirates' ship off Negril Point, while most of the crew members were in a drunken stupor. Anne Bonny urged her companions to fight, preferring death to dishonor, but the crew chose instead to try to hide and were swiftly captured. Their trial opened in Jamaica on November 16, 1720. With the exception of the handful of prisoners who managed to prove their innocence, John Rackham and all his crew were sentenced to hang forthwith. Anne Bonny famously told her pirate lover, as he went to the gallows, "I am sorry to see you here Jack, but if you had fought like a man, you need not be hanged like a dog."[40]

The women's trial, a week later, was a livelier affair, giving rise to some spirited exchanges. Sentenced to hang, Bonny retorted that she counted it "no great hardship or were it not for that, every cowardly fellow would turn pirate and so unfit the Seas, that men of courage must starve." She also declared her and Mary not guilty of the crime of piracy by reason that they didn't recognize the laws of the kingdom. Nonetheless, the verdict was returned: "You, Mary Read and Anne Bonny, alias Bonn, are to go from hence to the place whence you came, and from thence to the place of execution; where you shall be hanged by the neck till you are dead. And God of his infinite mercy be merciful to both your souls."

But, still, the two women pirates would have the last word. "Mi'Lord," they said, "we plead our bellies." English law forbade the execution of a woman with child. Both women were examined by a midwife and, declared pregnant, thrown into jail to await the births of their children. Mary died of fever before giving birth but Anne Bonny delivered her child and escaped hanging, probably through the intercession of her father. Some claimed to have seen her mingling in high society in Charleston; others said she eked out a meager existence as a pirate on the Indian Ocean, chasing her lost youth. No one really knows what happened to her. Tall tales from the tavern….

Page 78: Anne Bonny, 18th–century print.
Facing page: The body of Captain William Kidd, displayed over the Thames Estuary following his execution for piracy and murder in 1701, 19th–century print.

Olivier Misson, the Monk Caraccioli, and Thomas Tew *(late seventeenth century)*
The Pirate Philosophers of Libertalia *(Indian Ocean)*

What if the wicked pirate brethren were a force for good? This apparently ingenuous question was, it seems, given careful consideration by Olivier Misson and the Italian monk Caraccioli before they launched themselves into the most unlikely of utopian outlaw adventures: the creation of an egalitarian pirate republic, whose "true" existence is testified by Captain Johnson (Daniel Defoe) in his *General History of the Pyrates*. The astonishing encounter between these two idealistic souls transformed their accumulated slights and sufferings into a force for genuine social revolt. Olivier Misson's brilliant career sets him apart from the rest of the pirates who plied the Caribbean and the Indian Ocean, their records besmirched by pillaging and debauchery. Misson was an enlightened spirit, for whom piracy was not only a deliberate way of life but the daily, practical application of an altruistic, humanist, and philanthropic personal philosophy.

Misson read widely as a boy and received an excellent education. As a young man, he dreamed of sailing in the wake of his heroes on the high seas and persuaded his father to allow him to enlist as an apprentice with the *Victoire*, a Mediterranean ship aboard which he soon learned the art of sailing and navigation.

A brilliant Latinist, raised in Provence in southeastern France, Misson traveled to Rome, where he met a Dominican priest by the name of Caraccioli, who introduced him to the Eternal City and the frisson of revolutionary ideas. The two remained inseparable unto death. Caraccioli enlisted aboard Misson's ship, the *Victoire*; following a successful skirmish with an English ship, the *Winchelsea*, the pair convinced the crew to embrace a life of freedom, not under the black flag, synonymous with debauchery and immoral principles, but under a white flag bearing the words *A Deo A Libertate*—To God and Liberty—a standard that became the symbol of their rectitude and resolve.

The crew seized a cargo of rum and fine silks, and sold it in Cartagena before sailing for the Indian Ocean. En route, Misson seized a Dutch slave ship off the coast of Guinea, freeing its captives on the spot and declaring "that he had not exempted his neck from the galling yoke of slavery and asserted his own liberty, to enslave others."[41]

After rounding the Cape of Good Hope, the sailors stopped at the island of Anjouan (Nzwane), where Misson promptly fell in love with the sister of the queen, and Caraccioli with another royal lady of lesser rank, both of whom they married. The alliances drew the men into Anjouan's Lilliputian ancestral war with the neigboring island kingdom of Mohéli (Mwali). After a host of battles and ambushes, Misson—who detested cruelty and refused any form of bloodthirsty revenge—sought to convince the queen to make peace with her eternal rival, to no avail.

Tired of wasting their energies on petty local wars, Misson and Caraccioli turned once again to their master plan—the creation of an ideal republic where all men would be equal. They returned to sea with their respective spouses and experienced a handful of misadventures—one of which claimed Caraccioli's left leg—before reaching Madagascar. The two men explored the island's western coast and settled on Diego-Suarez, a sheltered bay at the northern tip. Here they founded Libertalia, land of freedom, populated by French, Dutch, English, and Portuguese prisoners from the ships they had captured, and a group of former Black slaves and Anjouans, all of whom became "Liberi."

The task ahead was immense, but the project was inspirational. Pirates and former prisoners got to work, building a small fort armed with forty cannon at the entrance to the bay, followed by a complete town of small houses and shops. Their only disappointment was the failure of any local natives to come and meet with them. Irritated by this lack of curiosity, Misson headed south on a

"He had not exempted his neck from the galling yoke of slavery and asserted his own liberty, to enslave others."

reconnaissance expedition and eventually discovered a native village. He made contact outside the compound perimeter, traded some fabrics for boiled rice and chickens and persuaded ten tribespeople to accompany him back to Libertalia. The traded goods soon ran out, however. The "free men" needed food and supplies. The founding fathers set out to sea once more, returning from expeditions along the African coast with substantial goods and provisions, and more Portuguese prisoners, who were released by Misson and allowed to leave on condition that they promised never to take arms against him. This would prove a serious mistake.

During one of these campaigns, Misson crossed the path of a die-hard pirate, the Englishman Thomas Tew. The two captains challenged each other before eventually exchanging civilities, during which the French freebooter praised the merits of his utopian republic.

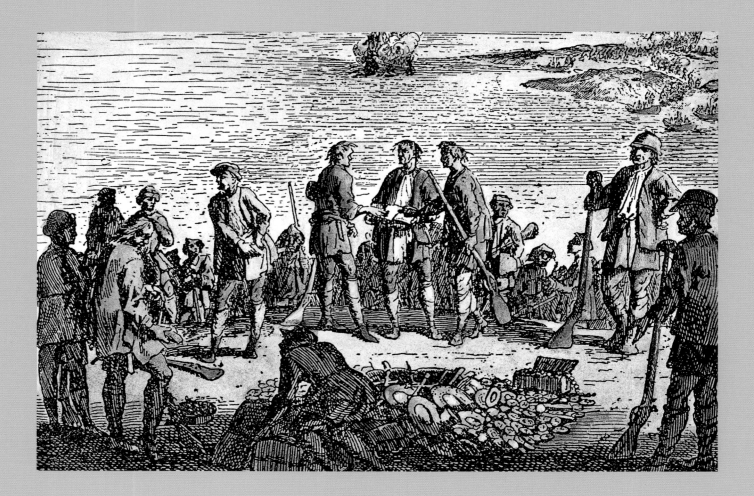

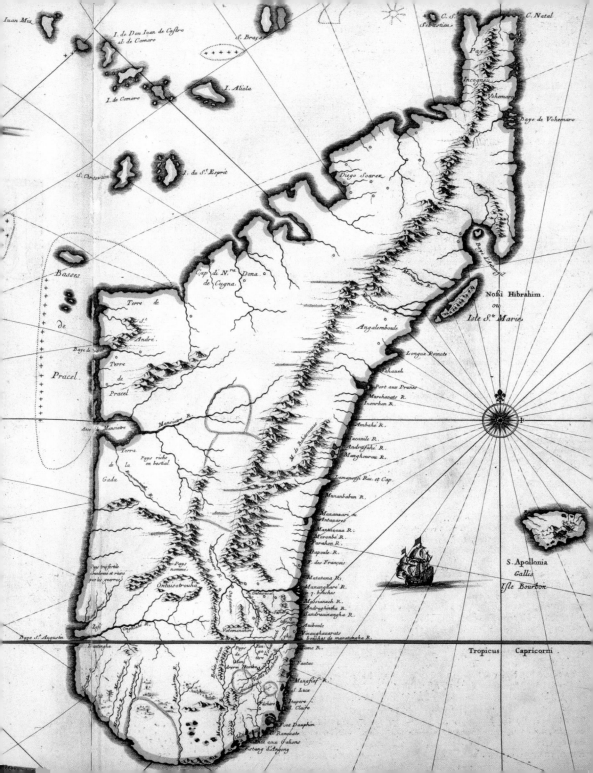

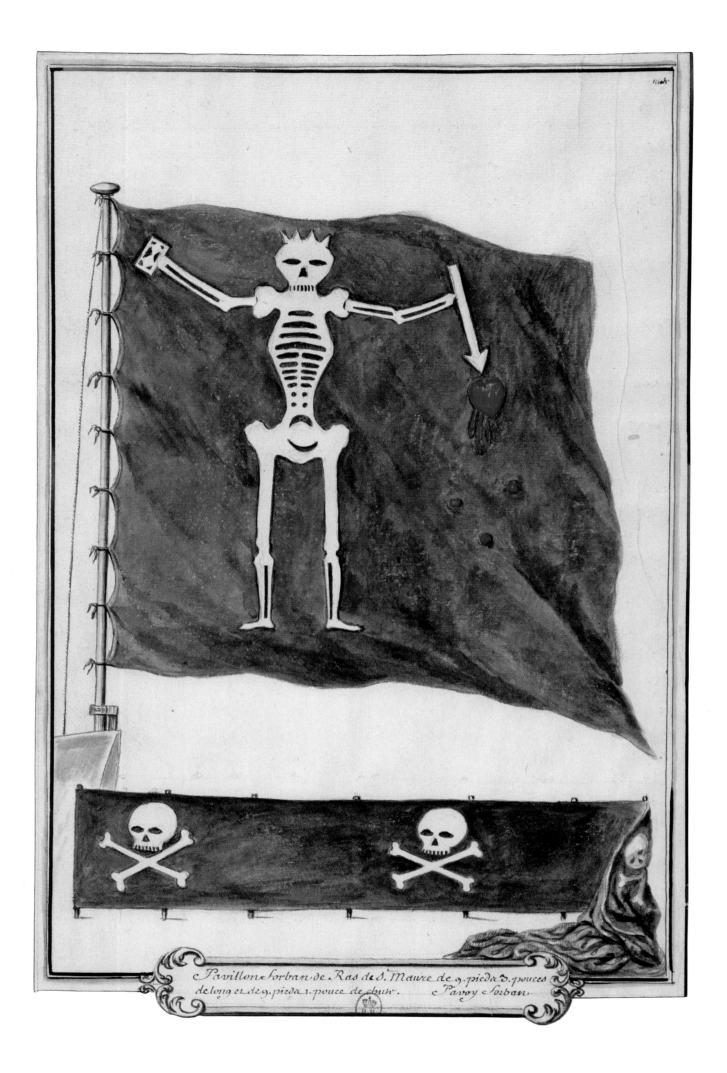

Pavillon forban de Ras de S. Maure de 9 pieds 3 pouces de long et de 9 pieds 1 pouce de chûte. Pavoy forban.

Tew was suspicious and asked to see Libertalia before committing himself to the project. Impressed by the town's peaceful atmosphere and the natural beauty of the site, Tew decided to join the great adventure. But life at such close quarters soon proved difficult for the French and English pirates. Insults and provocations escalated, forcing Caraccioli to step in before swords were drawn. The conflict led to the establishment of laws and a system of government for the pirate republic: "for where there were no coercive laws, the weakest would always be the sufferers, and everything must tend to confusion."[42]

Henceforward, disputes would be submitted for resolution by "calm and disinterested persons." The new republic elected a small parliament, with one representative for every ten people. This body then drew up a constitution and appointed a "Conservator" for a period of three years. Chattels and livestock were divided equally,

polite refusal: the outlaws had no intention of accepting as their masters people whom they judged to be more wicked than themselves. While Tew was ashore, a cyclone struck his ship, dragging his men down with it, while he watched helplessly. Stranded without a ship, he kept a lookout day after day for Misson's arrival. But when his prayers were answered, Misson brought bad news. A troop of natives had attacked the colony, destroying Libertalia and killing Caraccioli. All that was left to the two pirates were their aging sloops, bobbing in the bay, and a clutch of diamonds saved by Misson. Their dream of happiness was shattered. Misson was a broken man. With his faithful comrade and great utopia gone, he resolved to return home to France and retire from the world. With his characteristic spirit of fairness and equality, the disillusioned pirate shared his last treasure with Tew. The two men embraced then parted—Misson for France and Tew for America. But Misson's bad luck continued: caught

Being a utopian did not mean forsaking piracy.

and each man was granted ownership of his land. The constitution was written up and printed. Misson was elected "Conservator," Caraccioli was appointed Secretary of State, and Tew was named Admiral; the other delegates invented an international language drawing on the idioms of the different nationalities represented.

Being a utopian did not mean forsaking piracy. Two sloops were built, named the *Enfance* and the *Liberté*, joining Tew's ship the *Bijoux* and Misson's *Victoire*. The fleet renewed its bold attacks on Dutch, English, and Arab merchant ships, bringing continued prosperity to the community. The Portuguese prisoners released by Misson had forgotten their promise, however, and entered the bay with five warships. Of these, the "great captain" Misson sank two, put two others to flight, and captured the fifth. The treacherous ex-prisoners were all hanged, but other the members of the conquered crews were spared. Libertalia continued its happy existence. Everyone believed that their dream of a fairer world, free of constraints and oppression, could become a reality.

Tew set off to greet a band of ex-pirates living in hiding on the mainland, hoping for new recruits. He met with a

in a violent storm, Tew watched as his friend's sloop was torn in two. Misson died in the wreck.

Libertalia's last survivor finally reached New England, with one meager consolation: he had saved his friend's logbook and journal. An acquaintance of (the real) Captain Johnson found the book years later, in the sea chest of a sailor who had died at La Rochelle. Inspired by the story, Daniel Defoe handed down the legend of Libertalia to posterity.

Page 82: **The Life of Pirates on the Island of Madagascar,** *print taken from* **The Pirates Own Book** *by Charles Hellms, 1837.*
Page 84: Buccaneers sharing their booty, print found on the map of America by Nicolas de Fer, 1705.
Page 85: Map of Madagascar, taken from the Atlas Major by Johannes Blaeu, 1662.
Facing page: Pirate flag, 18th century.

Ching Shih (1784–1844)
The Widow Pirate of the China Sea

In the emerald waters of the east, the enemy was not the King of Spain, nor the Queen of England, but the powerful fighting junks and bloodthirsty admirals of the Emperor of China. Piracy and the pursuit of "transferred gods" were ancestral, flourishing trades. In the early nineteenth century, the scourge of the eastern seas was Madam Ching, a cruel widow obsessed with order and aestheticism. Her terrifying portrait is eloquently conjured by Jorge Luis Borges in his semi-fictional *Universal History of Iniquity*: "She was a sapling-thin woman of sleepy eyes and caries-riddled smile. Her oiled black hair shone brighter than her eyes."[43] Her repugnant physique masked great strength of character, an iron fist, and exceptional tactical genius.

Ching Shih was the widow of a powerful warlord who had long ruled over the region's pirate federation. Her promotion as head of the family fleet came about when her husband surrendered to the Chinese emperor in 1806 (he was lured to a life on land, with an official post as "master of imperial stables"), after which he was poisoned by his former associates (other versions of the story state simply that he died in combat). Ching Shih found herself at the head of six squadrons of junks, each consisting of a hundred ships armed with up to 25 cannon, recognizable by their colored banners: red, yellow, green, black, and purple. Madam Ching's own ship was decorated with a serpent figurehead. When Madam Ching assumed command, she was far from a novice in the art of war, having seconded her husband for many years and commanded one of his squadrons herself. Ching expanded, organized, and commanded the greatest pirate force ever assembled, with a stern, almost psychopathic sense of order, keen attention to detail, and unexpected touches of poetry. Each squadron chief was given an allegorical warrior name: "Bird and Stone," "Scourge of the Eastern Sea," "Jewel of the Whole Crew," "Wave of Many Fishes," and "High Sun."

Madam Ching's shipboard rules echo the Articles enforced on pirate vessels in the Caribbean and give an added insight into her subtle methods, her obsession with order and efficiency, and her puritanical morals:

Not the least thing shall be taken from the stolen and plundered goods. All shall be registered and the pirate receive for himself out of ten parts, only two: eight parts belong to the storehouse, called the general fund; taking anything out of this general fund without permission shall be death.

If any man goes privately on shore, or what is called transgressing the bars, he shall be taken and his ears perforated in the presence of the whole fleet; repeating the same, he shall suffer death.

No person shall debauch at his pleasure captive women taken in the villages and open spaces and brought on board a ship; he must request the ship's purser for permission and then go aside in the ship's hold. To use violence against any woman without the permission of the purser shall be punished by death.

More unusually, Ching Shih also imposed rules of conduct for her men ashore: all supplies taken or consumed were to be paid for and any infringement of the local people's rights was punishable by death. This "empress of the seas" was merciless in her pursuit of rich merchants, cutting off their heads without a second thought, but she also sought to protect the humblest and poorest in society, showing them great generosity.

Ching's rise to power was confirmed in 1808 during an all-out naval battle waged from dawn to dusk against the imperial fleet commanded by the aging Admiral Kuo Ling. Wrecks and corpses littered the sea, the Emperor's

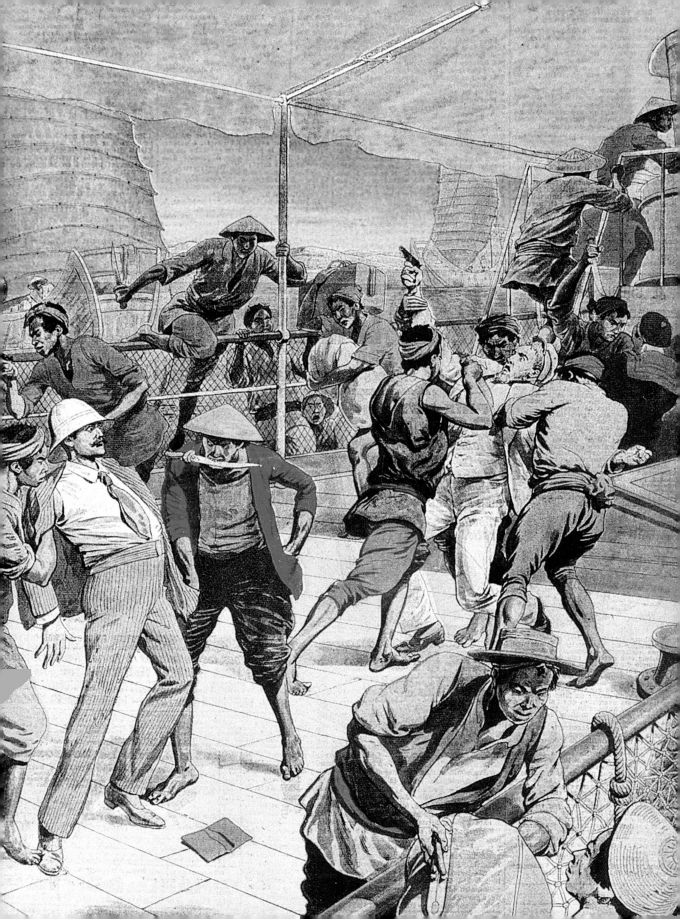

ships were repulsed and vanquished, and Admiral Ling was captured by a young lieutenant named Pau, who refused to kill him with his own hands. His honor wounded, the Admiral was driven to suicide under the indifferent gaze of Madam Ching, who justified her "clemency" with an extemporized poem, explaining that if she killed the Admiral there and then, in cold blood, she would be treated as his murderer if ever, one day, she was minded to surrender to the Emperor herself.

"No person shall debauch at his pleasure captive women taken in the villages and open spaces and brought on board a ship."

The Emperor Jia Qing could tolerate the pirate's threats and her constant challenge to his authority no longer. He appointed a new admiral, Lin Fa, with a mission to bring down Ching Shih's pirate armada once and for all. A new confrontation took place, on a calm, windless sea, trapping the junks. Eager to fight, the pirates threw themselves overboard in the hundreds, armed with two sabers tucked under each arm, hanging from their sheaths. Swimming underwater, they reached the imperial junks unnoticed and attacked. Madam Ching's triumph was complete: the enemy vessels were defeated, and Lin Fa was killed in the battle.

The following year, the winds of fortune turned and the skies darkened. Madam Ching experienced her first defeat, at the hands of a new admiral, Tsuen Mow-sun, sent from Beijing to destroy her. A subtle strategist, Tsuen learned the lessons of his predecessors' failures and avoided a head-on confrontation. Instead, he dispersed his ships along the coast, harassing the widow's vessels from all sides and setting fire to her own junk. Madam Ching was defeated, surviving only by slipping away in the midst of the carnage in a fragile sampan that had come to her aid. The cruel defeat redoubled her determination, however.

Her pride wounded, the pirate queen answered her humiliation with a series of bloodthirsty reprisals.

With obdurate determination, she reassembled a fleet of five hundred junks, gathered a force of sixty thousand men, and resumed her raids along the inshore rivers, pillaging and razing the countryside and villages, taking their inhabitants prisoner, and selling them into slavery.

Incapable of breaking her strength, the Emperor resorted to cunning, contacting each of Ching Shih's admirals in turn, offering them a complete, permanent amnesty. The first to be approached, with a mixture of violent threats and promised clemency, was the "Jewel of the Whole Crew." During the protracted negotiations, Madam Ching's spies informed her of the imperial plot. The pirate queen swept into battle, coming to the aid of her admiral's squadron just as the latter was preparing to strike a deal. Her brutal rejoinder forced the new imperial admiral, Ting Kwei-heu, to retreat. Acknowledging his defeat, he committed suicide. The queen of pirates was invincible, at the height of her powers, free to reign over China's seas and rivers, raising taxes and duties from shipping companies, and ransoming any foreign ship that dared to enter Chinese waters.

The Emperor refused to give in, however, and finally succeeded in rallying the dreaded pirate admiral O Po-tae to his cause, in exchange for control of two cities and a lucrative governor's post. This tactical success deprived Ching Shih of eight thousand sailors, one hundred and sixty ships, one hundred and fifty cannon, and five thousand weapons of all calibers. Worse, the surrender spread doubt and temptation among her remaining commanders.

Unsettled by the defection, Madam Ching consulted her soothsayers and amulets. The response was unanimous: she should end her supreme piratical rule and lead a normal life. Her surrender was negotiated with great delicacy on the waters of the Yangtze (or "Blue River"), with the regional governor of Xinjiang and a Portuguese delegation from Macao, whose demands caused one or two upsets before the matter was finally settled. On the appointed day, Madam Ching—dressed in her finest apparel—sailed up the river in triumph to the cheers of her sailors' wives and children. Legend has it that she enjoyed a peaceful retirement in the arms of the governor, who became her second husband.

Page 88: Illustration taken from Madam Ching, pirate chief *by Paul Gordeaux, 1970.*
Facing page: French steamboat attacked by Chinese pirates, illustrated supplement from the Petit Journal, *June 22, 1913.*

They rebelled against the demise of wide open spaces, and the advent of the industrial world

They might be known as Calamity Jane, Wyatt Earp, Billy the Kid, or Butch Cassidy…. In their youth, the conquest of the American West gave them a taste for the wild, riding free across the vast open spaces of their homeland, intoxicated by the smell of gunshot and a camp fire. In the words of the Wild West chronicler Paul West: "a man or a woman was isolated on the vast plateau under a punitive sky with uninterrupted wind […] alone with his or her thoughts. […] Bare tough lands made bare tough men." But the freedom of the wild came at a price: "frontiersmen [discovered] the farce of the impromptu, which occupied you for seconds only, but shaped you for years. You lived from impulsive act to impulsive act, filling the in-between time with liquor, cards and women."[44]

With the arrival of the railroad, the West was won, and their dreams were shattered, cutting short a lifestyle unfettered by any laws beyond the self-imposed rules of survival itself.

Others were called Frank and Jesse James, Bill Anderson, or Cole or James Younger. Proud supporters of the Confederate, they scorned the rule of law—federal, judicial, or religious. They enlisted in the Confederate army when they were scarcely adult, fighting the rise of an industrialized world that would abolish slavery and their ancestral way of life, inimical to the advent of a new economic order. They experienced the thrill of attack, the rush of adrenalin, and the fraternity of combat but ultimately suffered humiliation and defeat. No longer soldiers, they became outlaws, serving no cause but their own, armed with the weapons they once wielded for the Confederate standard, the Dixie flag.

Most had lost a father or mother in their earliest childhood. All spent their youth with a rifle in their hand, for food, protection, or self-defense. They'd learned how to break a stubborn horse and become a crack shot. At the age of twenty, history and economic progress pushed them aside; rejected by the world, bereft of their ideals and illusions, they felt abandoned and betrayed. No more wild spaces to conquer, no longer able to live free outside the law. Rejecting the inexorable march of change, they chose to live on the margins of a society that had ordered their surrender for a meager fistful of dollars. Rebels against authority in all its forms, they formed armed gangs, living on the proceeds of their raids. The economy prospered, there was money to be had, and they would take it by force and cunning. Progress brought the telegraph, the railroad, federal banking agencies, and private detectives. The outlaws of the West adapted their violent methods accordingly, attacking trains and banks on horseback.

"The first fatal bullet stains the legend with blood."

Convinced that society had robbed them of their rightful dues, the more idealistic among them argued that they were performing acts of charity, taking back the goods, money, and riches that the rich had secured for themselves on the backs of the poor. The press recounted their armed exploits, exaggerating them and shaming their perpetrators in the eyes of honest folk. They took the law into their own hands, but they were condemned as common criminals. One after another, they entered the storybooks of the Wild West, forgetting that the first fatal bullet stains the legend with blood.

Sharpshooters and the Call of Wide Open Spaces

"Well, if there aint' going to be any rules,
let's get the fight started."
Butch Cassidy

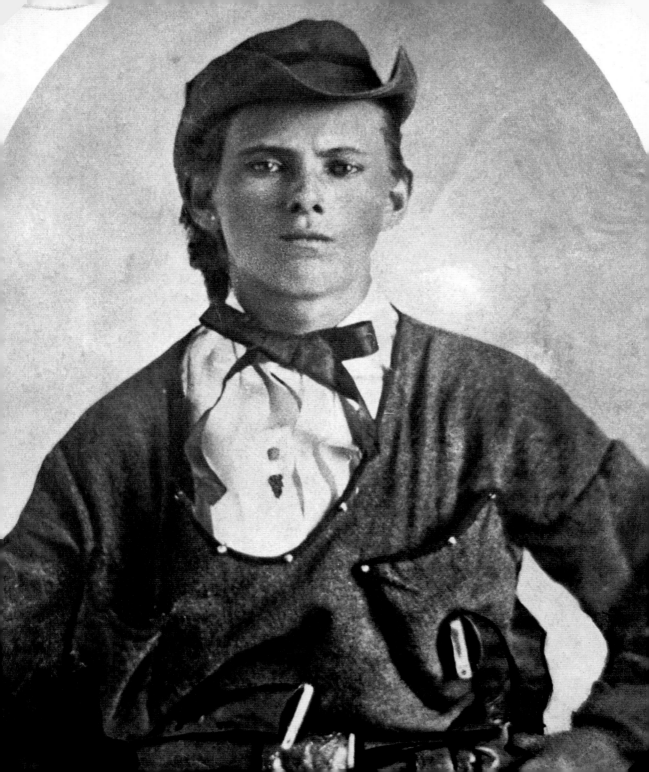

Jesse James (1837–1882), and the Quantrill and James Younger Gangs
Damnation and Redemption

On the morning of April 3, 1882, Jesse James put down his copy of the *Kansas City Times* on the breakfast table, finished his coffee and got to his feet. Irritated by a speck of dust on a picture hanging on the wall, he stood on a chair to brush it away. His murderer, known to history as "the coward" Robert Ford takes up the story:

> As he stood there, unarmed, with his back to me, it came to me suddenly, "Now or never is your chance. If you don't get him now he'll get you tonight." Without further thought or a moment's delay I pulled my revolver and leveled it as I sat. He heard the hammer click as I cocked it with my thumb and started to turn as I pulled the trigger. The ball struck him just behind the ear and he fell like a log, dead.[45]

Robert Ford had just won the ten-thousand-dollar reward offered for the arrest of the Mid-West's most wanted man. Nine months earlier, the traitor had joined James's gang, with his brother Charlie. John Edwards, the editor of the *Kansas City Times*, sensationalized the story of the treacherous gun-shot, transforming James from a notorious outlaw to a worthy heir of the mantle of Robin Hood. Throughout his life, Jesse James had always styled himself as a disinterested righter of wrongs:

> Just let a party of men commit a bold robbery, and the cry is to hang them, but Grant and his party can steal millions and it is all right. […] It hurts me very much to be called a thief. It makes me feel like they were trying to put me on a par with Grant and his party. Please rank me with [Alexander the Great and Napoleon] and not with the Grantites. Grant's party has no respect for any one. They rob the poor and the rich, and we rob the rich and give to the

poor […] I will close by hoping that Horace Greeley will defeat Grant, and then I can make an honest living, and then I will not have to rob, as taxes will not be so heavy.[46]

Who to believe? Jesse James, who liked to portray himself as an innocent soul resorting to violence only in self-defense, or those who claimed that he was a merciless killer and robber, motivated by nothing but a lust for money and adventure?

Jesse James was born on September 5, 1847, in Kearney, Missouri. The Civil War and the capitulation of the South were central to the fate of this son of a poor farmer-cum-Baptist minister, orphaned at the age of four when his father abandoned his wife and children for the mirage of Californian gold. Jesse was thirteen years old at the outbreak of the American Civil War. Five years later, his older brother Frank enlisted with the Confederate company of Missouri Breaks. The Kansas-Nebraska Act of 1854 set the pro-slavery state of Missouri against the neighboring, abolitionist state of Kansas. Relations were strained. "Abolitionist patriots" from Kansas fought bitterly with local rebel gangs. The most famous of these was the Quantrill Gang, headed by William Clark Quantrill, an ex-teacher turned professional gambler, whose brother had been killed as he watched by the Yankee militia. Quantrill was a man for whom revenge had become an obsession.

Frank was the first of the James brothers to join the Quantrill gang, in 1862. Jesse was out working the cornfields when the state militia attacked the family farm, seeking retribution for his brother's action. Jesse's stepfather was tortured as he watched, and Jesse himself was whipped. His mind was made up: he galloped off to join his older brother.

Jesse quickly made a friend of "Bloody" Bill Anderson, one of the gang's wildest, bravest lieutenants; Anderson in turn felt a deep affection for the fiery new recruit, admiring his

intelligence and fighting courage, despite his youth. Fighting under his mentor's black "regimental" flag, Jesse James showed a bravery bordering on recklessness. With eleven accomplices, he captured the Plattsburg garrison, stealing ten thousand dollars and leaving all forty-six of its Federal soldiers alive. In June 1863, the gang routed two hundred soldiers of the Ninth U.S. Cavalry on their way to Kansas City, despite being outnumbered three to one. Eighty soldiers were killed in the fight.

Blood calls to blood… The Yankee troops took to scalping any member of the Quantrill gang unlucky enough to fall into their hands. In return, the gang members resolved to exact "a scalp for a scalp." On September 27, 1864, Jesse, his brother Frank, and twenty other rebels exterminated eighty Federalists as they disembarked from the train at Centralia. Major A.V.E. Johnson set out in pursuit but was shot by Jesse himself, who went on to play an active role in the killing of two hundred and eighty two Federal soldiers of the three-hundred-strong company sent to arrest the Quantrills. In three years of war, Jesse was injured twenty-two times.

The Confederate companies were defeated one after the other, and surrendered. Jesse James decided to give himself up. On March 14, 1865, he was riding at the head of the Missouri insurgents, with a white flag tied around his hip, when the column crossed a Federal detachment of the 2nd Wisconsin Regiment, who opened fire. Struck by a bullet in the lung, Jesse spent several days fighting for his life. When he finally tried to surrender, his wild reputation went against him. Together with his brother, he was considered a Quantrill, and the government refused to grant an amnesty. Jesse and his comrades were, thus, condemned to a life as outlaws.

For sixteen years, Jesse lived the life of a wanted man, changing his identity and staying on the move to escape the Federal agents, Home Guardsmen, police, and Pinkerton detectives eager to track him down and claim the handsome reward. Sixteen years of long silences and disappearances, violence and murder committed in the name of social justice and obsolete Southern patriotism. Jesse James forged a double reputation, as a loving husband and devoted family man, and a pitiless gang leader, prepared to do anything to provide for his men and followers. From 1866 to 1882, he led a series of innovative attacks on horseback, targeting first banks and stagecoaches, and finally trains. He was officially responsible for seventeen deaths but always sought to justify his actions by claiming that, if he and his gang were thieves, at least they always stole in the light of day, and if they were killers, it was always in self-defense.[47]

$25,000 REWARD
JESSE JAMES
DEAD OR ALIVE

$15,000 REWARD FOR FRANK JAMES

$5000 Reward for any Known Member of the James Band

SIGNED:

ST. LOUIS MIDLAND RAILROAD

The composition and size of the new James Younger gang fluctuated over time, as its members were arrested or suffered violent death. The original line-up featured the two James brothers Jesse and Frank, the three Younger brothers (Cole, Jim, and Bob) and the former members of the Quantrill gang (the Miller brothers, the Hite brothers, Bill Ryan, Andy McGuire, Charlie Pitts, Archie Clements, and George Shepherd). Beginning with an attack on the town bank in Liberty, Nebraska, on February 13, 1866, the list of their wrongdoings is an endless catalogue of armed robbery and murder.

With the arrival of two new recruits, Jim Cummins and Dick Liddell, in July 1873, the gang began to specialize in attacks on trains: at Adair, Iowa, they hijacked the Chicago, Rock Island, and Pacific Railroad, making off with two thousand dollars. At Gad's Hill, Missouri, they attacked the Iron Mountain to Little Rock train, escaping with just twenty-two dollars. On December 12, they attacked the Kansas Pacific at Muncie, stealing sixty thousand dollars,

followed by the Missouri Pacific at Otterville, for sixty-five thousand dollars. Two portentous events now heralded Jesse's tragic end, marking him profoundly.

On January 26, 1875, Pinkerton agents seized the family farm, convinced that Jesse was hiding there. Jesse James Jr. relates his grandmother's account of the horrific scene, in a hagiography devoted to his father's life:

> One dark midnight while only me and the doctor, and my colored woman and my eight-year-old son, Archie, were alone, a bomb came crashing through the kitchen window. […] We rolled it into the fireplace to keep it from setting the house on fire. Then it exploded. A piece of the shell struck little Archie in the breast, going nearly through him and killing him almost instantly. Another piece tore my right arm off between the wrist and elbow. […] Those fiends had intended to kill us all with the bomb and then burn us up.[48]

The second event took place in the summer of 1876. Bill Chadwell convinced Jesse to attack the bank at Northfield, Minnesota, with seven companions. The hold-up was a fiasco: Miller and Chadwell were killed, and the others were all wounded. The gang fled, pursued by a posse. Charlie Pitt was killed, and the Younger brothers were arrested.

Tempted by the promised reward and weary of James's violent escapades, Southerners withdrew their popular support for the gang. James pulled off a further handful of lucrative attacks, but division and betrayals now brought the James-Younger Gang to an end. Tucker Basham turned himself in early 1881; Jesse shot down Ed Miller on August 7, when he threatened to desert; and Dick Little shot Tom Hite before he could give himself up to the Federal authorities. In the spring of 1882, only the James and Ford brothers remained; the latter were already secretly negotiating their freedom and the promise of a ransom for Jesse, wanted dead or alive.

Jesse's long-awaited murder—on April 3, 1882, at the hands of Robert Ford—brought his exhausting outlaw career to a close. Wreathed in posthumous glory, Jesse James was finally laid to the eternal rest he had dreamed of for so long. At the age of thirty-five, he paid for his crimes with his life but entered the legend of the West as a pioneer—the first man ever to attack a train on horseback—and a victim of betrayal, shot in the back by a loser.

Page 94: A young Jesse James, 19th century.
Page 96: Wanted poster with an offer of reward for the arrest of Jesse James, issued by the St. Louis Midland Railroad, 19th century.
Page 97: The home of Jesse and Frank James, 19th century.
Below: The James-Younger gang (from left to right):
Cole Younger, Jesse James, Bob Younger, Frank James, c. 1870.
Facing page: Front cover of Lives, Adventures, Exploits of Frank & Jesse James, *1882.*

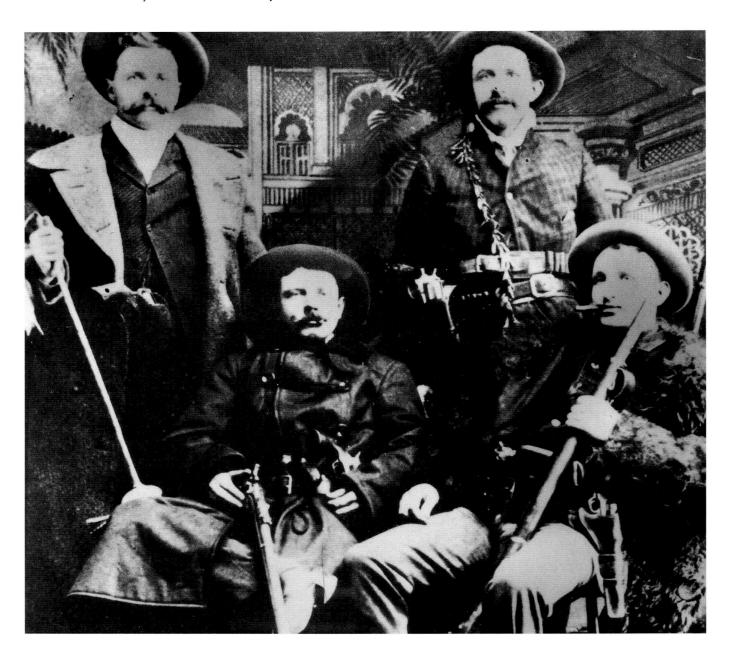

LIVES, ADVENTURES EXPLOITS

Frank AND Jesse James.

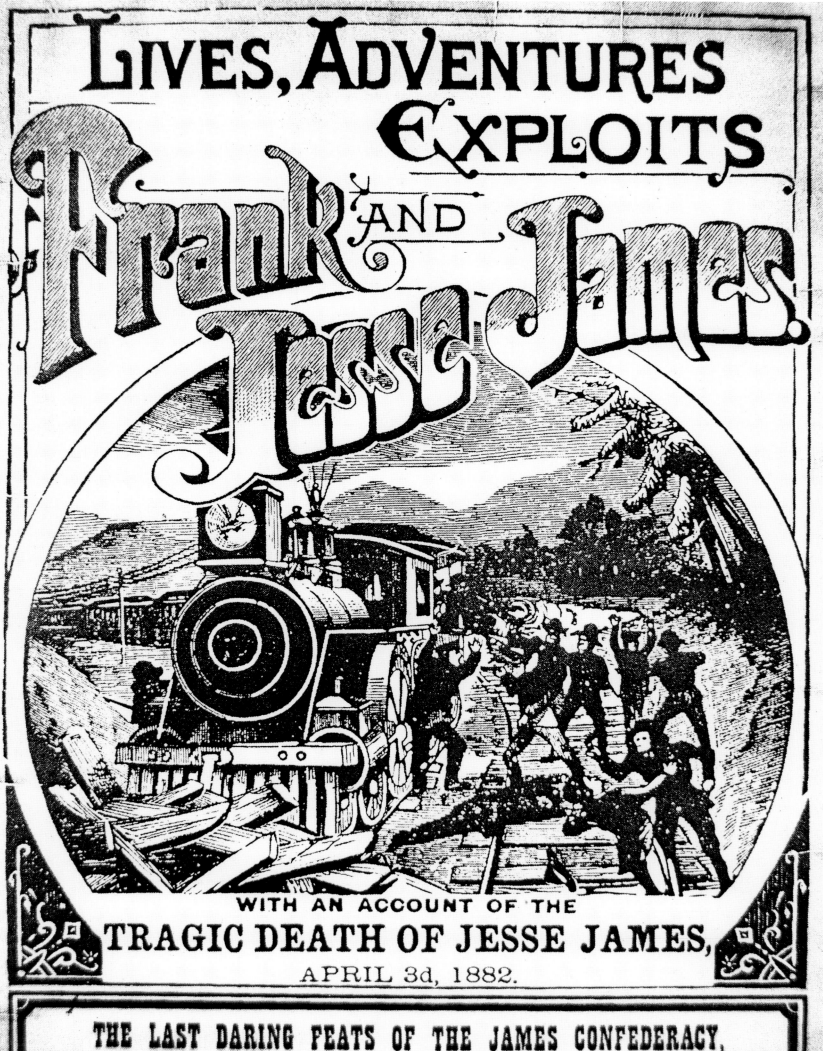

WITH AN ACCOUNT OF THE

TRAGIC DEATH OF JESSE JAMES,

APRIL 3d, 1882.

THE LAST DARING FEATS OF THE JAMES CONFEDERACY, ON THE ROCK ISLAND TRAIN, JULY 14, 1881

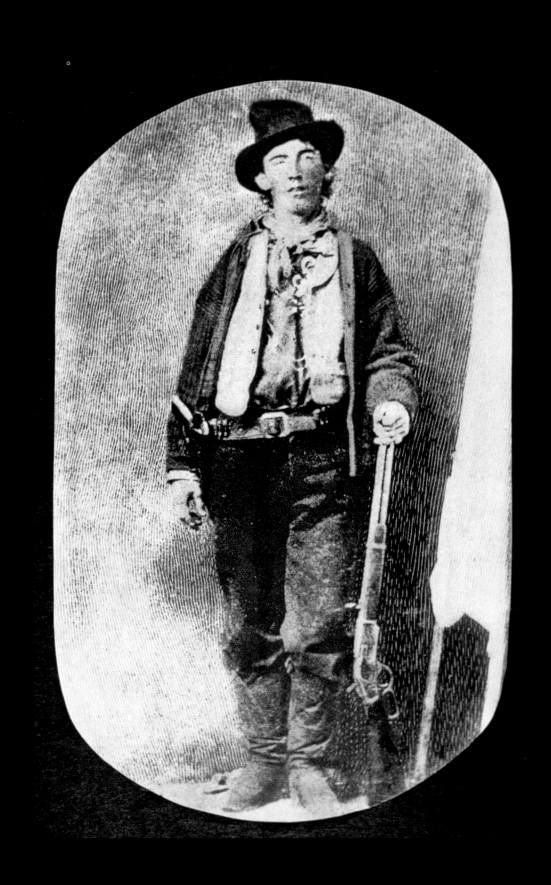

Pat Garrett (1850–1908) and Billy the Kid (1859?–1881)
A Fratricidal Friendship

When the cattle ranchers of Fort Sumner, New Mexico, elected Pat Garrett as sheriff of Lincoln County in November 1880, the new lawman took a moment to write to his friend Billy the Kid, advising him to clear out or face arrest and execution.

In the harsh world of the West, Pat Garrett is a surprising figure—apparently as fond of his enemies as he was of his allies, amiable to all, famous for always finishing a poker game, even when he had to interrupt it momentarily to settle a score with a passing criminal. His life was a succession of thrilling adventures. At the age of fifteen, Pat Garrett decided to get himself accustomed to alcohol. After a year-and-a-half of diligent apprenticeship, the adolescent boy was capable of downing two bottles of whisky without throwing up. At seventeen, during an armed raid, he fell in love with Juanita Martinez, the wife of the man he was about to rob. Garrett quit drinking and the two were married, but Juanita died of tuberculosis just a few days later. One month later, the young widower arrived in Sumner. The former bison-hunter took a job as a cowboy at the first property he came across. In less than two years, he had bought his own ranch and remarried, founding a family that eventually numbered five sons.

His first meeting with Billy the Kid took place in 1879, in a Fort Sumner saloon. Reassured by the cordial manner of his neighbor at the bar, Billy confided to Pat that he was without family, to which Pat reportedly replied "Well now, you've got me." The truth is difficult to ascertain, however. Pat Garrett made strident efforts to rewrite the history of their supposed friendship after his protégé's murder, portraying himself as the "enemy of evil."

Much of the short life of William Henry Bonney, *alias* Billy The Kid, remains a mystery, and many of the so-called facts are unreliable, not least his real name, and the date and place of his birth. Billy seems to have been born between 1859 and 1861, maybe in New York City, to a father who immediately sank without trace. His original last name is often thought to have been McCarty, but when his mother remarried one William Antrim, Billy took his new stepfather's last name and dropped his own first name as well, going by his middle name "Henry" for a while, so there wouldn't be two Williams in the house. That made him Henry Antrim. But it seems that this may well have been his second stepfather, while McCarty was the surname of his first stepfather—with his own father's surname being Bonney. (Although, it's also debated to which if any of these men his mother was lawfully wed.) At any rate, from 1877 onward he called himself William Henry Bonney. His mother was the one stable aspect in his life, as they moved west and she remarried once if not twice; her death from tuberculosis, in March 1873, made a deep impression on him. Billy's stepfather wasn't much of a family man, and at the age of fourteen Billy was left mostly to fend for himself, keeping bad company and being easily led into a life of petty theft and banditry. His friend, the doctor Henry Franklin Hoyt, described Billy at this period in his life as still beardless, but already clearly a leader. With his sangfroid, nerves of steel, and effectiveness, Hoyt wrote in his memoirs, Billy would have have been able to succeed at anything, had he been given the opportunity.

The scales were tipped the wrong way, however. At seventeen years of age, Billy killed a blacksmith by the name of "Windy" Cahill, in legitimate self-defense, as the result of an attack. He was arrested for murder, escaped, and began a hell-raising existence with the likes of Melquiades Segura, Jesse Evans, and Tom O'Keefe. Billy stole horses, cheated at cards, and killed three Native Americans to steal their furs. Hunted by the law, he crossed the Rio Grande and took refuge in the Rio Pecos Valley.

Back in Lincoln County, three wealthy cattle ranchers—John Chisum, Alex McSween, and John Tunstall—waged a

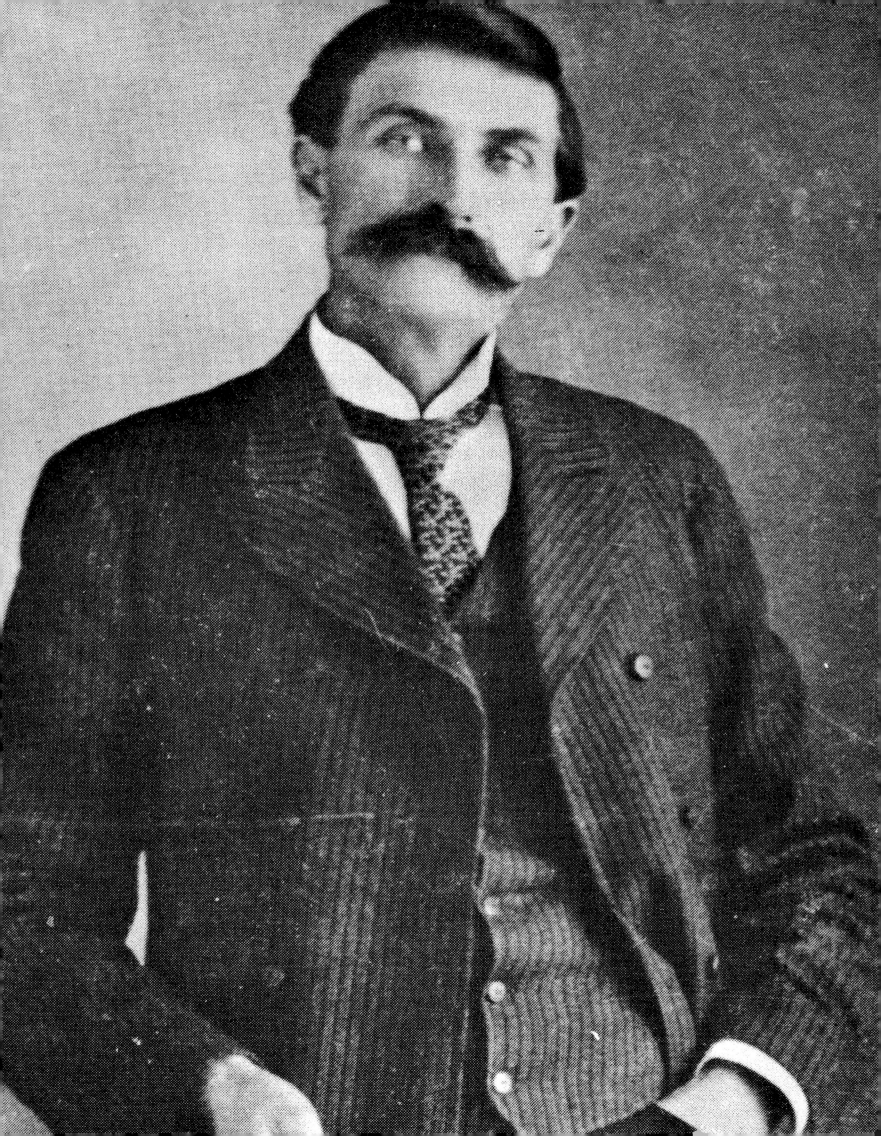

cruel war against a handful of smallholders who had banded together under the leadership of L.G. Murphy and Jimmy Dolan. Thanks to his reputation as a crack shot, Billy the Kid was hired by Chisum to chase cattle rustlers off his land, and subsequently hired by Chisum's associate Tunstall.

What had begun as a lawsuit soon degenerated into a full-scale blood feud. Tunstall was killed by Dolan's men on February 18, 1878. Tunstall's friend, the local magistrate Judge Wilson, ordered Billy to capture his murderers. The Kid tracked down the two men, by the names of Morton and Baker, but a disagreement broke out during their transfer to Lincoln. Some of Tunstall's cowhands wanted to settle the score with their boss's killers, but a man by the name of McClowsky tried to put a stop to their summary justice. In the confusion that followed, McClowsky was killed, Billy shot Morton, and Baker tried to escape. The violence

escalated when Marion Turner, the new sheriff of Lincoln County, created a volunteer vigilante force in June 1878, charged with putting an end to the activities of Tunstall's men, who were now calling themselves "the Regulators." According to Billy's Regulator friend Frank Coe:

I never enjoyed better company. He was humorous and told me many amusing stories. [...] Though he was serious in emergencies, his humor was often apparent even in such situations. Billy stood with us to the end, brave and reliable, one of the best soldiers we had. He never seemed to care for money, except to buy cartridges with. Cartridges were scarce, and he always used about ten times as many as everyone else. He would practice shooting at anything he saw, from every conceivable angle, on and off his horse. He never drank.[49]

An initial confrontation between the vigilantes and the Regulators left thirty men dead. The army was called in, forcing the Regulators to flee the scene and take refuge in Lincoln, at the home of the lawyer McSween. The building was set on fire, and the beseiged Regulators—who had already lost twelve men, including their host—were smoked out. Many gave themselves up, but Billy and ten survivors managed to escape.

In autumn 1878, Billy was blamed for the murder of Morris Bernstein, a Federal employee of the Mescalero Apache Indian Agency. The Kid was now a wanted man in every state of the Union. Sheriff Pat Garrett was appointed to put an end to the life of his friend, the Kid. When it came, Billy's death was suitably epic: captured by Garrett on the strength of a tip off, on December 20, 1881, Billy was taken to the prison at Santa Fe and sentenced to hang in Lincoln on May 13, the following year. Two weeks before his execution, however, he killed two of his guards and returned to his hideout at Fort Sumner, at the home of his friend Pete Maxwell, where he courted Maxwell's sister Paula. Maxwell refused to tolerate their affectionate relationship (in reality more of a platonic friendship). By all accounts, Maxwell alerted Garrett to Billy's presence under his roof. On the evening of July 14, 1881, Garrett slipped into Maxwell's bedroom:

Pete Maxwell gives a nervous giggle full of fear which Billy mistakes for embarrassment. Paulita! Jesus Christ. He leans forward again and moves his hands down the bed and then feels a man's boots. "0 my god Pete quien es?"
He is beginning to move back a couple of yards in amazement. Garrett is about to burst out laughing so he fires, leaving a powder scar on Maxwell's face that stayed with him all his life.[50]

On the twelfth stroke of midnight, the Kid's life came to an end, with a bullet through the heart. Questioned in jail a few weeks earlier about his relationship with Pat Garrett, he told a journalist from the *Texan Star* that his old friend Pat was making a lot of money cleaning up the area of people like himself. And, while they may have once been friends, he did not think about him very much anymore. But Pat Garrett did not make any money off of this capture either. He never saw the five hundred dollars promised to him for the arrest of the Kid. He died in 1908, from two bullets fired by an unknown assailant on a country road. The affair was never resolved, his murderer never found.

The price of betraying a friend, in the West.

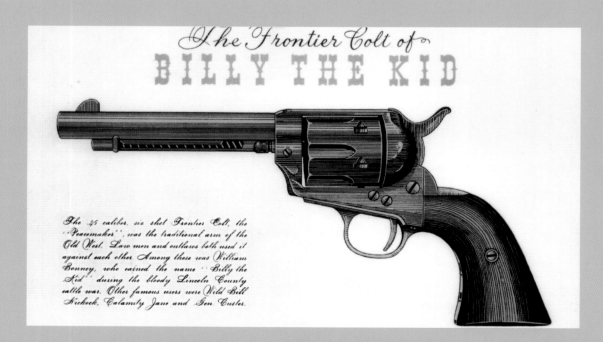

Page 100: Billy the Kid, 19th–century print.
Page 102: Pat Garrett, 19th century.
Page 103: Pat Garrett in pursuit of Billy the Kid, 1880.

Above: The revolver used by Billy the Kid, a Smith & Wesson, caliber 45, 19th century.
Facing page: Wanted poster with reward offer for the arrest of Billy the Kid, 19th century.

REWARD

($5,000.00)

Reward for the capture, dead or alive, of one Wm. Wright, better known as

"BILLY THE KID"

Age, 18. Height, 5 feet, 3 inches. Weight, 125 lbs. Light hair, blue eyes and even features. He is the leader of the worst band of desperadoes the Territory has ever had to deal with. The above reward will be paid for his capture or positive proof of his death.

JIM DALTON, Sheriff.

DEAD OR ALIVE!
"BILLY THE KID"

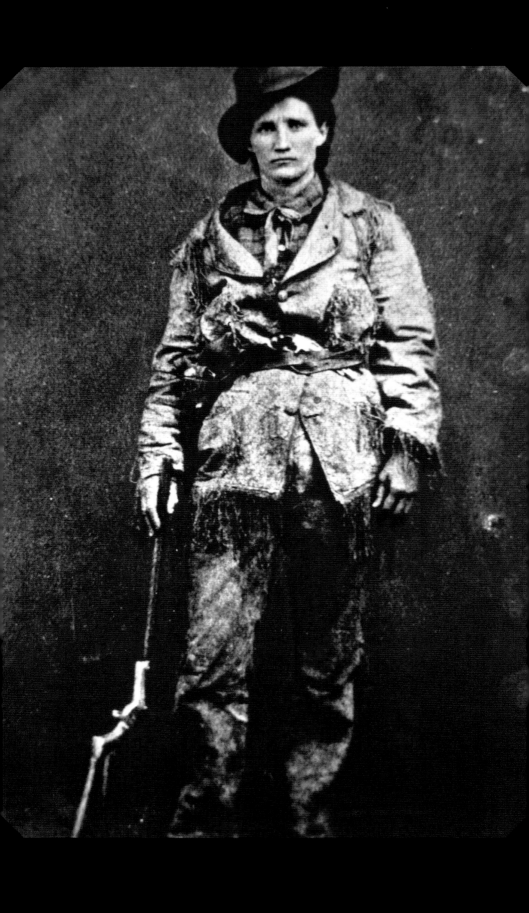

Calamity Jane
(Martha Jane Cannary, 1852–1903)
The Lonesome Cowgirl

A man named Mulog asked me to talk about my life and you should have heard the lies I told him. It's his business if he wants to print these lies and make money from them. I pretended to hardly know how to write. It will not deal with my life story.[51]

The life of Martha Jane Cannary-Burke, better known as Calamity Jane, is as extraordinary and mysterious as the woman herself. It is difficult, indeed, to disentangle fact from fiction in her intrepid life story: Cannary was a strong-willed, hard-boiled, prickly, and obsessively private woman, who made strenuous efforts to cover her tracks.

Born in Missouri in 1852, Martha headed west with her family—her father was a Mormon farmer, and her mother earned a living taking in laundry—at the age of twelve or thirteen. Her mother soon fell ill and died, and Martha found herself orphaned at the age of fourteen, with eyes for the wide open prairies.

Turning her back on conventional society, she dressed as a boy, swore, drank, and smoked like a trooper, and became skilled at taming wild horses and handling a gun. A fierce, independent spirit, she joined the ranks of the West's solitary riders and adventurers—and stayed for the rest of her life. She was scared of nothing, balked at nothing, neither the violent ways of her rough comrades, the scorn and jealousy of other women, outlaw ambushes, nor skirmishes with the "Indians," claiming with some pride that she was the only white-skinned person they feared.

Her pursuit of excitement and adventure knew no limits. On Satan, her loyal mount, her solitary rides took her across the states of Montana, Kansas, Dakota, and Wyoming. She worked as a navvy on the Northern Pacific Railroad. She served as a scout for General Custer in Arizona and for General Crook in the Black Hills. She herded cattle and drove a stagecoach. She claimed even to have ridden for the Pony Express, and although she didn't advertise the fact, she also had plenty of experience working in the rough dance halls of the Wild West. But her hard-living caught up with her in the end, and she entered the legend of the West as "Calamity Jane."

She loved to spin tall tales for people she met. Both she and Wild Bill Hickok have gone down in history as having said that she owed her nickname to Captain Egan, a man whose life she had once saved, rushing into a frontier battle to lift him on to her saddle. He lived, while everyone else in his company died.[52] However, in the bundle of unsent letters to her daughter, said to have been found among her possessions after her death, she wrote that it was, in fact, Hickok himself who gave her that name, after she'd warned him that she'd heard some outlaws planning his death.

These letters have never been authenticated but, assuming they are real, her tough exterior masked the heart of a guilt-stricken mother unable to care for her own daughter, who was given up to the care of a passing traveler. Written with great difficulty by the light of a camp fire, these astonishing letters to her daughter, "darling Janey," reveal a vulnerable, generous-hearted woman who kept a portrait of her daughter near and would kiss it, begging forgiveness.[53] Calamity Jane also claimed in these letters that Wild Bill Hickok, her great friend, was the father of this little Janey. Like the authenticity of the letters themselves, this has never been proven and seems unlikely. Hickok certainly never spoke of such a relationship with her, marrying someone else during the time they were friends—though friends they were, sharing an unshakeable love of daring and drink.

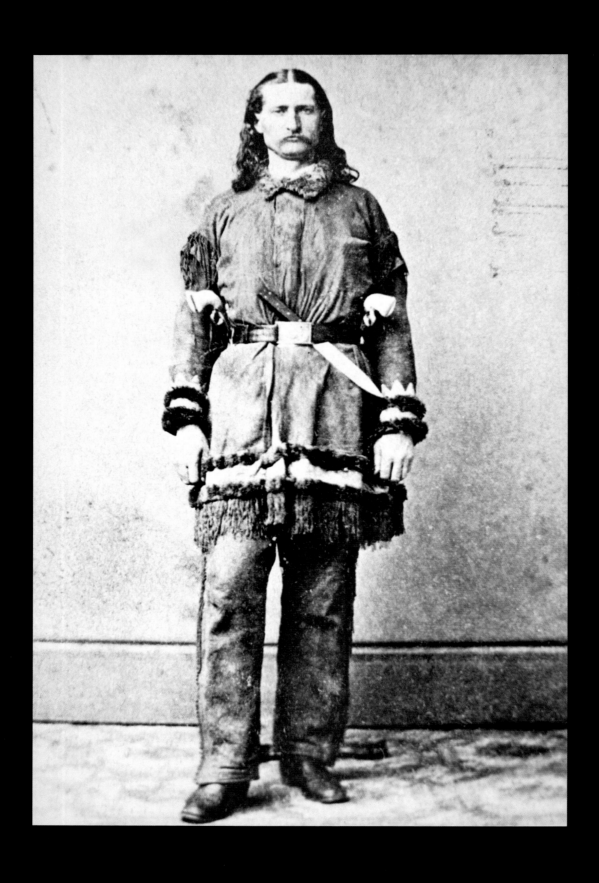

The most likely is that Calamity Jane was infatuated with Wild Bill Hickok, a sentiment that was not reciprocated. When he died in 1876, shot in the back during a poker game in the Number 10 saloon in Deadwood, South Dakota, she was said to have been inconsolable.

After his death, she stuck around for some years, prospecting at various mines in the region. In 1878, she became a nurse, caring selflessly for the residents of Deadwood while the town was ravaged by a smallpox epidemic and condemned to quarantine. Her love of adventure and the wide open spaces of the West eventually brought her back to life as a cowgirl, however, and she hit the road again.

Money was quickly earned or won, and quickly spent, largely in saloons. In 1885, she married a Texan named Clinton Burk. They ran an inn for a few years and then started traveling all over the West, trying to rake up interest in Calamity Jane's unusual personal history. The marriage produced a daughter but before a decade was up, her husband deserted her.

The West was won, and there wasn't much place left for Calamity Jane's special blend of hard riding and hard drinking. She still was an excellent shot, however, whose exploits had brought her wide fame. To escape poverty, she joined Buffalo Bill Cody's famous Wild West Show, traveling throughout the United States and Europe until her erratic behavior, caused by her constant drunkenness, got her summarily fired.

Calamity Jane died on August 2, 1903, at the age of fifty-one in Terry, South Dakota. The immediate cause was pneumonia, but her real killer was alcohol. Whether by chance or design, her grave lies within feet of Wild Bill Hickok's.

Page 106: Calamity Jane dressed in suede, on a reconnaissance mission for General Crook, 1895.
Facing page: Wild Bill Hickok, 19th century.
Below: Calamity Peak, South Dakota, named in honor of Calamity Jane, the first white female to enter the Black Hills Indian territory.
Page 110: Calamity Jane on horseback, September 1901.
Page 111: Calamity Jane, uncharacteristically wearing a dress, drinking with some men in Giltedge, Montana, 19th century.

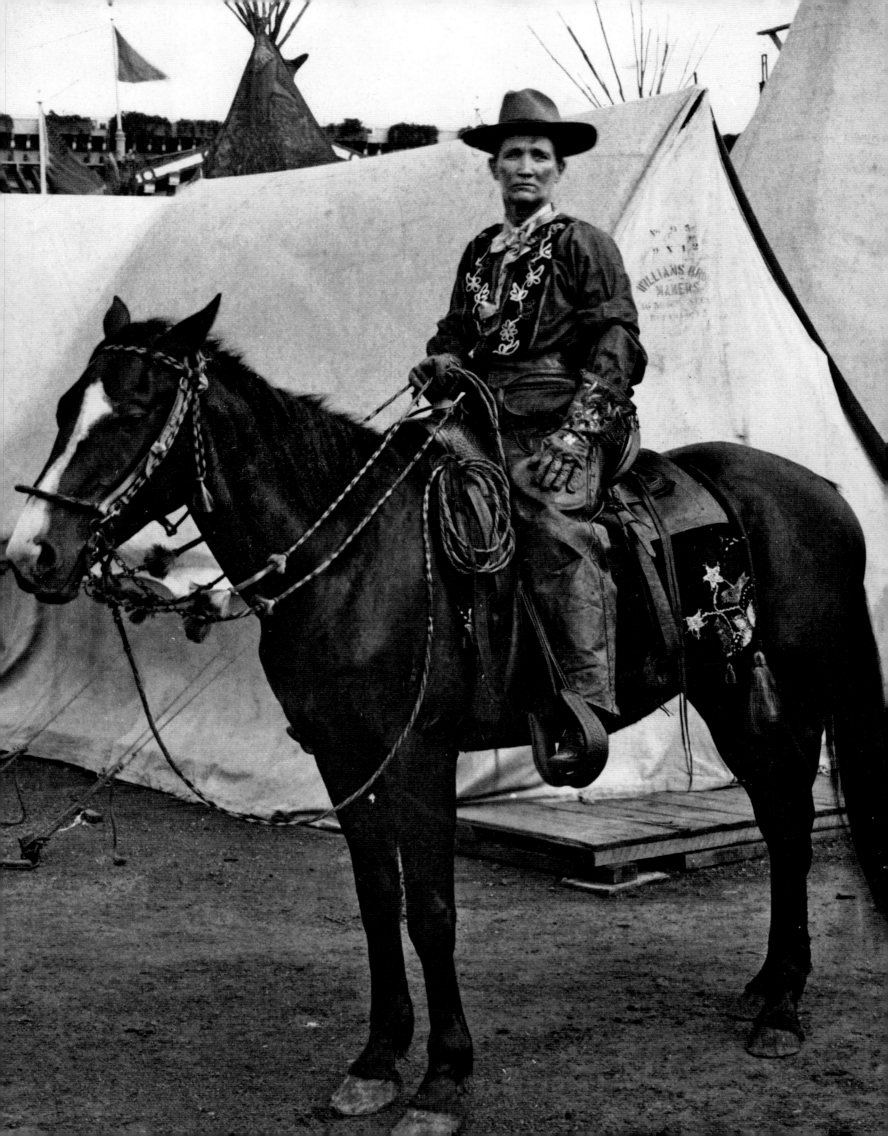

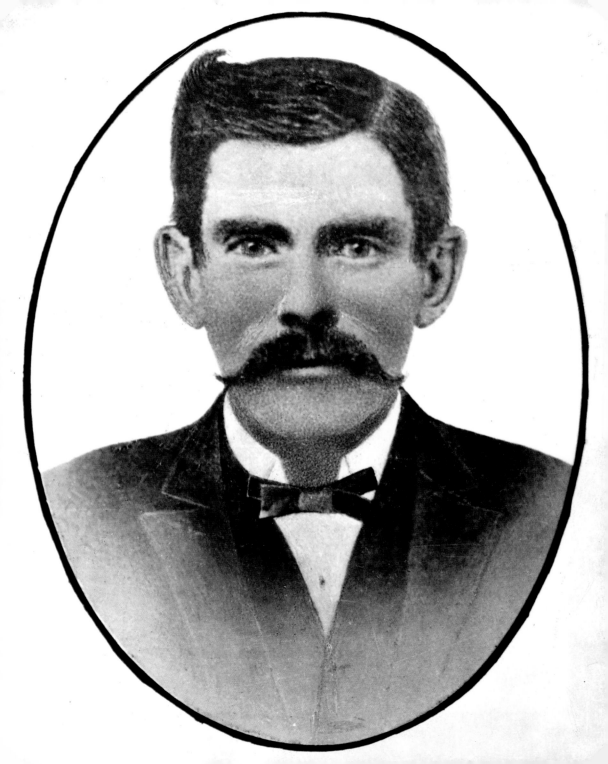

Wyatt Earp (1848–1929) and Doc Holliday (1851–1887)
Settling Scores at the O.K. Corral

In the words of Wyatt Earp, his acolyte and friend, Doc Holliday was "a dentist whom necessity had made a gambler; a gentleman whom disease had made a frontier vagabond; a philosopher whom life had made a caustic wit; a long, lean ash-blond fellow nearly dead with consumption and at the same time the most skillful gambler and nerviest, speediest, deadliest man with a six-gun I ever knew."[54]

Born on August 14, 1851, in Griffin, Georgia, John Henry Holliday was the only son of a well-to-do family. His elder sister Martha died young, fourteen months before he was born. Three events disrupted the young boy's peaceful, protected existence: the death of his adored mother, Alice Jane, from tuberculosis on September 16, 1866; his own infection with the disease; and his father's remarriage just three months after his mother's demise to Rachel Martin, a young girl of twenty-three to whom he took an immediate, strong dislike.

Like many young men of his class, Holliday followed a conventional path, studying with success to become a dentist, and receiving his diploma on March 1, 1872, from which he eventually earned the nickname "Doc" Holliday. His trigger-happy reputation exceeded his professional credentials, however. His first "shoot-out" occurred during the summer of 1872: angered by a group of young blacks swimming at his favorite place along the Valdosta River, Doc chased them away by shooting over their heads with his revolver.

Consumption devoured his lungs, forcing Doc to cough and spit during delicate dental procedures. His doctors were pessimistic. At the age of twenty-two, his days were officially numbered, and he chose instead to "live absurdly in an absurd world as best he could."[55] As advised, he left the damp air of Atlanta for the drier climate of the American West. In October 1873, he packed his things—not forgetting his knife and his six-gun revolver—stopping for a time in the city of Dallas, the last stop on the westbound railroad.

Plagued by repetitive and bloody coughing fits, he was unable to practice as a dentist, but he had a natural gift for gambling and cards. Doc soon established a reputation as a formidable professional player, as brilliant at poker and faro (his favorite game) as he was quick on the draw with his revolvers, which he wore butt forward.

From January 1875 until his meeting with Wyatt Earp at Fort Griffin, Texas, in 1877, Doc's trail is reputed to have been one of violence and death, as befits a professional card player of the time out West. One man wounded and another killed in Dallas, three shoot-outs and one man dead in Jacksboro, another killed at Fort Richardson, three dead in Central City, and a professional gambler left crippled in Denver. Doc knew he was doomed; this handsome young man, ravaged by consumption and accustomed to the shame of coughing phlegm into public spittoons and chamber pots, cared nothing for the opinion of others and knew no fear of death—which, due to his illness, was just around the corner for him, anyway.

Holliday is said to have been saved from a lynching in 1877 by a Hungarian prostitute known as "Big Nose Kate," for the size of her nasal appendage. Like Holliday, she was from a cultured and educated background; her father had also been a doctor. She became his companion and guardian angel; the two embarked on a wild wandering life, marked by explosive rows and stormy passion.

When Wyatt Earp entered the saloon at Fort Griffin to question Doc (who was playing cards) about his old associate Dave Rudabaugh (wanted for cattle rustling), the two took an immediate liking to each other. Doc proved unexpectedly affable and informative, and Wyatt showed his gratitude ever after. Surprised by Holliday's sickly appearance, Earp wasted no time in telling him how awful he looked. Still, a firm friendship sprung up between them. The taciturn Earp—a former bison-hunter turned

marshal—was idolized by Doc, the rich man's son adrift on drink and gambling.

In Dodge City, Kansas, Doc saved Earp's life for the first time. One evening, as he sat at a table in the Long Branch Saloon, Doc spotted a man pointing his revolver at Earp's back. Doc reacted in a flash, drawing his gun and firing a bullet straight through the assailant's body, killing him outright. One bold pistol shot had put Doc temporarily on the side of the good guys. The affair was sensationalized in the press, and the doors of the Wild West Hall of Fame were flung open to Earp and Holliday. The two friends soon rushed in….

As the railroad advanced, Dodge City became a dusty ghost town. One by one, the professional gamblers, prostitutes, and lawmen moved on: first Kate, then Wyatt, and finally Doc himself. Alone again, Doc returned to life as an outlaw. In Trinidad, he shot Kid Colton; in Las Vegas, he began practicing once more as a dentist then opened a saloon, settled an old score with Mike Gordon, and went on the run once again.

In the early summer of 1880, Kate and Doc—the two had met and made up in Prescott, Arizona—won forty thousand dollars at poker and headed for the nearby town of Tombstone, where an outcrop of silver ore had been discovered. Wyatt Earp and his three brothers—Virgil, Jim, and Morgan—had got there first. Virgil was appointed as a Federal deputy marshal, with Wyatt as deputy sheriff. Both resigned, however, when the Clanton gang consolidated their control of the region by winning a rigged election. With or without his sheriff's star, Wyatt Earp cut a tall imposing figure. As before in Wichita and Dodge City, he intended to establish himself as a custodian of order—and a focal point for hatred of the Clantons, McLowery, Curly Bill, and their men.

Doc became a regular at the Oriental Saloon, where his unpredictable behavior was soon noticed. One evening in October 1890, Doc got into a quarrel with another card player. When the saloon's owner, Milt Joyce, intervened, he was shot through the hand and grazed by a bullet to the ear. Doc got off lightly, with a fine of just twenty dollars.

On March 15, 1881, Wyatt was dealing the cards at the Oriental when a telegram arrived alerting him to an attack on a stagecoach carrying a cargo of gold ingots. The gold was safe, but the driver and one passenger were dead. The other passengers had recognized the Clanton gang under their assailants' masks, but the telegram threw suspicion on Doc, who was away from Tombstone that day. Doc defended himself by declaring that he would never kill two innocent people. He would have secured the loot, he said, by the simple expedient of shooting one of the horses. In a snit with him and plied with alcohol, Big Nose Kate signed testimony against him, but he was eventually acquitted. Kate left her lover once more, and Doc stayed on Tombstone, keeping watch over Wyatt, his hero. Deep down, he still fancied himself on the side of the angels and offered his services to the three Earp brothers, as a righter of wrongs. For Wyatt, Doc's role was clear—to watch his back: "You're not there to demonstrate the model of civic behavior. You're the allied force

hiding behind the cannons."[56] Meanwhile, Wyatt had fallen in love with the mistress of the corrupt Sheriff John Behan, a lawman operating in the pay of the Clanton-McLowery gang. The inevitable confrontation took place in Allen Street; death threats and insults were hurled as the tension mounted. The townspeople's security committee appointed Wyatt, Morgan Earp, and Doc as joint marshals, alongside Virgil.

After a night of drinking and mutual insults, the score was finally settled in a shoot-out at the O.K. Corral on October 26, 1881. Watched by the corrupt sheriff, Wyatt, Morgan, and Doc were the faster, more accurate shots: Billy Clanton, Billy Clairborne, and Tom and Frank McLowery were felled by their bullets. Virgil and Morgan Earp were seriously wounded. Ike Clanton was bent on revenge but chose to run for the moment. Doc and Wyatt spent the night in prison, for abuse of police powers, but their plea of legitimate self-defense held, and they were released the next day.

A few weeks later, Doc received a 45-caliber bullet at his hotel, together with a note from an "unknown friend," informing him that its twin would lodge in his neck one day soon. Doc had been warned. The first man to pay was Virgil, the elder of the Earp brothers, who was wounded

"Well, I'll be damned. This is funny."

by a bullet in the elbow. Next was Morgan, killed while playing billiards with his brother Wyatt. Each death demanded a new death. Blinded with grief, Wyatt Earp took the law into his own hands, launching a personal vendetta, and killing his brother's presumed assassin, Frank Stilwell, in Tucson, followed by Curly Bill Brocius in Mescal Springs.

Declared *persona non grata* in Arizona, Wyatt and Doc sought refuge in Colorado. On the station platform in Silver City, New Mexico, the two friends parted on a misunderstanding: Wyatt accused Doc of abandoning him in the midst of the gunfight at the O.K. Corral. He left to pursue his dreams of order and justice in Gunnison. Doc headed for Denver, where he was arrested and sank into a life of poverty as a petty swindler. His luck and health failed, and he decided to take a cure of sulfurous vapors at a sanatorium. The treatment offered no relief, however, and probably scorched his ravaged lungs further still.

Legend has it that on the eve of his death, his old friend Wyatt gave him back his marshal's badge and kissed Doc on the forehead. For fifteen years, Doc had chased the bullet that would bring relief from his suffering, only to die in bed—a fact recorded on his tombstone in Glenwood Springs, Colorado. Gazing down at his bootless feet, Doc is said to have uttered these now famous last words: "Well, I'll be damned. This is funny."

Page 112: Doc Holliday, 19th century.
Page 114: The Crystal Palace Saloon which Wyatt Earp regularly visited, 19th century.
Page 115: Charles Bassett, Wyatt Earp, Q. McLean, Neal Brown, W.H. Harris, Luke Short, Bat (William Barclay) Masterson, sheriffs, 19th century.

Facing page: Wyatt Earp, June 1883.
Above: The bodies of Tom & Frank McLaury and Bill Clanton after the shootout in O.K. Corral, Tombstone, Arizona, October 26, 1881.

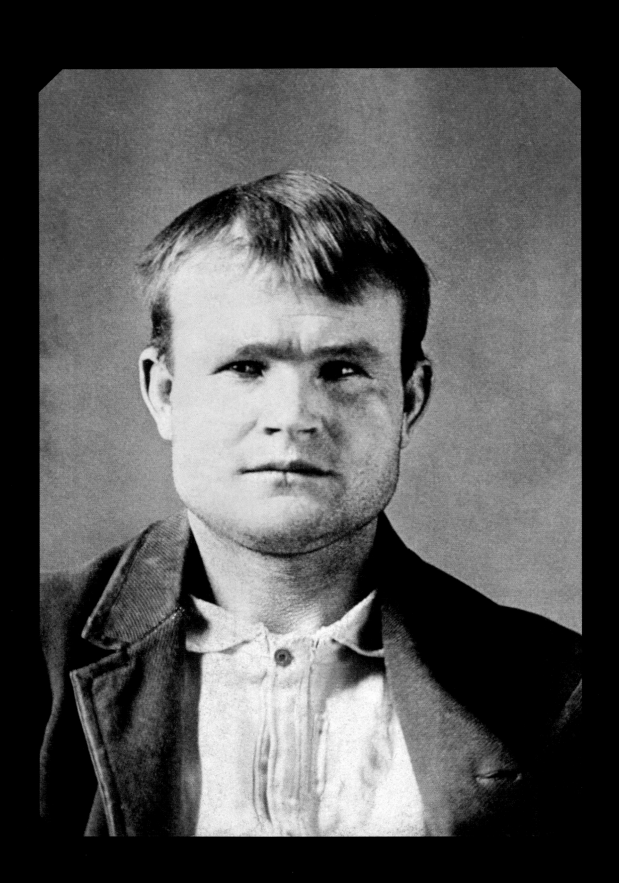

Butch Cassidy (1866–1908) and the Sundance Kid (1867–1908)
The Wild Bunch

Their real names were Robert Leroy Parker and Harry Longabaugh, but they went down in the history of the West as Butch Cassidy and the Sundance Kid. Trusting to their lucky stars, they thought they could outwit justice, vigilantes, and the "Pinkies" (detectives from the Pinkerton Agency), but fate and their criminal past caught up with them in San Vicente, in southern Bolivia. Before their tragic denouement Butch Cassidy swore they had never fired on an another human being (apart from a handful of lawmen and the bounty hunters hired to track them down). Still, they paid for their recklessness with their lives.

Three weeks before the shoot-out in San Vicente, they had attacked a bank convoy and stolen its mules. During a stop at a police post (which also served as a hotel and bar),

1856 to defend the Mormon state of Deseret—modern-day Utah and Montana—which had come under siege from federal troops for its adherence to the practice of polygamy. Parker was born on April 13, 1866, in Beaver, Utah. His family owned the Marshall ranch at Circleville. In school, he was a diligent pupil and student of the Mormon tablets. The rest of the time, he perfected his cowboy skills under the watchful eye of Mike Cassidy, a tough ranch hand, who led a double life as a cattle rustler.

While still a young teen, Parker experienced his first run-in with the law. Badly needing a new pair of overalls, he rode into town to find the general store closed. Rather than coming back another day, he broke in, selected some pants for himself, and left a note for the shopkeeper stating that

Butch had one bullet left: he put the barrel of his gun to his right eye and fired, so he could die a free man.

a corporal recognizd one of the convoy mules among their mounts. The Pinkies had placed a ransom of ten thousand dollars on their heads; unable to resist, the corporal reported them. The fight started at nightfall and continued until noon the next day. Ninety terrified soldiers, commanded by one Major Espinosa, confronted two hung-over desperadoes armed with only their six-gun revolvers. According to legend, Sundance was the first to die, of his wounds. Butch had one bullet left: he put the barrel of his gun to his right eye and fired, so he could die a free man.

Robert Leroy Parker was the grandson of an impoverished Mormon pastor who left England in September of

he would return soon to pay. The irate shopkeeper notified the town sheriff, but the matter was settled without any jail time for the youth. At the age of nineteen, the future Butch Cassidy experienced his second run-in with the law. Wrongly accused of stealing a Mexican saddle from the young son of a wealthy landowner, this time he was arrested and beaten by the local sheriff before being released. Innocent as these events might seem, Parker was on his way to becoming an outlaw. Mike Cassidy taught Parker how to brand cattle and break thoroughbreds, but he also initiated him into the art of horse-stealing, using a simple and highly effective technique: the pair would locate ranches in

neighboring states, with land adjoining the state boundary, then steal a handful of horses under cover of darkness, taking them over the border and beyond the reach of the neighboring state's law-enforcers. After their journey of several hundred miles, the stolen horses were put to pasture, hidden in a group of their fellow creatures, and sold.

Parker began a life roaming the trails of Wyoming, Montana, and Colorado, working as ranch hand and rustling livestock. As a sign of affection to Mike Cassidy (and possibly to spare his parents from shame), he adopted his mentor's last name. His new first name is said to have been the result of a laughable accident. The young outlaw asked to try one of his accomplice's guns, an old rifle nicknamed "The Butcher" and noted for its powerful recoil. The shot rang out, and Cassidy landed backwards in a pond, his arms and legs in the air. A baptism of fire (and water) that stayed with him forever. Robert Leroy Parker was forgotten. From now on, he was Butch Cassidy—or occasionally (as required) James Ryan, Lowe Maxwell, or James Maxwell.

In 1887, during an extended stay in Telluride, Colorado, Butch met the notorious McCarty brothers. The two outlaws taught him how to raid banks and attack trains. On June 24, 1889, the trio attacked the bank at San Miguel Valley, making off with twenty-one thousand dollars. Already wanted for horse-stealing, Butch was wounded in the face during a spirited arrest, which left him scarred on the temple for life. He fainted, was handcuffed, and ended up sentenced to two years in prison on July 15, 1894. Butch served eighteen months in the Wyoming State Penitentiary, as prisoner number 187, and was released on the promise that he would attempt no more crimes in the territory of Wyoming.

After Butch left prison, he spent the winter at Robber's Roost, a remote settlement in southeast Utah, with his mistress, Ann Basset. He frequented the notorious Hole in the Wall gang but was not a member, planning instead to establish a gang of his own—in his own image.

The following spring, he established a base at Brown's Hole in the Uintah Mountains, an impregnable hideout at

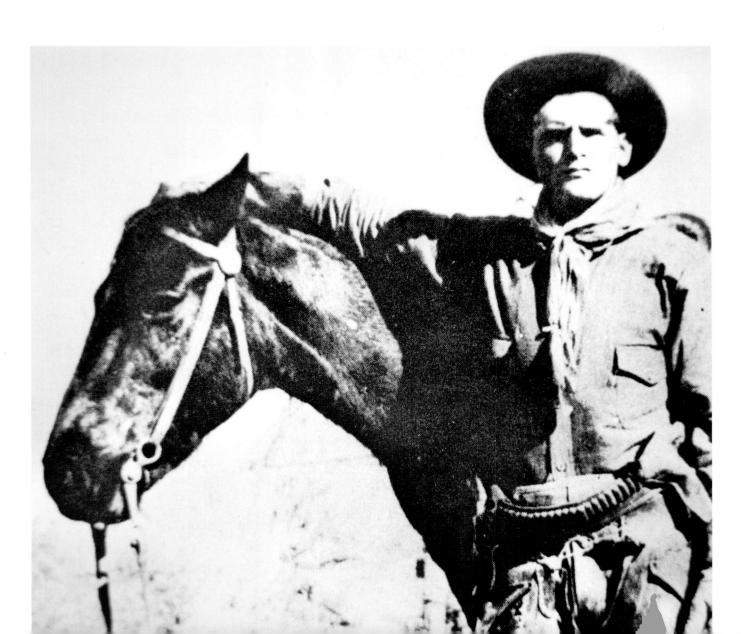

the crossing-point between three states: Wyoming, Utah, and Colorado. Butch wasted no more time on petty larcenies: the world belonged to people who rose at dawn to attack trains, and waited until nightfall to break into banks and blow open their safes. The "Wild Bunch" was born.

Among the rogues and outlaws attracted by Butch's innovative methods was a former member of the Hole in the Wall gang, Harry Longabaugh *alias* the Sundance Kid—a tall, well-built figure with a fine mustache, admired for his sang-froid and discretion. At first glance, the two men were complete opposites: one was a teetotaling extrovert, the other taciturn, withdrawn, and addicted to alcohol and women. Yet they became firm friends, remaining together for the rest of their lives. During his spell behind bars, Butch had given a great deal of thought to his scheme. He would no longer steal from private individuals but focus instead on "withdrawals" from banks, train operators, and mining companies. The gang would be headed by an inner circle of eleven members (Butch Cassidy, Sundance Kid, Harvey Logan, George Curry, Ben Kilpatrick, Bill Carver, Bill Cruzan, Bob Meeks, Harry Tracy, Elzy Lay, and a woman, Camilla Hanks), all of whom would vote democratically on the operations to be carried out, each decision requiring a majority two-thirds vote. Any resulting booty would be divided into two halves: the first for the informers (railroad employees, bank cashiers, telegraph operators, barbershop boys), and the second in equal parts for each participant in the operation, irrespective of his (or her) role.

When membership of the Wild Bunch reached one hundred fifty, the gang began operating as a train robbers' syndicate. Two groups completed the new organizational structure: "occasional" members and informers, paid according to the operations in which they took part.

From 1897 to 1899, the gang carried out a long list of bank raids and attacks on trains, the most famous of which was the Union Pacific train holdup, on June 2, 1899. A manhunt followed, and numerous arrests. Weary of living on the run, Butch Cassidy dreamed of an honest existence. At the end of 1899, he took a job as a cowboy in New Mexico. Cassidy claimed to have never killed or robbed a private individual and declared himself ready to pay back the sums he had stolen—at least those of which he stood accused.

Cassidy was a wanted man, but he headed for Ogden, Utah, nonetheless, to consult Judge Orlando W. Powers, a leading lawyer, on appropriate steps to an amnesty. His hopes of redemption were dashed, however. Butch had too

many bank raids and train holdups to his name, in too many states of the Union. Powers was a man of good sense. He advised Cassidy to start a new life in Canada or Latin America, but Butch was determined to pursue his goal and sought a meeting with Governor Wells of Utah. He discovered that he was wanted for a murder that he had not committed. Seeing his client's dismay, Powers made efforts to secure him a job with the Union Pacific Railroad, via the Pinkerton Agency, providing secure escort for trains. The negotiations came to nothing, however. There could be no question of Butch becoming a "Pinky"!

Faced with a choice between the southern sun and the snowy north, Butch and Sundance opted for warmer

climes, but they had no intention of heading south without funds. On August 29, 1900, they attacked the No. 3 train of the Union Pacific railroad at Tipton, Wyoming. The safe was empty, and the pair made off with just fifty dollars and forty cents. They had better luck on July 3, 1901, making off with sixty thousand dollars this time around. They decided to head for Argentina.

Meanwhile, however, Sundance had fallen in love with a surprising creature by the name of Etta Place. When the accomplices were reunited in New York on February 1, 1902, in the lobby of the Immigrant Hotel, Butch stared as Sundance arrived with the beautiful Etta on his arm. On February 20, the trio embarked for Buenos Aires aboard the steamship *Soldier Prince.* The new immigrants bought a forty-thousand acre ranch at Cholilo and led a peaceful existence as gentlemen farmers for the next three years. The Pinkerton Agency had not given up hope of their arrest, however. A Pinkerton agent, Frank Dimaio, was sent to Argentina, forcing the trio to run yet again

(without Etta, who had returned to New York). To survive, Butch and Sundance redoubled their crimes, attacking trains and banks in Argentina, Chile, and Bolivia.

A few days before his death, Cassidy confided his regrets—and his longing to turn back the clock some twenty years—in a letter to a friend. His recklessness, and the Pinkerton detectives, deprived him of the peaceful life he craved. But legends never die: eight years after his death, witnesses swore they had seen him at Brown's Hole, Idaho, or Price, in the saloon of his old friend Matt Warner.

Page 118: Butch Cassidy, prison photo, 1894.
Page 120: Advertisement for the Northern Pacific Railroad, 19th century.
Page 120: Butch Cassidy and his horse, 19th century.
Facing page: Butch Cassidy's prison form, 1896.
Below: The Wild Wild West: the Eagles, a rock group, staging a shootout for their album cover, 1972.

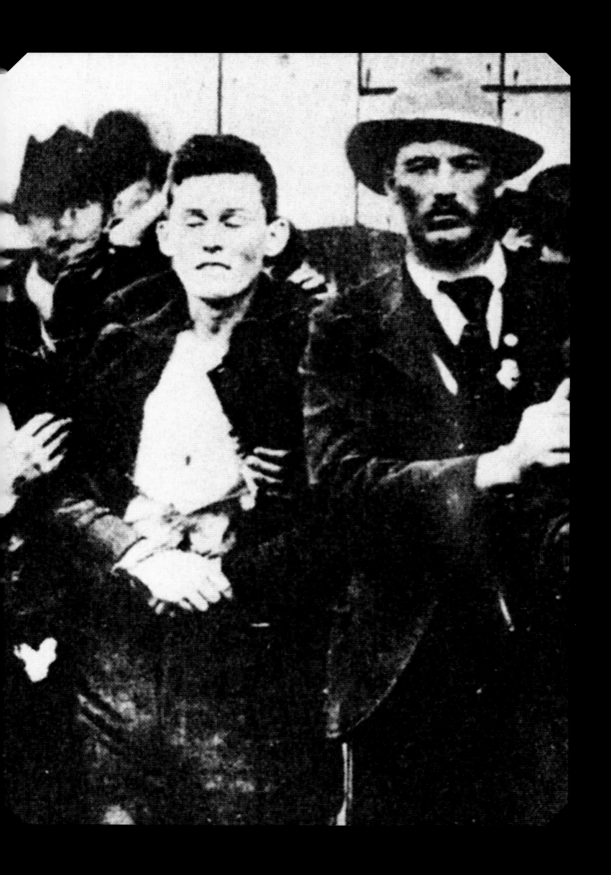

The Dalton Brothers: Grattan (1865–1892), Bill (1866–1895), Bob (1868–1892), and Emmett (1871–1937)

The Most Incompetent Gang in the West

The Dalton Brothers—the colorful quartet portrayed in Goscinny and Uderzo's *Lucky Luke* comic books—really existed. Like their comic caricatures, their story is a succession of botched raids, failures and, ultimately, tragic death.

It so happens that Frank, the oldest of the Dalton brothers, became a policeman noted for his courage and upstanding morals before being killed by an illicit liquor smuggler on November 29, 1887. Three of his nine brothers—Bob, Grattan ("Grat"), and Emmett—took advantage of his reflected posthumous glory to secure appointments as deputy sheriffs. Their passion for law and order proved short-lived, however.

Before becoming outlaws, the Daltons lived the conventional, austere life of so many pioneer families on the great American plains. Their parents were tireless workers and prolific progenitors, raising fifteen children—ten boys and five girls. The family began life as small farmers in Missouri, and later ran a saloon and grocery store before seeking their fortune out West. In 1882, they settled in Coffeyville County, Kansas, where conquered Indian territories were being parceled out to any tough pioneer family prepared to clear the scrub.

Following his elder brother's death, Bob became the chief henchman of his family's gang of petty delinquents. It all began with a simple lover's betrayal. While Bob Dalton was away working as a policeman in Arkansas, he learned that his fiancée, who had stayed behind in Coffeyville, had succumbed to the charms of young neighbor. Returning home, he laid an ambush for his rival and shot him straight through the heart, claiming self-defense. He was acquitted but removed from the police on charges of corruption, while his brothers Emmett and Grat reaped comfortable rewards from horse-stealing and livestock-rustling. Bob and Emmett left for New Mexico where they planned to open an illegal saloon. Grat and Littleton joined their brother Bill (an upstanding citizen prior to their arrival) in Tulare, California. The saloon failed, and Bob headed for Tulare, too, persuading his brother Grattan to turn his back on a law-abiding existence and work for easy money, instead.

The gang attacked easy, risk-free targets—stagecoaches and small stores—but their early successes inspired Bob (the self-appointed "brains" of their operations) to form a gang of his own and move into the big league, attacking trains. Their first attempt, in Alila, in February 1891, was a disaster. One of the engine drivers refused to unlock the mail carriage and was killed. The local people gave chase, and the four masked bandits were forced to flee empty-handed. In the pursuit that followed, Grat fell off his horse and was badly wounded, taking refuge at the home of his brother Bill. The incompetent horseman was recognized, however, and the house was surrounded. Grat was arrested and sentenced to twenty years in a Federal penitentiary. On April 1, however, he escaped during a transfer by train and headed for Oklahoma, where he was reunited with his brothers.

The Daltons, supported by a handful of accomplices, renewed their attacks on trains and banks, with varying degrees of success. On July 15, 1892, they finally made off with a substantial haul at Adair, Oklahoma, killing two passersby in the process. This first major triumph rekindled their dreams of grandeur and marked the beginning of the end. Bob dreamed of pulling off a great coup that would ensure them a place in the history of the West. Having grown up in Coffeyville, and knowing every last corner of the county, he planned a simultaneous attack on the two local banks—the First National and the Condon—on October 5, 1892, with the help of his two brothers and three associates: Dick Broadwell, Bill Powers, and Bill Doolin. Nothing went according to plan. On the edge of town, Doolin's horse fell lame and had to be abandoned

with its rider. The town's main square—where the gang planned to tether their horses for the getaway—was being dug up for building work, forcing them to use a less accessible alleyway nearby. On the way into Coffeyville, a passerby recognized the three brothers and raised the alarm. While the gang got to work in two separate groups—Bob and his brother Emmett at the First National; Grat, Dick, and Bill at the Condon—the townspeople lay in wait with the local sheriffs, ready to settle the score when the outlaws emerged. Realizing they had been spotted, Bob and Emmett—with a haul of twenty thousand dollars—emerged from the bank using three customers as a human shield but were met with a hail of bullets, forcing them to retreat inside. Exiting through a hidden door, they found themselves face-to-face with a young boy, who was killed by Bob in cold blood, on the spot. The two made their escape, Emmett dragging the heavy sack of booty and Bob

providing covering fire, killing two citizens who threatened them and a cashier who had given chase.

Over at the Condon Bank, things were scarcely any better. The head cashier asked for ten minutes to open the safe, claiming it was protected by a sophisticated timing device. Impatient to bring the affair to a close, the sheriff ordered an attack on the bank. The three bandits took advantage of the ensuing confusion to slip away down a side alley, and rejoin their brothers and the waiting horses. The crowd blocked the narrow street at both ends, however, making escape impossible. Crouching behind the carcasses of their dead horses, the Daltons returned fire. Grat struck one of the sheriffs in the chest, killing him instantly. The street battle looked set to last, and the outcome was far from certain. But the gang had reckoned without John Kloehr, a lone marksman armed with a Winchester rifle, hidden behind a heavy door. Faster on the draw than Bob, Kloehr shot the "brains" of the operation. Powers and Broadwell, fleeing on horseback, were felled in a hail of bullets, as was Grat. Emmett, still lugging the booty, leapt astride a horse but circled back to try to pick up Bob. Kloehr got him in the shoulder, and he was shot about twenty additional times in the arm, shoulders, and back. He fell from his horse, and the crowd would have lynched him right there but, figuring he would die soon anyway and could provide information in the meantime, the sheriff had him taken up to be seen to by an old doctor in a nearby hotel. To everyone's astonishment, he survived and went on to face trial.

Emmett was treated by an elderly doctor in the local hotel. He had escaped death and then was spared the noose but sentenced to prison. An exemplary inmate, he was released in 1920 after fourteen years, and settled in Los Angeles, where he worked in real estate and film, and campaigned for prison reform. He died a respectable man, on July 13, 1937, in his own bed.

Ironically, Bill Dalton—an upstanding member of society until the death of his two brothers—became an outlaw in his turn, joining a new gang formed by Bill Doolin, who had survived the attack on Coffeyville safe and sound, thanks to the premature wounding of his horse. The last of the Daltons was eventually tracked down by a police squadron at the family ranch, besieged and struck in the back by a caliber 45 bullet, killing him outright at the age of thirty.

Bob had achieved his dream: the Dalton Brothers did, indeed, go down in the legend of the West—as a bunch of stupid, bloodthirsty incompetents.

The Dalton Brothers did, indeed, go down in the legend of the West—as a bunch of stupid, bloodthirsty incompetents.

Page 124: The bodies of Robert and Grattan Dalton, killed during an attempted robbery of the Coffeyville bank, 1892.
Facing page: The Dalton Gang targeted in anger by the citizens of

Coffeyville, print published in the National Police Gazette, *October 5, 1892.*
Above: The Condon and Company Bank of Coffeyville, 1892.

The Pinkerton Agency
The Outlaws' Evil Eye

In the burgeoning West, law and order, other people's belongings, and private property were sacred, even if they were acquired on the backs of the poorest in society. Trigger-happy outlaws could not be allowed to threaten the development of the railroad, mines, and the banking system. Whether the outlaws referred to their operations as "withdrawals," "restitutions," or theft, their repeated attacks—most often on horseback—on banks, trains, mines, and grand ranches were considered intolerable. Their perpetrators had to be hunted, tracked down, and punished.

Sheriffs, marshals, and policemen quickly proved inadequate to the task or powerless in the face of the new forms of violence threatening the economic rise of the West. Bankers, businessmen, and railroad entrepreneurs decided to call in a new race of hardened sleuths: the private detectives of the Pinkerton Agency.

Nothing predisposed Allan Pinkerton, the agency's eponymous founder, to become the scourge of the intrepid, trigger-happy outlaws of the West, in the middle of the nineteenth century. Born in 1819 in Glasgow, he emigrated from Scotland to the United States in 1842 with his new bride, Joan Carfrae. Pinkerton took a first job as a cooper in Illinois, where his moral rectitude and respect for the law led him to accept the delicate post of deputy sheriff. His shrewd approach led to the unmasking of a network of forgers. His local reputation thus consolidated, he enlisted in the Chicago police.

In 1850, Pinkerton decided to strike out alone, founding the first-ever private detective agency, an organization whose notorious motto—"We never sleep"—beneath the device of an open eye, resulted in many nights of insomnia for the outlaws of the West. Pinkerton enjoyed dazzling success, and clients flocked to his door.

In 1861, the agency uncovered a Confederate plot to assassinate Abraham Lincoln, ensuring its fame across the Union. The agency sided with the federal troops in the Civil War, with Allan Pinkerton taking charge of intelligence operations for the northern states. When in 1869 he suffered an aneurysm, curtailing his activities, Allan called on his two sons, William and Robert, to help take charge of the agency. By then, it employed about ten thousand people, including the first female detective, Kate Warne.

A hundred and fifty years after it was founded, Pinkerton Consulting and Investigations continues to operate as a division of Securitas AB. The company's website celebrates the agency's history as the scourge of Jesse James, the Younger and Dalton Gangs, and the Wild Bunch and their charismatic chief Butch Cassidy but draws a veil over its less glorious involvement in the infiltration of America's first mining unions—the so-called Molly Maguires—in Pennsylvania, in the 1870s. Not that its part in the proceedings will ever be able to slide into complete obscurity. Sir Arthur Conan Doyle, the creator of Sherlock Holmes, took the dramatic affair—which ended with the hanging of seventeen Irish trade unionists—as the basis for his successful novel, *The Valley of Fear*.

Facing page: "Hands in the air!": poster from the Pinkerton detective agency, 19th century.

They rebelled against the taboos and tedium of everyday life

Disinherited second sons, strong-headed rebels, fatherless or illegitimate or orphaned children: they aspired in adolescence to a world to match their wildest dreams, a world of freedom with no rules but their own will and desire for adventure.

About the Far East or the Arabian Peninsula's Fertile Crescent, they knew nothing or almost nothing. The most learned or religious among them imagined infinite expanses of sand or dark volcanic rock, fortresses and minarets, crusades and intrepid expeditions opposing Christian knights and Muslim emirs. All were rebels, less interested in becoming outlaws than the prospect of living beyond the reach of convention and rules. The shores or by camel, never recovering from the shock of their first encounter with its pitiless, arid expanse, so indifferent to human suffering. All fell instantly in love, cutting themselves off forever from the Old World they left behind. They lived outside time, "far from the madding crowd" and its social conventions.

To survive or slake their thirst for adventure, they transgressed the bans placed in their way by religion or morality. In their new guise, they were spies, arms traffickers, and smugglers. They penetrated in secret into the protected holy places of the Middle East. They killed—occasionally—out of necessity, self-defense, or to impose their authority, never for personal gain. These insatiable

To survive or slake their thirst for adventure, they transgressed the bans placed in their way by religion or morality. In their new guise, they were spies, arms traffickers, and smugglers.

of the Red Sea—and the Suez Canal, opened in 1869—were an invitation to discover the land of the *Arabian Nights*. Delightedly, they set sail, eager to escape the consuming monotony of everyday life.

Mastering local languages and dialects, and dressed in local costume—better adapted to the burning sun that desiccated their throats—these desert voyagers embraced the customs of their adopted peoples, even (in some cases) converting to Islam and undergoing circumcision.

Their names were Renaud de Châtillon, Richard Burton, Arthur Rimbaud, Lawrence of Arabia, Henri de Monfreid… The kingdoms of the Middle East and the Horn of Africa became their adopted homelands. The desert held them in its thrall, and they crossed it on foot devils of the desert found themselves caught in an infernal spiral, constantly craving new dangers, greater risks, and the wildest, most extreme places.

Journeying with the wind at their heels, they courted death to such an extent that often they seemed in a hurry to leave this world. Immeasurably tough, they imposed their own ascetic lifestyles on those around them and took pitiless revenge on their enemies or anyone seeking to stand in their way. Torn between their high moral ideals and their illegal activities, they expiated the burden of their licit and illicit adventures through suffering. The arid immensity of the desert was their mirror; they respected no laws other than those they imposed upon themselves.

Desert Devils
from the Arabian Peninsula
to the Horn of Africa

"*All men dream; but not equally. Those who dream by night in the dusty recesses of their minds wake in the day to find that it was vanity; but the dreamers of the day are dangerous men, for they may act out their dreams with open eyes, to make it possible.*"

Lawrence of Arabia, *The Seven Pillars of Wisdom*

Renaud de Châtillon (1120–1187)
The Anti-knight of the East

Asked which adventurer interested him the most, the French philosopher-politician André Malraux cited Renaud de Châtillon—"the anti-knight"[57]—an obscure, not to say baffling choice of hero, at first sight. To the Christians who fought with him or against him, Renaud de Châtillon was a crusader devoid of moral scruples; to his Muslim enemies, he was a toxic figure, the embodiment of absolute evil, a diabolical presence to be wiped off the face of the earth.

Renaud's detractors portray him as a wicked outlaw, a man singlehandedly responsible for the failure of Western attempts to secure Christian rule in medieval Jerusalem. But before drawing universal scorn upon his own head, this wicked knight pursued a quite extraordinary career.

Born in the 1120s, in Châtillon-Coligny along the banks of the Loing River, Renaud spent an unremarkable youth as the younger son of a petty French nobleman, Hervé de Donzy, studying the humanities in the morning, and learning to ride and handle weapons in the afternoon. With no fief or fortune to inherit, Renaud would have to seek glory in arms, if he was one day to find a wife and secure lands of his own.

Like many other disinherited knights, Renaud turned to the Holy Land. Galvanized by the fiery words of Bernard de Clairvaux—who called upon the soldiers of Christ to kill with impunity and die with assurance in the defense of the Eastern Church—he set out for Jerusalem via Constantinople on June 23, 1147, in the company of Louis VII of France, his wife Eleanor of Aquitaine, a host of five thousand knights, and forty thousand ordinary pilgrims traveling on foot. The arduous journey was plagued with rain, cold, hunger, and occasional attacks from the Greeks and Turks. In the words of the second crusade's chronicler Eudes de Deuil, the finest flower of France wilted along the way before the expedition finally reached Jerusalem in March 1148. Renaud was a passive spectator on this chaotic crusade, making no comment on the excesses of his godforsaken co-religionists and accepting the French military defeat at the gates of Damascus with humility and resignation.

But when Louis VII returned to France in July 1149, Renaud de Châtillon stayed on the Holy Land, fighting in the service of the young king of Jerusalem, Baudouin III. His reputation as a fine knight and loyal servant reached the ears of Princess Constance of Poitiers, widowed with four children at the age of twenty-two by her husband, Raymond of Antioch. The rich heiress disdained her many renowned noble suitors, but was seduced by the dashing style and courtesy of this modest warrior, eleven years her senior. There could be no question of marriage without the blessing of Baudouin III, who was away laying siege to Ascalon, in the south of the country. In his history of medieval Palestine (*L'Estoire d'Eracles*), the Franco-Syrian churchman William of Tyre describes the meeting between the sovereign and his vassal when it finally took place: "Renaud fell at the feet of Baudouin III and begged him humbly not to refuse so great an honor, as with God's help and the support of the king, he would have the strength to defend Antioch and would always be under his command. [...] The King granted his wish. In Antioch, Renaud returned and married the lady he so greatly desired."

By late summer in the year 1153, this disinherited son of a nobleman from Gien had good cause to rejoice: he had found a wife, and become the ruler of the principality of Antioch, a fortified caravanserai at the crossroads of every trade route in the region. Renaud intended to secure riches for himself and impose his authority. But he reckoned without Aimery de Limoges, the Christian patriarch of Antioch, a man who was now deprived of his power and influence over Princess Constance, who had until then

been a vulnerable young widow. Aimery denounced the marriage as unworthy; when news of his remarks reached Renaud's ears, the young knight's response was swift. The aging churchman was arrested—despite his poor health—and imprisoned in Antioch, at the top of the keep. His head was coated in honey and exposed to the sun, so that he was plagued with heat and flies. Under pressure from Baudouin, the patriarch was eventually released and took refuge in Jerusalem, but Renaud was triumphant: his inventive exploit secured his reputation as an exceptional, merciless warrior. With the brusqueness that characterized him, the new prince of Antioch was free to devote himself to regional affairs.

Renaud was called on by Emperor Manuel I Comnenus of Byzantine to provide military support in the war against Thoros II of Armenia, in the southern Anatolian province of Cilicia. Remembering his mercenary past, Renaud obligingly fought the enemy of his ally of convenience, but there was no honor or glory to be gained from it: the expedition was a fiasco. In addition, the Emperor failed to honor his financial commitments, leaving Renaud to return home furious and in debt, determined to exact his due payment. His pride wounded, Renaud now sealed an alliance with Thoros II and set sail for the neighboring island of Cyprus, then under Byzantine rule, arriving in the spring of 1155. Renaud was seized with a murderous rage that also infected his troops: nothing was spared. Crops were burnt. Churches, castles, and homes were pillaged. Women, children, and the old were mistreated, and rich landowners ransomed. Monks and churchmen had their ears and noses cut off before being sent into exile in Constantinople. The spoils were quickly gathered and quickly spent. Condemnation of Renaud's campaign was immediate and unanimous. He was ostracized by the lords of the East.

But the man of war was still a man of his word, answering every call to arms from Baudouin III. Renaud took part in the capture of Shaîzar and fought alongside his sovereign in 1158 at the storming of Harim, inflicting a bloody defeat on Sultan Nur al-Din Mahmud. Renaud was a political pragmatist. Anticipating Manuel I's inevitable response to the sack of Cyprus—and mindful that the latter's niece had just married Baudouin III—he traveled to Mamistra barefoot with a rope around his neck, to prostrate himself before the Greek dignitary. But this was not enough. In April 1159, watched by Baudouin, Renaud swore allegiance to Manuel I Comnenus in his citadel at Antioch. Renaud was

forced, with difficulty, to swallow his pride and fly the Greek standard from his tallest tower.

From 1160 onward, Renaud returned to his old ways, raiding and rustling livestock. On November 23, returning to Antioch with a substantial haul, he was chased and captured by the milk brother of Nur al-Din Mahmud. Taken to Aleppo in leg irons, the Prince of Antioch was paraded before the city's Muslims then sentenced to rot in prison, as payment for his misdeeds and impieties. Renaud bore his punishment with humility and learned Arabic. Nur al-Din Mahmud demanded a colossal ransom of one hundred and twenty thousand gold dinars for his release.

But the Prince of Antioch's fearsome reputation now turned against him. No one hurried to gather the required sums. Nur al-Din Mahmud died in May 1174 without receiving a single dinar, and Renaud waited another fifteen years before Manuel I Comnenus, his former adversary and sovereign, and the Hungarian King Bela III, his new son-in-law, paid up. Free again, at the age of fifty-six, he discovered that his wife had died two years after his arrest, that his stepdaughter Marie of Antioch had married Manuel I Comnenus, that his stepson Bohemond III had become Prince of Antioch, that following the death of Baudouin III the throne of Jerusalem had been successively occupied by the king's brother Aymeric I and his nephew Baudouin IV, and that a certain Salâh al-Dîn Yûsuf—Saladin (righteousness of the faith, in Arabic) to the eastern Christians– had been proclaimed "Commander of the Faithful." Based in Cairo, the new sultan—a Kurdish Sunni lieutenant of Nur al-Din Mahmud—was pursuing a sacred mission to chase the Christian infidels out of the Holy Land.

Renaud's years in captivity had done little to tame him. From 1176 onward he returned to his old penchants—provocation, violence, and ransom—with a new strategic target: Mecca and the forces of Islam. He remained staunchly loyal to the king of Jerusalem, Baudouin IV. Plagued with leprosy, the king appreciated the courage, loyal, and military skill of his old warrior, appointing Renaud as regent of the kingdom, and commander of the Christian armies. Renaud's first marriage had brought him Antioch and glory; his second, to Etiennette de Milly—the young widow of Miles de Plancy—brought him a new fiefdom. Renaud became the lord of Montreal and Jordan, establishing a base at the celebrated fortress known as the Krak des Chevaliers, from which to launch his assaults on the "enemies of the Cross of Christ."

His valor and determination were undimmed, in spite of his advancing years. On November 25, 1177, the new lord of Hebron routed Saladin and his Mamluk bodyguards at Montgisard. Renaud was haunted by twin obsessions: personal gain and the destruction of Islam. Ignoring the truce agreed between Baudouin IV and Saladin, he ransomed or pillaged Arab caravans passing through his lands. Eager to make up for his lost years in the Syrian cells, he embarked on a grandiose scheme to conquer Arabia, forgetting all too soon that Saladin—inspired with religious fervor—was a tenacious, formidable enemy.

Renaud's insatiable thirst for riches was his downfall. Inspired by the capture of Tayma, he launched a maritime expedition across the Red Sea in 1182. The brave knight became a pirate, building five galleons in his fief and transporting by camel each of them piece by piece to the port of Ascalon, where they were assembled. The operation was a success. The Franks seized sixteen ships laden with goods and pilgrims at Aydhâb and marched on Mecca from the port of al-Harach. Renaud dreamed of seizing the remains of the prophet Mohammed himself, but the Islamic forces were quick to respond to his sacrilegeous threat.

Renaud and his men were defeated just a few miles from Mecca, by Saladin's younger brother. The lord of Hebron managed to escape, but three hundred of his men were taken prisoner and executed, like sacrificial animals by the slitting of their throats. Saladin never forgot Renaud's sacrilege, condemning him as an evil beast that must be eradicated. In November 1183, the sultan penetrated the outer baileys of the Krak but did not try to attack the citadel, where Renaud and his family had taken refuge. He waited until 1187 before exacting his revenge, with the breaking of a truce that was supposed to have lasted four years. Baudouin IV died in the spring of 1186, closely followed by his nephew Baudouin V at just seven years of age. With Renaud's support, Guy de Lusignan and his wife Sybille, Baudouin's sister, were crowned king and queen of Jerusalem, against the will of the Eastern barons. In his new position of power, Renaud proved incorrigible. In spite of the truce signed a year earlier with Saladin, he took possession of a rich Arab caravan passing through his lands, transporting Saladin's own sister. This was too much. Determined not to lose face another time, Saladin swore to kill Renaud, if ever he laid hands on him.

The incident revived the Holy War; Palestine and the Arab peninsula erupted. The inevitable confrontation took place on July 4, 1187. The Battle of the Horns of Hattin was fought in blistering heat; the dehydrated Frankish forces were defeated by a force of twenty-five thousand Saracens from all over the Middle East. The great Cross of Christ was taken down, and the King of Jerusalem and Renaud de Châtillon were taken prisoner. As promised, Saladin beheaded his detested enemy Renaud himself, with a single blow of his saber.

At the hour of his death, Renaud—the corrupt, courageous, fervently religious knight—may well have remembered the words of Bernard de Clairvaux, his father in faith: "He who dies, dies for his own good; he who kills, kills for Christ." He chose martyrdom rather than renounce his Christian faith. The Latin kingdom of Jerusalem and the East collapsed. Thousands of Frankish prisoners were sold into slavery all over Arabia. On October 2, 1187, Saladin entered Jerusalem in triumph. The Christian presence in the Holy Land was imperiled, the Holy City lost forever, and the name of Renaud de Châtillon cursed for all time.

Page 132: The Christians of Jerusalem proceed in front of Saladin following the capture of the holy city, print, 1872–76.
Below: Renaud de Châtillon taken prisoner, a miniature by the master of Fauvel, taken from the **Roman de Godefroi de Bouillon,** *1337.*

Richard Francis Burton (1821–1890)
The Outlaw Explorer

Learned academic, ethnologist, explorer, and erotic translator: can Sir Richard Francis Burton truly be qualified as an outlaw? If, as outlaws, we include those living on the margins of conventional society and its rules, then this collector of taboos—who consistently placed himself at the margins of convention and the law—deserves to be counted, at the very least, among the extended family of unrepentant rebels.

Burton was born on March 19, 1821, in the Devonshire town of Torquay, along the English Riviera. His father was an Irish professional soldier, and his mother was a Scotswoman, whose ancestor—according to Burton—had had an illicit liaison with Louis XIV of France. From childhood, Burton preferred the path of frivolity to the straight furrow ploughed by his family. He was the grandson of a pastor, and while Richard dreamed of becoming an officer in the army, his father sent him to Trinity College, Oxford, to study theology with a mind to enter the Church. But the young Burton preferred dueling with rapiers, and studying Arabic and Persian, to the critical analysis of the Bible. Two years after his arrival, the wayward student was expelled for taking part in a horse race, an activity strictly forbidden.

In October 1842, Richard enlisted in Baroda, India, as a subaltern officer in the Eighteenth Regiment of the Bombay Native Infantry, a military company financed by the British East India Company. He was paid sixpence a day for his administrative role but quickly found the discipline and strict order of army life intolerable. He studied local dialects (Gujarati, Hindustani, and Marathi), and went on to master forty different languages throughout his life, including eleven dialects. It was in Indian company, which he courted while on photographic and intelligence missions in the Islamic region of Sindh, that the young officer felt most at ease: he readily adopted local dress, and his wild ways and armed escapades earned him the nickname "Dick the Ruffian."

Richard returned to Europe in March 1849, going to live with his mother and sister in Boulogne, where he enrolled in a fencing school and met Isabel Arundell, his future wife. He wrote a number of ethnological, geographical, and esoteric books during this period, including a remarkable treatise on the art of falconry in the Indus Valley. By the end of his life, Burton's writings included some forty-three accounts of his travels, numerous grammars and lexicons of Indian and African dialects, a collection of Sufi-inspired poetry, (*The Kasidah of Haji Abdu El-Yezdi*), and unexpurgated translations of the *Kama Sutra*, the *Ananga Ranga*, the *Arabian Nights*, and *The Perfumed Garden of the Sheikh Nefzawi*, a planned new edition of which was destroyed by Burton's wife after his death, together with almost all of his diaries and journals.

Burton was fascinated by transgressions and taboos of every kind: geographical, political, religious, moral, and sexual. His lean, bony physique reflected his determination and complex character: swarthy, with a coal-black moustache, a vigorous chin, an "angel forehead" and "demon jaw" (as described by his biographer Thomas Wright)?[58] and later an impressive scar on his right cheek. Burton's piercing gaze echoed his essential nature, devoid of any tenderness.

Mecca was forbidden to non-Muslims in Burton's day. To enter the city meant risking death. In 1853, Burton took a sabbatical year from the army to do just that. He dressed as an Afghan Pathan, made an in-depth study of Islamic rituals, and even took the precaution of having himself circumcised in case he was examined. He journeyed up the Nile, taking four months to reach Medina and Mecca, and stopping en route in Cairo, where he lost himself in the city and the voluptuous delights of hashish. Finally, riding on the back of a dromedary, this "Chartered Vagabond"[59] discovered the desert.

Burton crossed the Red Sea on an overloaded steamboat, got embroiled in a fistfight, and joined a camel train at Yenbo, heading for Medina across the burning sands. The convoy

was attacked by Bedouins on a high pass, and twelve pilgrims were killed. Worse still, a widely circulated story tells how Burton forgot to squat when urinating, in the Muslim fashion, and was spotted by a young Arab boy, whom he promptly killed to avoid discovery. Asked about the incident by a friend, the author Bram Stoker, Burton is said to have replied: "The desert has its own laws and there—supremely of all the East—to kill is a small offence. In any case what could I do? It had to be his life or mine."[60] In his later years, however, he took pains to label this story as pure fiction.

After an extended stop in Medina, where he treated an infected foot, Burton continued his clandestine pilgrimage and finally reached Mecca.

Entering the forbidden shrine, the hardened adventurer could scarcely conceal his excitement:

There at last it lay, the bourn of my long and weary pilgrimage, realising the plans and hopes of many and many a year. [...] How few [Christians] have looked upon the celebrated shrine! I may truly say that of all the worshippers who clung weeping to the curtain or who pressed their beating hearts to the stone, none felt for the moment a deeper emotion than did [this] hadji from the far-north.[61]

Flushed with the success of his Arabian journey, the new hadji decided to travel to Harar, in Ethiopia. An ancient prophesy stated that this closed Muslim city would fall the day a Christian passed through its gates. For Burton's latest challenge, the inveterate breaker of taboos joined forces with three British army officers—the lieutenant and geographer G.E. Herne, Lieutenant William Stroyan, and Lieutenant John Speke, who became his closest friend and, ultimately, his worst enemy.

While his companions set about exploring Somalia, Burton traveled to Harar alone, disguised as a Muslim merchant, before deciding on an open approach to the local emir, Ahmed Abubakr, armed with a diplomatic letter from

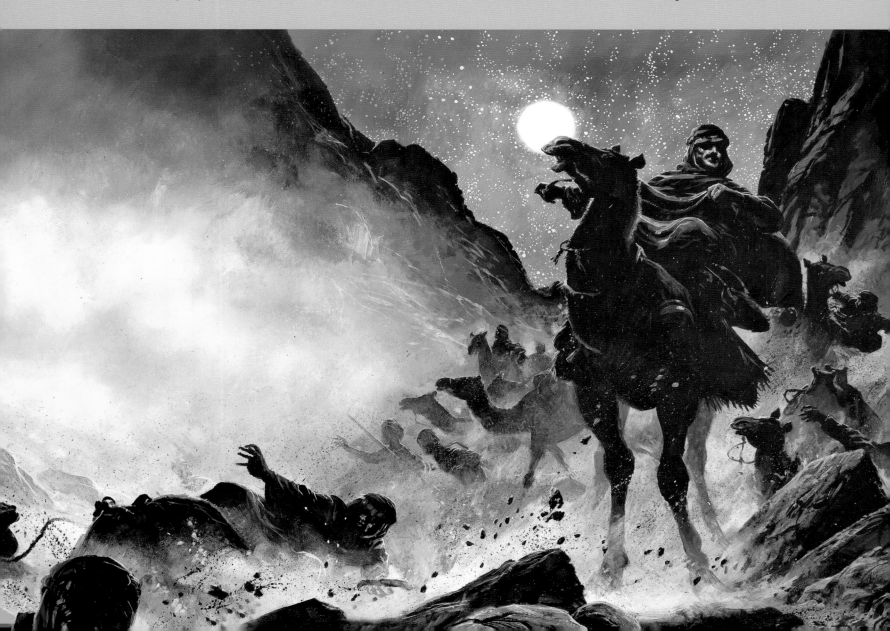

the British Political Agent at Aden. Racked with consumption, the young emir admitted him to the city but forbade him to leave. Burton found himself a hostage to his own curiosity. When he was finally allowed out, he reported his initial disappointment at the city's grim appearance, "Nothing conspicuous […] but two grey minarets of rude shape."[62] A meager reward for the proud traveler!

Burton now embarked on a search for the sources of the Nile. The expedition—including his three companions—bivouacked near Berbera on April 19, 1855, where the camp was attacked by a hundred Somalis armed with spears and thin daggers. One spear was thrust through Burton's cheek, shattering four molars, removing part of his palate

the two explorers set out separately for England, jealous and deeply suspicious of each other ever after.

Eager for a share in the glory, and despite his promise to say nothing before Burton's return, Speke revealed his discovery on May 9, 1859, to the enthusiastic acclaim of the members of the prestigious Royal Geographical Society; Burton was left to tackle the debts accrued on their trip. The two men became rivals, the more so when Speke secured funds for a new expedition without Burton, aimed at validating his discovery. The controversy escalated with bitter exchanges of letters and articles in the press. In April 1860, Speke set out for Africa's Great Lakes without his old associate, accompanied by the army officer James Grant.

"He noblest lives and noblest dies who makes and keeps his self-made laws."

and re-emerging through the opposite cheek. Stroyan was found dead, and Speke was wounded in the thigh. Only Herne survived unscathed.

But Burton was an obstinate man with an anthropologist's fascination for the lifestyles and customs of others, haunted by the lure of Africa. Determined to reach the source of the Nile from the south, Burton and Speke were the first Westerners to set eyes on Lake Tanganyika, on February 13, 1858. Identifying the source of the White Nile proved impossible, however. Their progress was hindered by inadequate maps and surveying equipment, and sickness—Speke was suffering from temporary blindness and Burton, weak with malaria, was unable to walk. With the blind (almost literally) leading the blind, and following the nonappearance of the expedition's boat, relationships were strained and nerves frayed. Exhausted, Burton stopped at Kazeh, leaving Speke to carry on the search for the source of the great river alone. On August 3, 1858, after walking for twelve days, Speke reached Lake Ukerewe, which he renamed Lake Victoria in honor of his nation's "gracious sovereign." Speke was in no doubt: he was standing at the source of the Nile, although unable to provide conclusive proof. Irritated by the extraordinary news, Burton greeted his colleague's joy with scorn and skepticism. He remained convinced—wrongly—that the White Nile rose in Lake Tanganyika. The two men's supposed friendship never recovered from this geographical disagreement. From Aden,

After a challenging, exhausting journey, the two succeeded in descending the full length of the Nile.

Burton's pride was wounded. He left for the United States, attracted by the "Mormon Mecca"—Salt Lake City in Utah. The split with Speke was definitive; its denouement was to prove tragic. Their official confrontation was scheduled for the annual congress of the Royal Geographical Society in Bath on September 15, 1864. It was cut short. The two explorers ignored one another on the first day of the conference. On the next, as Burton was preparing to take the podium, he was informed that Speke had been killed the previous evening, while out hunting on his cousin's estate. Grief-stricken, and convinced that Speke had committed suicide, Burton preferred not to deliver his speech. Years later he acknowledged, with Henry Stanley, that Lake Tanganyika was the main source, not of the Nile, but of the "mighty Congo."[63]

Following Speke's death, Burton—who was now married to Isabel—lost interest in exploration and focused his energies on fresh taboos, reading and translating a series of bold erotic texts. Sexual and prohibited practices had featured large in his ethnological observations on his travels. During his time in the Indian army, he carried out an official investigation into the homosexual brothels of Karachi and produced a secret report into British officers' relations with male prostitutes. On his journey to Harar, he was fascinated by the Somali nomads' passing affairs with foreigners

and produced lengthy descriptions of the practices of excision and infibulation. He also accumulated sexual experiences, contracting syphilis and other venereal diseases.

At the age of forty, his renown and geographical expertise led to an invitation to join the British Foreign Service, continuing his double life as a man of action and letters. He served as British Consul at Fernando Po, Santos, Damascus, and finally at Trieste, where he died of a heart attack in October 1890, after receiving last rites at his wife's request—to the indignation of his friends.

Burton's extraordinary career and outlaw philosophy are encapsulated in the closing lines of his poem *The Kasidah*— written and published during his lifetime under a pseudonym:

Do what thy manhood bids thee do, from none but self expect applause;
He noblest lives and noblest dies who makes and keeps his self-made laws.

Page 136: Richard Burton, 19th century.
Page 138: Journey toward the forbidden city: Richard Burton and his companions in an ambush, illustration by Oliver Frey, 1985.
Below: Mecca, 19th century.
Facing page: Richard Burton wrapped in a blanket, 1855–70.

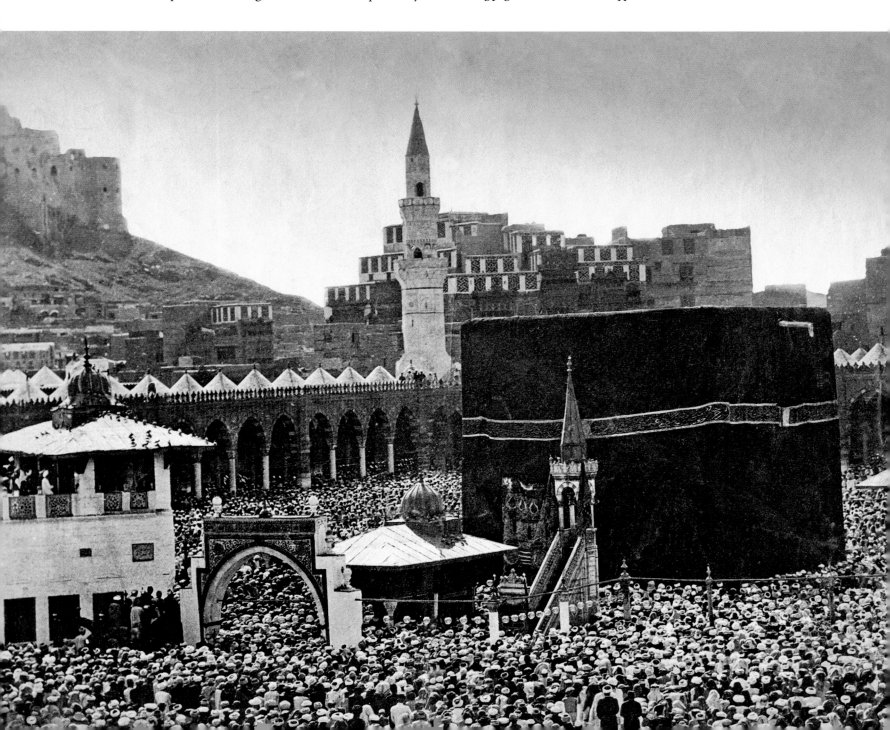

Arthur Rimbaud (1854–1891)
The Trafficker who Walked on the Wind

History remembers Arthur Rimbaud as a poet of genius and inspiration, and savors the scandalous love affair he conducted in his late teens with his companion-in-absinthe Paul Verlaine, which ended one drunken evening with Verlaine shooting the young poet in the leg in a jealous rage. History forgets how, at the age of twenty-one, Rimbaud—who was born in the small French town of Charleville—turned his back on poetry forever and crossed oceans and deserts in search of new excitement. Beginning in February 1875, Rimbaud—the eternal unstable dreamer—wandered the highways and byways of Europe from Stuttgart to Milan, drawn by the promise of illicit adventure. In June of the same year, the ragged vagabond fell ill and was taken home from Marseilles, where he had been working on the docks while waiting for a passage to Spain, to fight for the Carlist cause. This early war-mongering scheme failed, but the scent of gunpowder continued to pursue him. One year later, he enlisted for six years and three hundred florins as a mercenary in the Dutch colonial army, fighting Muslim separatists in Indonesia.

On June 10, 1876, Rimbaud boarded the *Prins Van Oranje* at Den Helder, bound for Java via Gibraltar, Naples, and the newly opened Suez Canal. In the small town of Salatiga, the regiment drilled and perfected its skills at arms, waiting for the baptism of fire in northern Sumatra. Hating authority in all its forms, and loathing the intimacy of army life, Rimbaud took advantage of the Mass on the Feast of the Assumption of the Virgin, August 15th, to run away. Three weeks of garrison life had transformed the eager, would-be soldier into a deserter. Rimbaud assumed a false identity and returned to Europe under sail, aboard a Scottish cargo ship. He retained a horror of the army for the rest of his life but had uncovered a longing for travel to exotic, far-flung places. From now on, he would face danger on his own account.

Fascinated by the East, Rimbaud planned a trip to Egypt and used his abundant free time to learn Arabic. At the end of October 1878, he left Charleville, crossed the snowbound Saint-Gottard pass on foot, embarked in Genoa for Alexandria, and eventually found himself in Cyprus, where he worked as a foreman for a quarrying operation and a building company, living out the lines from his poem *A Season in Hell*:

> If I've a taste, it's not alone
> For the earth and stones,
> Rocks, coal, iron, air,
> That's my daily fare.[64]

Four years earlier, the poet had contemplated the shores of the Red Sea from the deck of the *Prins Van Oranje*; in August 1880, he decided to return to Aden, and took a job with Bardey & Co., an import-export agency. Lulled by the haunting laments of the locals, he spent his days supervising the sorting and grading of coffee beans. A new life began to take shape. Rimbaud familiarized himself with Arab customs and the complex art of negotiation, two factors that were to alter the course of his existence, and transform his life into the stuff of storybook adventure.

In November 1880, Rimbaud was given a job in Bardey & Co's Harar office. At Harar, the eternal rebel became a nitpicking administrator, tackling paperwork and issuing reports, orders, and reprimands. He discovered the depressing existence of the white-skinned colonial fortune-hunter and became obsessed with accumulating as much money as possible, as quickly as possible. In October 1885, weary of life as a petty employee, Rimbaud decided to launch a parallel, private operation as an arms dealer—a venture that required considerable time and care under the best of circumstances, and particularly when it came to transporting two thousand and forty cartridge rifles and sixty thousand Remington cartridges by camel train through Abyssinia, in

the hope of selling them for a handsome price to the cruel, cunning Ethiopian emperor Menilek II.

Rimbaud was a novice trafficker. He invested twelve thousand francs in the venture—two-thirds of his earnings for six years' work—and joined forces with two successive partners, both Frenchmen of dubious character. The first, by the name of Labatut, fell ill and returned home to France, to die; the second, Paul Soleillet, died of an embolism in the middle of the desert. The expedition had scarcely begun before it turned to fiasco: with no available camels or transit permits, Rimbaud was forced to wait eight months in the blistering heat of Tadjurah before embarking on a fifty-day journey across the most arid of deserts. The expedition set off in September 1887 and took five months—not fifty days—to reach Farré, the first outpost of the Ethiopian province of Choa, on February 6, 1887.

New difficulties and disappointments awaited him. The kingdom's chief steward, Walda Tadek, responsible for verifying the contents of the caravans, exacted his dues and took a strong dislike to Rimbaud, despite the usual gifts. Furthermore, Rimbaud's thirty-four Abyssinian camel-drivers demanded payment on the spot, of a higher-than-agreed sum. The Emperor Menilek himself had left Choa to attack the closed Muslim city of Harar, then in the hands of the Emir Abdullaï. Worse still, Rimbaud—unaware of the death of his former associate Labatut—discovered that the latter still owed considerable sums of money to the Emperor and a native wife. Menilek conquered Harar, making sure to urinate on the city mosque from the top of its minaret before ordering its destruction and the erection of a Coptic church on its ruins. He returned to his new capital, Entotto, in triumph.

Rimbaud took four days to reach the emperor's court from Ankober, the former capital, where he had been waiting for twenty days. He was finally received by Menilek on March 12, after waiting for two hours in a palace antechamber:

My coffers and guns were placed before the king, who invited me to open them in his presence.... He was enchanted by my parasols. I presented him with the model I had chosen for him [...] he took the lot. The emperor took about a quarter of the goods I laid before him. Menilek insisted on having my watch [...] I was forced to point out that it was the only one I had left, and that I needed it to know the hour of the sun at any time of day. He took my excellent field-glass, telling me that his own was highly mediocre, and that he would give it to me in exchange.[65]

Menilek was a wily, slippery war chief. He suffered the novice arms-dealer to present his guns and reminded him of the original price agreed with Labatut, before embarking on a series of delicate negotiations, while amiably forbidding the young trafficker from selling any of his wares to his private subjects and speedily deducting the cost of the caravan's sojourn in his kingdom—plus Labatut's debts—from the initial asking price. Rimbaud had no choice and no other prospective clients; he was forced to acquiesce to the royal will, even agreeing to be paid later, by draft, in Harar. The financial outcome reflected the expedition as a whole: disastrous. Rimbaud wrote to his mother: "I find myself, at the outcome of the operation, with capital losses of sixty per cent, not counting twenty-one months of exhausting travails wasted on this miserable affair."

As a meager reward for his efforts, Rimbaud now enjoyed a claim to fame as the first European to reach Entotto from Harar by a new route and was duly feted by the Société de Géographie Française with a few lines in its prestigious journal.

His second venture as an arms dealer—begun in January 1888—was scarcely more successful. Rimbaud was asked by his new partner, Armand Savouré, to escort a camel train from Harar, carrying three thousand guns and a hundred and- fifty thousand cartridges to a secluded cove on the Red Sea, within the kingdom of Choa. He pocketed the payment of two thousand francs for his role in the operation, and disappeared with the money, without providing the promised camels, leaving his associate to struggle for months at Obock to find fit beasts for the illicit cargo.

In May 1888 Rimbaud, his back to the wall, set up his own trading business in Harar—described by the poet as "a repulsive cloaca"—in a Turkish-owned building on the market square, near the city's mosque. He knuckled down, scraped a living together, and was consumed with bitterness. Depending on the success or otherwise of his affairs, his mood ranged from utter defeat to caustic sarcasm. He was regarded as an eccentric, gloomy, taciturn character, cultivated and cynical, silent about his own past but much given to wounding rejoinders and the drafting of business letters dripping with irony and sarcasm.

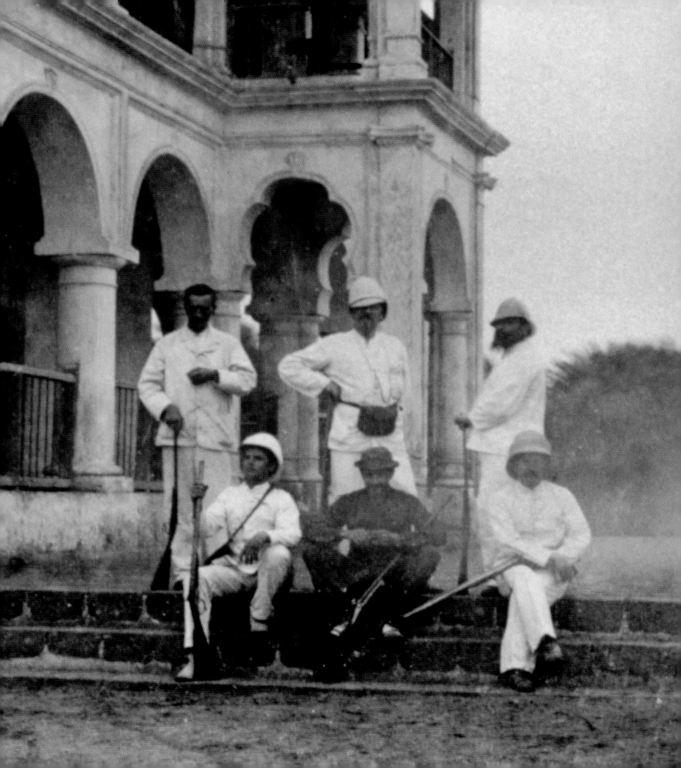

While Rimbaud dissipated himself between the twin lures of the desert and illegal trade, Paris finally recognized his poetic genius. Too late. Rimbaud had moved on, living a life of dreams and earthly suffering.

For years now, Rimbaud's blue-eyed, angelic face had become emaciated; his washed-out gaze, still shot through with the occasional devilish spark, was ashen. No need to end his life with an act of desperation: his extenuated health was failing him. In February 1891 he suffered a swollen knee, making movement impossible for this desert wanderer. Turning his back forever on the Horn of Africa, and his young lover Djami, he was taken to Zeilah on a stretcher, and from there to Aden where he sailed for Marseilles aboard the *Amazone*. His doctors (wrongly) diagnosed dangerously advanced synovitis, and feared the onset of gangrene. In fact, Rimbaud was suffering from osteosarcoma, a malignant bone tumor sometimes known as "rider's bone."

Rimbaud's right leg was amputated on May 27, 1891, at the Hospital of the Immaculate Conception. The fleet-footed trafficker was no longer, in the words of Verlaine, *l'homme aux semelles de vent* ("the man with soles of wind"); he never recovered. In August, he dreamed of traveling once more but was consumed by fever. His remaining strength failed, and he died on November 10, 1891, at 10 o'clock in the morning. Rimbaud could face the dark skies of *A Season in Hell* in peace; he had taken his thirst for adventure, heroism, dust, and adrenalin to the limit. The notorious poet died an outlaw at the age of thirty-seven, indifferent to the literary acclaim he had fled, to be his own man.

Page 142: Arthur Rimbaud in a garden of banana trees in Hara, self-portrait, 1883.
Page 145: **Les voyages forment la jeunesse,** *Arthur Rimbaud as seen by Paul Verlaine, 19th century.*
Facing page: Arthur Rimbaud, 19th century.
Below: Aden, Yemen, 19th century.

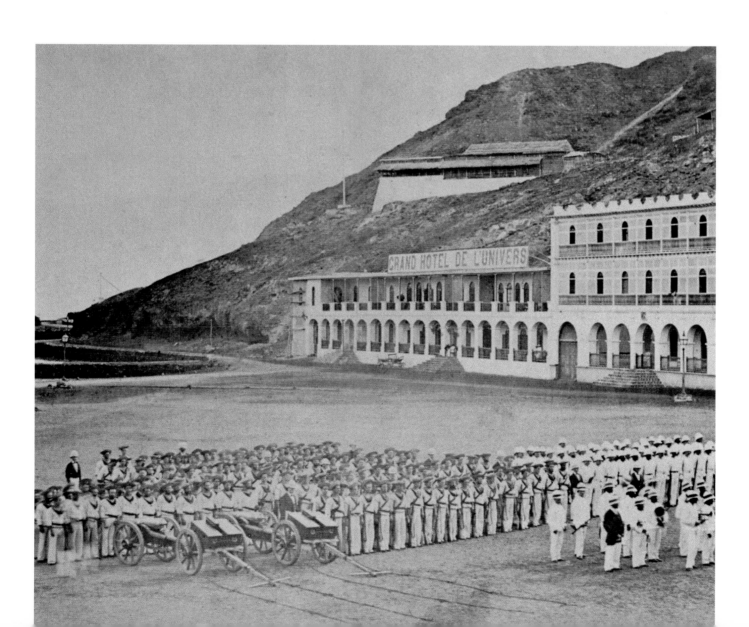

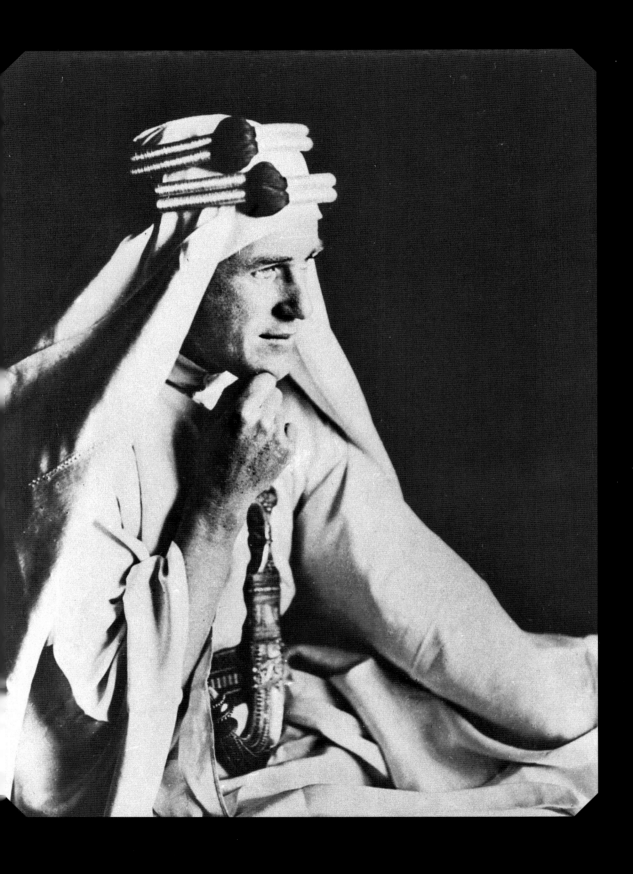

Lawrence of Arabia (1888–1935)
The Secret Agent of the Sands

May 13, 1935. Who was the man lying motionless beside his shattered motorcycle—a Brough SS100, known to its owner as *George the Seventh*—at the foot of an ancient oak tree beside a road in southern England, a deep, nine-inch gash across his head? Was he Thomas Edward Lawrence, better known as Lawrence of Arabia, or the second-class soldier John Hulme Ross, or his double, the soldier T.E. Shaw? T.E. Lawrence's last moments matched his celebrated life: shrouded in myth and mystery. Did he die in a simple traffic accident on this straight road—hindered by two cyclists he had tried to overtake—or did he deliberately end his life, after several unsuccessful attempts, by driving his powerful machine into the majestic tree? The truth is unimportant.

But does this tormented hero hold a place in the great pantheon of outlaws? The many different identities assumed during his lifetime, and his clandestine expeditions to remote, lost corners of the world, plead in his favor. As Lawrence himself—a small, thin, unattractive man with limpid eyes set in deep, purplish sockets—acknowledged, "The dreamers of the day are dangerous men, for they may act out their dreams with open eyes, to make it possible. This I did."[66] Lawrence may not have been an outlaw in the strict sense of the term, but he lived perpetually on the margins, beyond the conventions and norms of his day. Behind this marginality lay a guilty wound that never healed: born in Wales on August 16, 1888, Thomas Edward Lawrence was the illegitimate child of an adulterous liaison between Sir Thomas Chapman and his daughters' governess, a beautiful woman fifteen years his junior, whom he never married. In the puritanical British society of his day, divorce was out of the question; Thomas Edward's father chose to flee overseas under a bland, assumed name: Lawrence. From adolescence, Thomas Edward—his father's second son—turned his back on the morals and manners of the time, for an alternative world of epic adventures, castle strongholds, and brave knights. He studied archaeology at Jesus College, Oxford, graduating with first-class honors and writing a dissertation on the influence of European military architecture on the Crusades at the end of the twelfth century. His passion for the past, old stones, the military arts, and fortifications never left him.

On June 18, 1909, indifferent to the searing summer heat, he set out on the road to the legendary East—Greece, Carthage, Egypt, and Syria. Armed with a Kodak camera and tripod, he hiked across Palestine, Lebanon, and Greater Syria, wondering at the celebrated fortress known as the Krak des Chevaliers, the former stronghold of Renaud de Châtillon, which he considered the most perfectly fortified structure in the world. Lawrence—known affectionately to his brothers as Ned—had found the region in which he wanted to spend the rest of his life. In September 1909, he was invited by the Oxford archaeologist D.G. Hogarth to accept a traveling fellowship as part of an expedition to excavate Carchemish, the ancient Hittite capital on the frontier between Syria and southern Turkey. The young graduate bought a twin-lens camera equipped with a zoom, packed his bags, and set off immediately. Arabic became his second language, and he adopted Bedouin customs and dress—an *abaya* and *keffieh* held in place with an *agal* of gold braid. From archaeology, Lawrence turned to espionage. A German consortium was building a railway line from Berlin to Baghdad, paid for by the Turkish government, for whom it would facilitate the mobilization of the Ottoman armies at the gates of Britain's colonies in the Persian Gulf. At the request of the British Secret Service, Lawrence took meticulous surveys and photographs of the project, observing its progress day by day from a bridge over the Euphrates. Lawrence and his Arab friend Dahoum were arrested by the Turkish military, in search of new recruits, but gave their captors the slip and vanished into the night.

A second railroad had just opened between Aleppo and Medina, transporting Turkish troops to the heart of Sinai and the edge of the Suez Canal, then under British control. Lawrence traveled to Negev in secret and produced the first modern map of this strategic region, meticulously recording the water holes and passable roads.

At the outbreak of the First World War, Lawrence was in Cairo, working for the British Secret Service. His mastery of Arabic made him a punctilious translator and skilled interrogator, widely feared by the Turkish prisoners. But he yearned for action, the desert, and a clandestine life. In June 1916, Lawrence turned his back on conventional military operations, adopted Bedouin dress once again, and joined his Arab brothers for an epic adventure that would take him into the history books as Lawrence of Arabia.

Lawrence received official permission to approach Faysal, the third son of the emir of Mecca, Hussein ibn'Ali, who was a descendant of Mohammed through his daughter Fatima—and who had recently led a revolt against the Turks, Germany's ally in the Middle East. In the shadow of the novice leader, Lawrence played an important role in the Arab uprising. There were many traps and pitfalls along the way. Lawrence settled quarrels between rival tribes by acting as a mediator and supplier of arms and other equipment. His activities earned him a series of sobriquets—Abu Khayal (the Man with the Knight, in reference to the British gold coins he distributed, bearing the effigy of Saint George killing the dragon) or Abu Giné (Guinea Man)—before becoming known affectionately to the Arabs as "Al Aurens."

The war was not yet won, and Lawrence became a keen strategist. Defying conventional military rules, he became the model of a modern undercover "guerilla." Open confrontation was no longer possible: the aim was to surprise the enemy when least expected, using accurate intelligence and speed to attack enemy infrastructures. "The death of a Turkish bridge or rail, machine or gun or charge of high explosive, was more profitable to us than the death of a Turk."[67] This inspired revolutionary remained a man of action at heart. He trained and led his troops, and ensured the application of his ideas and tactics on the ground.

Aqaba was a strategic Red Sea port in the hands of the Turks. Lawrence decided to capture it and shatter the Ottoman blockade of the British troops in the region—a risky operation. He decided to cross the dreaded Nufud Desert and attack the Turkish troops from the rear. In blistering heat and sun, the expedition exhausted Lawrence's men and their mounts. Rival clans clashed, there were mutterings of rebellion, a man was killed. Lawrence was forced to execute the murderer, so as to restore order among his desperate troops. The Turks were duly surprised and surrendered. On July 6, 1917, Aqaba and Hejaz were liberated. On November 20, 1917, Lawrence—disguised in rags and barefoot—was arrested during an intelligence mission to Deraa. The Turks had issued a substantial reward for the capture of their enemy: if his identity was discovered now, he faced certain death. Incognito in regional dress, Lawrence was beaten, whipped, and raped by the local bey. He managed to escape without revealing his true identity, but bore the psychological scars of his ordeal for the rest of his life.

Lawrence's tactics won the day, however. On December 11, 1917, he entered Jerusalem in triumph, as a lieutenant-colonal alongside his mentor, General Allenby. On October 1, 1918, the Arab and British troops entered Damascus. Described in *The Seven Pillars of Wisdom*, Lawrence's triumphant campaign later became the personal bible of the Viet Minh commander-in-chief, General Giap.

At the Treaty of Versailles, the French and English divided the Middle East between them: Lebanon and Syria for France; Jordan, Iraq, and Palestine for Britain. Lawrence was present at the negotiations, as part of the British diplomatic delegation. Faysal was disappointed by this act of betrayal on the part of his military adviser. He reproached Lawrence for favoring the interests of his native, rather than his adopted, land. The two men quarreled permanently. The dream of a Greater Arab nation would have to wait.

Lawrence's exploits were sensationalized and misreported by an American journalist, Lowell Thomas, in a series of immensely popular illustrated lectures in London, at Covent Garden and the Royal Albert Hall. Watching unrecognized from his seat at the back, Lawrence was horrified by the grandiloquent hagiography. Terrified that he would acquire a taste for this disproportionate celebrity, he went undercover once more, enlisting as a private in the Royal Air Force under the name John Hulme Ross, an episode recounted in his book, *The Mint*. Lawrence's cover was blown by a journalist from the British press, and he left the RAF in 1923. The press's search for Lawrence soon became a full-scale manhunt. The former desert warrior sank into a depression, writing sadly to a friend, the novelist E.M. Forster, that he was a broken, damaged man.

In his pursuit of anonymity, Lawrence took on another new identity, enlisting as a private in the Royal Tank Corps at Bovington under the name T.E. Shaw. But history repeated itself. Unmasked once again, he escaped the pack of journalists at his heels by traveling to Pakistan and Miran Shah on the border with Afghanistan, before returning to England and the RAF. Lawrence became obsessed with a single idea: to disappear forever.

He died on May 19, 1935.

In his last letter that served as a self-obituary and was addressed to his friend the Great War poet Robert Graves, he wrote:

> Is it age coming on, or what? But I loathe the notion of being celluloided. My rare visits to cinemas always deepen in me a sense of their superficial falsity—vulgarity, I would have said, only I like the vulgarity that means common man. […] The camera seems wholly in place as journalism: but when it tries to re-create it boobs and sets my teeth on edge. So there won't be a film of me.

Little did he know that his story would be the subject of one the greatest and most influential films of all time. Lawrence remained a determined "outlaw" to the end. Legend even has it that his body was replaced in his coffin by one hundred and forty pounds of sand from the Syrian desert, and taken in secret by plane to Carchemish, where it was cremated and the ashes scattered on the banks of the Euphrates.

Page 148: Lawrence of Arabia, 1915.
Below: Lawrence of Arabia on a camel's back, 1915.

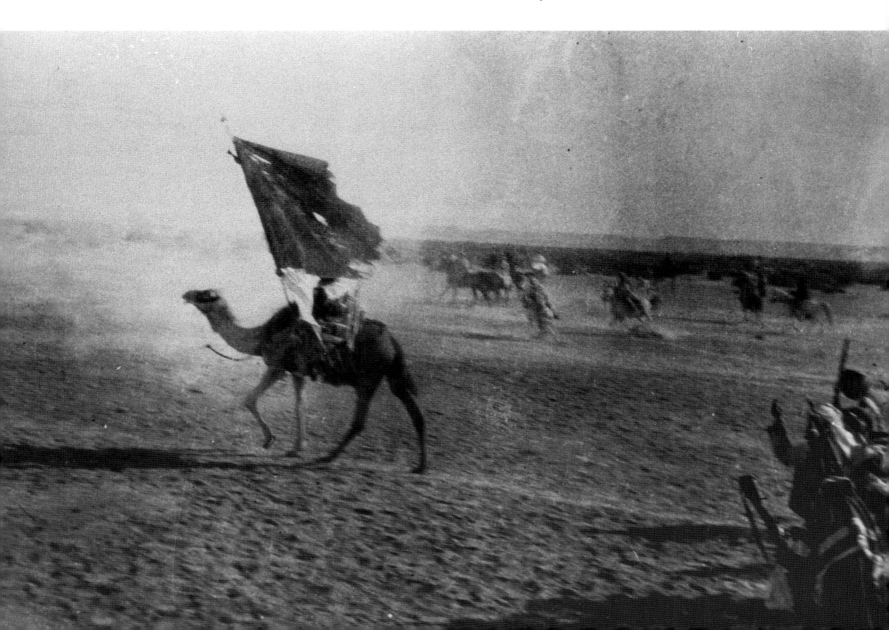

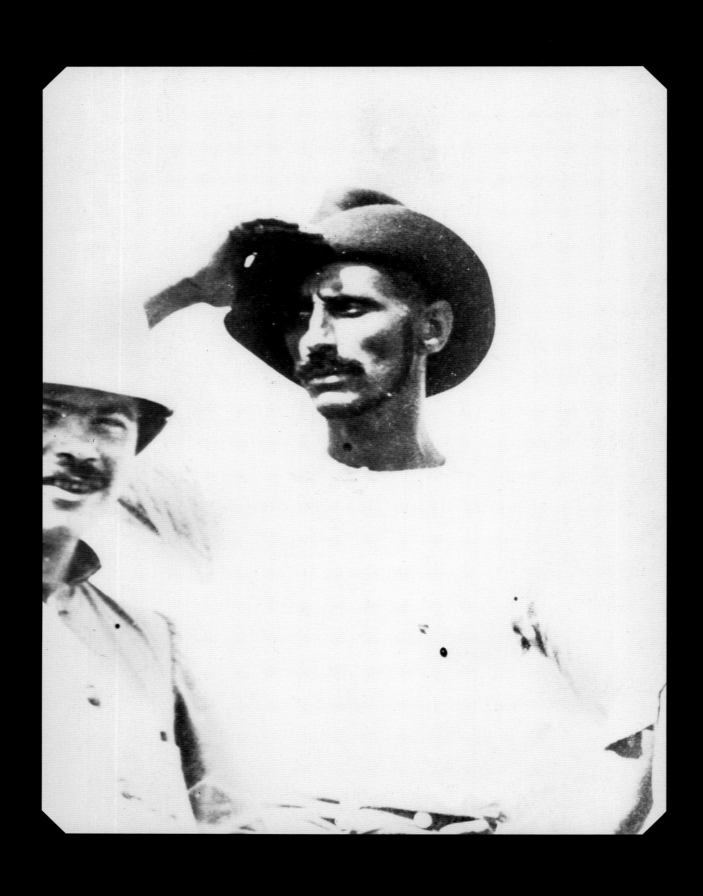

Henri de Monfreid (1879–1974)
The Desert Pirate

Henri Léon Romain de Monfreid was born on November 14, 1879, at La Franqui on the shores of the Mediterranean, to a colorful family that included Marguerite Barrière, his paternal grandmother, an eccentric, liberated woman who went by the name of Countess Caroline de Monfreid. In 1850, Caroline had traveled to New York to join her lover, the jeweler Gideon Reed, a former associate of her husband François Jacoby (but now his sworn enemy). The couple produced a child, Georges-Daniel de Monfreid, whose birth was never officially registered, and who was never recognized by his father. Georges-Daniel was duly equipped with false papers, fake American citizenship, and his mother's invented aristocratic title. He became an artist and a close associate of Maillol, Matisse, Violet, and Gauguin, selling the latter's paintings as a favor to his friend. When he was twenty-one years old, Georges-Daniel married Amélie Bertrand, the daughter of the owner of a sanatorium, where he had come to take a cure. Two years later, the couple produced a son, Henri.

Georges-Daniel loved the bohemian life, sailing, entertaining his painter friends, and visiting his mother Caroline in the family's Pyrenean property at Saint-Clément. An inveterate dilettante and womanizer, he soon abandoned his wife for Annette Bonfils, a young model who posed for Gauguin. Georges-Daniel and Amélie divorced, leaving Henri to be brought up under the Catalonian sun, by his paternal grandparents.

Neglected and left to his own devices, Henri was uninterested in his studies, preferring the rush of wind on canvas to the silence of the schoolroom. He attended a succession of boarding schools and local colleges, and discovered the joys of sex at an early age with domestic servants, including his mother's maid. While studying for a second time to enter the Lycée Saint-Louis, the young Monfreid set up house with Lucie Dauvergne, a girl of seventeen he had picked up in a doorway one drunken evening. Dauvergne was already pregnant, by the owner of a hotel. The pleasure-loving student lived a life of poverty and debauchery; he failed his examinations (the prestigious French *concours d'ingénieur*), and Lucie was forced to leave her new-born baby Lucien in the care of the public authorities. Henri had successfully avoided military service until then, but the system now caught up with him. He avoided the draft by swallowing a bottle of chlorine and simulating the symptoms of tuberculosis.

With little or no money, the couple subsisted in a series of squalid, unheated attic rooms. To survive, Lucie found work at Paris's central market, Les Halles. Henri worked variously at Les Halles, as a door-to-door salesman for the coffee brand Planteur de Caïffa, washing cars, and chauffeuring, before finally taking a job as a chemist with the dairy company Maggi. The couple's financial situation improved. Henri repaid Lucien's care costs and took back the baby boy, recognizing and raising him as his own son, despite his family's disapproval. On June 5, 1905, Lucie gave birth to another boy, Marcel. Monfreid expanded his career as a milk inspector by becoming an inveterate collector of farm girls, a blackmailer, and a fraudster, adding vegetable oil to the milk he was sent to certify.

Paradoxically, sickness saved his life, and brought his disastrous liaison with Lucie to an end. Struck with brucellosis (Malta fever, generally caused by the ingestion of unsterilized milk), Henri sank into a physical and moral decline. His long convalescence with his father at Saint-Clément forced him to face facts and take a radical decision: he would flee a life "as flat as a field of beetroot" and live as a free man, "far from the common herd" and the constraints of bourgeois society. His desire to break away from the Old World coincided with his definitive separation from Lucie. He removed their two sons from her care; from now on, the boys were looked after by Armgart Freudenfeld, a statuesque young

German friend of his father, who was staying at Saint-Clément and soon found her way into Henri's bed. Henri felt no more genuine affection for Armgart than he had for Lucie, but the girl fell madly in love with the young rebel— his smoldering gaze, tousled hair, and elegant mustache. She proved a persistent and ultimately successful suitor. In need of a sympathetic shoulder to cry on, and a mother for Lucien and Marcel, Monfreid married Armgart in 1913, and fathered three more children.

In 1911, on the strength of a passing contact, Monfreid decided to make his fortune in the city of Diré Dawa, in Ethiopia. "My existence is of value to me only insofar as it is useful to others. [...] This gives me a strength unknown to those forced to rely on their own egotism," he wrote to Armgart, at a low ebb one night. Like Rimbaud before him, he found a job with a French trader, a leather and coffee dealer by the name of Marcel Guigniony. Like the great trafficker-poet he learned Arabic, was suspicious of the local European community, and adopted local customs. He also set up home with a local woman, bought a female slave with whom he fathered a child, took a second local companion, and finally—like Richard Burton—had himself circumcised.

Monfreid had scarcely mastered the ropes of trade in the region when—unable to live without a frisson of danger— he crossed the line and became a bona-fide outlaw. In June 1912, he bought an Arab dhow, recruited a Yemeni captain, and went into business as an illicit arms dealer. At the same time, in exchange for immunity from prosecution, he gathered valuable intelligence for the French governor of Djibouti. Monfreid also became an illicit pearl trader, identifying the best pearl-fishing grounds on his illegal expeditions. In January 1914, he took the helm of his new dhow, the *Fath el-Rahman*, with a crew of three Somali pearl-divers. The expedition set sail for Massawa and the Dahalak islands, three hundred and seventy-five miles north of Djibouti.

In contact with the sea and danger, Monfreid became a changed man. His tanned physique, which he coated in butter believing it would protect him from the sun, was thin and wiry. He sported a turban, ate dry wheat cakes, lived simply, converted to Islam, and showed pitiless cruelty to his enemies. The locals called him Abd el-Haï, "the living slave," one of the ninety-nine names of Allah.

Business prospered. The Somali and Danakil Arabs treated Monfreid as one of their own and made a point of buying the rifles and munitions he braved French customs and Red Sea storms to procure for them. The outbreak of World War I brought disarray, however. His German wife, still living in France, suffered repeated slights and insults, and he was forced to hide significant stocks of arms by burying them on the island of Mascali. Unable to sell his wares, his finances suffered. The adventurer dreamed of fighting the Prussians, who were "laying waste to our beautiful provinces," at home on dry land.

Following a tip-off, Monfreid's arms caches were discovered; the smuggler was arrested and incarcerated in the dank cells of a Djibouti prison. On his release, Monfreid was exempted from the draft for the second time in his life and set out to sea once again, carrying out espionage missions against the Turks. He began trafficking hashish between Greece and Egypt via Djibouti and took advantage of the English blockade of the Red Sea to launch a new line of business, ferrying passengers between the coasts of Africa and Arabia.

Henri de Monfreid was joined by his wife, his daughter Gisèle, and his adopted son Lucien, who died four years later, devoured by a shark. The family settled in Obock, where he qualified as a long-haul ship's captain and began fitting out a one-hundred–ton coaster at Aden. The boat was quickly commandeered by the British, claiming it would be used for espionage and arms trafficking. Monfreid was undeterred by the British, however, and decided to build a sister ship to his old schooner, this time at Obock: a one-hundred-and-fifteen-foot, two-hundred-and-fifty-ton yacht named *Ibn el-Bahar* (Son of the Sea). Sadly, the great ship struck an underwater reef and sank. But Monfreid was obstinate. Inspired by Rudyard Kipling's famous poem,

> [If you can] watch the things you gave your life to, broken,
> And stoop and build'em up with wornout tools [...]
> And lose, and start again at your beginnings
> And never breathe a word about your loss [...]
> You'll be a Man, my son!

he built and launched another new boat at Obock, the *Altaïr*, fitted with a diesel engine. The smuggler began operating on a new scale, transporting bigger and bigger cargoes of hashish from Mumbai. Despite Monfreid's naturally suspicious nature, one of his associates succeeded in stealing six tons of the lucrative drug. Furious at being duped, Henri fitted the *Altaïr* with an eighty-pound gun and pursued the thief for four months, finally tracking him down in the Seychelles.

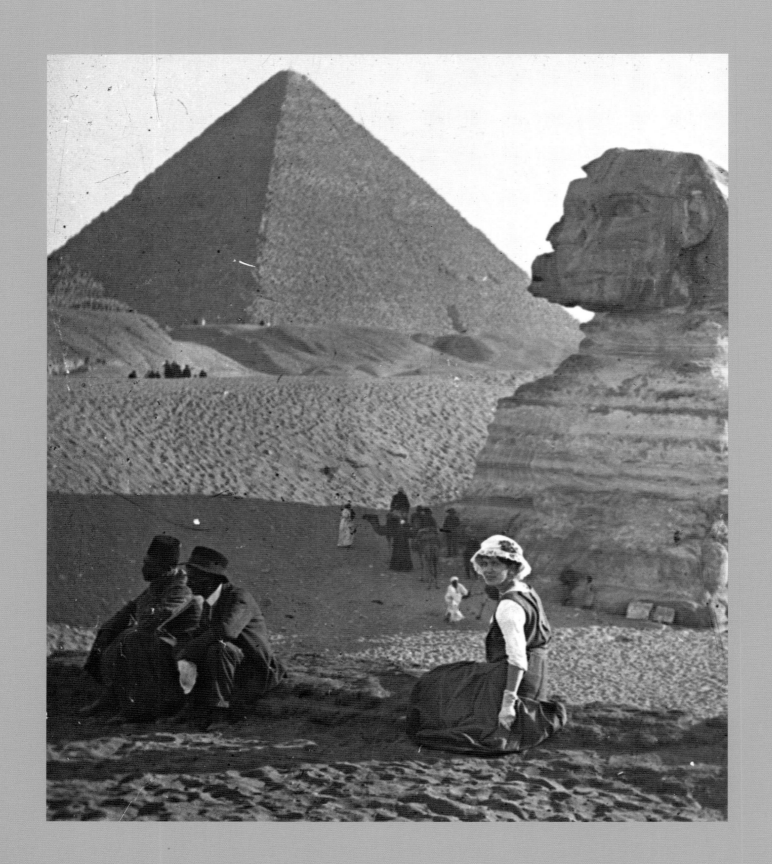

The two struck a compromise; Monfreid took back his original cargo plus that of his former partner, and sold the lot—a total of twelve tons—in Egypt, at a significant profit.

Monfreid was now a rich man, and he sought to consolidate his social status. The arms and drug-smuggler invested a fortune in two power stations in Djibouti and Diré Dawa. Armgart found it increasingly difficult to bear the suffocating heat and the *khamsin*, a burning desert wind that desiccates the lungs. Henri moved the family to Arawé, in the region of Harar, creating a verdant paradise in the bend of a local river. The move did little to disturb the day-to-day existence of this hardened sea dog, who spent just a few days at home each year.

On August 16, 1926, lured by the promise of riches and contraband, Monfreid killed a man—Joseph Heybou, a mixed-race Somali who posed a threat to his German trade in cocaine and morphine. From drug-trafficking, Henri crossed the irrevocable line: he had become a murderer. His memoir, *Hashish: True Adventures of a Red Sea Smuggler*,[68] tells how he shot his adversary in the head, almost at point-blank range. Torn between moral idealism and his penchant for trafficking substances that he found increasingly harmful and dangerous, Monfreid began to question the adventurous life that had changed him so deeply. His incarceration in Djibouti, in 1928, marked the end of Monfreid's life as a

smuggler. He embraced a new life on his release, devoting himself to painting and journalism while Armgart, weary of her husband's dalliances and misdemeanors, settled with her three children in Neuilly-sur-Seine. On May 15, 1933, Monfreid was expelled from Ethiopia and returned to France. On the advice of the Academician Joseph Kessel, who romanticized his friend's tumultuous life in the novel *Fortune Carrée*, Monfreid changed the "i" in his name to a more distinguished-looking "y" and began to write. His perilous voyages and outlaw activities inspired some seventy-five novels, from *Les Secrets de la Mer Rouge* (*The Secrets of the Red Sea*) published in 1931, to *Le Feu de Saint-Elme* (*Saint Elmo's Fire*) published in 1973.

Henri de Monfreid died on December 13, 1974, at the age of ninety-five, in a small village in the French region of Brenne, taking with him the secrets of a hidden fortune that his heirs never found. The pirate of the Red Sea and the burning desert could rest in peace, however. He had passed on his love of illicit adventure to millions of readers.

Page 152: Henri de Monfreid, 20th century.
Page 154: Ship launch in Obock, 1920.
Facing Page: The Egyptian Sphinx, photo by Henri de Monfreid, 1915.
Below: Cart/trolley on a makeshift railway following the removal of a bridge, photo by Henri de Monfreid, 1911.

They rebelled against conventional morality, and the immoral accumulation of wealth

Many knew hunger from their earliest childhood. Insistent hunger that gripped the stomach and infiltrated the brain. Hunger that became, for many of these activists, an obsession and the first cause of their rebellion against a world that had condemned them to penury and misery. As Victor Serge confessed, in his *Memoirs of a Revolutionary*: "If in my twelfth year, you had asked me, 'What is life?', I would have answered 'I don't know but I do know that it means: you will think, you will fight, you will be hungry … and you will survive.'"[69]

From uneasy children, these rebels grew up to become outlaws quick to challenge the society of their birth, a society they held responsible for all their sufferings and ills. In their eyes, theft and restitution were the best ways to feed themselves and provide relief for the poorest of the poor. As the French anarchist and illegalist Marius Jacob declared at this trial:

> I have devoted myself to theft, not for gain or lucre, but as a matter of principle and justice. I preferred to keep my freedom, my independence, my dignity as a man, rather than work as master's hireling. I preferred to rob than be robbed … theft exists because everything belongs to the merest few.

They were idealists who favored action over theory. Their enemies were the police, judges, property-owners, the bourgeoisie. Like Ernst von Salomon, they hated respectable society, advocating revolution and adventure, although many were eventually forced to admit—like Victor Serge—that, faced with the impossibility of escape, their only choice had been to fight. They had known violence and terror, and they used violence and terror against their enemies.

But no one attacks authority with impunity. From the autocrats of Russia to the democracies and republics of Europe and the United States, or the ancestral caste system of India, the response was the same: repression in the face of any challenge to the established order. All of these outsiders experienced exhausting manhunts, the solitary existence of the fugitive, prison, hard labor, or deportation.

Mikhail Bakunin spent eight years in the Peter and Paul Fortress in Saint Petersburg before being deported to Siberia, from where he escaped after four years. Jules Bonnot spent just a few months behind bars for battery, contempt, and assaulting an officer of the law, and chose suicide rather than face imprisonment a second time. Marius Jacob endured twenty-two years of hard labor, Victor Serge spent five years in prison in Paris, one year behind bars in the French department of Sarthe, and three in the Urals. Ernst von Salomon was imprisoned twice—for five years by the Weimar Republic and another year, as a prisoner of war, by the American forces. Durruti languished in the dank cells of a Spanish jail before being sent into exile in the Canary Islands. Emmett Grogan knew the jails of New York while he was still a minor. Bobby Sands was incarcerated for three years then sentenced to a further fourteen—a penalty brought to an end after just seven months by his fatal hunger strike. Phoolan Devi waited eleven years behind bars for a trial that never took place.

All hated the society that had humiliated them and flouted their rights. All dreamed of justice and a better world where property—if it existed at all—would be available to everyone. In the grip of despair, suicide beckoned. Bonnot chose to shoot himself in the head rather than surrender to the police. Bobby Sands starved himself to death. Their personal revolutions—individual, anarchist, or conservative—never saw the light of day, thwarted by Communism, Nazism, or the power of money. None lived to see the brave new world of their dreams.

Illegalists, Anarchists, and Revolutionaries

"Property is theft!"
Pierre-Joseph Proudhon, *What is Property?*, 1840

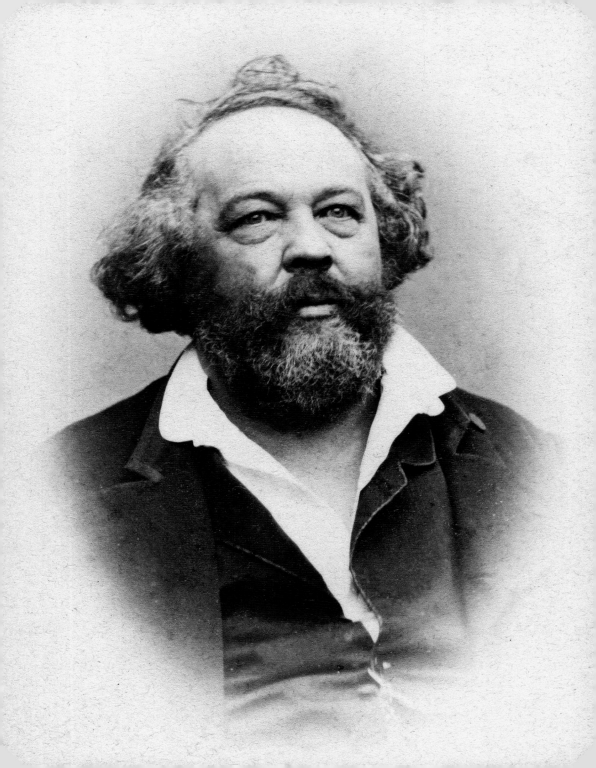

Mikhail Bakunin (1814–1876)
The Giant of Anarchism

Asked by a comrade to identify his greatest weakness, Mikhail Bakunin confided the keys to his fiery character, in a flash of lucidity, "There is a capital fault in my nature: a love of the fantastic, of extraordinary, unprecedented adventures, enterprises opening limitless horizons. [...] I would suffocate in an ordinary existence. [...] My soul is in a state of perpetual agitation, demanding action, movement, life..."[70]

The third of eleven children, born on May 8, 1914, near Tver, a small city of about a thousand souls, to a country squire, Mikhaïl Alexandrovitch Bakunin reached the age of twenty-five before transforming the innate force of his convictions into a powerful weapon of combat. A sickly child, the idealist and rebel lost himself in books, and was seduced by the concept of anarchism. As an adolescent, Mikhail determined to live as a free man, fighting strictures of every kind—familial, military, administrative, and political. With his huge frame, stentorian voice, wild mane of hair, and unruly beard, Bakunin was an energetic figure, always on the move, an eloquent speaker, seductive at first, and ultimately detestable.

Nothing halted the inexorable progress of Bakunin's career. He left his family at the age of fourteen, deserted from the army as a young officer at the age of twenty, and turned his back on Russian autocracy at the age of twenty-six, after working as a teacher of mathematics. He was fascinated by western Europe, spoke French and German better than his native Russian, and read the works of the great German thinkers: Goethe, Schiller, Fichte, Hegel. The eternal student took refuge in Berlin and Dresden, before settling in Switzerland to escape police harassment, together with many budding revolutionaries of his day. Eventually, he moved to Belgium and France, the cradle of so many great popular uprisings.

Bakunin was a passionate devotee of Hegel's dialectical scheme, according to which the negation of a negation brings synthesis, the desire for destruction becoming a creative force in its own right. He opposed Marx, who maintained that theory was the root of all action, arguing instead that action should come before theory. The self-regarding, authoritarian political scientist and the generous, libertarian bohemian never saw eye-to-eye.

The intellectual rebel of the smoke-filled back rooms of a hundred cafés then became a militant revolutionary internationalist. His hunger and thirst for the glorious day of revolution took precedence over the material practicalities of everyday life. Mikhail subsisted on debts and loans that he invariably failed to repay, fighting despair and the impulse to suicide in 1845, when he learned that a decree issued by Czar Nicholas I had robbed him of his status as a Russian citizen and nobleman, confiscating his property and condemning him to permanent deportation to Siberia if he ever set foot in his native country again.

Unable to fulfill an impossible love affair with his sister Tatiana, Bakunin threw himself body and soul into the revolutionary cause. He told a friend that he was saving himself for the revolution. The revolution would be his bride. In February 1847, the rumblings of revolution became a roar. From Paris to Milan, from Vienna to Berlin, the crown heads of Europe were toppled.

Bakunin's towering figure strutted proudly amid the heady fervor of the Paris barricades. The eternal melancholic rediscovered his lust for life, taking up his pilgrim's baton and preaching the cause, first in Germany, then in Silesia and Poland, and finally in Prague, where he faced the military in an armed standoff. His wandering life and pragmatic sense moderated his optimism and cooled his ardor, however, prompting him to believe, "Revolution is always three parts fantasy and one part reality." Bakunin's failure was total. The counterrevolution triumphed, but he held fast to his ideals. "I do not believe in constitutions, or

laws. We need something else: passion and life, a new world with no laws, and hence truly free."

Bakunin was not interested, unlike Marx, in preaching a proletarian revolution. For him, the revolution (in eastern Europe) would be agrarian, an uprising of the exploited peasantry that would usher in a great Slavic republic. Meanwhile, the *Neue Rheinische Zeitung* (The New Journal of the Rhine), to which Marx was a regular contributor, denounced Bakunin as a Russian agent. Mikhail was possessed with a single idea: to overthrow the czar in a general uprising of the Slavic peoples of eastern Europe. He was still a Russian at heart; he detested the German bourgeoisie and their lukewarm lip-service to the notion of democracy. More isolated than ever, Bakunin, the idealistic agitator, was now *persona non grata* in Berlin; he traveled to Bohemia in the hope of provoking a popular uprising before returning to Dresden under cover and becoming a friend of Richard Wagner, whose music and interpretation of Beethoven's Ninth Symphony comforted his revolutionary ardor.

While not its instigator, Bakunin found himself at the head of a spontaneous insurrection on May 4, 1848, an event that secured his place in history as a professional revolutionary. Five days of intense joy ended with a prison sentence, clamped in leg irons. Kept in solitary confinement, isolated from everyday life and events, Bakunin found inner peace. He awaited death with calm serenity—a more desirable outcome, for him, than life imprisonment, incompatible with his giant's frame. The only thing he lacked, he said, was the "company of men, essential to happiness." His civil trial was a drawn-out affair. In January 1850, sentence was delivered at last: death, commuted six months later to perpetual hard labor. Russia reacted with threats, demanding his extradition. After protracted negotiations, "the most dangerous man in Europe" was taken to Prague, then Olmutz, and finally delivered to the Russian authorities on May 15, 1851. After an absence of eleven years, he returned to his native country and was thrown into the dark cells of the Peter and Paul Fortress in Saint Petersburg, at the mercy of the czar.

Intrigued by his prisoner's fame and curious to understand how a former Russian army officer could become the father of revolutions across Europe, Nicolas I sent his interior minister, Count Orloff, to collect Bakunin's written confessions. Deprived of contact with the outside world, Mikhail had sunk into a new decline. The offer of a supply of paper and pencils was an unexpected lifeline for this intellectual, bubbling with ideas. Not for him the classic criminal's

apology, denying his beliefs and his comrades of old. Bakunin hesitated but finally embarked on an extraordinary, epic text full of cunning and ambiguities, a mix of despair, soaring hopes, and visionary premonitions. "Russia is driven by fear, and fear destroys all life, all intelligence, every noble impulse of the soul… I wanted revolution," he conceded at the bottom of one page, before returning to the question that haunted him still. "What degrees of barbarism and brutal ferocity are attainable by the Russian peasantry in revolt?"

The czar examined the coruscating text with unconcealed fascination, and recommended it to his eldest son as "curious and highly instructive." Nicolas I distrusted his prisoner, however, and refused to have the hardened agitator transferred to Siberia, condemning Bakunin to a life of perpetual inactivity, the harshest punishment of all. For a compulsive activist like Bakunin, his personal freedom was more important than life itself.

In 1857, physically diminished by eight years in solitary confinement, Bakunin marked his forty-fourth birthday with a despairing plea to the new Czar Alexander II to free him from the horror of dying in solitary reclusion and deliver him from this most atrocious punishment. This time, the response was favorable. Bakunin was taken to Tomsk in western Siberia, where he fell in love with Antonia Kviatkowska—the daughter of a Polish exile, twenty-five years his junior, and married her.

Two years later, the couple moved to Irkutsk, where Mikhail accepted a menial job as a salesman. His revolutionary ardor was rekindled, and his old obsessions—enfranchisement for the serfs, the creation of public tribunals, education for all, the abolition of bureaucracy—surfaced once again. Using a commercial trip as his pretext, Bakunin traveled to the port of Nicolayevsk, where he set sail for London, arriving in Christmas 1861. He returned to a life of debt, poverty, and anarchist activism.

The fiery philosopher issued a host of inflammatory pronouncements, "If blood there must be, then blood will flow," and was a wholehearted supporter of the Polish insurrection of January 1863. Repression, with its cortege of horrors, triumphed once again. From 1864 onward, Bakunin—who had been joined by his wife—divided his time between London, Paris, Florence, and Naples. Anarchism, synonymous with absolute freedom, became his sole creed; the cruel struggle against every form of authority—state or socialist—was his warhorse. To bring down

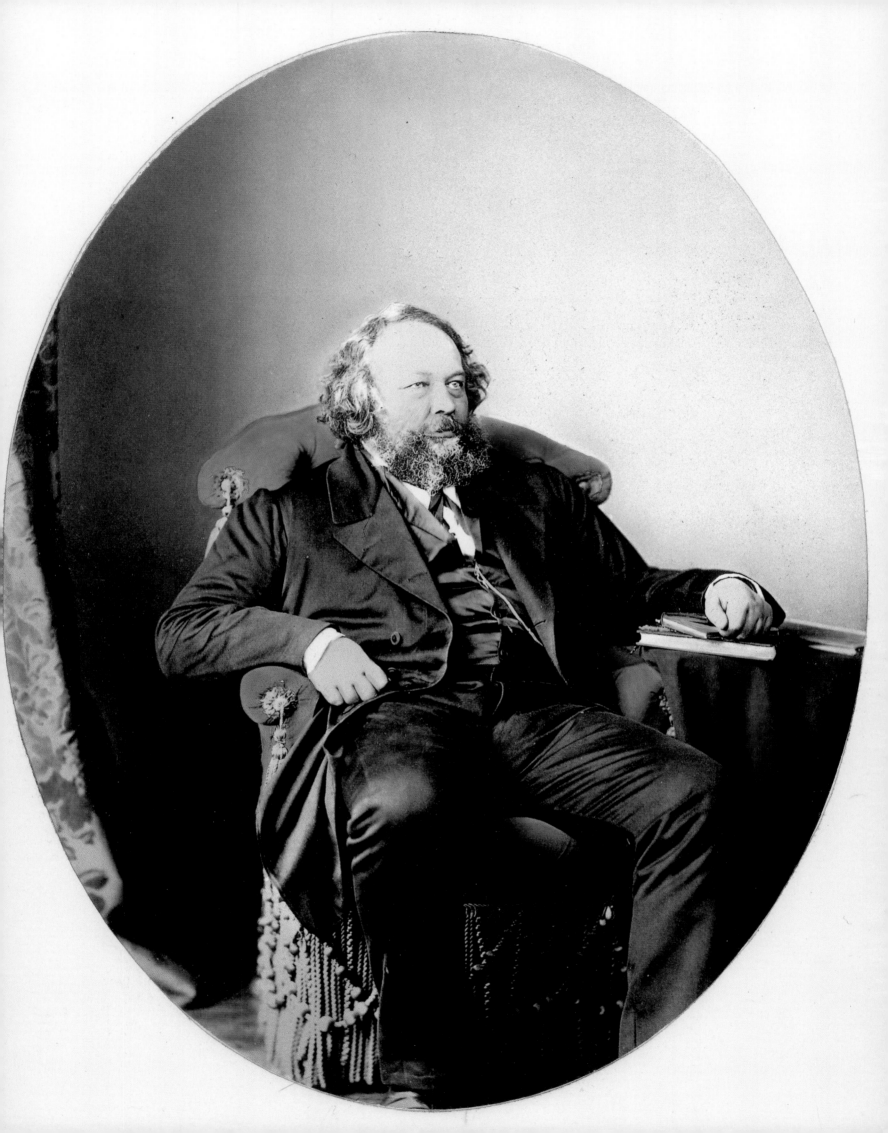

the established social order, Bakunin created a secret international organization, the International Fraternity, with himself as the brains, chief weapon, and preacher. The organization was fronted by an official mouthpiece, the International Alliance for Socialist Democracy. The guiding themes of the Fraternity's program sprang from Bakunin's *Revolutionary Catechism*, written 1851, while he was still in prison in Russia.

It follows that in order to regenerate society, we must first completely uproot this political and social system founded on inequality, privilege, and contempt for humanity. After having reconstructed society on the basis of the most complete liberty, equality, and justice—not to mention work—for all and an enlightened education inspired by respect for man—public opinion will then reflect the new humanity and become a natural guardian of the most absolute liberty.

At the Fraternity's Berne Congress, Bakunin clearly stated his opposition to Marx, declaring his hatred for Communism on the basis of it being the negation of freedom, while at the same time adhering to the federation of labor unions known as the First International that was headed by Marx, for tactical reasons.

On July 19, 1870, France declared war on Prussia. Marx openly supported the Prussians, and Bakunin hoped for a French defeat that would create the conditions for a popular uprising, leading to a socialist revolution that would spread from France to the whole of Europe. In early September, Bakunin traveled to Lyons incognito, issuing a call to general insurrection entitled "*La Fédération Révolutionnaire des Communes*," and founding the Comité central du salut de la France (the Central Committee for the Salvation of France), an organization whose influence and activities failed to spread further than Lyons itself. Bakunin wanted to arm the workers, but the Central Committee opposed the idea. On September 28, the

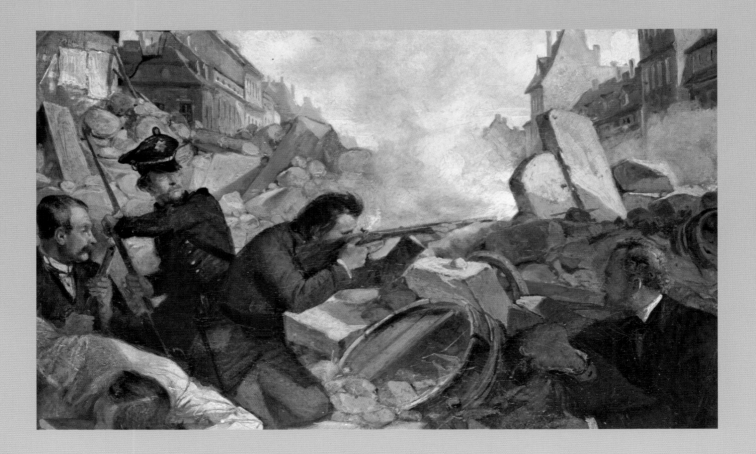

operation failed, and the anarchist leader fled to a life of poverty in Locarno. The indefatigable leader continued to agitate, however, taking advantage of his presence in Italy to remobilize revolutionary cells still dreaming of a Europe-wide uprising, in the wake of the bloody repression of the Paris Commune.

At the International Workingmen's Association's Hague Congress, in September 1872, Bakunin's libertarian socialists (in favor of self-determination for the masses) opposed Marx's authoritarian socialists, who favored the creation of a proletarian avant-garde. Disillusioned, the aging militant found himself sidelined, a situation from which he occasionally bounced back but from which he never fully recovered.

Internal dissent, financial imbroglios with his friend Cafiero, and physical exhaustion conspired to bring down the old lion of revolution. Bakunin acknowledged his lassitude and impotence in a moving letter written in October 1873:

During the last nine years more than enough ideas for the salvation of the world have been developed in the International (if the world can be saved by ideas) and I defy anyone to come up with a new one. […] Above all, now is the time for the organization of the forces of the proletariat. But this organization must be the task of the proletariat itself. If I were young, I would live among the workers and share their life of toil, would together with them participate in this necessary work of proletarian organization. But neither my age nor my health allows this. [71]

The giant of the anarchist movement, who dreamed of death at the barricades, died a broken man, of acute uremia, on July 1, 1876, in Berne. To future generations hungry for revolution, he left a bubbling cauldron of ideas and a discreet epitaph carved on his tombstone: "Remember he who sacrificed all for the freedom of his country."

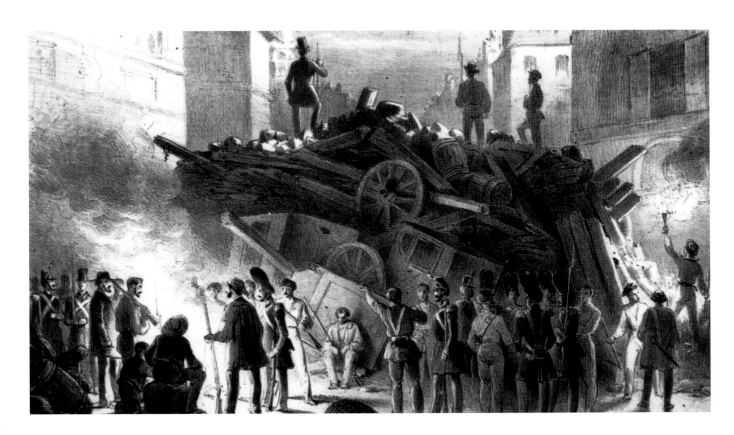

Page 160: Bakunin, 19th century.
Page 163: Bakunin, 1863.
Facing page: Fighting in the barricades, May 1849, painting by Julius Scholtz, 1849.

Above: Barricade in rue Saint-Martin, night of the February 23–24, lithograph based on a drawing by Ange Louis Janet-Lange, 1848.

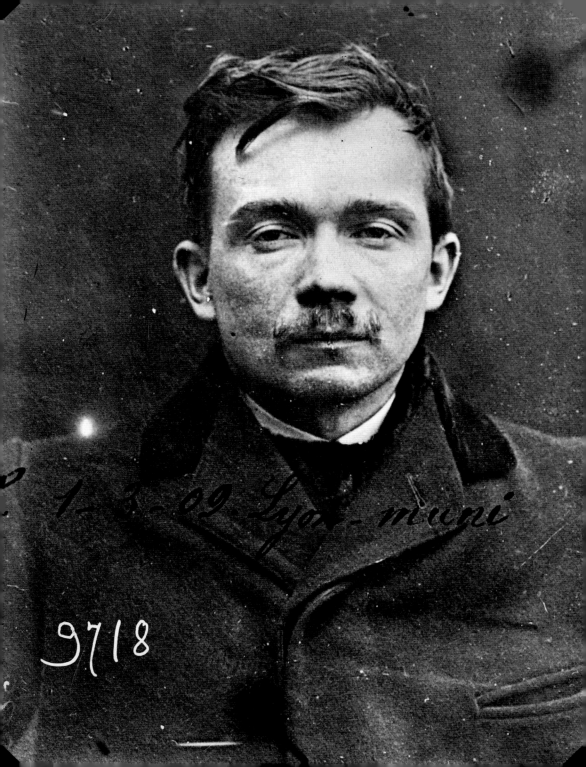

Jules and the Bonnot Gang *(1876–1912)*
Outlaws of the Belle Époque

They saw themselves as outsiders, and refused to submit to established order of any kind. Rejecting conventional society, they freed themselves from its constraints and conventions, embracing the outlaw life at the age of twenty. The most famous of this generation of outlaws—bent on sabotaging the economic machine through theft—and the most extreme, absolute outsider of them all, was Jules Bonnot.

Born on October 14, 1876 at Pont-de-Roide in the French department of Doubs, Jules lost his mother at a young age, like so many apprentice outlaws before him. He was just five years old. He and his brother, Justin, who committed suicide as a teenager after a lover's tiff, were looked after by their grandmother, who found herself powerless to control the wild, rebellious pair. Bonnot's school report describes him as "an intelligent pupil, but lazy, undisciplined, and insolent." Jules was frequently excluded from the classroom and often brutal to his classmates.[72] Forced to leave school and earn his keep, the spotty, withdrawn thirteen-year-old found work as a mechanic. He was inspired by anarchist ideas and soon became a militant trade unionist, earning a reputation as a trouble-maker and constantly changing jobs.

Bonnot eventually found himself at the Berliet plant in Lyons, where he discovered the magic of the motorcar. His libertarian spirit was incompatible with authority and factory hierarchies, however, and he soon went into partnership with a naive idealist by the name of Demange, opening his own car-repair workshop. Bonnot worked as a mechanic by day and a criminal by night, robbing, dealing in stolen cars and illicit alcohol, blowing up safes, and forging money to compensate for the meager rewards of his legitimate business.

Small and plainly dressed, he gave off the appearance of being a lowly office worker rather than a gangster. His face, emaciated by poverty and pockmarked by juvenile acne, featured a thick mustache and piercing blue-gray eyes, deeply set in cavernous orbits. From an early age, Jules had suffered beatings from his father and the lick of the police constable's stiff blue cape. At nineteen, he was a hardened labor unionist, striker, and revolutionary, often coming to blows with the police, brawling, and in jail. His mottoes were the favorite slogans of the Belle Époque revolutionaries: "Poor work for poor pay"; or "Set yourself free, buy a gun! If you need money, steal!"

Bonnot was a man of few charms, but he took up with a young peasant girl, Sophie Burdet, during his military service. The couple married and had two children, but Bonnot's personal jinx was close behind: their first baby died after just four days, and his wife left him a few months after the birth of the second, for an attentive, well-intentioned union official. Betrayed by his own wife, Bonnot was left bitter and disillusioned, sinking further into solitude and distrustful of his friends.

Around the same time, he joined forces with an Italian anarchist, a small man with blond, curly hair and known as Platano (or, sometimes, as Mandino). The two men set about robbing and stealing cars, motorbikes, and bicycles, convinced that individual Illegalist action in the form of numerous petty "reprisals" was the most effective way to undermine and bring down conventional society. Jules also fell in love with his landlord's wife, Judith Thollon, a beautiful woman of twenty-seven, and promised her that they would start a new life together in England, as soon as he had amassed enough money.

Bonnot and Platano were now wanted in Lyons so, on November 26, 1911, they decided to leave for Paris. It was raining, and the road was long. Their eighteen horsepower Buire skidded repeatedly. The atmosphere was morose. On the 28th, just as they were nearing the end of their journey, the fan belt snapped. While Jules carried out the repairs, Platano began toying with his partner's Browning pistol.

LE BILAN DE LA BANDE CARROUY, BONNOT, GARNIER ET Cie

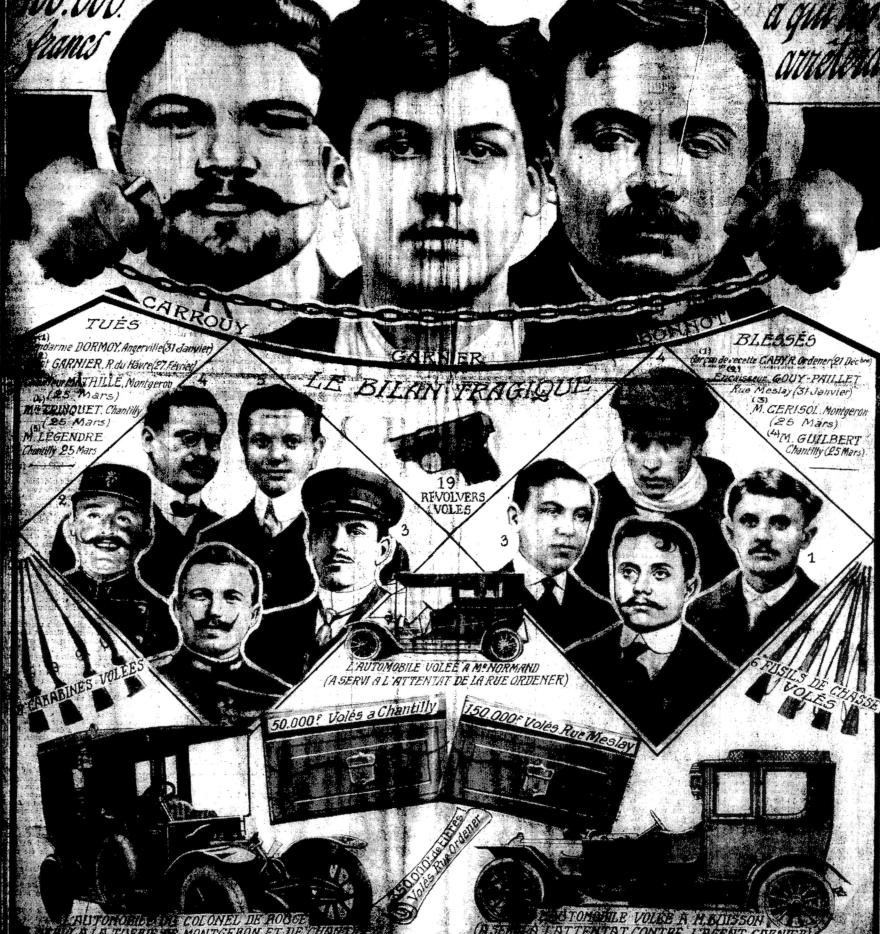

100.000 francs

a qui les arrêtera

CARROUY — GARNIER — BONNOT

LE BILAN TRAGIQUE

TUÉS

(1) Gendarme DORMOY, Angerville (31 janvier)
GARNIER, R. du Hâvre (27 février)
Chauffeur MATHILLE, Montgeron (25 Mars)
M. TRINQUET, Chantilly (25 Mars)
M. LÉGENDRE Chantilly 25 Mars

BLESSÉS

(1) Garçon de recette GABY, R. Ordener (21 Déc bre)
(2) Encaisseur GOUY-PAILLET Rue Meslay (31 Janvier)
(3) M. CÉRISOL, Montgeron (25 Mars)
(4) M. GUILBERT Chantilly (25 Mars)

19 REVOLVERS VOLÉS

CARABINES VOLÉES

6 FUSILS DE CHASSE VOLÉS

L'AUTOMOBILE VOLÉE A Mr NORMAND (A SERVI A L'ATTENTAT DE LA RUE ORDENER)

50.000f Volés a Chantilly

150.000f Volés Rue Meslay

50.000 de titres Volés Rue Ordener

L'AUTOMOBILE DU COLONEL DE ROSSE (A SERVI A LA TUERIE DE MONTGERON ET DE CHANTILLY)

L'AUTOMOBILE VOLÉE A M. BUSSON (A SERVI A L'ATTENTAT CONTRE L'AGENT GARNIER)

Angrily, Bonnot snatched the weapon from his hands. A shot rang out, and Platano was wounded. Jules watched his associate moaning and writhing in pain, and decided to shoot him dead. The noise alerted a local gamekeeper, who arrived in time to witness Bonnot's transformation: no longer just a militant anarchist, he had become a murderer. He fled to Paris, where he swiftly began frequenting the capital's libertarian milieu and became a leading activist.

A group of desperate idealists (the future hardcore of the "Bonnot Gang") had established an anarchist headquarters in a flowery suburban bungalow at Romainville: Lorulot (the owner), Eugène Dieudonné, Louise (his ex-wife, known as the Red Venus, and now Lorulot's lover), Raymond Callemin (known as Raymond la Science), Édouard Carouy, Marius Metge, Octave Garnier (known as Octave le Terrassier), the poet René Valet, the youth Soudy, Élie Monnier (known as Simentoff), and Viktor Kibalchich (later known as Victor Serge) and his mistress Rirette Maîtrejean.

Total revolution was nigh! The gang's uncompromising brand of anarchism drove them to act on their ideals. The fine line between militant activism and outright banditry was soon crossed. A succession of break-ins, post office hold-ups, and nocturnal robberies produced only meager pickings, however. In December 1911, Jules Bonnot was introduced to the gang by Dieudonné and became their driver. The violence escalated, and innocent blood flowed. Bonnot's picture, headlined as "Platano's murderer," was on the front page of every newspaper. Meanwhile, Judith was arrested in Lyons. Jules was a marked man, as well as one who was ready to do anything to avenge his mistress. He soon established himself as the "military adviser" of this "association of free individuals," whose motto was "strike fast and disappear."

The gang's first truly sensational operation took place on December 21, 1911, a hold-up at the Société Générale bank, involving a cashier by the name of Ernest Caby. The press sensationalized the story of what was, indeed, the world's first-ever motorized hold-up. The gang made off in a getaway car, with Jules at the wheel. Much was also made of reports of a fourth man at the scene. A deputy security chief by the name of Louis Jouin was put in charge of the investigation. Jouin was described by Victor Serge in his memoirs as a thin man with a long, miserable face, but courteous, and almost likeable. He would find no friend in Bonnot, however.

The desperate band of extremists was caught in a suicidal spiral. Convinced they faced the guillotine, the bandits felt they had nothing to lose. Garnier sent a provocative letter to the newspaper *Matin de Paris* on March 19, authenticated by his fingerprint. He knew he faced defeat, he wrote, but he intended to exact a high price for his opponents' victory.

The first members of the gang to be caught had been uninvolved in the murderous hold-up: Victor Serge, who was wrongly identified as the gang leader, and his girlfriend, Rirette. Their arrests were followed by that of Eugène Dieudonné, who was accused of being the "fourth man" at the bank robbery, but also persistently claimed innocence. Revolted by these arbitrary arrests, René Valet, Élie Monnier, and André Soudy, all of whom had taken a backseat in the gang's criminal activities until then, now joined forces with the hell-fire trio of Bonnot, Garnier, and Callemin.

On March 25, 1912, the six accomplices mounted an ambush at Montgeron, hijacking a De Dion-Bouton car, killing its owner and chauffeur, and setting off for Chantilly, where they attacked the local branch of the Société Générale, to cries of "*Vive la mort!*" (Long live death!). The gang killed three bank employees and made off with thirty-five thousand francs, ten thousand gold coins, and four thousand pieces of silver.

The gang's criminal rampage provoked paranoia and outrage throughout France. A huge manhunt was launched, with Louis Jouin in charge. Fatally, the six bandits decided

Between shots, he wrote his will . . . asserting his status as an outsider to society.

to split up, each hoping for the chance to return to a more respectable life. Both the police and the Société Générale, however, offered significant rewards for any information leading to the bank robbers' arrests. The lure of easy money paid off. Soudy was stopped on a tip-off at Berck-Plage on March 30, Carouy near Palaiseau on April 4, and Raymond Callemin on April 7 at his home on rue de la Tour-d'Auvergne, probably betrayed by his mistress Louise.

On April 24, Bonnot himself narrowly escaped arrest after killing Jouin, his hated enemy, in Ivry-sur-Seine. Wounded in the arm, he made the mistake of asking for

treatment at a pharmacy, before taking refuge in Charly-le-Roi, at the home of a garage-owner and friend by the name of Dubois. Bonnot was discovered on April 27, during a search. Twenty thousand people flocked to the scene of the spectacular siege, which lasted the entire morning. Five hundred armed men confronted a single outlaw. Bonnot knew his time was up. Between shots, he wrote his will at a table in the house, asserting his status as an outsider to society, his right to live—which France's "imbecilic and criminal" society had taken away, and his lack of regret.

His pencil lead broke, and a final phrase was inscribed in his own blood: Madame Thollon, an associate of the gang's named Antoine Gauzy, and Dieudonné were all innocent. Bonnot shot himself in the head, survived, and fired again. He died in agony on the way to the Hôtel-Dieu hospital.

Valet and Garnier were killed at Nogent-sur-Marne on May 14. Callemin, Monnier, and Soudy were condemned to death in February 1913 and guillotined on April 21 in front of the Santé prison in Paris. Dieudonné's death sentence was commuted to hard labor for life. Metge and Carouy, who would go on to commit suicide in his cell, received the same sentence, and Victor Serge spent five years in jail. Their six-year reign of terror over the bourgeois society of the Belle Époque was at an end. The Bonnot Gang was no more.

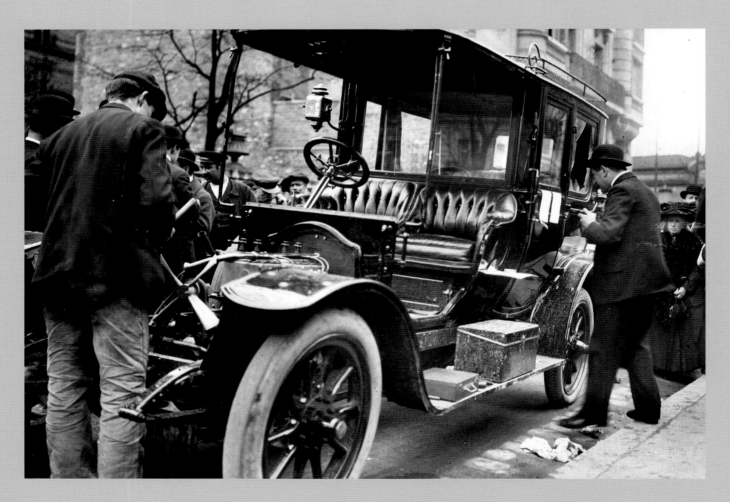

Page 166: Jules Joseph Bonnot, 20th century.
Page 168: The Bonnot Gang, print accompanied by an offer of
100 000 francs for their capture, published in the newspaper
Excelsior, *20th century.*
Above: The Bonnot Gang's abandoned car being examined by police
following their attack on the Chantilly Société Générale,

March 25, 1912.
Facing page: André Soudy, member of the Bonnot Gang, pretending
to aim at the photographer, 1912.
Following pages: Anthropometric images of Eugène Dieudonné,
February 29, 1912.

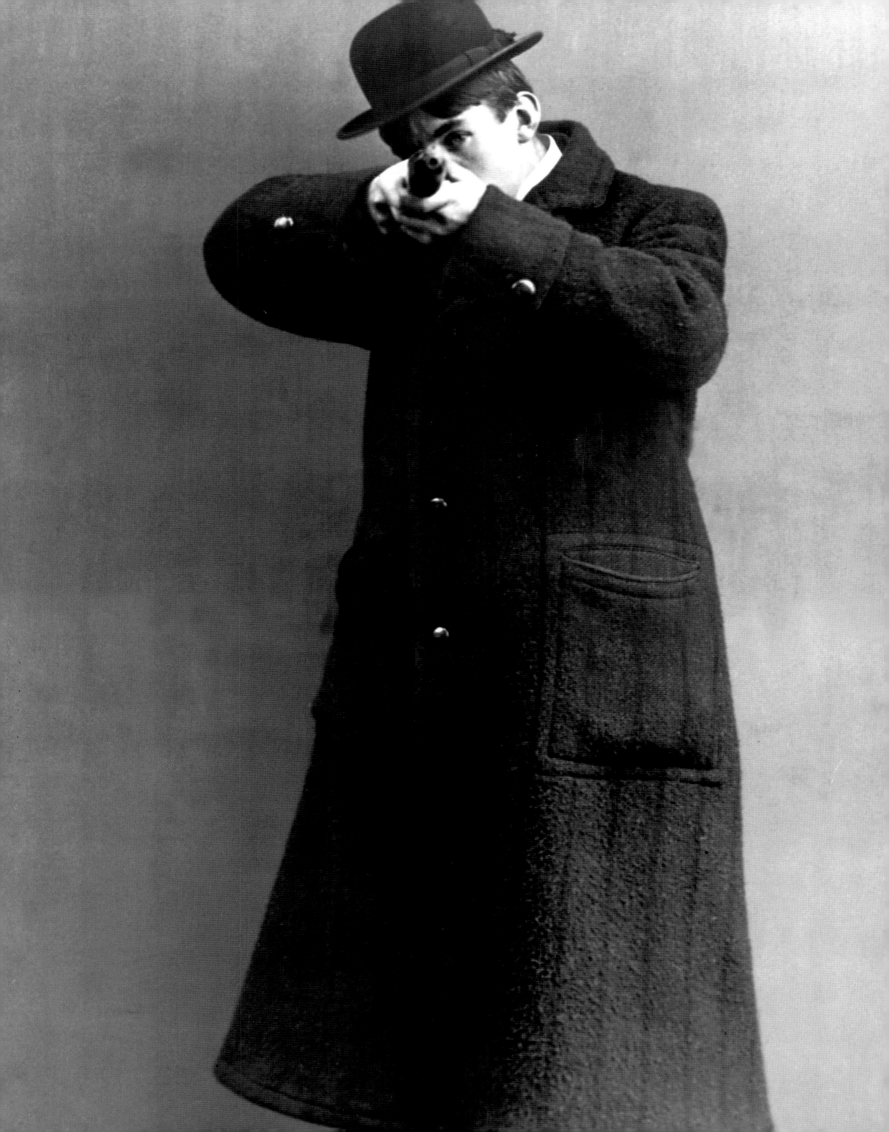

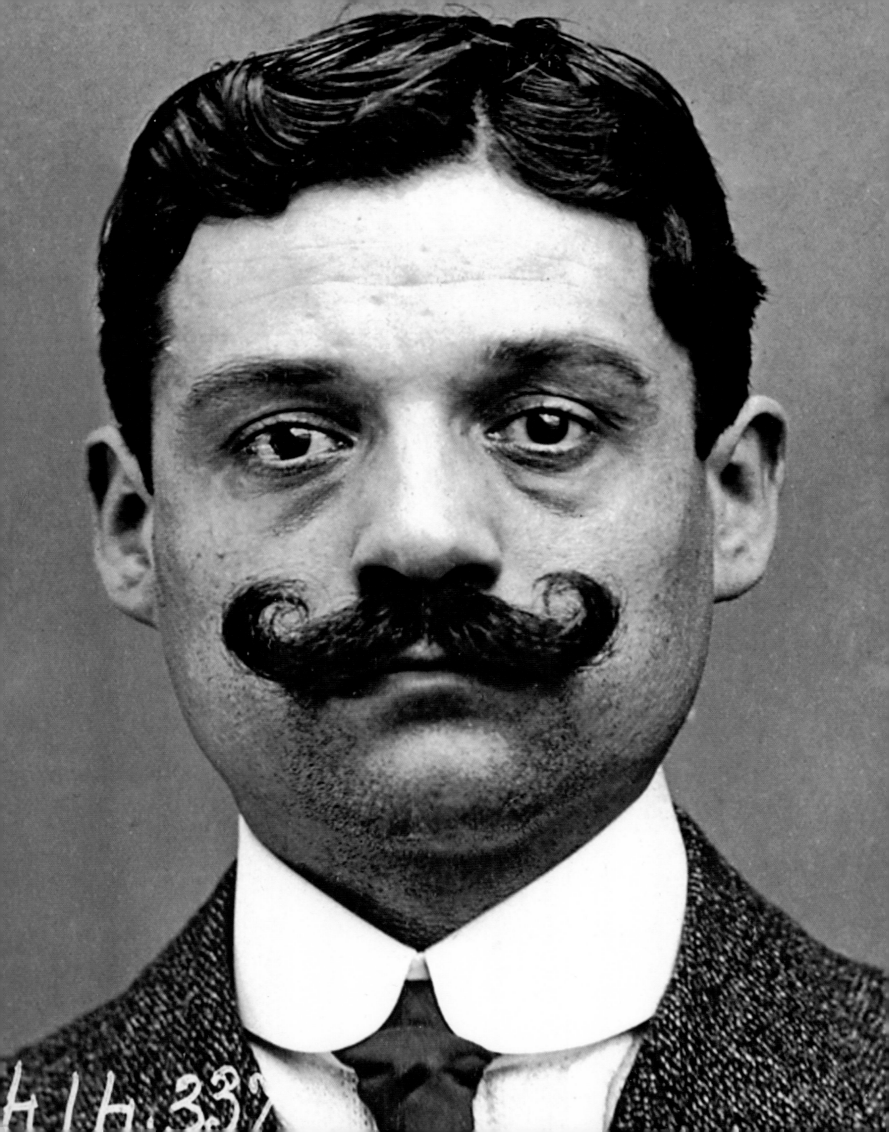

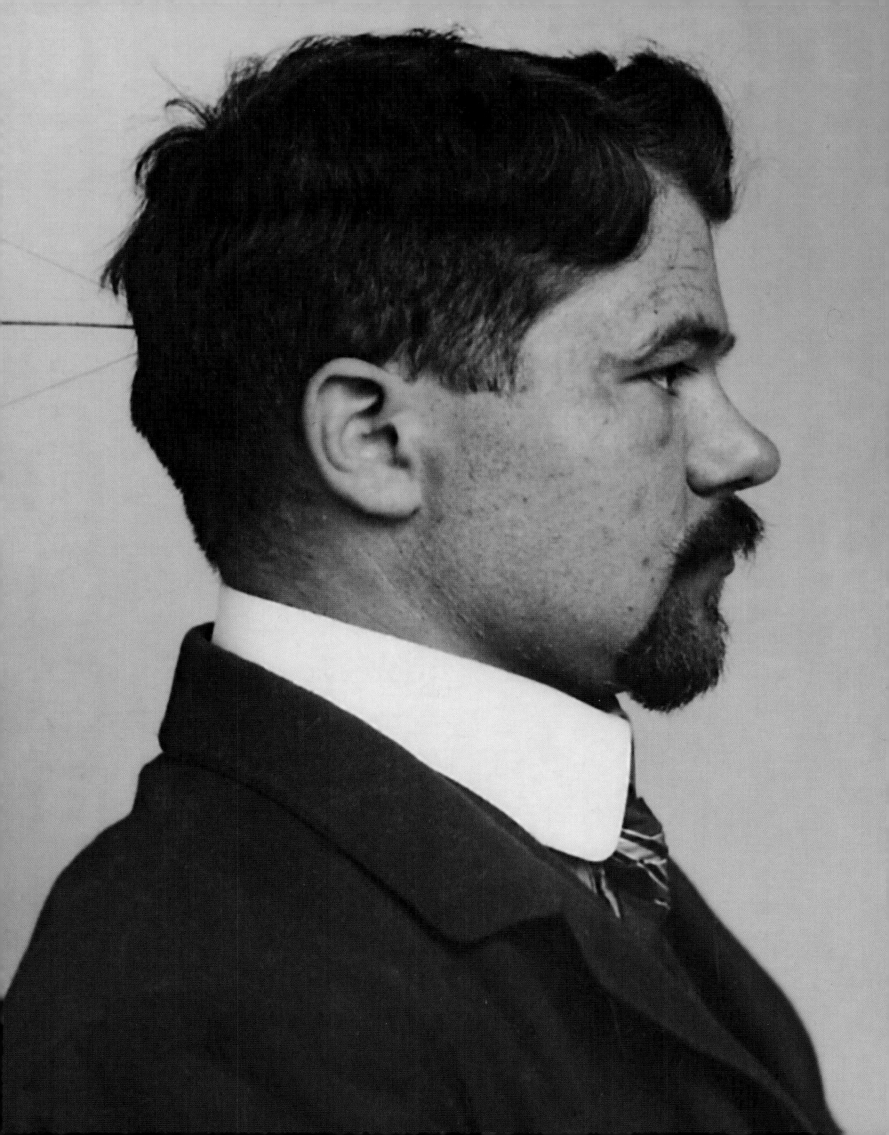

Escande 28.4.03 6715

Marius Jacob (1879–1954)
The Gentleman Thief of Illegalism

Not all illegalists die by the bullet. On August 1954, ill and exhausted by a life of perpetual revolt, Marius Jacob wrote in a letter to his friends, "I leave you without despair, a smile on my lips, peace in my heart […] stuffing the infirmities that lie in wait for the onset of old age […] I have lived. I can die."[73] Then he plunged a syringe full of morphine into his emaciated arm. Immortalized as the inspiration for the fictional character Arsène Lupin, the gentleman thief could take his bow with no regrets. His outlaw escapades live on.

Originally from Alsace, his family settled in Marseilles in 1850, earning a comfortable living from the sea. Alexandre Marius was born in 1879, At the age of eleven, he gained his *certificat d'études* at the local Jesuit school and followed his father, Joseph Jacob, to sea. Emulating the heroes of his favorite author Jules Verne, he enlisted as a cabin boy aboard the *Thibet*, bound for the Congo. His first experience as a ship's apprentice led to a post as a novice helmsman aboard the *Ville de Nouméa*. But Jacob soon tired of the harsh regime of life at sea. When the ship arrived in Sydney, he went ashore and deserted. With no money, the adolescent dreamer enlisted aboard a whaling ship. When not pursuing their prey, the crew dabbled in acts of piracy. The experience earned Jacob a fortune, albeit one that reeked of blood. He returned home to France and escaped hanging by pure luck. Shortly after he left them, his fellow crew-members were all arrested, tried, and executed.

In Marseilles, Jacob returned to sea, but his experience of penury, shipwreck, exploitation, trickery, unseaworthy vessels, and violence left him bitter and disillusioned. At the age of sixteen, poor health forced him to abandon life as a mariner. Attracted by anarchist ideas, he spent his abundant free time reading, especially Victor Hugo. He was inflamed by Hugo's controversial last novel, *Quatre-Vingt-Treize*, with their stinging denunciation of society's parasitic trinity: the priesthood, the judiciary, and the military.

A naturally solitary adolescent, Jacob struck up a friendship with a young, libertarian neighbor who easily converted him to the revolutionary ideals propounded by Proudhon and Mikhail Bakunin. In spring 1893, Europe was rocked by a series of bomb attacks and assassinations that were met with swift, merciless repression. Hastily judged and executed, their perpetrators became folk heroes. Jacob, who now was going by his middle name, Marius, was seized with revolutionary fever. With a handful of comrades, the novice activist produced a series of handmade explosives, but he had no time to use them. He was betrayed by one of the many police informers operating under cover in libertarian circles and spent six months in prison.

Now with a criminal record, Marius was a marked man. He tried, unsuccessfully, to pursue an honest career, working as a typographer and a pharmacist's assistant. But as soon as his activist past caught up with him, his employers were reluctant to keep him on. Marius found himself on the street, out of work and more committed than ever to his anarchist ideals.

The young reprobate eschewed desperate and violent attacks on prominent buildings and institutions, preferring to concentrate on the private property of the rich. His new motto would become famous: "Bombs only scare the poor, so let us steal from the bourgeois and redistribute [the spoils] to the poor!" At the age of eighteen, Marius Jacob joined the ranks of the Illegalists, operating with cunning and a sense of humor.

His first sensational stunt, reported in *Le Petit Parisien* on April 2, 1897, was a masterstroke; as a result of it, his victims became the laughingstock of France, and he was firmly established as a lovable rogue. With his comrades, he targeted a well-known charitable institution in Marseilles that provided loans to the poor in exchange for pawned goods. The newspaper account tells it all:

Four decently-dressed individuals approached a commissioner at the Mont-de-Piété. One of the men, wearing a sash and claiming to be a police superintendant, presented a rogatory commission and requested that the commissioner hand over a large quantity of gems and jewelry, which his partners then loaded into closed boxes. The man wrote out an official receipt, assuring the commissioner that everything would be returned after it had been examined by the public prosecutor.

And so, without the resource of any weapon but his ingenuity, Marius made off with a hefty prize. He went immediately into hiding but was sentenced *in absentia* to five years in prison and a fine of three thousand francs. Unluckily for him, he was spotted on a Toulon street by one of his former accomplices, who betrayed him to the police in exchange for his own acquittal. Marius was arrested and transferred to Aix-en-Provence to await trial. Knowing what was in store for him, he simulated madness and got himself sent to an asylum at Mont-Perril instead, from where he escaped with help from his father. Marius's spell behind bars had given him time to reflect, however. No more break-ins without an ideological justification. From now on, the fruits of his exploits would be redistributed to comrades in difficulty or used to finance the cause.

Marius created an anarchist gang known as the Travailleurs de nuit (the Night Workers), which was organized into brigades, each of which guaranteed to respect a set of rules drawn up by their own free consent. There would be no killing except in self-defense, and only then if the attack-

"I have lived. I can die."

ers were policemen; the gang's only targets were rich property owners, the nobility, judges, the military, and the property of the clergy. Part of the spoils would be donated to the anarchist movement. (Although he stuck to them, few of his comrades complied with these high-minded principles, however.) Jacob had also given careful thought to the gang's operational tactics. He opened a hardware store in Montpellier, where he received free leaflets detailing effective safe-breaking

techniques, and a foundry in Paris, where the booty was transformed into gold ingots, bypassing the usual (overly talkative) receivers of stolen goods.

Jacob's favorite targets were churches and wealthy private homes. He had a particular penchant for disguises of all kinds: curates' robes, officers' uniforms, dinner jackets.... Each "brigade" featured a gang of three: a lone scout armed with so-called "seals" (pieces of folded card that were to be inserted into the doorframes of targeted homes, to verify the owner's absence), followed the next day by two accomplices, who would arrive by train to carry out the break-in.

From Cherbourg to Le Mans, via Paris, Tours, and Orléans, most of France's major cities received a visit from "Attila," the name with which Jacob signed his calling cards, invariably adding a wry phrase such as, "We make war on the judges of peace," or "To Almighty God, find your thieves."[74] At his trial in Amiens, Jacob eventually answered to a hundred-and-fifty-six separate charges.

Jacob was twice forced to fire a weapon to escape the police. The first occasion was in Orléans, where he was traced to a hotel room with an accomplice named Royère. The policeman, an agent by the name of Couillot, suffered several bullet wounds but survived. On April 21, 1903, in Abbeville, a bungled operation put an end to Jacob's career as a thief, forever. Surprised by a neighbor while burglarizing a private townhouse, Jacob and two accomplices, Bour and Pélissard, made off on foot across the countryside to the small town of Pont-Rémy, arriving at two o'clock in the morning. The next train was not due until six o'clock. Ever the evangelical militant, Jacob spent the intervening time trying to convert the station guard to his libertarian ideas. The suspicious guard excused himself for a few minutes and alerted the police station at Abbeville. When the ticket kiosk opened, a police agent by the name of Pruvost and a brigadeer named Auquier were sent to the scene. Bour killed Pruvost with a bullet through the heart; Jacob fired on the second man, escaped into the countryside, and was finally apprehended by force near Airaines. Their trial opened in Amiens on March 8, 1905. Despite the charges against him—murder, gang theft, and criminal conspiracy, all punishable by the guillotine—Jacob kept his cool, as reported in the local press:

His energetic countenance gave him a hard appearance. He kept his hat on his head:
"Remove your hat", ordered the presiding judge.
"Your head's covered", retorted Jacob.

"Rise."

"You're seated."

"Do you agree with your fellow accused, in their objections to certain members of the jury?"

"I agree with no one, we do not recognize your jurors' right to judge us."[75]

At the third hearing, the master burglar presented his revolutionary ideas with characteristic verve and flair:

I am far from disgusted by work: in fact, work delights me. […] What disgusts me is the experience of sweating blood and water for a meager hand-out, to create riches from which I am excluded. […] Rather than beg for that which is rightfully mine, I prefer insurgency, fighting my enemies hand to hand by declaring war on the rich, and attacking their property.

At the sixth hearing, the accused argued angrily with the presiding judge, intoned the communist anthem *L'Internationale*, left the dock, and refused to return. Jacob was twenty-four years old. In November 1905, the court handed down a life sentence of hard labor, at the Iles du Salut prison camp in French Guiana.

Deemed an exceptionally dangerous criminal, to be kept under the closest surveillance, Jacob was accorded a special cage on the voyage out, shared with only three other convicts, while the remaining prisoners were crammed fifty to a cage. His formidable reputation prevented him from being imprisoned, once he arrived in Guiana, in more favorable conditions, but it also ultimately saved him from what was essentially a death sentence in all but name. His fellow convicts respected him, and Marius soon emerged as their leader, committed to a new struggle with the penal administration. His leadership came at a high price, however, as he was repeatedly sent to the prison dungeon, a cell with no natural light

whose occupants were clamped in irons each evening. Marius's *bête noir* was the camp commandant, named Michel, a man who quickly decided that he must either kill Jacob, or face defeat and death himself. Marius's weapons of choice against Michel and the treatment he received at the prison camp were the military, maritime, and penal codes of French law, providing the basis for repeated appeals and complaints to the Minister of Justice. He received prominent support in his struggle from a noted source, Dr Louis Rousseau, a military doctor who had arrived at the Iles de Salut in September 1920.

Jacob masterminded eighteen escape attempts, making sails in secret and devising endless bold, far-fetched schemes for reaching the open sea. He was often betrayed or unlucky, and never succeeded.

A tragic event changed the course of his prison career forever. In 1908, a prisoner by the name of Capeletti, "one of the lowest intelligences in the labor camp," tried to poison him. Warned by another convict, Jacob was seized with fury, stabbing the villain repeatedly, and killing him. He was sentenced to five years in the cells, reduced on appeal to two—twenty-four months alone in a cell, forbidden to talk.

His mother's determination and the mobilization of public opinion in his favor eventually paid off. Jacob was allowed to return to France at the end of 1925 to serve his last three years in prison there.

At the age of seventy-five, the big-hearted anarchist decided it was time to go. Before committing suicide, Marius Jacob left one of his celebrated calling cards, proving once again that humor, a generous spirit, and Illegalism can make good bedfellows. It read, "Laundry washed, rinsed, dried, but not ironed. I'm feeling lazy. Apologies. You'll find two liters of rosé next to the basket. Your health!"

Page 174: Alexandre Marius Jacob, 1905.

Page 177: Watercolor of Alexandre Jacob painted on the Salut Islands, taken from a letter to his mother, 1909.

Above: The convicts leaving for Guyana from Saint-Martin,

Ile de Ré: the penal colony departs, postcard, 20th century.

Facing page: A daring duo of robbers on rue de Quincampoix, L'Illustration, *1901.*

Victor Serge (1890–1947)
The Libertarian without Frontiers

In his *Memoirs of a Revolutionary*[76] Victor Serge (born Kibalchich) reveals the secret of fifty years of living outside society's laws and conventions:

> Even before I emerged from childhood, I seem to have experienced, deeply at heart, that paradoxical feeling which was to dominate me all through the first part of my life: that of living in a world without any possible escape, in which there was nothing for it but to fight for an impossible escape. [...] Early on, I learnt [...] that the only meaning of life lies in conscious participation in the making of history. The more I think of that, the more deeply true it seems to be. It follows that one must range oneself actively against everything that diminishes man, and involve oneself in all struggles which tend to liberate and enlarge him.

Born in Brussels on December 30, 1890, the stateless infant followed in the footsteps of his remarkable father, an ex-officer of the Russian imperial guard who had joined Narodnaya Volya (The Will of the People), a nihilist movement responsible for the assassination of Czar Alexander II, nine years before Victor's birth. Kibalchich senior finally turned his sword on the Russian army itself before fleeing to Switzerland to escape the death penalty. His actions had condemned his family to penury: there was scarcely any money for food (Victor's younger brother, Raoul, died of malnutrition) and still less for education. Victor Lvovich Kibalchich made do with his father's improvised lessons at home and became a diligent visitor of Belgium's museums and libraries, slaking his insatiable thirst for knowledge by reading Louis Blanc's *History of the French Revolution* and Zola's *Rougon-Macquart* by candlelight.

When he was thirteen years old, Victor's parents separated, forcing him to take a succession of jobs to survive that included photographer's apprentice, office boy, and graphic artist. Stricken with poverty, his revolutionary ideals flourished, and he took up with a young outcast by the name of Raymond Callemin, who would remain his companion rebel-in-arms until the latter's death at the guillotine. Socialist cells were springing up all over Belgium, often disappearing again almost immediately, victims of their own endemic feuding and factional splits. Victor and Raymond mixed with the young socialist guard of Ixelles, frequenting a group founded by Emile Chapelier called *L'Expérience* and an anarchist colony dubbed *L'Essai* (the Attempt) that was founded by Fortuné Henry in the forest of the Ardennes and whose motto—displayed on the wall above a saucer—was "Take what you want, leave what you can." The two eventually joined the *Groupe Révolutionnaire de Bruxelles*, where Victor signed his first published articles with the name *Le Rétif* (The Rebel).

Victor eventually tired of the groups' sterile activities and headed for Paris where he divided his time between teaching French to young Russians (in order to eat) and the libertarian circles of the Latin Quarter (to feed his revolutionary ardor). The French capital was gripped by Illegalism and anarchism, with frequent bombings and hasty arrests. Victor found himself caught between two camps: his friends—Raymond Callemin (now known as Raymond la Science), Édouard Carouy, Octave Garnier, and André Soudy, all fascinated by the desperate activism of Jules Bonnot—and the revolutionary individualists Albert Libertad and Édouard Ferral, who were convinced that personal transformation and revolutionary action must go hand in hand. Victor's mind was soon made up. As the murders and armed bank raids escalated, the libertarian thinker chose solidarity with his (by now) outlaw friends. "I'm with the bandits," he wrote, although he condemned their blind rampages.

Victor preferred the battle of ideas to the suicidal downward spiral of Illegalism. His acerbic pen became his weapon of choice. With his lover, Rirette Maîtrejean, he worked on Albert Libertad's journal *L'Anarchiste*, eventually becoming its director. His inflammatory articles—in which he declared that "all governments are the same, and anarchists want none of them" and that "we must act urgently to incite anarchist minorities against the brutalization of the bourgeois, the workers, and 'workerists'"—put him on the wrong side of Clémenceau's reprehensible laws. He was charged with criminal conspiracy but refused to betray his outlaw comrades to Louis Jouin, the deputy security chief in charge of the manhunt for the Bonnot Gang. In 1912, Victor was sent to the Santé prison in Paris to await his trial. In the end, he was sentenced to five years in prison for concealing two revolvers, which he apparently knew nothing about, in the offices of *L'Anarchiste*. Rirette was acquitted and married him, to obtain visiting rights. Four other detainees, including Raymond la Science and the young Soudy, were sentenced to death and publicly executed.

Victor left Melun prison on January 31, 1917, after serving his full five-year sentence. Europe and Russia were in the grip of World War I. As a Russian national, he was forbidden to remain on French soil, so he took refuge in Barcelona under the pseudonym Victor Serge. He wrote articles supporting the Catalan uprising and denouncing the war before finally enlisting in the army of the new socialist Russian republic.

Serge infringed the terms of his exile from France, however, and was imprisoned in the department of Sarthe despite his army enlistment papers. In February 1919, he was released in exchange for a number of French officers imprisoned in Russia and finally returned to his ancestral homeland—the fertile soil of his libertarian, democratic, and egalitarian beliefs—at the age of twenty-eight. Serge the idealist was plainly disappointed with what he found. Petrograd (as Saint Petersburg had been then renamed), he wrote, was the capital of cold, hunger, hatred, and tenacity. But his enthusiasm as a militant socialist was clear: the world would be saved by a global revolution. In the face of the advancing White Guard, who threatened the Bolsheviks' October revolution with the support of foreign powers, Victor chose his camp, despite his horror of tyrannical repression, centralized bureaucracy, and the mass executions carried out by the Cheka, the newly created state security organization. He would not, he said, stand against the Bolsheviks nor would he remain neutral. He would stand with them, of his own free will, while asserting his right to free, critical thought.

In May 1919, the hardened anarchist activist joined the Russian Communist party. Serge took up residence at the Astoria Hotel in Petrograd alongside the hated directors of the secret police and Grigori Zinoviev, who was in charge of Petrograd's city and regional government and would become chairman of the Comintern, as the Communist International was known. Serge became an omnipresent figure, fighting on all fronts. He contributed to Petrograd's Bolshevik newspaper, set up the Comintern's publishing operation, and directed the organization's Latin section. He wrote Communist tracts and calls to resistance, and was responsible for opening and classifying the archives of the Okhrana (the Imperial Secret Police), an experience which horrified him.

Threatened by famine, economic chaos, desertions, the arbitrary reign of terror, and bureaucratic authoritarianism, the Russian Revolution looked increasingly unstable. Serge swallowed his criticisms and doubts, devoting himself to the propaganda campaign for a Communist revolution in the rest of Europe.

In March 1921, sailors and workers staged a revolt at Kronstadt, founding their own soviet, and demanding press freedom, union freedom, the right to free association, the release of political prisoners, and the abolition of official propaganda. The movement's bravery and courage were equaled only by the regime's pitiless suppression of its activities. Victor was torn between his anarchist ideals, and his revolutionary pragmatism. In spite of himself, he sided with the Communist party. But the unjustified loss of life and the permanent reign of terror challenged his loyalty forever.

Amid a climate of intrigue in Moscow, heightened by Lenin's paralytic grip on power, Trotsky's dictatorial character, and the dark machinations of Stalin, Serge was sent on a secret Comintern mission to Berlin with his second wife, Liuba Russakov, and their three-year-old son, Vlady, to foment a German Communist insurrection. The Soviets' secret convoy of arms was seized, however, and the coup d'état (scheduled for October 25, 1923) was a pitiful failure. Moscow saved face by condemning the opportunism and incompetence of communist activists in Germany. Serge fled with his family to Vienna, from where he penned a series of brilliant columns published in proletarian newspapers all over the world. At the end of 1925, the Comintern's Executive Committee invited him to return to Petrograd, which was now called Leningrad. Serge found a city in the grip of

misery. His intellectual friends had either committed suicide or were being hunted. Open corruption and prostitution went unchecked; the bureaucratic dictatorship had been replaced by the dictatorship of a proletariat mired in poverty and unemployment. Stalin and Trotsky, who had just established a left-wing opposition movement, were locked in a bitter power struggle. Serge now took an open stance against the regime and was exiled from the party in April 1928, after thirty-six years as a devoted member.

Administrative harassment and police persecution became daily realities for Victor's family. Serge's constitution proved resilient, hardened by twenty years of deprivation, but his wife succumbed to mental illness and journeyed through a series of psychiatric hospitals. She never fully recovered. Victor lived in forced isolation, choosing to denounce Stalin's crimes and the tragic fates of his comrades—who were now denied the status of "psychological entities"—in fiction, writing a total of thirty-three novels, from *Men in Prison* (published in 1930) to *The Unforgiving Years* (published after his death).

"The world would be saved by a global revolution."

His inevitable arrest came on March 8, 1933. Now a public enemy of Communism, Serge was sentenced without trial and deported to Orenburg in the Urals. Paralyzed with hunger and existing in a state of constant insecurity, his long-standing friendships with French intellectuals such as Romain Rolland, Georges Duhamel, and André Gide saved him from certain death. On April 16, 1936, he and his immediate family were expelled from the USSR and returned to Paris, the city of his youth, and now the hotbed of the Front Populaire. Victor continued to suffer harassment from the French Communist Party and the Soviet organization that had replaced the Cheka, the GPU. Rejected from the *Syndicat du Livre*, France's Communist-influenced publishing trade union, he turned once again to menial jobs and a life of poverty, before seeking escape from France with his son. (His wife would stay behind in a French mental institution.). He no longer possessed his Soviet nationality and was *persona non grata* in the United States but managed, in 1941, to find refuge in Mexico, where Trotsky had famously been killed by a GPU

agent wielding an ice-axe less than one year earlier. When Victor Serge died of heart failure in a Mexican taxi on November 17, 1947, exhausted by a life of incessant struggle, he left behind what he termed "a victorious revolution that had turned out badly, a handful of failed revolutions." Toward the end, he no longer had any "confidence in either mankind or the future."[77]

The anarchist's hopes and dreams were dashed. Shortly before his death, in reference to his future grave, he asked "Why write a name?" And, so, his anonymous remains were interred in a communal grave, with the outcast and hungry whose poverty he had hoped to end.

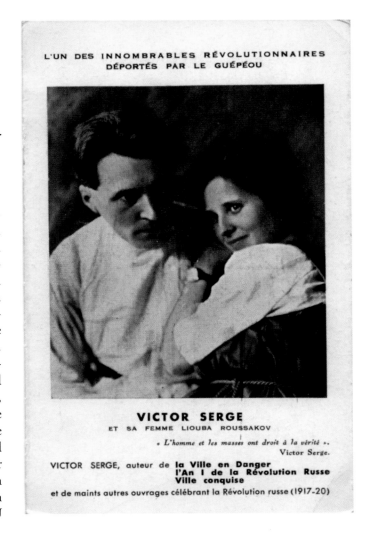

Page 180: Victor Serge, 1912.
Above: Victor Serge and his wife Liuba, 1929.

Buenaventura Durruti (1896–1936)
The Spanish Anarchist

Buenaventura Durruti, the son of a working-class family from the city of Leon, in Spain, was born an anarchist (on July 14, 1896) and died an anarchist. "I was a rebel by intuition," he confided at the age of seventeen, when he joined the ranks of the local metalworkers' union. "I think my fate was decided in advance." He went on to embrace the path of insurrection, forever. His father had shown him the way, taking part in the great welders' strike of 1903 and languishing in a Spanish jail for his pains. Buenaventura stepped into the breach, marching on the road to revolution and never looking back.

There could be no question of compromise, no possibility of giving up the struggle: the young Durruti was a man of unstoppable drive, committed to seeing his ideals through to the end. At the age of eighteen, he joined Spain's northern railway company and took part in a series of strikes, revolts, and arson attacks on depots and locomotives in August 1917, at the head of a group of young saboteurs. Disowned by his trade union, and fired by the company, he sought refuge in Gijón with the mine-workers of Asturia, before crossing the Pyrenees into France to escape prison. In contact with other Spanish anarchist exiles, the militant unionist became a political activist and joined the powerful Confédération Nationale du Travail, known as the CNT, in January 1919. He returned to Spain, where he was arrested for desertion, and forced to escape to France once more.

Durruti finally returned home in 1920, founding Los Pistoleros, a group of young anarchists who launched an unsuccessful assassination attempt against the Spanish king, Alfonso XIII. The group then embarked on a series of holdups to pay for guns and weaponry. In 1922, with his friend and accomplice Francisco Ascaso, Durruti established a cell known as Los Solidarios—a hard-core group that eventually gave rise to the Iberian Anarchist Federation. Los Solidarios specialized in assassinating leading figures from the worlds of politics (Languia and the ex-governor, Regueral) and the Church (Cardinal Soldevila). Now wanted in Spain, Durruti and Ascaso decided to take their revolutionary expertise to Latin America. They killed a wealthy plantation-owner in Cuba, and robbed banks and currency exchange offices for the cause, in Mexico, Peru, Chile, and Argentina, before returning to Europe in the face of mounting police pressure.

The two were questioned again in Paris, following another attempted assassination of their old nemesis, King Alfonso XIII of Spain, on a trip to the French capital. They were sentenced to six months in prison and narrowly escaped extradition to Spain and Argentina. Now began a life on the run across Europe, with Durruti's lover, Émilienne Morin, known as Mimi, who lived with Buenaventura until his death, although she never married him, declaring that civil weddings meant setting foot inside the local city hall, something no anarchist would ever do.

In April 1931, Spain was declared a republic. Durruti returned to Barcelona as the head of the Catalan anarchist movement, fomenting strikes, uprisings, and assaults on military barracks and police headquarters. The self-declared Catalan Republic attempted to introduce a form of "libertarian communism," in which money and private property were banned. The movement failed; Ascaso and Durruti were arrested and deported to Western Sahara and then to the Canary Islands. In February 1936, the nationalist Popular Front scored an important electoral victory in Spain. The hell-raising duo returned to Barcelona to plan a popular uprising with a new cell, known as Nosotros (Us, in Spanish).

Planned for July 19, 1936, the revolt spread throughout the city. Durruti was in charge of the fighting on Plaça de Catalunya, where gangs of workers confronted army troops, while Ascaso coordinated the operation as a whole, from Plaça Alco del Teatro. The attacks and counterattacks lasted for twenty-four hours, during which Ascaso was shot and killed by a bullet through the forehead. By one

o'clock in the afternoon, the anarchists controlled the whole of Barcelona and struck an alliance with the socialists to form a city and regional administration. Madrid was besieged by the Nationalists under Franco but remained in the hands of the republican government. Durruti had no intention of stopping there; he planned to liberate the whole of Spain from the Nationalist threat, starting with the province of Aragon, which had fallen under Nationalist control. The first column of anarchist militiamen—known as the "Durruti Column" after its leader, its ranks swelled by international volunteers from France, Germany, Italy, England, and the United States—marched on the Nationalist forces in Saragossa. Lacking munitions, they were unable to take the city, however. The fighting persisted. The civil war dragged on. Madrid threatened to fall to the Nationalists under Franco, and the Durruti Column hastened to the city's aid. On November 14, 1936, Durruti addressed his troops, saying, "I trust in victory. My only regret is that I speak to you today in a military barracks. One day, the barracks will be obliterated, and we will live in freedom." On November 15, the Column, deprived of heavy weaponry and under fire from enemy machine guns, lost a third of its men. On the 16th, it suffered heavy bombardment

from German Junkers, who had joined the party on the side of Franco's Nationalists. The 17th saw renewed fire from airborne forces. On the 18th, two-thirds of Durruti's militia lay dead in the mud. The exhausted survivors were overcome with despair. On the 19th, at two o'clock in the afternoon, Durruti, at the head of an attack on Madrid's university hospital, was struck with a bullet to the heart. He died the next day, at six o'clock in the morning.

Four days later, a crowd of over two hundred thousand accompanied Durruti to his last resting place. The militant libertarian and anti-militarist was granted the posthumous title of lieutenant-colonel and entered the pantheon of Spain's great republican heroes. A historical hijacking that angered his companion, Emilienne Morin:

His last words—"We will give up everything except victory"—became the slogan of the Spanish forces; but each person interpreted them according to the needs of their own organization and politics. When he spoke of victory, Durruti meant the victory of the popular militia. But he loathed the idea of an imperfect victory, in other words the victory of a republican bourgeoisie that would contribute nothing to the transformation of society.[78]

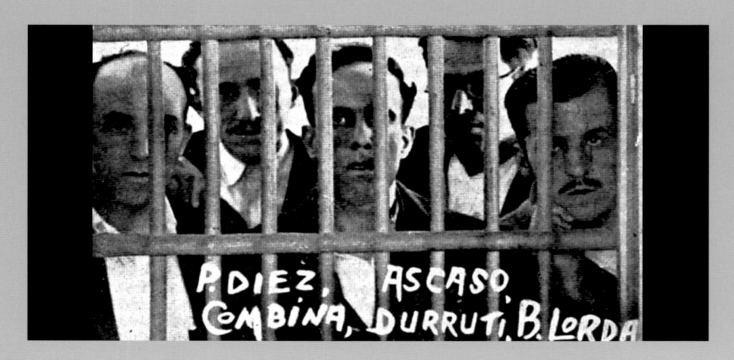

Page 184: Buenaventura Durruti giving orders to attack in Saragossa, August 2, 1936.
Above: Santa Maria Prison, Cadiz, 1933.

Facing page: Anarchist fighter in front of a CNT-FAI flag during the Spanish war, postcard 1937.

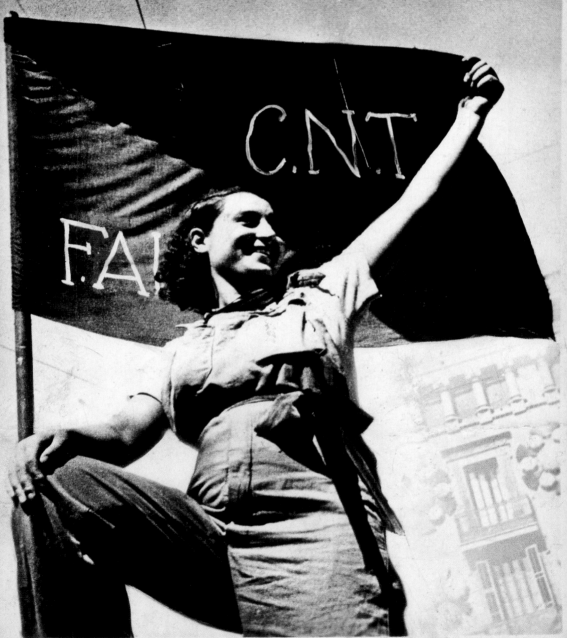

LA LUCHA
EN BARCELONA

Ernst von Salomon (1902–1972)
The Prussian Reprobate

Jean-Paul Sartre maintained that "freedom is what you do with what's been done to you."

Ernst von Salomon could hardly disagree. Sent by his father to the royal cadet school at Karlsruhe when he was just eleven years old, the young boy was marked forever by the words intoned during his first lesson: "Gentlemen, you are here to learn how to die." The Prussian spirit—an all-encompassing aesthetic based on order, tradition, and the cult of the state—never left him.

When the 1918 armistice sounded the downfall of Germany and the defeat of her army, Ernst von Salomon had only one regret: to have seen the end of the war before he had time to take part. The young cadet refused to give up, nonetheless, enlisting at the age of eighteen in the Freikorps units sent to Silesia, East Prussian, and the Baltic to defend the crumbling German state and wash away the stain of defeat on the Western Front, with victory in the east. The desperate endeavor was not in vain. With their backs to the wall, the Allies allowed Germany to keep Silesia, which was taken back from Poland after a monumental struggle.

Home from the front, the ex-lieutenant took part in the Kapp Putsch of 1920—an attempted coup d'état organized by the conservative politician Wolfgang Kapp and a former naval captain, Harman Ehrhardt. Von Salomon experienced the heady elation of the barricades, convinced that "revolution ushers in new ideas." The putsch failed, tipping Germany into chaos. To survive, the lost soldier opened an exchange kiosk and swindled his clients by capitalizing on Germany's galloping inflation rate. He was nostalgic for the comradeship of the Freikorps and took up with his former brothers-in-arms, who had turned to conpsiracy in the meantime.

Nationalist cells were springing up all over Germany. Von Salomon chose to join the smallest, known to the police as the Organization Consul. "There were just a few of us, about thirty, the most active men from the Freikorps and Ehrhardt's volunteers."[79] The cadets' motto (Learn to Die), and the anarchists' slogan (Liberty or Death) soon caught up with him. "I carried out bomb attacks quite deliberately, knowing that this would mean death for me."[80] With a handful of comrades, he decided to attempt the assassination of Walter Rathenau, the Weimar Republic's minister of foreign affairs. Following the Treaty of Versailles, Rathenau had agreed at a meeting in Genoa to the payment of war reparations to the Allies. For Von Salomon and his accomplices, the idea of their humiliated country paying so much as a single deutschmark to her former enemies was intolerable. "Every politician who was party to upholding the terms of the treaties had to be eliminated."[81] Worse still, the deal meant submitting to accords that had been signed by a representative of the right-wing bourgeoisie.

As Von Salomon would explain, they were "against the bourgeoisie; they were for adventure, for revolution, a revolution that was directed against the bourgeoisie, too."[82] On June 24, 1922, at half past ten in the morning, the conspirators went into action. They were three in all: Kern (the leader), Techow (the driver), and Fischer. Von Salomon had taken part in the planning and preparations by going to Hamburg to recruit Techow but stayed behind when the car set off in pursuit of Rathenau.

Ernst von Salomon takes up the story in his book *The Outlaws* based on the account of a passerby. He recounts that when the car overtook the other one by about half its length, one of the men in it leaned out of the window, a large pistol in his hand, and pointed it at the man in the other car. Once the shooting was over, the man's accomplice apparently threw a hand grenade directly into the

other car. The car jumped up.[83] Rathenau was struck by several bullets and died instantly. But far from provoking the hoped-for uprising, the crime turned against its perpetrators.

The whole of Germany mourned the death of its former minister and condemned the assassination. Even Ehrhardt, Von Salomon's spiritual father, denounced the crime as imbecilic. The German government promised a ransom of a million marks for the fugitives' capture. Determined to help his friends, Von Salomon procured the money and a set of false passports; following leads in newspaper reports, he tried in vain to contact them. The police were quicker. The conspirators had taken refuge in the highest tower of the castle at Saaleck but were betrayed by two villagers eager for the promised reward. Kern was killed by a bullet to the head, and Fischer committed suicide. The cell did not survive their death; the members went their separate ways, living in constant fear.

Identified as the "mysterious stranger" who had accompanied the assassins immediately prior to the crime, Ernst von Salomon was arrested in Frankfurt. Still a minor when the attack was carried out, he escaped the death penalty but spent five years in prison, and was deprived of his civil

Von Salomon did not abandon his political struggle, and for a time he was a committed supporter of the peasant cause in Schleswig-Holstein. He played no part, however, in the rise of National Socialism, denouncing Hitler—whom he once met in Ehrhardt's Munich offices—as a "falsifier," who used his talents as an orator to pervert the order and hierarchy of the Prussian state. The former cadet dismissed Hitler's vision of the world as "a hotchpotch of the most absurd ideas."

Von Salomon had not seen the last of prison, however. When the Americans liberated Germany after World War II, his past caught up with him once again. Suspected of Nazi sympathies, he was interned in an American camp in 1945 and 1946. Like every other prisoner, he was required to complete a meticulous questionnaire, covering a hundred and thirty-seven points.[85] The former activist made the administrative document his own, transforming it into a work of literature that enjoyed worldwide success when it was published in 1952. In his answer to question 24, regarding his criminal past and his complicity with Kern in the assassination of Rathenau, Von Salomon replied: "A comrade is someone you can count on absolutely."

"A comrade is someone you can count on absolutely."

rights for a further five. After his trial he felt that no more would he and his kind know peace. As he states in *The Outlaws*, they had become a cursed generation and had agreed to their destiny. There was nothing they desired more than freedom and now freedom had been torn from them.[84] Convicted a second time, for plotting to murder one of his organization's militants who had betrayed him, Ernst received a concurrent sentence of three years in prison for assault and battery. As he recalled in the autobiography of his revolutionary years, he chose not to kill the man, however, at the last minute. Slowly, he began to press down on the trigger.... But a consummate weariness overtook him. He looked at the man's terrified face and told him—"Get lost!" The former Freikorps lieutenant received an amnesty in 1928.

Page 188: Ernst von Salomon, 1930.
Facing page: Putsch fighters' artillery post in Berlin-Neukölln, on the corner of Weisestraß, during the Kapp Putsch, March 13–17, 1920.

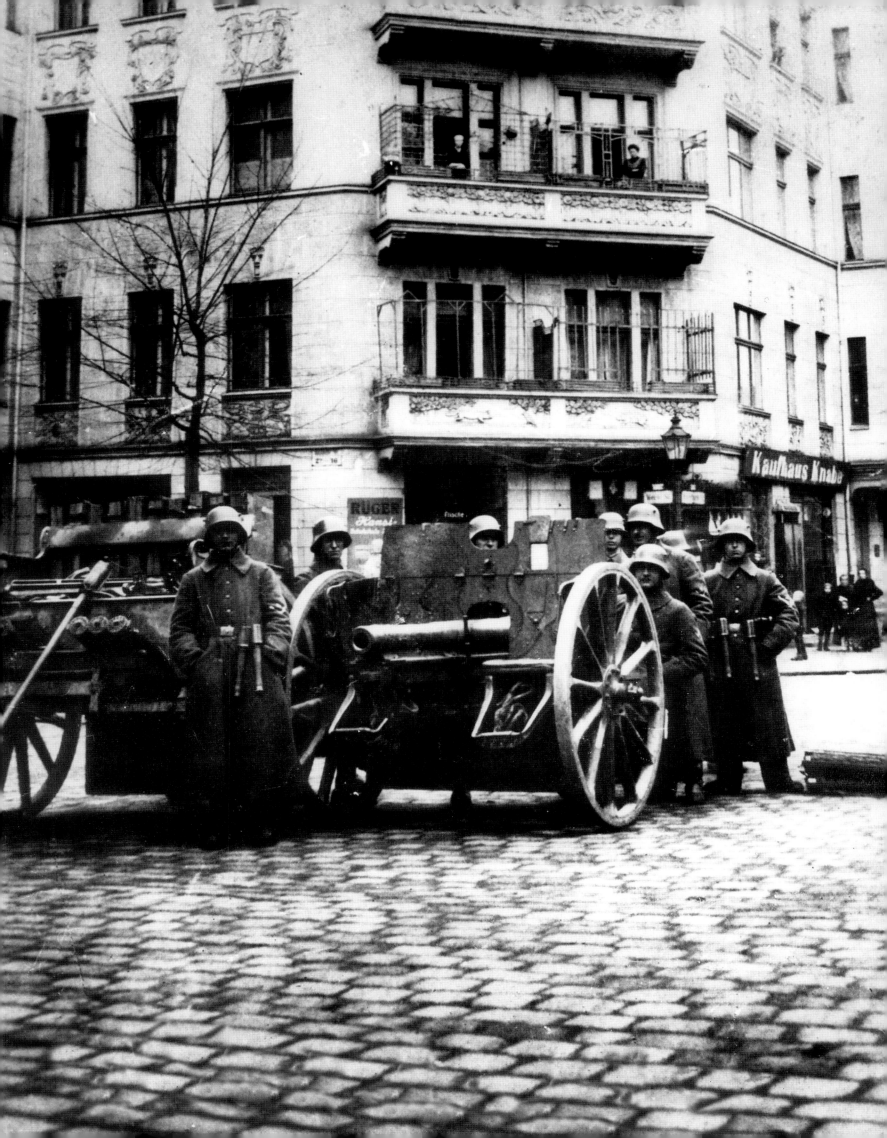

Eugene Grogan, alias Kenny Wisdom, alias Emmett Grogan (1944–1978)
The Californian Digger

On April 1, 1978, Emmett Grogan turned up the collar of his jacket and sprang down the steps to the New York subway, leaping aboard the F train that would take him to Brooklyn. He never got out of the subway car. Grogan's body was found huddled on a seat by a subway employee at the Coney Island terminus. His heart had stopped beating, probably the result of heroin abuse. After twenty-five years as an outlaw, the most celebrated of California's Haight-Ashbury Diggers had taken his final bow, the victim of drugs and the rigors of life on the run.

Before his "outlaw" career in California, where he faked insanity to escape the Vietnam draft and embarked on his high-profile "restitutions" to the poor, Eugene Groganalias (Emmett Grogan) spent his youth in New York, thieving, hustling, and playing ringolevio, a form of street tag with its roots in the Great Depression, involving two sides, each of which tries to capture every member of the opposing team. As Albie Baker notes in the introduction to Grogan's autobiography: "It was a game of life and death. A game to be fought rather than played […] Ringolevio prepared us for life: the violence, the inequities, the poverty, the wars."[86]

Born a rebel, on November 28, 1944, Grogan grew up to become an accomplished burglar, adopting the precepts of his hero Alvin Karpis, a Chicago gangster, as his own. He insisted he wasn't a crook. A thief was someone who left his house to earn his daily bread by robbing a bank or breaking into a home to grab some goods or to kidnap someone. A crook, on the other hand, was a piece of scum, a rat of the worst kind. From the start, Emmett had his own set of rules. According to his autobiography—which, like everything else about Grogan, demanded a flexibility with fact and reality—at the age of thirteen, Grogan discovered heroin, skipped school, and shot up several times a day, experiencing the hell of withdrawal and dependency, stealing and holding up pharmacies and dealers to feed his habit.

He wound up in prison a year later but his sentence was eventually annulled due to his young age. Prison wasn't necessarily a waste of time, though, he claimed—lots of guys came out knowing a new trade. Moreover, his months in prison had served to break his heroin addiction, and he entered a prestigious private school run by Jesuits. Grogan claimed that he hastily promised to become a reformed, irreproachable character but, in reality, he had one idea in mind, to become a thief in order to live as a free man, targeting the Park Avenue apartments of his new classmates. His technique, he said, was simple: charm the girls with his angel face, identify his targets at the wild parties he attended, and return to carry out the operation while the super-rich families were away sunning themselves in the Bahamas. During the school Christmas holiday of 1958, he broke into no fewer than ten apartments via the laundry lifts and service stairs, stealing family jewels and selling them to a crooked jeweler for forty thousand dollars.

At the age of sixteen, Grogan decied to bypass the underworld fences, infringing one of the basic rules of his criminal fraternity. According to *Ringolevio*, to escape inevitable reprisals, he secured a false passport and boarded the *S.S. Niew Amsterdam* for Europe, where he spent four years traveling around France, Austria, Germany, and Italy, squandering his fortune and stealing the occasional work of art to supplement his funds. He spent a short time in prison for a drug offence in which he had played no part. His informer paid for his betrayal with a bullet through the head. He then visited Dublin, on the path of his Irish ancestry, found work as a warehouseman with Guinness, and became friendly with a group of IRA militants, taking part in operations to blow up bridges and control-points on the frontier with the British-administered north, and Nelson's Pillar in Dublin. (This last is almost sure to be part of the great fictions that were substance of Emmett's self-made legend, especially as he went on to claim that he was in the U.S. in 1966 at the time of the bombing of Nelson's Pillar.). He had little taste for the armed struggle, however, and returned to London, where he earned a living writing pornographic short stories and attempted a handful of small-time robberies.

On November 21, 1965, the year of his twenty-first birthday, the prodigal son returned to New York, to be reunited with his family. America was bogged down in the Vietnam War; Grogan was reported to the authorities by a friend's sister and received his draft papers. Private Grogan sailed through his initial classes and was sent to California

for officer training. But the eternal rebel had no intention of going to war. He used a rocket-firing exercise to simulate a crazed breakdown, provoking widespread panic, and was sent to the neuro-psychiatric ward of Letterman General Hospital, before being released from service.

Grogan settled in San Francisco, where he discovered LSD and the hippie communes of Haight-Ashbury, the capital of the counterculture that was breaking over America's West Coast like a great wave. The former Eugene became "Emmett." With an old pal, Billy Landout, the newly minted Emmett intended to make the Flower People's utopian ideals a reality. Taking up theater, the two friends joined up with a handful of other actors to found a radical gang of community activists that called themselves "The Diggers," a seventeenth-century community founded in the English county of Surrey, whose members used common land to grow food for themselves, distributing the surplus to the poorest in society. They then began distributing pamphlets known as the Diggers Papers, propounding their subversive view of society. "The U.S. standard of living is a bourgeois baby blanket for executives who scream in their sleep [...] Our fight is with those who would kill us through dumb work, insane wars, dull money morality."[87] Three centuries later, Emmett decided to copy them.

The idealistic robber's first public success involved amassing foodstuffs—both legally and illegally—from the central market in San Francisco, and turning them into one hundred quarts of stew that he and his friends loaded into two huge milk canisters. While Emmett peeled the vegetables and boiled the meat for the stew, Billy distributed tracts and posters announcing a hand-out of hot stew at four o'clock in the afternoon, in the park on Panhandle Street: "It's free because it's yours!" The announcement was signed "the Diggers." The free meals drew hundreds of penniless takers, recognizable by the soup bowls tied to their belts, in the months that followed. Grogan and his friends progressed from "soup for the people" to objects and clothes, almost none of which, they boasted, was secondhand. Next, the Diggers opened a free medical clinic, staged a series of "happenings" (described as ticketless street theater), and established the Council for the Summer of Love. The Diggers' dedication to "doing your own thing" culminated in the distribution of free tabs of acid (LSD).

The police kept a wary eye on the Diggers' activities, carrying out a series of pointless arrests, often leading to farcical trials. The real threat came from the success of

the movement itself. Disaffected kids ran away from home and flocked to Haight-Ashbury from all over the United States, looking for a new life. Parents were outraged, and the San Francisco authorities threatened to arrest the Digger leaders, whom they held responsible for the staggering rise in juvenile delinquency in the city. Meanwhile, the people truly profiting from influx of youngsters were the shopkeepers of Haight-Ashbury, provoking a furious, memorable outburst from Grogan:

> You're going to allow these pitiful scams to [...] provide you all with a facade which'll represent your deep, heartfelt concern and empathy for the community. A community which ain't gonna keep letting you guys off forever because you play stupid. No, someday it's gonna find out that all of you have been aware, conscious of what you were doin' 'n' not doin' all the time. That you knew what you were makin' all along! An' when they do find that out, they're gonna bomb everyone of you 'n your shops, 'n the banks where you been depositing the money you been makin' out of existence! Blow every f***in' thing away![88]

The Diggers leaders began, however, to argue over the best way to advance their cause. The more politically minded wanted to transform their countercultural revolution into a violent uprising. Exhausted by days spent thieving to supply the Diggers' free canteens and stores, Emmett Grogan took a back seat, and traveled to Europe in May 1968, where he was witness to the Prague Spring and the Paris barricades. When he returned to San Francisco, Grogan had a hard time recognizing his Diggers in the fractious group squabbling over their share of the glory. He joined the Black Panthers for a time, and became a close associate of their leader Bobby Seale, creating the Free Breakfast for Children program in Oakland. But Grogan had reached the end of his road. He hitchhiked back to New York in 1970, living rough, and returning to heavy drug abuse. A shadow of his former self, the living legend allowed heroin to finish its evil work.

Page 192: Emmett Grogan, 1972.
Page 193: The famous cable cars of San Francisco, 1967.
Facing page: The young digger sat on a car offering free films, 1966–67.

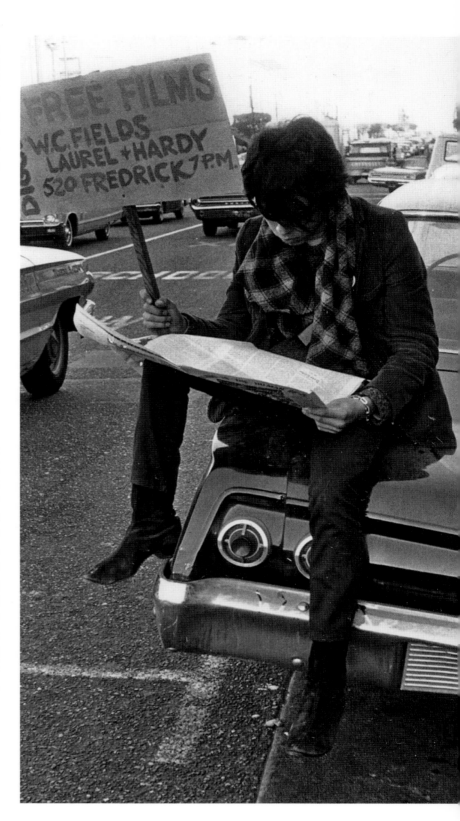

Bobby Sands (1954–1981)
The Lost Soldier of the Irish Republican Army

On May 5, 1981, at 1.17 a.m., Bobby Sands died in the infirmary of Her Majesty's Prison Maze, the infamous prison at Long Kesh in Northern Ireland, after a hunger strike lasting sixty-four days. He was a Catholic and a volunteer in the Irish Republican Army, aged twenty-seven, with a four-year-old son named Gerard by his estranged wife Geraldine.

Bobby was an Irishman born in the part of the northeastern province of Ulster under British and Protestant control. During his youth, the Sands family were forced to move house due to intimidation and attacks from Protestant militia, and he was also compelled to give up an apprenticeship as a coachbuilder. Bobby's mind was made up: this adolescent would support the Irish Republican cause, in a war of independence that was to transform his life.

Sands was first arrested in October 1972, in a Belfast house that was also found to contain four revolvers. He spent five years in prison and was accorded Special Category Status as a "prisoner of war" under the terms of a deal negotiated between the British government and the IRA, with a view to a truce. He was released in 1976 but arrested again the following October and sentenced to fourteen years in prison.

Meanwhile, the British government had introduced new legislation revoking the Special Category status of the Republican prisoners. Faced with a choice between acceptance or revolt, Sands chose revolt, leading the Republican prisoners in a protest over the new conditions. It was a nonviolent protest but its relentless escalation would lead to his death.

Together with his Republican comrades, Sands refused to take part in prison activities or wear the prison uniform; they wrapped themselves in prison blankets. Following vicious attacks on Republican prisoners during "slopping out" (when they left their cells to empty their portable latrines), the men also began or refusing to leave their cells to slop out. They tried to empty their buckets under the doors out the windows, but the guards boarded these up. So, they urinated on the floors of their cells and smeared their excrement on the walls. Thus began what was known variously as the "dirty protest" or the "no-wash protest." As punishment for their actions, they were deprived of television, radio, and all reading matter except the Bible.

In the newly-built "H" blocks 3, 4, and 5—the scene of the Republican prisoners' dirty protest—the stench was foul. The prisoners suffered skin complaints, and their cells became infested with maggots. Occasionally, prison officers were able to hose the cells, but the protests would always begin again, immediately afterward.

On March 1, 1981, Bobby Sands began his hunger strike. On April 9, already seriously ill, he was elected as member of parliament for the Northern Irish constituency of Fermanagh and South Tyrone, on an "Anti H-block/-Armagh Political Prisoner" ticket. After a month on hunger strike, he had lost twenty-four pounds. His determination was matched only by the obduracy of the British prime minister, Margaret Thatcher. By April 30, Bobby Sands had lost sixty-six pounds and his sight. He was speaking with difficulty. But there was no question of turning back. He would see his martyrdom through to the end.

At the beginning of his hunger strike, Sands wrote in his journal, "I am standing on the threshold of another trembling world. May God have mercy on my soul." After sixty-six days, his emaciated body embarked on its final journey. Nine of his fellow Republican inmates, joining the hunger protest, would meet the same tragic death before James Prior, British Secretary of State for Northern Ireland, announced a series of measures on October 6, 1981, allowing Republican prisoners (among other privileges) the right to wear their own clothes.

Facing page: A young Irishman before a photo of Bobby Sands during the hunger strike of March until April 20, 1981.
Following pages: Daily life in Bogside, a nationalist area, 1976.

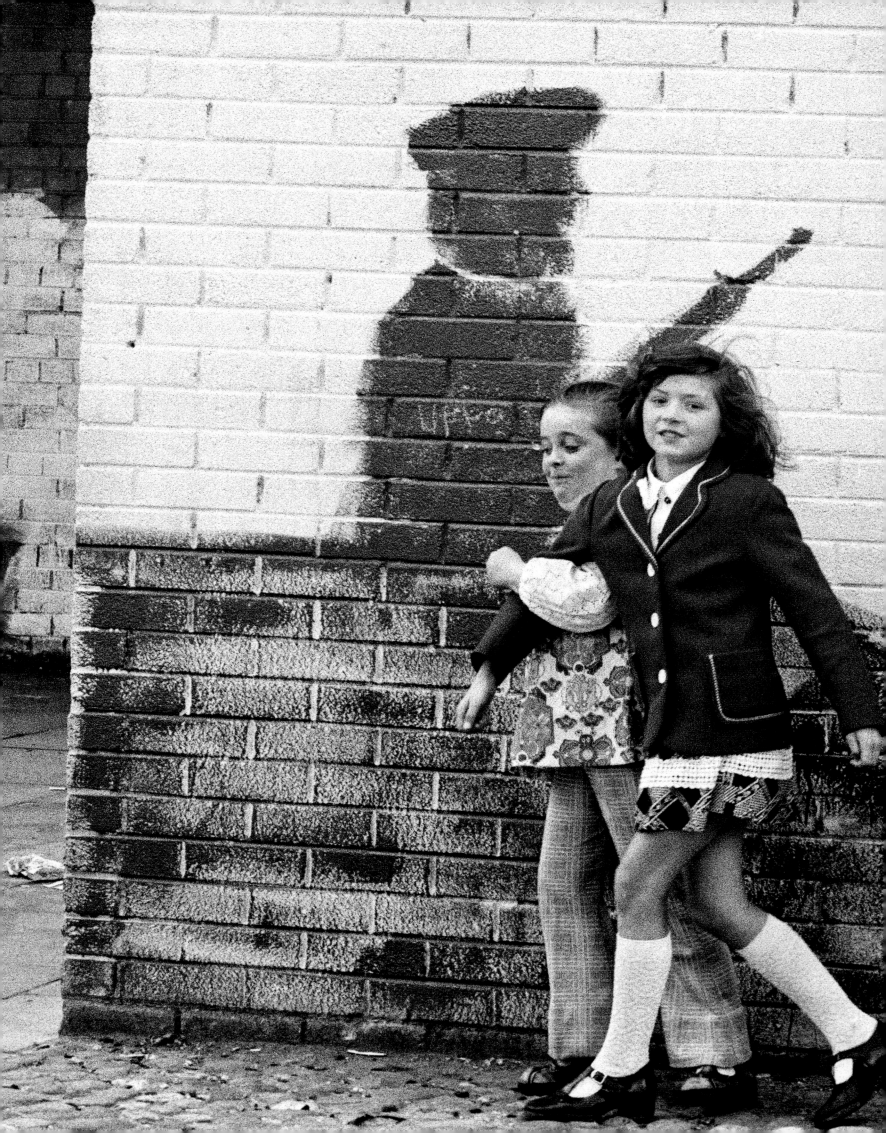

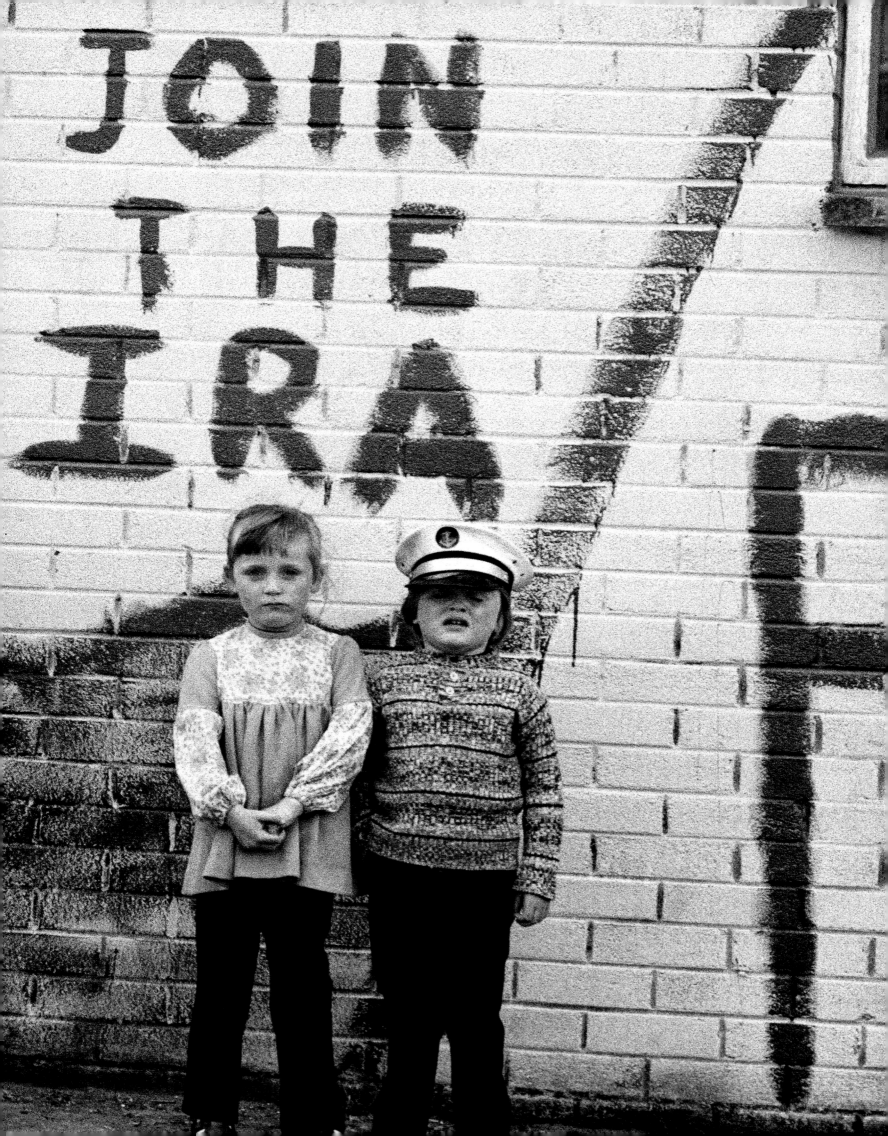

Phoolan Devi *(1963–2001)*

India's Bandit Queen

"I was born an underdog, but I became a Queen," wrote Phoolan Devi, in her autobiography.[89]

A bandit queen that is, who could neither read nor write, nor count beyond the fingers of one hand.

Phoolan Devi was born in the village of Gurha Ka Purwa in Uttar Pradesh, in 1957 (by her own account) or 1963 (according to official records), on the day of a flower festival, hence her name, which means flower in Hindi. Her family were poverty-stricken peasants of the Mala caste, part of India's Dalit caste group, once known as the "untouchables." Phoolan was married at the age of eleven to a thirty-five-year-old widower by the name of Putti Lal, cutting short a girlhood that was typical of her caste: days spent working in the fields, constant hunger, fragile health, and lashes of the *lathi* (a long cane of bamboo) for the slightest misdemeanor. This marriage offer had its advantages, however. As a previously married man, the dowry he demanded from her family was more reasonable.

Phoolan had not yet reached puberty. On the evening of their wedding, her new husband and master—graying at the temples—promised not to take her to live under his roof until she was sixteen. The next day, however, he changed his mind and insisted that his child bride leave with him. Phoolan was taken by force to the nuptial home, crying out to anyone who would listen that she was no man's wife. Passersby giggled at the sight of the new couple, like "a goose hitched to a camel."[90] Phoolan was terrorized, busying herself with the housework and domestic animals, before being beaten and finally raped by her new spouse.

Sickness saved her from further beatings for the time being, however. She returned to her parents' home while her husband, indifferent to laws forbidding marriage with a minor, issued repeated violent threats to get her back. Finally, bereft of further arguments, he gave up. Phoolan, now an adolescent, remained with her family, in disgrace, working in the fields, and hungry and poverty-stricken once more.

Her society was governed by strict, immutable laws. The poor must submit and graciously carry out the tasks demanded of them by the local landowners and potentates. As Phoolan neared the age of fifteen, she began to rebel, braving inevitable punishments, provoking endless scandal, and bringing shame on herself and her family. Eventually, disowned by her father and haunted by her bad reputation, she found herself all alone in challenging the higher castes. She was raped once again, in the full knowledge of her parents, by the sons of respectable local families. Then, although she had never stolen in her life, she found herself accused of being a *dacoit*—an armed bandit and highway robber, widely feared as a wild "monster" living rough in the jungles.

As Phoolan had stolen nothing, she had nothing to confess. She willingly gave herself up to the police but was beaten once again. To escape further violence, she finally admitted to an invented crime—and was subsequently raped by her torturers. Phoolan Devi became obsessed with one idea: vengeance. "I wanted to see them roasted alive. I wanted to hear them beg for mercy," she would later write.[91]

Convicted and imprisoned, Phoolan was freed on bail and returned to her village, where she faced universal hostility. She was now truly "untouchable," even forbidden access to the village well. Her successive rapes meant she was no longer fit for marriage. But she refused to give up hope, stealing and attacking anyone who robbed or mistreated her. "Because [people] lived in fear, I realized, all you had to do was frighten them! Because they used violence, you had to be violent too!"[92]

Her reputation as a woman of easy virtue reached the neighboring villages. Phoolan was captured by a bandit gang consisting of two rival caste factions—thakurs[93] and malas[94]—who fought over her "ownership." Seven thakurs, including their chief Babu Gujar, were killed in the confrontation. Vikram, who ruled the mala clan, fell in love with Phoolan, took her as his wife, and made her his

accomplice at the head of the gang. She had been accused as a dacoit, and now she became one.

The novice bandit took part in raids on rich properties, hesitant at first, and then with fiery zeal. As far as she was concerned, Vikram Mallah and Phoolan Devi were honorable bandits, acting in accordance with an elaborate set of rules.

> A mala could loot a thakur if he was rich, and punish or kill him if he was a rapist. If the thakur was honourable, then the mala would respect him. Vengeance could only be exacted on behalf of someone of your own community. A mallah could avenge another mallah but he couldn't take revenge against someone of his own family or community. It was to these rules, this unwritten code, that I owed my life.[95]

Through her contact with Vikram and his men, Phoolan was transformed. She cut her hair like a boy, sported a police uniform with two stars, handled weapons, gave orders, and no longer pushed her lover away when he embraced her. Phoolan tamed the jungle, growing accustomed to the gang's grueling nocturnal raids and chases. She wanted to punish those who had beaten, raped, and humiliated her, starting with her first husband Putti Lal and his cousin Mayadin, whom she held responsible for her family's miserable condition.

One evening, with Vikram and his men, she banged on the door of her former spouse. Armed with the branch of a neem tree, she administered a thorough beating, paying particular attention to the man's genitals. Lal was abandoned naked on a country road, his face bruised and swollen, with a written explanation, as required by dacoit tradition: "This is what happens to old men who marry young girls."

A few weeks later, Phoolan attacked Mansukh, the brother-in-law of Lal's cousin Mayadin. It was Mansukh who had betrayed her to the police and had her imprisoned for a nonexistent robbery. He was lured into the woods, supposedly for a rendezvous with the police. He was met by Phoolan, who killed him in cold blood.

Phoolan was now a wanted woman. At the age of seventeen, the young vigilante had become a mala legend, acclaimed by the peasants of her caste and hailed as the incarnation of the Hindu deity Durga, a goddess representing invincibility, salvation in adversity, self-reliance, and patient perseverance. The very name Phoolan Devi brought terror to the hearts of the rich and a sense of liberation to those of the poor. But Phoolan was not fooled by excessive shows of gratitude and recognition. She knew all too well the suggestible, fickle nature of the mob.

Phoolan and Vikram Mallah masterminded and signed the gang's operations together. Under their joint leadership, the gang prospered and money poured in. Against his mens' advice, Vikram decided to bail one of his former comrades from prison, a man he looked on as his "guru." Shri Ram was a thakur and suspicious of malas. His entry into the gang stirred up old caste rivalries. One after another, the mala gang members left Vikram and his wife to join their new accomplices. One night, Shri Ram insulted Phoolan and shot Vikram in the back. Phoolan and Vikram were forced to flee, searching desperately for a cooperative surgeon. The couple separated to escape the police; the other gang members were killed or arrested. Vikram was announced as presumed dead, but he survived and joined Phoolan once again, carrying out one or two further raids—despite the bullet lodged in his body—to remind the police that he was still alive. Shri Ram had the final word, however. One night, he completed his dark mission, killing Vikram, and abducting Phoolan, whom he paraded naked and blindfold through a succession of thakur villages, declaring that the "mala whore" had killed her own lover. Phoolan was saved by a member of the leading Brahmin caste, who helped her escape.

Alone and exhausted, she took refuge in the jungle, clinging to the hope of revenge. She formed a new gang, which would quickly grow to include twenty-five members, and was careful to recruit only honorable dacoits. Two criteria determined her choice: the men had to accept her as leader and treat her as a man.

Phoolan trusted to her guiding star: during the Hindu festival of light, Diwali, she recovered jewelry, property deeds, and money from a rich landowner who had seized them from the poor, handing them back to their rightful owners. But she had not given up the idea of revenge against Shri Ram and his brother Lala. After a first attempt on their lives, the two disguised themselves as women in order to escape. The second attempt, at Behmai, ended in a bloodbath. Twenty-two thakurs were killed by Phoolan's enraged malas and their female leader. Shri Ram escaped unhurt, but was finally killed by his brother Lala, following a quarrel over a woman.

Phoolan now had a prize of a hundred and fifty thousand rupees on her head. Several times, the police acted on reliable information, thinking to trap her. But, on every occasion, she managed to escape. Her men deserted or betrayed her, and she spent several months roaming the jungle, trying

to form a small gang, one last time. Her morale had failed her. The only question now was whether to give herself up immediately or wait. Her bandits were exhausted, half-starved, and filthy. They wanted to give themselves up; if their chief surrendered with them, their lives would be spared. They urged her to capitulate. Contacts were made with a police official from Padhya Pradesh.

On February 13, 1983, before a cheering crowd, Phoolan Devi handed her rifle and cartridge belt to chief minister Arjun Singh. After a brief sojourn in the fortress at Gwalior, where the prison director charged visitors ten rupees each to view the bandit queen, Phoolan spent eleven years in Delhi's Tihar prison. She never stood trial. A total of fifty-seven pros-ecuting judges were appointed to take charge of her case, but each withdrew from the task, one after the other.

On February 21, 1994, Phoolan Devi was finally freed thanks to the actions of the chief minister of Uttar Pradesh, Mulayam Singh, who was a mala like herself. After this,

Phoolan renounced violence and lawlessness, converted to Buddhism, became a member of the Socialist Samajwadi party, and resumed her fight for justice, replacing the bullet with the ballot box. She was elected as a member of parlia-ment, confronting the fundamentalist Hindu Bharatiya Janata Party and her country's highest castes at the heart of the Indian legislature.

Phoolan's bandit past resurfaced, however. On July 25, 2001, she was struck by six bullets, fired by a thakur outside her home in New Delhi. Shortly before her death, the woman who could neither read nor write justified her actions as India's bandit queen. "I helped the poor people by giving them money and I punished the wicked with the same tor-tures they inflicted on others, because I knew the police never listened to the complaints of the poor."[96]

Page 200: Phoolan Devi, 2001.
Below: Phoolan Devi leading her companions, 20th century.

They rebelled against the strong arm of the banks and the power of money

Bonnie Parker: Hey, that ain't ours!
Clyde Barrow: Sure it is.
Bonnie Parker: But we come in this one.
Clyde Barrow: That don't mean we have to go home in it![97]

This kind of implacable logic finds an echo, some sixty years later, in the response by the notorious French criminal and "public enemy" Jacques Mesrine to a question from a journalist on the newspaper *Libération*:

To me, it's no more stupid and pointless to die with a bullet in the head, than at the wheel of a Renault R16, or on the shop floor at Usinor [a French steelworks], working for the minimum wage. In my case, my trade means I earn a living from crime. A certain kind of crime that consists not in attacking little old men, but banks. [...] If I nick twenty million from a bank, it's no big deal. Hold-ups are my job.[98]

Banks are the focus of revolt for every modern gangster. In periods of prosperity, holdups and attacks on strong rooms give instant access to the riches of a society they have rejected or that has rejected them. In times of crisis, banks are held responsible for the ruin of small-time property owners, reclaiming their goods as repayment for loans granted at extortionate rates. Targeting banks means reappropriating money secured through legitimate theft. From the celebrated lovers Bonnie and Clyde to the Frenchmen Jacques Mesrine and Pierre Loutrel (known as Pierrot le Fou) or to Ronnie Biggs and the Great Train Robbers, the story remains the same: why get up early every morning and break your back earning a pittance, when you can earn a year's—if not a lifetime's—salary in one brave holdup?

And yet, as Mesrine's accomplice François Besse admitted, "Other people's belongings were never of any great importance. I never stole simply in order to possess something." All too quickly, the taste for adventure and the thrill of risk taking overtake the lure of lucre and personal gain. An honorable criminal never steals from the poor, or so he likes to proclaim. But often he will refuse to recognize that, first and foremost, he is satisfying his own ego, his private impulses and desires. Few latter-day Robin Hoods genuinely "redistribute" their spoils to the poor beyond a round of drinks, a tab paid, occasional flurries of barroom generosity. In the twentieth and twenty-first centuries, it's every man for himself.

The contemporary bank robber may squander the spoils of his latest holdup in a single evening, but he will soon find it harder and harder to do without the adrenalin rush of the heist itself. He embarks on an infernal cycle that robs his life, and the lives of those around him, of meaning and worth. Until the first, inevitable bullet fired in self-defense or to settle old scores, the threshold from which, once crossed, there is no way back.

"I die a free man."

"I condemned myself the day I put a weapon in my own hand, and used it," confessed Mesrine in his memoir, *L'Instinct de mort*. A ruinous, hellish manhunt follows, and the criminal always loses. Faced with a choice between freedom and death, escape from the maddening hell of prison comes in a hail of police bullets, suicide, or a final bid for freedom on the run, before the outlaw's last gasp—echoing the cancerous death rattle of Albert Spaggiari, famed gangster from Nice—"I die a free man."

City Hoodlums
and Urban Gangs

"Some will turn me into a hero, but there are no heroes in crime. There are just men who ... are marginal, and who don't respect laws because laws are made for the rich and powerful."

Recorded testament left by Jacques Mesrine

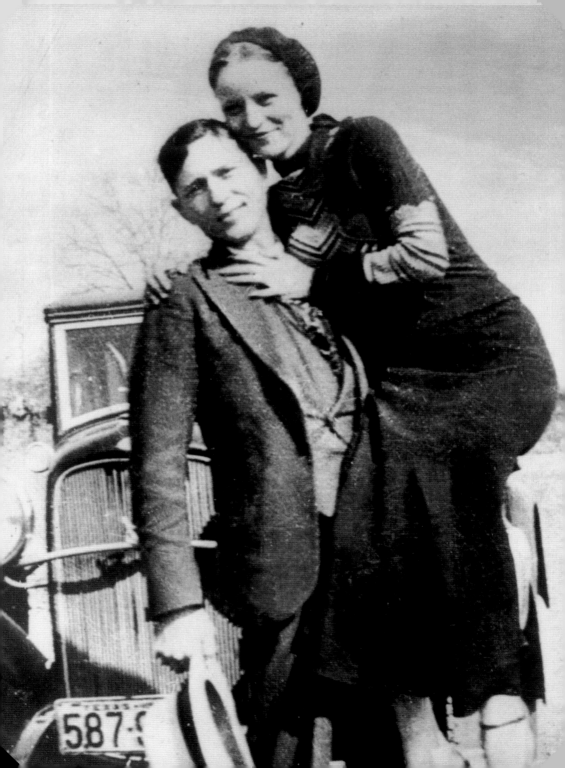

Bonnie Parker (1910–1934) and Clyde Barrow (1909–1934)
Loving, Living, and Dying by the Gun

America was sinking, all over. The Wall Street crash of 1929 had ruined the middle classes. Unable to stave off debt and ruin any longer, small-time farmers saw their property seized. Unemployed workers slept with hunger in their bellies, without work or hope, on the sidewalks of the great cities. Poverty replaced the opulent dreams of the height of the capitalist boom years. Disillusioned youths took to petty thievery, and robbing grocery stores to survive.

Their eyes met for the first time in West Dallas, in 1930. Her name was Bonnie Parker, born nineteen years earlier on October 1, 1910, to a comfortable Texan family. She was slight, blonde (though she would dye her hair auburn), and lively; a former ace student, who'd won her high school's spelling bee and liked to write poetry. Then she'd met and married, at the age of sixteen, Roy Thornton, a petty criminal. He was now serving out a fifty-five-year prison sentence, and she was working in a diner, daydreaming of a prince to come sweep her away in an open-top Buick.

His name was Clyde Barrow. Clyde Champion Barrow, he liked to say, though it really was Clyde Chestnut Barrow. He was twenty years old, also slender, with a still-boyish face, born in Telico, Texas, in 1909, to a family of poverty-stricken sharecroppers. He had just served two years in prison for stealing cars and holding up a petrol station.

By all accounts, it was love at first sight.

In the famous movie by Arthur Penn about their doomed love affair, Clyde bought her a Coke in a service station and strutted his stuff, boasting that he had cut off two toes with an axe to avoid prison work. To impress his new girl, he took an anthracite-colored P38 from out of his jacket and proceeded to rob the neighborhood grocery store while she watched, fascinated. The pair stole a car and left town, never to return. She nestled against him; the car swerved. Clyde pushed her away. Flirting wasn't his cup of tea. All too often, he had watched as his mother wept, the victim of violence at the hands of his father. He had shunned love since childhood. Disappointed, Bonnie sulked and shrank back against the passenger door, determined to try her luck again later. The couple exchanged their old banger for a canary-yellow sports coupe and spent their first night in an abandoned farmhouse. They slept side-by-side, like brother and sister. In the morning, Clyde taught Bonnie how to shoot a revolver; Bonnie proved to be a crack shot. Their pockets were empty. Their minds were made up. They would rob banks.

In reality, Clyde didn't tell Bonnie right off the bat about his life as a small-time criminal. She found out about it when he was picked up by the police a few days after they met and stuffed into a cell. The discovery didn't bother her much. She smuggled him in a shotgun, so he could escape. He was soon recaptured but managed to get paroled after just a year—though not before having those two toes caught off, at his own request, by another inmate so he could be excused from work detail. All that time he was put away, Bonnie continued to visit him.

In February 1932, the couple were reunited—and that was when their life of crime together took wing. They joined up with one young gunman and, when he left them, picked up another. Clyde's brother, Buck, was released from his own time spent up the river, and he also joined their gang, bringing along his wife, Blanche. It wasn't long before everyone in Texas, and even in the neighboring states, claimed either to have been victim to or to know someone who'd been victim to the crime-crazy couple. In their lifetime, they'd become the stuff of legend.

Accounts vary; film director Arthur Penn's puts them in Mineola, in Kansas, in 1932, attacking the town's main bank on a sunny Saturday afternoon in 1932.[99] Bonnie and Clyde head for the cashiers, and fill a paper bag with bundles of notes. Meanwhile, their accomplice, whom Penn calls Clarence (his real name was William Daniel Jones, and, until

he was shot to death during a drug transaction in 1974, he always claimed to have been an unwilling accomplice, a childhood friend of Clyde's, who served mostly as the couple's driver and mechanic) parks the car along the curb. When the pair emerges, he struggled to maneuver the Chevrolet out from between two large limousines. Too late—the director of the bank bars their way, and a police car appears on the horizon. Clyde fires through the window. The director collapses, dead on the spot. With that move, the couple becomes murderers, doomed to end their days in jail, die in a hail of police bullets, or fry in the electric chair. A prolonged manhunt begins; blood calls for blood.

The press seizes the story, making headline news across the United States. Clyde's brother, Buck—fresh out of the Huntsville penitentiary—and his young wife Blanche, daughter of a devoutly religious farmer who sometimes served as a lay minister, join the gang on the run. The two women loath each other from the start. Bonnie is an extrovert and a self-important *poseuse*, fascinated by glitz and fancy things; Blanche had counseled her husband to give himself up to the law. Still the five continue on with their life of crime together.

Cut to the next scene: anxious to cover their tracks, the group rent a small apartment in Joplin, Missouri. A delivery boy for a local grocery store mistake them for a gang of bootleggers and inform the police of their whereabouts. Surrounded by the forces of law and order, they open fire and kill three police officers during their escape. The seemingly charmed group, now known as the Barrow Gang, are declared Public Enemy No. 1. Their path crosses that of a Texas Ranger by the name of Frank Hamer, sent to arrest them. They seize his weapon. Clyde has the absurd idea of abandoning this figure of law enforcement, beaten and handcuffed, in a boat in the middle of a lake. Hamer swears his eternal hatred for the gang. It's no idle threat. He will become their worst enemy.

The gang returns to West Dallas. Bonnie sees her mother, aged and drawn with anxiety. But the gang no longer has any choice, even if they wanted to stop. They continue on the run, moving from state to state to escape justice and the police. After Texas, it is Oklahoma, then Kansas, then Iowa.

Their nerves fray. Bonnie can bear her accomplices no longer. The gang find a brief respite in Platte City, Iowa, but their suspicious behavior catches the attention of a cop, who raises the alarm. As night falls, the police surround the run-down motel where the gang is holed up.

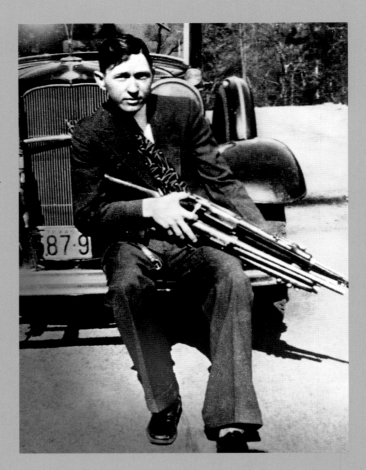

The operation becomes a bloodbath. For the assailants: four policemen shot dead and three others wounded, meaning the Barrow Gang has now committed twelve murders in four years. For the gangsters: Buck is seriously wounded, and Blanche has been nicked by a bullet in the face. With their backs to the wall, the gang are forced to abandon their bullet-riddled cars in a field. Buck is pouring blood. Undecided as to what to do next, they spent the night in a clearing. At dawn, they are spotted by the local police, the sheriff of Dexter, and a posse of farmers armed with rifles, determined to be rid of them. Running for their lives, they fight their way through a cornfield, with their pursuers closing in. Clyde is shot in the hand; Buck collapses, exhausted, and dies of his injuries. Blanche gives herself up. The three remaining members of the gang manage to escape by swimming across a stream.

In the film version, Bonnie and Clyde are about to meet their end. But, in reality, Clyde had one last great stunt to carry off. Deeply resentful of the treatment he'd

received while in the Texas correctional system, it's widely believed he'd broadened his life of criminality as an act of protest against the system even more than one of greed. At any rate, in January 1934, he engineered what would be known as the Eastham Breakout, allowing the escape of several inmates. It was the coup of his short life—but it would prove fatal. For one thing, it provoked the full-blown wrath of the Texas Department of Corrections. They determined to stop this duo, once and for all. For another, it linked them up with escaped inmate Henry Methvin, whose father would—in return for having his son's life spared—betray the bloody lovers.

On May 23, 1934, near the Methvin's farm in Louisiana, a posse of four Texan (including Frank Hamer) and two Louisiana police officers ambushed Bonnie and Clyde. No warning was given; the law shot immediately, and they shot to kill. Barrow died instantly. With a long scream, Harper followed.

Sometime before their deaths, Bonnie wrote a prophetic poem, whose last verse went like this:

Some day they'll go down together;
They'll bury them side by side;
To few it'll be grief—
To the law a relief—
But it's death for Bonnie and Clyde.[100]

Page 206: Bonnie Parker in the arms of Clyde Barrow, c. 1934.
Facing page: Clyde Barrow, c. 1932–34.
Below: The car in which Bonnie and Clyde were shot down, 1934.

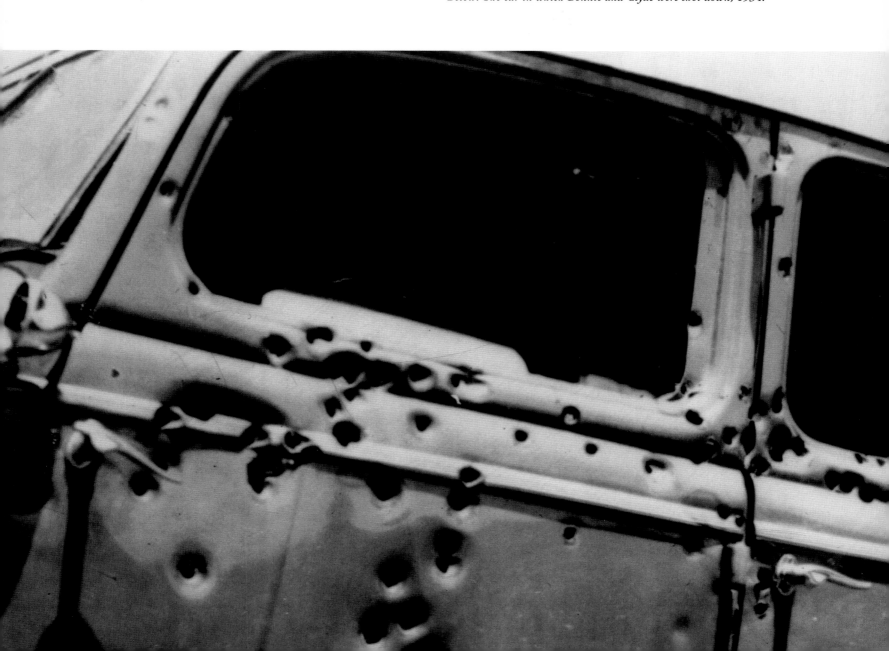

Pierre Loutrel, known as Pierrot le Fou (1916-1946)

From the Traction Gang to Murder and Madness

His name was Pierre Loutrel; the French *milieu* (the Nice-based mafia) called him Pierrot la Valise (Pete the Valise), then Pierrot la Voiture (Pete the Car), and finally Pierrot le Fou (Crazy Pete). History and the cinema have seized the legend of this enemy of the people, enshrining him an as icon of post-war gangsterism. Yet nothing at his birth—on March 5, 1916, in Château-du-Loir in the French department of Sarthe—predisposed this *enfant terrible* to become the scourge of the law and bullion convoys across France. Loutrel was born into a wealthy farming family, apparently destined for the comfortable life of a rich landowner.

At the age of fifteen, he answered the call of the sea and a life of adventure, leaving behind the material comforts and security that were his birthright. Loutrel ran away to Marseilles and enlisted as an ordinary seaman on a cargo ship, plying the oceans of the world. On returning home to France, he lost himself in the world of Marseilles Old Port, discovering a passion for the local aperitif, pastis. He lived a hand-to-mouth existence, surviving on petty theft, and soon landed in the Baumettes prison. Military service beckoned, and his criminal record took him to Foum Tatouine in Tunisia, the headquarters of the notorious *Bat'd'Af* (France's African batalions of light infantry), and a labor camp populated by crooks and dangerous hotheads. Loutrel had no intention of becoming some hard man's pet catamite. He fought for the respect of his fellow inmates, including a diminutive boxer by the name of Jo Attia, who would become his companion to the bitter end.

In 1941, under the German occupation, Loutrel ran a Paris bar and hotel with his regular girlfriend, Marinette Chadefaux. Hermann Brandl, an officer in the Abwehr on a posting to the French capital, had the idea of engaging the Paris underworld to carry out his dirty work, notably black market supplies. Loutrel, a regular at the Champs Elysées bars frequented by strutting German officers, seized the

opportunity to get rich quickly, easily, and with little or no risk. He joined the notorious Carlingue, or "French Gestapo," a company of French auxiliaries (almost all culled from the *milieu* or criminal circles), smartly dressed, generous to a fault, enjoying the high life.

Loutrel had three unfortunate weaknesses: alcohol (which he drank to excess), firearms (which he used to excess), and cars, which he collected—eleven- and fifteen- horsepower open-top Citroen Tractions and, above all, a splended blood-red Talbot-Lago coupé. On outings to the brothels of Pigalle, he fell in with a bunch of dubious rogues who were later to form the so-called *Gang des Tractions Avant* (the Front-Drive Traction Gang): Abel Danos, Henri Fefeu, Lucien Le Ny, and Georges Boucheseiche. While the Allies were landing in Normandy, in June 1944, Loutrel became involved in a drunken brawl in a Montparnasse bar with a certain Inspector Ricordeau—a noted Gaulist—and left the man dead in the street. Enough was enough. Loutrel was summoned by the German Kommandantur and given a severe warning. He left Paris for Toulouse, where he joined the Resistance, becoming an armed enforcer for the Morhange network, specializing in the liquidation of traitors and German officers. Loutrel, who now went by the name of Lieutenant d'Héricourt, purged his dubious past through the barrel of his P38 revolver, earning himself a *tricolore* armband and a reputation as a courageous patriot. Something he would later use to his advantage.

Loutrel was still a criminal, however, carrying out dastardly personal crimes under the cover of his acceptable new face. His brief period in the Resistance led him to work for the DGER—the French secret service, created under the "free" Vichy regime. In Spain, "Pierrot la Valise" executed a Jewish businessman with Gestapo links, by the name of Szkolnikoff, followed by anyone likely to remind him (or anyone else) of his years as a *collabo*—a Nazi collaborator. At the end of 1945, he joined forces with Jo Attia, his old

comrade from the *Bat'd'Af*, now a survivor of the infamous Mauthausen concentration camps, who evidently chose to overlook Loutrel's collaborationist episode.

In February 1946, the Traction Gang got off to a roaring start. On February 7, they attacked a van supplying the Crédit Lyonnais bank on avenue Parmentier, stealing three million francs. On the 10th, they attacked a post-office van at the Gare de Lyon in eastern Paris, making off with three million francs. And, on March 4, at Issy-les-Moulineaux, they held up a bank treasurer and cashier, stealing seven million. Ten days later, in Nice, two gas company employees were attacked, earning the gang just over a million francs.

"Pierrot" sank further into alcoholism, however. In Marseilles, the gang failed badly. Blind drunk, Loutrel killed a cashier and made off with seven hundred thousand francs. With his brain addled by drink, he was as quick to draw a gun as he was to reach for the bottle. The *milieu* was on its guard, and his friends began to worry about his unpredictable, excessive behavior. When drunk, he was capable of the worst and became known to all as Pierrot le Fou (Crazy Pete). Sober, he was still capable of pulling off ingenious stunts, as he proved in Nice, on July 1. Dressed as a painter and decorator, he entered the Hôtel des Postes with an accomplice, overpowered the postal workers, and calmly walked out with thirty-three million francs (the biggest sum ever stolen in France in an armed robbery), joining his friends nearby, at the wheel of one of their trademark front-drive Citroën Tractions. The police gave chase all the way along the Côte d'Azur, arresting him in Marseilles and taking him to L'Évêché, the Marseilles police headquarters. Here, Crazy Pete gave his guards the slip, seized a machine gun, and escaped. He returned to Paris, where he carried out a further series of breathtaking holdups.

The money slipped through his fingers. Pierrot squandered his spoils in the capital's seamy bars, indifferent to the warrants issued for his arrest. His crazy ways knew no limits. One night, in a bar on the Champs-Elysées, he encountered Martine Carol (the future star of French cinema), fell

madly in love, and abducted her in front of her stupefied friends. Their liaison was shortlived, and the actress received a huge bouquet of roses a few days later, by way of compensation. The card read: "With apologies, from Pierrot le Fou."

The gangster was at the height of his career. Smarting at the ridicule inflicted on them due to his successes, the police decided to strike back. Through a reliable informer, the police commissioner in charge of the man-hunt, named Casanova, learned that Pierrot and his gang were carousing at an inn on the banks of the Marne River. Arriving at the scene, he found virually every member of the gang present, with the exception of their leader, who was busy downing drinks in a neighboring bar. While an impressive police force surrounded the inn, Loutrel—who had been warned by telephone—rolled up outside, at the wheel of his Delahaye. His accomplices climbed aboard, and the gang escaped in a hail of bullets, right from under the noses of the police.

The incident was a serious alarm call for the gang, however. The police began to score a few points of their own: Henri Fefeu, an old comrade from the *Bat d'Af*, was arrested at a garage in the town of Meaux, where he had taken a stolen Traction for repairs.

Pierrot le Fou took refuge at Porcheville, in the home of Edmond Courtois—another old *Bat d'Af* comrade—prowling like a caged animal and permanently drunk. On November 6, he could stand the inactivity no longer and headed for Paris to rob a local jeweler's shop on rue Boissière. Reluctantly, his two remaining loyal companions—Jo Attia and Boucheseiche—agreed to provide his getaway. Pierrot, drunk as usual, bungled the robbery and wounded the jeweler in the stomach. The man's wife screamed, and the hardened gangster abandoned the booty to make a run for it, diving into his friends' Traction and trying to stuff his revolver into his belt. He accidently cocked the gun, firing a bullet straight through his bladder and out through his rectum.

Loutrel was seriously wounded. A crooked surgeon agreed to operate overnight, in a discreet clinic in eastern Paris. Pierrot would have to be moved the next day. His old comrades stole an ambulance and decided to take him to Porcheville. The chaotic transfer proved fatal. Loutrel died that night. Loutrel's body was rolled in a blanket and buried on the Ile-de-Gillier. When his old girlfriend, Marinette Chadefaux, heard of Pierrot's death, she accused the gang of having assassinated him, unable to handle his wild behavior any longer. Marinette had become a risk, and Boucheseiche shot her in the head as she stood over her lover's tomb.

The history of the Traction Gang ended as it had started, in a bloodbath, chaos, and murder.

Page 210: In order to identify a body suspected of belonging to Pierrot le Fou, rediscovered three years after his death, the police superimposed an image of the skull onto an anthropometric photo, 1949.
Facing page: Pierrot le Fou at the steering wheel of a Delahaye, Saint-Maur-des-Fossés, c. 1946.
Below: Jo Attia and Pierre Loutrel, c. 1937.

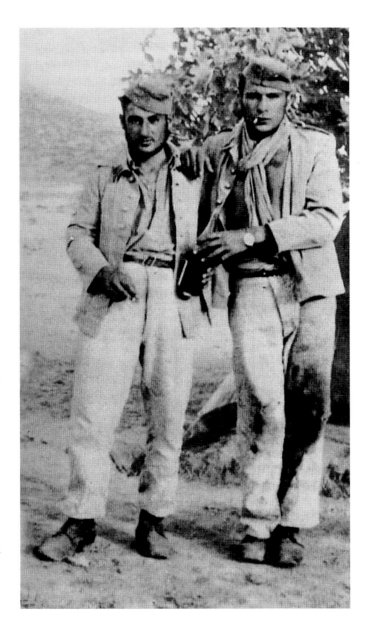

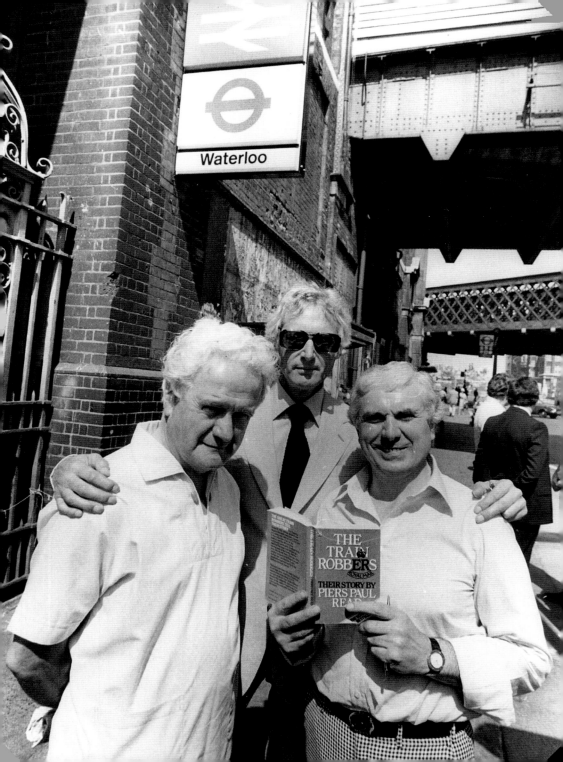

Bruce Reynolds (1931–) and Ronald Biggs (1929–)

The Great Train Robbery (August 8, 1963)

Tired of cleaning windows, or working in bars and warehouses, they chose—on the threshold of adulthood—to join the murky world of London's gangland. Why get up at dawn, cram into public transport, and wear yourself out at work for a pittance, when with a modicum of talent, you could earn a year's salary on a successful overnight "job"? They were born in Elephant and Castle, a working-class area of south London, and met at the King's Head, the Walk-In, or the Shirley Ann, smoke-filled pubs and private clubs where elegantly dressed hoodlums gathered over a Guinness or a glass of Johnny Walker, intent on making their fortune. Their names were Buster Edwards, Charlie Wilson, Bruce Reynolds, Bill Jennings, Jimmy White, Roy James, and Gordon Goody. Their first gang was known as the "City Gents," thanks to their impeccable three-piece suits. The Gents practiced their art with varying degrees of success, robbing jewelers' shops, holding up banks, racketeering, and safe-breaking. The unlucky ones did time in prison. Their specialty was holding up train and airline companies on the night before payday, making off with the employees' salary money. After a successful haul of cash destined for the pay packets of London's railway workers, they attacked the airline company BOAC, escaping with sixty-two thousand pounds. They had hoped for five times that amount, but instead they earned themselves a fine criminal reputation and received tip-offs about forthcoming cash convoys on the railways.

Between the cost of hiring lawyers and their newfound, luxurious lifestyles, the stolen money soon ran out. By mid-January 1963, they had to start all over again. But this time, on a quite different scale.

The Gents' initial heists provoked envy and admiration. A second, more discreet but highly efficient gang (the South Coast Raiders) specialized in seizing high-value packages in transit on the London-to-Brighton railway line. Its leader was Roger Cordrey, a florist and stern family man, crippled by gambling debts. His three accomplices—Frank Munroe, Bob Welch, and Tommy Wisbey—would distract the ticket controllers and train guard while the brains of the gang got to work in the guards' van and the post office carriage.

Money poured in, the business flourished, and the train companies introduced extra security, forcing the gangsters to adapt their methods. They took to halting trains in the depths of the countryside to attack them.

Cordrey studied the signalmen's instruction manuals and devised an ingenious system to block the signal lights on red, halting the train. In January 1963, Brian Field, a crooked London lawyer, introduced the City Gents to a mysterious Irishman who revealed that large quantities of cash from the coffers of Scottish banks were carried every week in the second carriage of the Glasgow to London post office train. In early August, while Scotland celebrated a public holiday, up to five million pounds would be ferried south. The solution was obvious: the train would be stopped in the countryside, the locomotive and the first two carriages would be uncoupled and broken open, and the sacks of cash transferred to a waiting van.

The Gents were on the lookout for a specialist capable of blocking the signals and halting the train in a suitable spot for the transfer of the sacks. Cordrey's reputation reached the ear of Buster Edwards. In exchange for his part in the holdup, he demanded a ten thousand-pound advance and insisted on the participation of his accomplices. Since the raid on the BOAC offices, however, the Gents had run out of cash. As luck would have it, however, one of their number—Jim Hussey—had done time in Munich with a former member of the Waffen SS called Horst. Horst let it be known that he was supported by a powerful organization of substantial means. Contacts were renewed; meetings took place in London. The Germans agreed to put twenty thousand pounds up front, in exchange for a significant share of the haul: two million pounds.

In the weeks prior to the holdup, the gang pinpointed an isolated bridge a few miles from the town of Tring and rented a farmhouse at Leatherslade—twenty miles from the scene of the raid—where they could hole up for a few days while the search died down. They recruited a retired train driver known as Stan Agate, bought a van and two Land-Rovers that they disguised as military vehicles, and acquired army uniforms and blue workers' overalls for themselves.

On the eve of the robbery, sixteen members of the gang gathered at Leatherslade, playing Monopoly to pass the time or sleeping in the upstairs bedrooms. Ten men formed part of the main gang: Buster Edwards and his friend Bill Jennings, Bruce Reynolds and his brother-in-law John Daly, Jimmy White and his mate Alf Thomas, Gordon Goody, Charlie Wilson, Roy James, and Jim Hussey. Four belonged to a second group: Roger Cordrey, Bob Welch, Tommy Wisbey, and Frank Munroe. Two additional characters complemented the lineup of hardened professional hoodlums: Stan Agate, the elderly train driver who would drive the locomotive, and a German nicknamed Sigi, who was there to keep a close eye on his countrymen's interests in the operation. The atmosphere was tense; the two gangs exchanged wounding comments and acerbic banter. The attack was planned for 3:30a.m. on August 8, 1963. At half past midnight, Bruce Reynolds, sporting an army officer's uniform, gave the starting signal.

The convoy of vehicles took a roundabout route to the bridge, where the men took up their positions. The gang cut the telephone wires leading to the emergency call box then tampered with the signal system. At three minutes past three, the halo from the train's headlights appeared in the distance. The signal was activated, and the train stopped at the red light. While two of the robbers busied themselves uncoupling the two front carriages, five others waited by the righthand side of the track to knock out the train driver. Buster Edwards hauled himself into the cabin and struck the driver, Frank Mills, in the face. Stan Agate proved unable to re-start the engine, and Mills was reinstated at the controls, under threats from the rest of the gang. The train shuddered to a halt about 330 yards further down the line, in front of the first signal. The gang broke into the post office carriage before immobilizing the terrified postal workers with brutal violence.

The men formed a chain to transfer the mail sacks to the waiting van, gasping under the weight. Exhausted, they left six sacks behind at the scene and one on the railway embankment as they made their getaway. The gang returned to their hideout along remote, circuitous, deserted country roads.

The atmosphere was euphoric. They had stolen a hundred and twenty sacks of used banknotes and pulled off the biggest mail robbery of all time. The wads of five- and ten-pound notes were stacked up the ceiling, but when the booty was added up, the haul amounted to two-and-a-half million pounds instead of the expected five. Still, once the Germans had received their cut—summarily reduced by the gang to a million pounds—and after paying out commission money due to informers and one-off participants, each member of the gang would receive ninety thousand pounds, an enormous amount for the time.

The train guard raised the alarm an hour-and-a-half after the robbery. The investigation was entrusted first to the Aylesbury local police. Scotland Yard got involved the following afternoon. The postal workers reported that the gangsters had threatened to return in half an hour, if they moved. From this, the police concluded that the gang had found a hideout within a radius of twenty-seven miles. The local population was invited to report any movements of suspicious-looking military vehicles and any unusual signs of activity

As if a higher justice had elected to deprive the gangsters of their ill-gotten gains.

around remote farmhouses. This meant that the gang was unable to use their van or Range Rover. Nor were they going to hide out at the farmhouse until Sunday! On Thursday afternoon, they decided to disperse the next morning, but the members charged with torching the premises were in too much of a hurry. Five days later, acting on a tip-off from a young cattle farmer, the police discovered the farmhouse and were able to collect numerous clues and fingerprints, including the Monopoly board, apparently played with real money after the heist, from which they were able to lift fingerprints.

On August 14, Roger Cordrey was the first gang member to be arrested, in Bournemouth trying to rent a garage in which to hide his loot. Unfortunately, the garage was owned by the widow of a police officer, who informed the

investigation. The Yard closed in, seizing Cordrey and fifty-six thousand pounds. On August 16, a couple walking in the woods near Dorking, in Surrey, found a briefcase together with bags containing a hundred-and-ninety thousand pounds and an invoice in the name of the gang's lawyer, Field, who was questioned a few days later. Another discovery was made in a trailer at Box Hill, three thousand four hundred pounds and the fingerprints of Jimmy White. In the farm at Leatherslade, forensic officers identified Charlie Wilson's fingerprints on a box of salt, Bruce Reynolds's prints on the Monopoly set, and Ronnie Biggs's on a Pyrex dish. Palm prints included Jim Hussey's on the van, Edward Butler's on the bath-tub rail, and Buster Edwards's on a sheet of wrapping paper. On August 22, photographs of the main suspects were published in the newspapers. Charles Wilson was arrested at his home. The florist of a London hotel mistook Gordon Goody for Bruce Reynolds, and the police arrested him in his room at two o'clock in the morning. He was released but convicted a few weeks later thanks to the traces of paint on his shoes. The police captured Ronald Biggs on September 4, Brian Field on September 14, and John Weather on the 17th, followed by Hussey and Wisbey. Bob Welsh and John Daly were ratted on by their friends, and Roy James by an anonymous telephone tip-off. All three were questioned at the beginning of December. Following mirky negotiations, and on the promise of an amnesty, Alf Thomas gave himself up.

When their trial opened at the Buckinghamshire Assizes on January 20, 1964, twelve men stood accused of the robbery, and two million pounds were still nowhere to be found. Two men—Bill Jennings and old Stan Agate—had escaped police attention. Three others—Buster Edwards, Bruce Reynolds, and Jimmy White—were still on the run. The only man to plead guilty and stand trial separately was Roger

Cordrey. After a nine-week hearing, the main defendants were found guilty of conspiring to rob the night mail train and guilty of the violent robbery of a hundred and twenty sacks of used notes. Passing sentence, the presiding judge Justice Davies commented that the men's "horrific" crime demanded the severest of punishments, as a deterrent to others, and a reminder that crime does not pay.

The sentences were harsh. The men were sentenced to twenty-five years in prison for conspiracy and thirty for violent robbery. All of their sentences were confirmed on appeal. With the exception of Ronald Biggs and Charlie Wilson, who managed a spectacular escape from Wandworth prison on July 7 1965—Wilson was re-arrested after just three years on the run, but Biggs, who had plastic surgery, lived openly in Brazil for thirty-five years going as far as selling "Ronnie Biggs" souvenirs to tourists—the leading members of the gang faced twelve grim years behind bars. Most often in solitary confinement, the infamous robbers were bullied and taunted by prison officers who took delight in humiliating them. Ironically, the majority of the Great Train Robbers—as they came to be known—left prison penniless if not destitute, robbed during their time "inside" by the trusted friends left in charge of their loot. Even Ronnie Biggs, who voluntarily returned to the United Kingdom in 2001 in a blaze of publicity, would end up spending years in prison, his fortune all but gone. As if a higher justice had elected to deprive the gangsters of their ill-gotten gains.

Page 214: Roger Cordrey, Bruce Reynolds and Buster Edwards at Waterloo Station, London, about to debark on a promotion tour for their book, July 18, 1979.
Below: The bridge where the bandits stopped a postal train running from Glasgow to London, 1963.

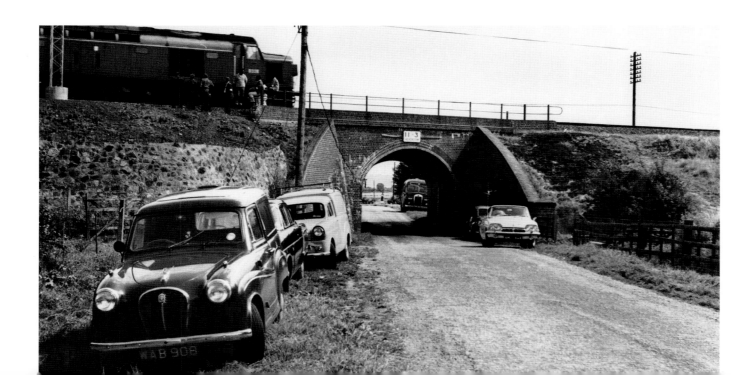

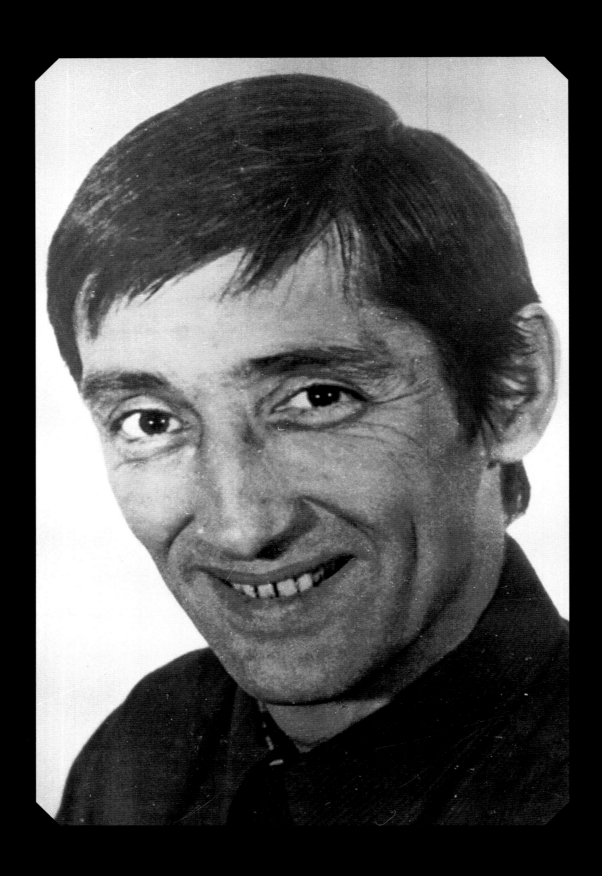

Alfred Spaggiari (1933–1989)
The Great Riviera Bank Heist

On the morning of July 19, 1976, two employees of the Société Générale bank in Nice—at no. 8, avenue Jean Médecin—went down to the strong room to open the armored door. Strangely, their keys seemed to be turning in empty space, unable to shift the heavy mechanism. They called the locksmith responsible for maintaining the system, but he was similarly unable to open the door, with one small difference. The keys were turning in the locks, but something had been placed inside, blocking the system. The only solution was to drill a hole through the concrete wall, big enough for a man to pass. At 3 o'clock in the afternoon, the duty manager crawled through into the strong room, to find that the door's bolts had been soldered shut from inside. His astonishment was as great as the crime he discovered. Of the bank's four thousand safe deposit boxes, three hundred and seventy-one had been broken open. Difficult at first sight to evaluate the losses; the bank would have to wait for each box's keyholder to reveal the nature of its hidden contents. The final tally put the value of the loot at forty-six million francs—France's "heist of the century."

Chaos reigned in the strong room's two sections. Treasury bills had been trampled underfoot, and pornographic photographs—reportedly taken from within deposit boxes and typically featuring their owners, well-known figures in and around Nice—had been stuck on the walls. Cheap jewelry had been thrown to one side by an expert connoisseur; sterling-silver soup tureens had been used as toilets, and marriage certificates and wills as toilet paper. The space was scattered with the remains of meals, cigar butts, empty wine bottles, pairs of used rubber gloves, and abandoned chisels and crowbars. A painting stuck on one safety deposit box bore a strange handwritten inscription—*Ni armes ni violence et sans haine* (Neither weapons nor violence and without hatred)—above a peace symbol, in the form of a dove's foot within a circle.

The investigation began that afternoon. The police discovered a tunnel measuring twenty-six feet long and thirty-five meters wide, leading from the sewers that passed near the underground strong room—the result of long weeks of hard labor, drilling through rock, clay, limestone, bricks, and concrete to reach the treasure. The heist had been thoroughly organized and planned by a gang of criminal geniuses; the tunnel was linked to a sewer outlet that emerged some one-and-a-half miles from the bank, the last section of which was big enough to accommodate a four-wheel-drive car. In the adjacent wall cavities, the investigators found a professional armory of oxygen andacetylene tanks, blow torches, hydraulic cylinders, jacks, drills, camping stoves, and fire extinguishers.

On July 23, Société Générale offered a reward of one million francs for any information leading to the gang's arrest. The thirty-strong team in charge of the investigation were obsessed with one question: who were the brains and gang behind this incredible break-in, the biggest in French history? Initial suspicions focused, without proof, on the godfathers of the Marseilles underworld, the *milieu*. But three tip-offs led the investigators along the trail to the real, mysterious "brains" of the operation.

The first came from a policeman who, ten days earlier, had checked the papers of four individuals and a suspect car loitering around a shuttered holiday villa at Castagniers, six miles from Nice. All four were known to the police, with significant criminal records. Dominique Poggi, a fifty-year-old Corsican pimp, had been found guilty of arms trafficking; Daniel Michelucci was a convicted thief, implicated in a murder in Italy; Christian D. was "known unfavorably to the police"; and the last man, Alain Pons, provided a false identity. The owner of the group's Renault 5, who made a run from the scene, had a conviction for murder. Being found to have committed no crime the night they were stopped, they

had been released without charge. However, when the villa itself was searched on July 27, it yielded a couple of important clues. Wine bottles found inside were the same as those left in the strong room, and mud on a flashlight in the house was identical to that lining the walls of the tunnel. The police had the beginnings of a trail.

A second report from the Nice security services confirmed the police's suspicions. On June 10, two individuals had been surprised at 10 p.m. in a parking lot, with sports bags containing chisels. They were taken to the police station, where their identities were checked. The first was Gérard Vigier, the second none other than Daniel Michelucci, one of the four questioned at Castagniers. Analysis of the chisels showed them to come from the same production series as those found in the sewers. At the end of September, two small-time crooks previously unknown to the police made a fatal mistake; through two accomplices, they attempted to sell nine gold ingots from the robbery, at a branch of the Crédit Agricole bank on the Côte d'Azur. The cashier raised the alarm, and the men were arrested a few days later. They decided to talk. That spring, they said, they had met a Nice-based photographer in a bar, looking for accomplices for a big heist. The pair took a liking to the personable character and had introduced him to Dominique Poggi, a leading light in the Marseilles *milieu*. The photographer's name was Albert Spaggiari.

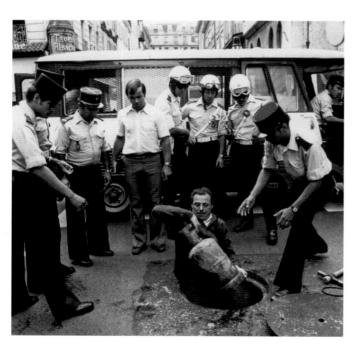

The next day, Bert (as he was known) was apprehended and arrested in a brasserie opposite his photography store. After thirty-six hours of questioning, Spaggiari relented. Anxious to spare his wife, Audi, from prison, he admitted he was the brains behind the Nice break-in.

The police searched Spaggiari's *bergerie*, a remote shepherd's cottage in the hills above Vence, called *Les Oies Sauvages* (The Wild Geese) and discovered a cache of arms and explosives in the garden. But who was this tall, lean figure—a swaggering, elegant man of forty-three? A compulsive liar, a megalomaniac, a dangerous activist with links to the international far right? Or an idealist and dreamer, as he liked to declare?

> My motto would be: dream and when you have stopped dreaming, walk 'til you can't walk anymore, chase after your dreams. […] My dreams were all my books.[101]

Born on December 14, 1932, in Laragne in the French department of the Hautes-Alpes, Albert Romain Spaggiari came from a family of Italian immigrant builders. His father died when he was a small child, and his mother moved to Hyères, where she opened a lingerie boutique. A turbulent, combative child, Albert was sent to a religious boarding school but ran away to Palermo at the age of sixteen, determined to join his hero, the Sicilian outlaw Salvatore Giuliano. Spaggiari was arrested and returned to France, where he enlisted as a volunteer in the Third Colonial Parachute Regiment, bound for Indochina. His first major holdup soon followed, at the Milk-Bar, a military brothel in Hanoi. Spaggiari was sentenced to jail for five years, serving two-and-a-half years before returning to France in 1957. Two years later, he married a young nurse of Italian origin, Marcella Audi di Grivetta, known simply as Audi. The couple settled in Dakar, Senegal, where Spaggiari found work as a coppersmith and locksmith with a manufacturer of safes and strongboxes. In 1960, they returned to France. Spaggiari sympathized with the French colonial cause in Algeria and spent four years behind bars for illegally hoarding firearms and ammunition, his private hobby and principal weakness. At Paris's Santé prison, Spaggiari played the flamboyant "Mr. Big" and became a close associate of three other members of the OAS (the *Organisation Armée Secrète*, a French terrorist group opposed to Algerian independence): Michel "Le Toc," Robert C., and Michael Marshall, who would remain loyal to him.

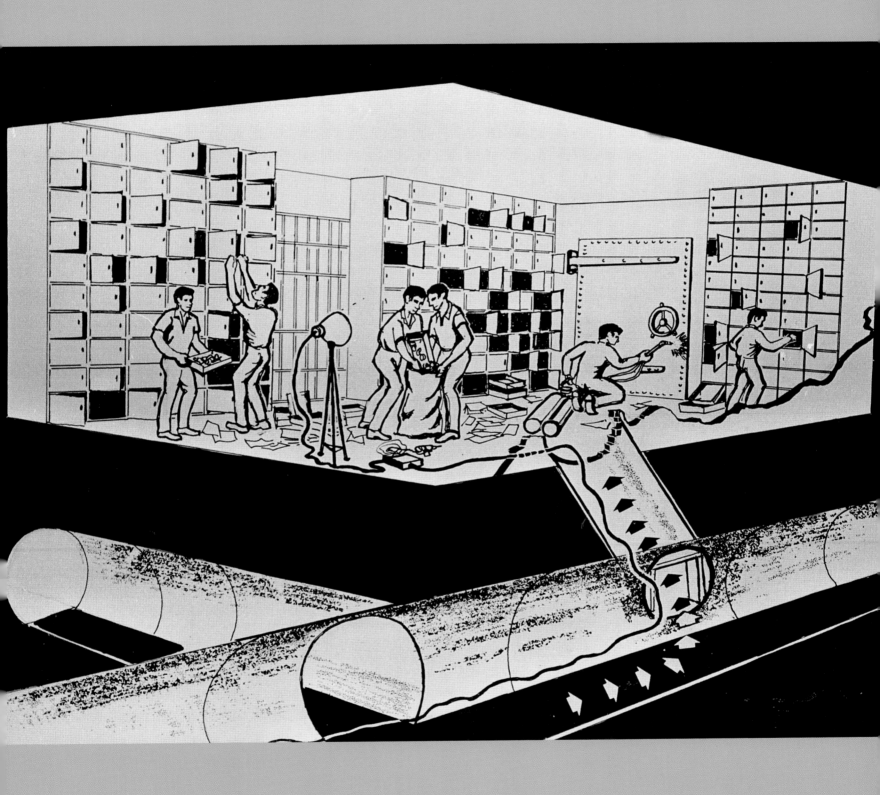

On his release, Spaggiari returned to Nice and opened a photography business, chiefly devoted to photographing weddings at the City Hall, where he was granted accreditation.

But Spaggiari was soon bored. He had seen the world, and he missed the rush of adrenalin and dreamed of glory, adventure, and fame. Leaving a manager to look after his business, he spent his time reading the adventures of the Red Sea smuggler Henri de Monfreid, and the biographies of Gilles de Rais, Mandrin, and Robin Hood. He wandered the streets of Nice, on the lookout for a spectacular coup. One drab day in April 1974, he came across a crime novel by Robert Pollock entitled, *Loophole, or How to Rob a Bank*. Eureka! He devoured the book in a single night. The story of a gang of English robbers breaking into a city bank through the sewers gave him the big idea he had been so desperately waiting for. The next day, he began. He rented a safe deposit box at the Société Générale branch on avenue Jean-Médecin, searched out everything he could about the Nice sewers, exploring them inch by inch, befriended a talkative bank employee in a bar, and began testing the strongroom's security system with an accomplice, who took photographs. This was a huge job, impossible to carry off unaided. Spaggiari sought the help of a group of experienced bank-robbers. Alain Bournat and Francis Pellegrin—two small-time felons he met in a bar—introduced him to Dominique Poggi and the Marseilles *milieu*. Blinded by his pride and wild dreams, Spaggiari walked unawares into a nest of vipers and realized his folly too late. The initial deal was clear, however: each of them would bring ten men to the job, and the loot—minus the operational costs—would be split into two equal halves, to be distributed by each chief to his men. Right to the end, the *milieu* fooled Spaggiari into thinking he was the mastermind and boss of the operation. Honor mattered little, provided the underworld got its money.

On May 7, 1976, the twenty-strong gang set itself to work, ankle deep in mud, detritus, and excrement. The plan was to work from Friday night to Monday morning each week, to avoid attracting attention. While the gangsters wore themselves out digging underground, accomplices equipped with walkie-talkies kept a lookout at street level. On June 25, the diggers reached the strongroom. Now came the most difficult part—breaking through the backs of the safe-deposit boxes lining the walls. The Marseilles gangsters favored blow-torches, but Spaggiari preferred a high-pressure hydraulic cylinder. His choice won the day. On July 16, the jubilant gang broke into the inner sanctum and spent three nights breaking into three hundred and seventeen boxes (the break-in coincided with a long weekend for Bastille Day, on July 14). After his arrest, Spaggiari was incarcerated in Nice prison. Every Thursday he was taken from his cell to an office in the Palace of Justice, to face his investigating judge Richard Bouazis. Spaggiari provided abundant details about the technicalities of the heist but kept silent as the identity of his accomplices. He played the honorable rogue, and his old comrades from the Santé—Michel Le Toc and Robert C.—didn't let him down. The two descended on Nice, rented a discreet apartment in the Old Town, bought a powerful motorbike, and on Thursday, March 10, 1977, waited under the windows of the judge's office, twenty-five feet above. At 5 o'clock, Spaggiari rose from his chair, complaining of the heat. He approached the magistrate's chair, opened the window, and jumped, landing unhurt on the roof of a Renault 6 parked nearby. The motorbike roared away, and Spaggiari was never caught again.

Questioned about his motives by the French journalist Bernard Pivot, who met him in secret following the publication of his memoir, *Le Journal d'une truffe*, Spaggiari declared, "I wasn't looking to make a profit, I was looking to accomplish a feat." He recognized that robbing the bank had cost him a lot more than he had gained. "I was well off. I had houses in Provence, I had a lot of things I no longer have."[102] After twelve years on the run, the brains of the Great Riviera Bank Robbery had spent every last centime of his loot on false identity papers, hideouts, protection, plastic surgery, and bad company. Forgers and crooks of every kind charged him dearly for their services, convinced he was still a rich man. Spaggiari the smooth talker and poseur—a tireless interviewee, addicted to notoriety—had served his purpose for the Marseilles *milieu*, who wanted nothing further to do with him. He never received his share of the monies realised by the sale of the stolen jewelry.

Spaggiari dreamed of returning to his beloved France, the country he had fought for—or, at least, so he claimed—in Indochina. His lawyers advised him against returning home; the French justice system was not in the habit of striking deals with hoodlums, even regretful ones. He died of lung cancer, after an operation under a false name in a Parisian clinic, on June 8, 1989, at the age of fifty-six. His run had come to an end. But, his last words: "I die a free man."

Page 218: Albert Spaggiari, c. 1976.
Page 220: Police at the site of the heist in Nice, July 1976.
Page 221: The Heist in Nice, illustration, 1976.
Facing page: "Bert" posing for the press in Rio de Janeiro, disguised in a wig, 1982.

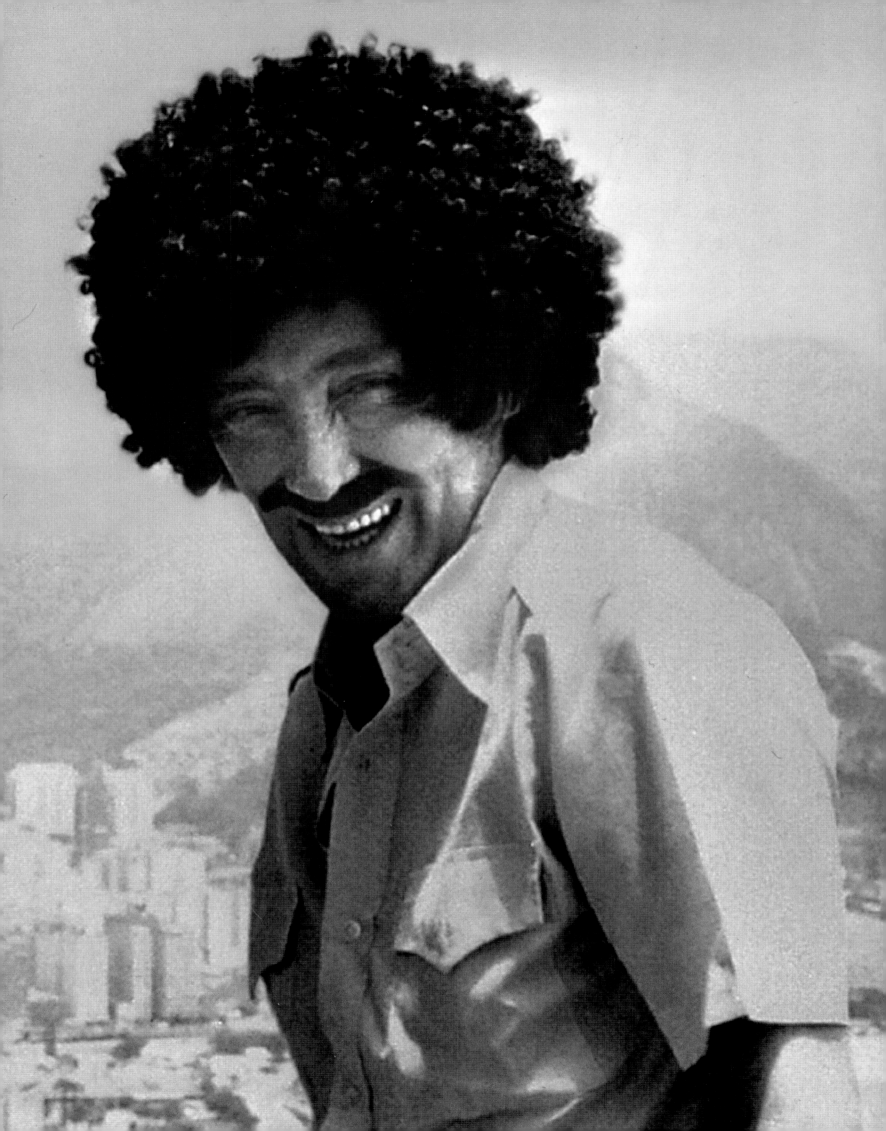

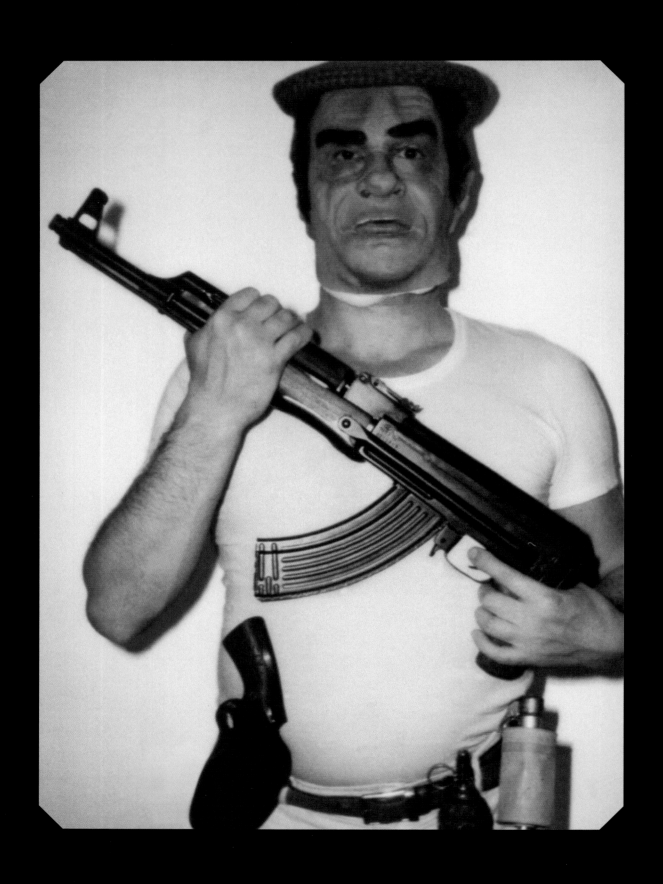

Jacques Mesrine (1936–1979) and François Besse (1944–)
France's Public Enemy Number One and the Repentant Robber

"Monsieur Besse is no Robin Hood. He treats human beings like mere objects."[103]

The remark said it all. The lawyer for the husband-and-wife bankers abducted by François Besse and Jacques Mesrine returned to her seat. She had just put France's most feared gangster duo of the 1970s firmly in their place.

The wild-beast duo of French crime first met in 1976, in the high-security sector of Fresnes prison. Mesrine was forty years old, Besse thirty-two. Both had impressive lists of holdups to their names. Mesrine had admitted to thirty-nine crimes. Besse had committed a good thirty break-ins and holdups with never a drop of blood spilled. Both had already spent several years in prison—Evreux, Orléans, and the Paris Santé for Mesrine; Strasbourg, Cognac, Bordeaux, and Marseilles for Besse. Each had pulled off three successful escapes. Besse, the smaller of the two, was a quiet, composed man with a piercing stare. Mesrine, the taller man, was a mouthy, extravagant character.

The second child of a happy family—his parents were textile designers—Jacques Mesrine was born in 1936 in a small apartment in Clichy-sous-Bois. He was deprived of his father as a child (Mesrine senior spent the war years in a German prison), however, and proved a reluctant scholar, despite his superior intelligence. By the age of sixteen he had been expelled from school and was roaming the grimy streets of Pigalle in Paris, working at a succession of menial jobs: running errands for a fabric store, delivering newspapers.... In 1959, back at home after three years' military service in Algeria, he committed his first robberies, preying on apartments in the smarter quarters of Paris and ending up behind bars in 1962. His first murder was of a pimp who had disfigured one of Mesrine's conquests. Following his release from prison, he fell in love with a prostitute, broke safes, and committed holdups

and robberies in France and Canada. Mesrine kidnapped a wealthy, handicapped industrialist, went back to prison in Quebec, escaped, killed two forest rangers, and returned to France at the end of 1972, carrying out an average of five holdups per week. Arrested once more, he escaped from the Compiègne Palace of Justice on June 6, 1973, but was caught again in September and sent to Fresne Prison then the Santé in Paris—where he joined forces with Besse to escape from the high-security section.

François Besse's childhood began less happily. He was born in Cognac on July 24, 1944, to a Charentaise mother and an undeclared father. He knew poverty and hunger from an early age and grew up small and sickly, known to all as "le petit François." Besse was not a gifted student; he failed his school certificate and began a lackluster apprenticeship as an electrician, from which he was eventually released before sinking into a downward spiral of delinquency and crime at the age of seventeen. His first bungled burglary led to his first arrest and his first spell in prison, in Strasbourg. Besse's short criminal record stuck, and his attempts at going straight were short lived, despite his best efforts. His rake's progress was inevitable. Like so many others before him, he espoused the dream of the honorable outlaw, "other people's belongings were never of any great importance. I never stole simply in order to possess something."[104] Questioned about a burglary in which he taken no part, Besse was sentenced to seven years in prison. Faced with knuckling down or breaking free, his mind was made up. After just two months, he escaped, living on the run in secret, marginalized forever.

Besse was discovered in Bordeaux, in February 1973, and opened fire on the police before pressing the gun to his own heart, preferring death to the inside of a prison cell. But he missed and was sent to hospital and prison once again, where he read Virgil and Plato on the advice of the chaplain.

He remained obsessed with the idea of escape, however, and had already made two successful attempts—on August 7, 1974 and October 20, 1975—before meeting Mesrine on a walk in the high-security sector of Fresnes prison.

The two gangsters were dangerous men, but the inhuman conditions of the high-security section made them into wild beasts: windowless whitewashed cells, solitary confinement, and silence, no personal effects or metal cutlery—meat was torn at with the bare teeth, no visits or cell mates, one short walk each day in a small courtyard covered with a metal roof grille. The two inmates were transferred to the high-security section of the Santé, in Paris. Escape seemed impossible, but the two worked tirelessly at a plan. Mesrine and Besse kept a low profile, no more pointless acts of revolt. They trained hard in the prison gym and kept themsleves fit.

On May 8, 1978, the pair went into action. Mesrine asked to see his lawyer. Besse had acquired a tear-gas spray in a packet of biscuits. Two revolvers, a rope, and a saw had been hidden by accomplices in the ceiling of the room where Mesrine (le Grand) was to meet his lawyer. Besse convinced a prison guard to open the door, saying he had to return a thick file of documents. Mesrine leapt out, armed with the weapons he had recovered from the ventilation shaft of the meeting room, taking the guards and prison director hostage. A third detainee—Carman Rives—joined the duo, now wearing the prison guards' uniforms. The fugitives climbed the prison wall and were fired on by the police. Rives was killed, but Mesrine and Besse escaped unharmed, ejecting the driver of a passing Renault 20 from his seat and losing themselves in the Paris traffic.

The escaped convicts spent six months living in a quiet alley in the eighteenth arrondissement, at no. 8, passage Charles-Albert. Life on the run was expensive, and they soon got back to work, holding up a gun store with no attempt to disguise their identities. The press flattered their proud egos, and they felt like the masters of the universe, living the grand life. The pair headed for Deauville, where they broke into

the casino and made off with a small amount of money, before throwing themselves into a breathless chase across the Normandy countryside. Mesrine received a bullet in the back during an exchange of fire at a roadblock.

Back in Paris, Mesrine and Besse abducted the director of a bank in Noisy-le-Sec. In exchange for his family's safety, the man agreed to open the branch safe. Nightly trips to Pigalle alternated with bold, spectacular crimes. Sylvia, a bar hostess, joined the duo, and all three left for Italy, Algeria, and England. The two men's characters and natural inclinations now came to the fore: Mesrine, the smooth talker and performer, dreamed of hitting the headlines by kidnapping a magistrate as revenge for his long years in prison. Besse, taciturn and reserved, dreamed of retirement in the sun with his lover, who had joined him in London. Mesrine and Besse separated, and never saw one another again. Besse settled in Brussels, where he was arrested on March 11, 1979; Mesrine returned to Paris, broke into the home of a judge by the name of Petit but

decided not to kidnap him, then abducted a property magnate instead, for a ransom of six million francs. A subsequent kidnap victim—a journalist for a newspaper, *Minute*—was tortured.

In France, Besse was sentenced to death in his absence, for a holdup committed in October 1978 at a bureau de change near Paris's Grands Boulevards. If he was extradited from Belgium, he would be re-tried under French law. Faced with the prospect of the guillotine in his home country, "petit François" confessed to a number of invented crimes with the aim of staying in Belgium. Meanwhile, the "fugitive king" took advantage of a hearing at the Brussels Law Courts in June 1979 to escape yet again.

In Paris, the judicial police and the Minister of the Interior were outraged at the media's sensational reporting of the two gangsters' escapades. Commissioner Bouvard, who had arrested Mesrine without bloodshed in 1973, was charged with apprehending France's public enemy no. 1, once and for all. On November 2, 1979, the anti-gang

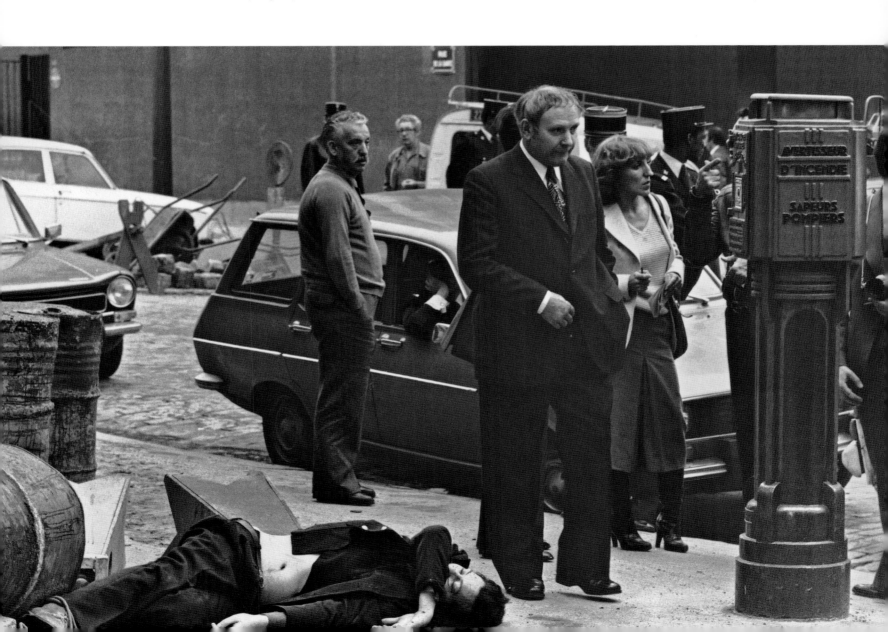

police squad trapped Mesrine at the Porte de Clignancourt and took matters into their own hands. Riddled with eighteen bullets, Mesrine collapsed onto the dashboard of his BMW. The "public enemy number one" or "wild beast" was no more.

François Besse headed for Spain, and the only trade he knew, robbery. Arrested for a break-in at a jewelry store, he was imprisoned in Madrid's Carabanchel prison, from where he escaped yet again on February 16, 1983, during a transfer to hospital for treatment for a supposed stomach complaint. Now on his sixth run, he was accompanied this time by a young Spanish beauty. In January 1986, a rumor spread along the benches of France's courts of law and the offices of the organized crime squad: Besse had been murdered by one of his accomplices from the *Gang des Postiches*. France breathed easily again—and so could Besse.

"I was mistaken. Today, I am keenly aware of the evil I have done."

With his Spanish lover, he embarked on an eight-year run around the world. But like so many other fugitives, Besse, whose girlfriend was pregnant, longed for home. In spring 1994, the son of the Charentes region settled in a discreet furnished apartment in Angoulême. He had a family to feed. He broke into a bank and supermarket: two crimes, four months apart. His fingerprints were found at his hideout. Presumed dead, Besse was now resurrected.

The police woke up to the fact of Besse's return, and the chase began all over again, this time with a wife and baby in tow—a little girl, born in secret. The fifty-year-old ex-convict discovered the joys of fatherhood and the love of a good woman. After Spain, the family moved to Morocco. On November 3, 1994, he allowed himself to be questioned by three inspectors in a Tangiers restaurant and was extradited to France on February 14, 1996. Back to Gradignan, the prison he had first entered at the age of twenty.

Besse had never killed a man, but his past misdemeanors and his friendship with Mesrine blackened his name. Tried in Angoulême, he was sentenced to five years for criminal conspiracy and eight years for two holdups. Added to the sum of his many existing unfinished prison sentences, Besse faced a total of twenty-eight years in jail, starting at Saint-Maur, near Châteauroux. What to do? Face a slow death or resist? The tantalizing question burned brighter than ever. But Besse surprised everyone. The record-breaking escapee renounced his old tricks and became a model inmate. He took his baccalaureate (in literature), rediscovered the great Latin and Greek thinkers, and developed a passion for philosophy. Behind bars, Besse adopted a motto from Virgil's *Aeneid*: "Such suffering as I can foresee, I will endure" and applied himself to the question of the true nature of an "honest man." The armed robber made his greatest escape, into thought and reflection.

Besse was judged at the Paris Assizes in 2002, twenty-five years after his escape from the Santé, the holdups at the gun shop and Deauville casino, and the kidnapping of the banker in Noisy-le-Sec. He surprised his judges and jurors by his objective point of view and his personal transformation. "I was mistaken. Today, I am keenly aware of the evil I have done," he acknowledged, apologizing to his victims. Besse's lawyer pressed for a sentence of thirteen years, to serve concurrently with his existing sentences. The court sentenced him to eight but rejected the request for the sentences to serve concurrently.

On February 16, 2006, Besse was granted a conditional release. On February 27, at half past five in the morning, he stepped out into the misty Sologne morning, a free man. He had served ten years in prison, out of a sentence of twenty-three. The repentant armed robber could look forward to a peaceful retirement at the end of his long criminal career.

Page 224: Jacques Mesrine, masked, 1970.
Page 226: Jacques Mesrine, behind bars at the QHS de la Santé, 1978.
Page 227: Body of Carman Rives, 26 years old, shot during his attempted escape from la Santé, whilst Jacques Mesrine and François Besse managed to flee, May 8, 1978.
Facing page: François Besse, 1994.
Following pages: The many faces of Mesrine, 1979.

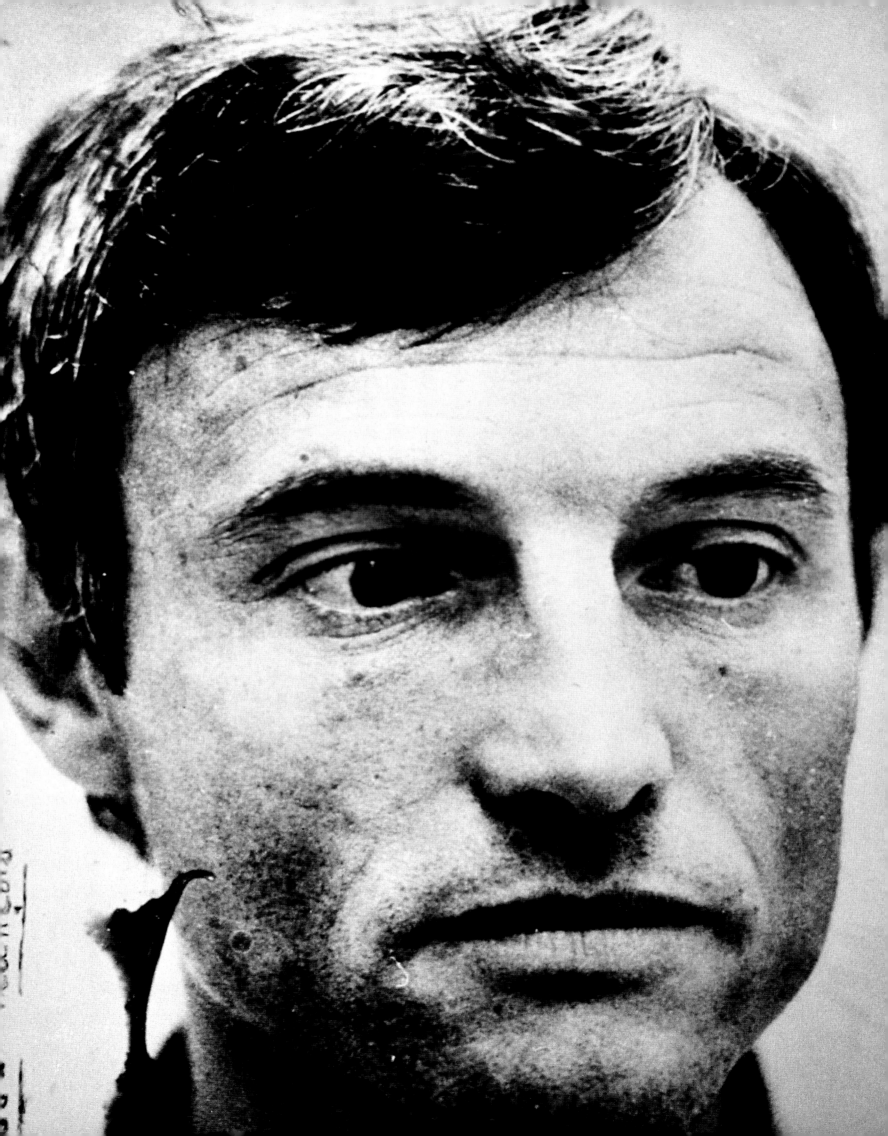

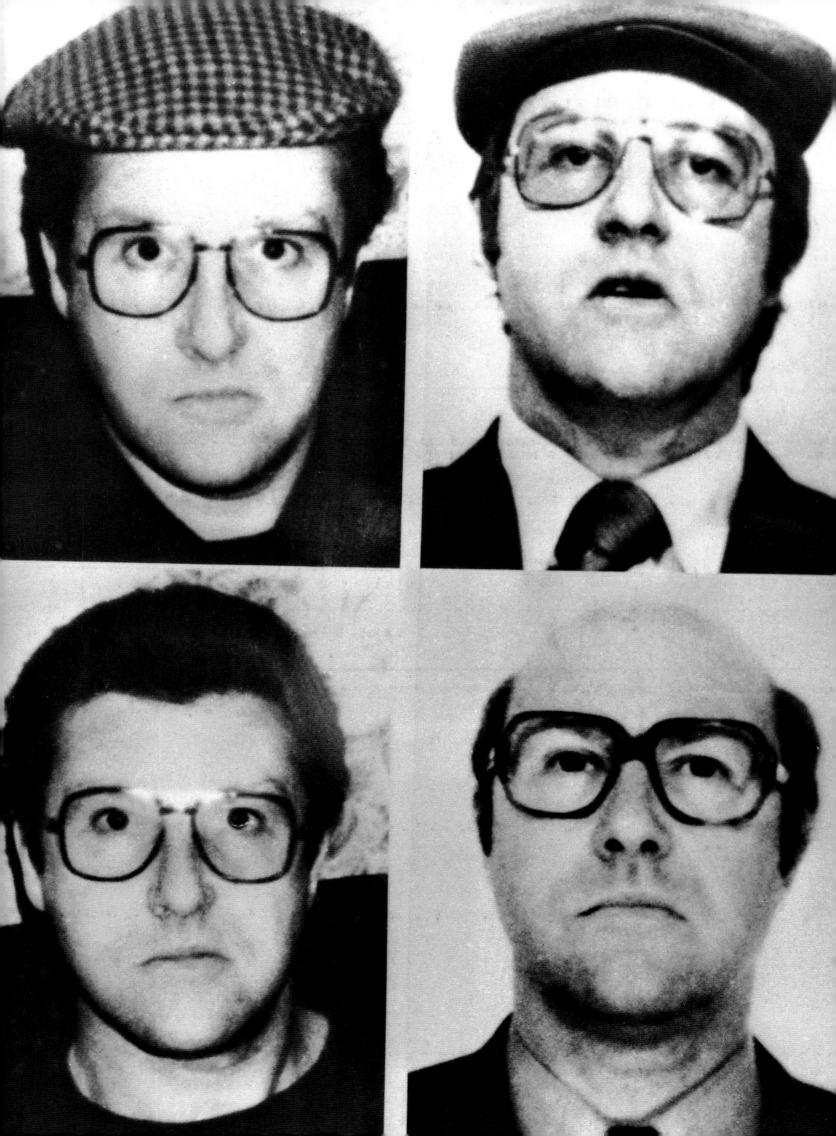

Twenty-first Century Outlaws

The end of a year spent in the company of bandits and brigands, pirates and corsairs, Illegalists and idealists, gangsters and revolutionaries. Long nights journeying in their wake—on the run from justice and the police, hot on our heels—crossing jungles and deserts, seas and rivers, thick forests, and urban infernos. Dozens of books devoured with bated breath, thousands of pages scanned with swollen exhausted eyes, in an attempt to understand the desperate struggles throughout history of outlaws of every kind to change the world through the embrace of violence and illegality.

The generosity of our big-hearted brigands has been eroded over the centuries. Anarchists and "outsiders," the last survivors of the romantic philanthropic outlaws of yesteryear, have left behind their zeal to usher in a new world—robbing the rich to give to the poor—in the labor camps and the Siberian gulag, under the trenchant blade of the guillotine.

In the twenty-first century, genuine subversives, rejecting authority in all its forms—religious, moral, economic, or political—are rare, indeed. The conquerors of impossible dreams and the great rebels of this world have given up the cause, lost in the urban jungle. Individualism has overtaken idealism.

From time to time, here and there, a few lines in the press report an uprising in the heart of Africa or the distant corners of the Indian subcontinent, a last stand for justice, led by a latter-day Robin Hood determined to reclaim a few miserable spoils from the rich or his country's central powers for redistribution to the poor, before being arrested and killed.

But this is the stuff of anecdote. In French-speaking Quebec, a handful of radicals have taken up the cause of the California Diggers, but their generous undertaking lacks the wild folly of Emmett Grogan. Off the coasts of Somalia and Venezuela, and through the Malacca Strait, intrepid pirates attack cargo ships and pleasure yachts wandering off-course. but their businesslike violence has little in common with their historical ancestors.

Even the great mobsters have been called to order. The French hoodlum Antonio Ferrara is the new king of great escapes and spectacular holdups, but how many other small-time crooks and petty thieves have proved ready to turn tail and sell themselves and their onetime comrades for a reduced sentence or a few grams of heroin?

We might hope that the world's impending ecological disaster would inspire a few brave souls to take up the flame and oppose the destruction of its precious riches, but today's rebels often just prefer to sign petitions and appear in TV studios in their struggles to save the world.

Today's outlaws infest other storm-tossed seas and new jungles: the world of high finance and computer networks, attacking obscure financial markets before being caught red-handed and losing everything. No flair, no panache, no honorable gesture

Robin Hood may never have truly existed, but his heroic life was a role model that inspired many a vocation. Today, his legend inspires no one. Our world is dying, and more than ever we need another (outlaw) hero.

INTRODUCTION

1 The response of a reporter on the *Shinbone Star*, to James Stewart's confession in John Ford's classic Western *The Man who Shot Liberty Valance*.

ROBIN HOOD AND THE OUTLAWS OF THE FOREST

2 A. Dumas, *The Prince of Thieves*, trans. A. Allinson (London: Methuen & Co, 1904).
3 *Ibid.*
4 A small landowner in medieval England.
5 *Ibid.*
6 *Ibid.*
7 A wandering scholar in medieval Europe, famed for intemperance and riotous behavior, and the composition of satirical and ribald Latin songs.
8 F. Carco, *The Romance of Villon*, trans. Hamish Miles (New York: Knopf, 1927).
9 *Ibid.*
10 F. Villon, *The Poems of François Villon*, trans. Galway Kinnell
11 *Ibid.*
12 Anonymous, *Abrégé de la vie de Louis Mandrin, chef de contrebandiers en France* (Paris: Allia, 1991).
13 *Ibid.*
14 *Ibid.*
15 *Ibid.*
16 *Ibid.*
17 *Ibid.*
18 Stendhal, *Mémoires d'un Touriste*, 1838.
19 Jean Siccardi, *Gaspard de Besse* (Paris: Éditions du Rocher, 2005).
20 *Ibid.*
21 Jean Aicard, *Discours de Gaspard de Besse aux bagnards* (Librairie Nationale, 1919).
22 Henry Thoreau, from *Civil Disobedience*, in *Walden and Civil Disobedience*, (New York: Penguin Classics, 1983).
23 *Ibid.*
24 *Ibid.*
25 *Ibid.*, from *Walden*.
26 Gilles Farcet, *Henry Thoreau, l'éveillé du Nouveau Monde* (Auxerre: Sang de la terre, 1998)
27 Oleron Barretto, "No sertão," *A Voz do sertão*, (May 10, 1936).
28 Rubem Braga, *Diario de Pernambuco*,(February 2, 1935).

THE BLACK SAIL AND THE CALL OF THE HIGH SEAS

29 A.-O. Exquemelin, *Histoire des aventuriers filibustiers* (1686), (Quebec: Les Presses de L'Université Laval, 2005).
30 Daniel Defoe, *A General History of the Pyrates*, ed. Manuel Schonhorn, (New York: Dover Publications, 1999).
31 Michel Le Bris, *D'or, de rêves et de sang* (Paris: Hachette, 2001).
32 E.F. Benson, *Sir Francis Drake*, 1927.
33 *Ibid.*
34 A. Exquemelin, *The Buccaneers of America*, trans. Alexis Brown (New York: Courier Dover Publications, 2000).
35 John Esquemeling [A.-O. Exquemelin], *The Buccaneers of America: In the Original English Translation of 1684* (New York: Cosimo Inc., 2007).
36 A modern version of the articles as listed in Daniel Defoe's *General History of the Pyrates*, quoted in Lisa Yount, *Pirates* (San Diego: Lucent Books, 2002).
37 D. Defoe, *A General History of the Pyrates*, (New York: Courier Dover Publications, 1999).
38 *Ibid.*

39 *Ibid.*
40 *Ibid.*
41 *Ibid.*
42 *Ibid.*
43 Jose Luis Borges, *A Universal History of Iniquity*, trans. Andrew Hurley, (New York: Penguin Classics, 1998).

SHARP SHOOTERS AND THE CALL OF WIDE OPEN SPACES

44 Paul West, *O.K.: The Corral, the Earps and Doc Holliday, a Novel* (New York: Simon and Schuster, 2001).
45 Declaration by Robert Ford to Governor Thomas Crittenden, *The Crittenden Memoirs* (New York: G. P. Putnam's Sons, 1936).
46 The so-called "Robin Hood" letter, addressed to John Edwards and presumed to have been written by Jesse James (although signed "Dick Turpin"), printed in *The Kansas City Times* on October 15, 1872.
47 Jesse James, Jr., *Jesse James, My Father: The First and Only True Story of His Adventures Ever Written*, (Sequoyah Books, 2003).
48 *Ibid.*
49 Pat Garrett, *The Authentic Life of Billy the Kid*, (Norman, Oklahoma: University of Oklahoma Press, 2000).
50 Michael Ondaatje, *The collected works of Billy the Kid; left-handed poems* (Toronto: Anansi, 1970).
51 From a letter to her daughter, Janey, dated January 20, 1901, see Martha Jane Cannary Hickok, *Calamity Jane's Letters to her Daughter* (Berkeley, Shameless Hussy Press, 1976).
52 From a pamphlet written by Martha Cannary Burk, *Life and Adventures of Calamity Jane*, 1896.
53 Martha Jane Cannary Hickok, *Calamity Jane's Letters to her Daughter*, (Berkeley: Shameless Hussy Press, 1976).
54 Paul West, *Ibid.*
55 *Ibid.*
56 *Ibid.*

DESERT DEVILS, FROM THE ARABIAN PENINSULA TO THE HORN OF AFRICA

57 André Malraux, *Anti-memoirs*, trans. Terence Kilmartin (New York: Bantam, 1967).
58 Thomas Wright, *The Life of Sir Richard Burton* (New York: Burt Franklin, 1968).
59 Fawn Brodie, *The Devil Drives: A Life of Sir Richard Burton*, (New York: W.W. Norton, 1984).
60 *Ibid.*
61 Richard Burton, *Personal Narrative of a Pilgrimage to Al-Madinah and Meccah* (London: George Bell & Sons, 1906).
62 R, Burton, *First Footsteps in East Africa; or an Exploration of Harar* (London: Longman, Brown, Green, and Longmans, 1856).
63 Brodie, *The Devil Drives: A life of Sir Richard Burton*, (New York: W.W. Norton, 1984).
64 Arthur Rimbaud, *A Season in Hell, and Drunken Boat*, trans. Louise Varese (New York: New Directions Pub. Corp., 1961)
65 Jules Borelli, *Journal des voyages. Aventures de terre et de mer. En Abyssinie et au pays Galla* (Paris: Librairie Illustrée, 1891).
66 T.E. Lawrence, *The Seven Pillars of Wisdom*.
67 *Ibid.*
68 Henri Monfreid, *Hashish: True Adventures of a Red Sea Smuggler*, trans. Helen Buchanan Bell (London: Macdonald, 1974).

ILLEGALISTS, ANARCHISTS, AND REVOLUTIONARIES

69 Victor Serge, *Memoirs of a Revolutionary* (London: Oxford University Press, 1963).
70 H.E. Kaminski, *Bakounine, La Vie d'un révolutionnaire*, Collection *La Petite Vermillon* (Paris: La Table Ronde, 2003).
71 Sam Dolgoff, *Bakunin on Anarchism* (New York: Knopf, 1972).
72 Richard Parry, *The Bonnot Gang* (London: Rebel Press, 1987).
73 Alain Sergent, *Un anarchiste de la Belle Époque: Alexandre Marius Jacob* (Toulouse: Libertaires, 2005).
74 *Ibid.*
75 *Ibid.*
76 Victor Serge, *Memoirs of a Revolutionary* (London: Oxford University Press, 1963).
77 *Ibid.*
78 Emilienne Morin, "Nuestra Victoria," *Le Libertaire* (November 17, 1938).
79 Radio interview on August 9, 1972 with Pierre-André Boutang of the French broadcaster ORTF.
80 *Ibid.*
81 *Ibid.*
82 Ernst von Salomon, *The Answers of Ernst von Salomon to the 131 questions in the Allied Military Government Fragebogen*, trans. Constantine Fitzgibbon (London: Putnam, 1954).
83 Ernst von Salomon, *The Outlaws*, trans. Ian Morrow (London: Jonathan Cape, 1931.
84 *Ibid.*
85 Ibid, *The Answers.*
86 Emmett Grogan, *Ringolevio: A life played for keeps* (Boston: Little, Brown, 1972).
87 "No Frozen Moments for Tomorrow's Fantasy," in The Diggers Papers, *The Realist*, August 1968.
88 Emmett Grogan, *Ringolevio: A life played for keeps* (Boston: Little, Brown, 1972).
89 *I, Phoolan Devi: The Autobiography of India's Bandit Queen* (New York: Time Warner Paperbacks, 1997).
90 *Ibid.*
91 *Ibid.*
92 *Ibid.*
93 Members of the superior *kshatriya*, or warrior, caste.
94 Members of the inferior *shudra* caste, known as the tillers of the soil.
95 *Ibid.*
96 *Ibid.*

CITY HOODLUMS AND URBAN GANGS

97 David Newman and Robert Benton, *Bonnie and Clyde, a Faber Classic Screenplay* (London: Faber & Faber, 1998).
98 Interview by Gilles Millet, *Libération*, January 1979.
99 David Newman and Robert Benton, *Bonnie and Clyde, a Faber Classic Screenplay* (London: Faber & Faber, 1998).
100 Bonnie Harper, from "The Story of Bonnie and Clyde." The poem appeared in several newspapers during their crime spree.
101 Christophe Hondelatte, *Albert Spaggiari, le casse du siècle: "Ni armes, ni violence et sans haine"*, Michel Lafon, 2007.
102 A. Spaggiari, in an interview with Bernard Pivot for the television show, *Apostrophes*.
103 Mathieu Delahousse, *François Besse, la métamorphose d'un lieutenant de Mesrine* (Paris: Flammarion, 2006).
104 *Ibid.*

ROBIN HOOD AND THE OUTLAWS OF THE FOREST
ANONYME. *Abrégé de la vie de Louis Mandrin, chef de contrebandiers en France.* Paris: Allia, 1991.
AMY DE LA BRETÉQUE, François. *La Légende de Robin des Bois.* Toulouse: Privat, 2001.
CARCO, Francis. *The Romance of Villon*, trans. Hamish Miles. New York: Knopf, 1927.
DUMAS, Alexandre. *Le Prince des voleurs.* J'ai Lu. Paris: Flammarion, 1998.
—— *The Prince of Thieves*, trans. A. Allinson. London: Methuen & Co. 1904.
FARCET, Gilles. *Henry Thoreau, l'éveillé du nouveau monde.* Auxerre: Sang de la terre, 1998
GRUNSPAN-JASMIN Élise. *Lampiao, vies et morts d'un bandit brésilien* Paris: PUF, 2001
HALIMI, Gisèle. *La Kahina.* Paris: Plon, 2006
IKOR, Roger. *La Kahina.* Paris: Encre, 1979.
PEYRAMAURE, Michel. *Les Trois Bandits*, tome 2, "Mandrin". Paris: Robert Laffont, 2007.
SCOTT, SIR Walter. *Ivanhoe.* Oxford World's Classics. London: Oxford University Press, 2008.
SICCARDI, Jean. *Gaspard de Besse.* Paris: Rocher, 2005.
TEULÉ, Jean. *Je, François Villon.* Paris: Pocket, 2007.
THOREAU, Henry. *Walden and Civil Disobedience.* New York: Penguin Classics, 1983.
—— *Walking.* New York: Cosimo, 2006.
—— *Life Without Principle.* Forgotten Books, 2008.
VILLON, François. *The Poems of François Villon*, trans. Galway Kinnell. Lebanon, New Hampshire: University Press of New Hampshire, 1982.

THE BLACK SAIL AND THE CALL OF THE HIGH SEAS
BOUILLET and CHASSANG. *Dictionnaire universel d'histoire et de géographie.* Paris: Hachette, 1878.
DEFOE, Daniel (*alias* Captain Johnson). *A General History of the Pyrates* New York: Couvier Dover Publications, 1999.
DESCHAMPS, Hubert. *Les Pirates à Madagascar.* Champigneulles: Berger-Levrault, 1972.
EXMELIN, Alexandre-Olivier. *Histoire des aventuriers flibustiers* Quebec: Presse de L'Université Laval, 2005.
FARINE, Charles. *Les Barberousse* La Rochelle: La Découvrance, 2007.
GERRARD, Roy. *Francis Drake, le hardi navigateur* Rennes: Ouest France, 1990.
JAEGER, Gérard. *Les Amazones des sept mers.* Paris: Le Félin, 2003.
LAPOUGE, Gilles. *Pirates and Buccaneers*, Hachette Illustrated UK, 2004.
LE BRIS, Michel. *L'Aventure de la flibuste.* Paris: Hoëbeke, 2002.
—— *D'or, de rêve et de sang l'époque de la flibuste (1494–1588).* Paris: Hachette Littératures, 2004
LEMONNIER, Léon. *Sir Francis Drake, la grande légende de la mer.* Brussels: La Renaissance du Livre, 1932.
MOREAU, Jean-Pierre. *Pirates.* Paris: Taillandier, 2006.
NEUKIRCHEN, Heinz. *Pirates sur toutes les mers du monde.* éditions Hier & Demain, 1978.
RAMSEIER, Mikhaïl Wadimovitch. *La Voile noire des pirates* Lausanne: Favre, 2006.
STEVENSON, Robert. *Treasure Island.* Vintage Classics. London: Vintage, 2008.

SHARP SHOOTERS AND THE CALL OF WIDE OPEN SPACES
BIANCHI, Didier. *Les Hors-la-loi de l'Ouest américain.* Paris: Crépin-Leblond, 1995.
CALAMITY Jane. *Calamity Jane's Letters to her Daughter.* Berkeley: Shameless Hussy Press, 1976.
CHASTENET, Jacques. *En avant vers l'Ouest ou la conquête des États-Unis par les Américains.* Paris: Perrin, 1967.
DUFOUR, Hortense. *Calamity Jane, le diable blanc*, Paris: Flammarion, 2001.
GARRETT, Pat. *The Authentic Life of Billy the Kid.* Norman, Oklahoma: University of Oklahoma Press, 2000.
HANSEN, Ron. *The Assassination of Jesse James by the Coward Robert Ford.* London: Harper Collins 2007.

JAMES JR., Jesse. *Jesse James, My Father: The First and Only True Story of His Adventures Ever Written.* Sequoyah Books, 2003.
JAQUIN, Philippe. *Vers l'Ouest, un nouveau monde.* Paris: Gallimard, 1987.
JAQUIN, Philippe and Daniel Royot. *Go West, une histoire de l'Ouest américain d'hier à aujourd'hui.* Paris: Champs Flammarion, 2004.
LAMBERT, Christophe. *Contes et récits de la conquête de l'Ouest.* Paris: Nathan Jeunesse, 2000.
MARTIN, Roger. *Les Mémoires de Butch Cassidy.* Paris: Dagorno, 1994.
MARTIN, Wilson. *Buffalo Bill's Wild West.* Greenhill Books, 1999.
ONDAATJE, Michael. *The Collected Works of Billy the Kid: Left-Handed Poems.* Toronto: Anansi, 1970.
STUART, Lake. *Le Héros du Far West.* Paris: Gallimard, 1936.
ULYATT, Kenneth. *La Vie d'un cow-boy, dans l'Ouest américain vers 1870.* Paris: Flammarion, 1977.
UTLEY, Robert M. *Billy the Kid: A Short and Violent Life.* London: Tauris Parke, 2000.
WEST, Paul. *O.K.: The Corral, the Earps and Doc Holliday, a Novel.* New York: Simon and Schuster, 2001.

DESERT DEVILS, FROM THE ARABIAN PENINSULA TO THE HORN OF AFRICA
AUBÉ, Pierre. *Un croisé contre Saladin, Renaud de Châtillon.* Paris: Fayard, 2007.
BENOIST-MECHIN, Jacques. *Lawrence d'Arabie.* Paris: Perrin, 2003.
—— *Ibn-Séoud ou la naissance d'un royaume,* Complexe, 1999
BORER, Alain. *Rimbaud en Abyssinie.* Paris: Points Seuil, 2004.
BRODIE, Fawn. *The Devil Drives: A Life of Sir Richard Burton.* New York: W.W. Norton, 1984.
BURTON, Richard. *Personal Narrative of a Pilgrimage to Al-Madinah and Meccah.* London: George Bell & Sons, 1906.
GRANDCLÉMENT, Daniel. *L'Incroyable Henry de Monfreid.* Paris: Grasset, 1990.
KESSEL, Joseph. *Fortune Carré* Paris: Pocket, 2002.
LAHLOU, Raphaël. *Lawrence d'Arabie ou l'épopée des sables.* Paris: Bernard Giovanangeli, 2005.
LAWRENCE, Thomas Edward. *Seven Pillars of Wisdom.* London: Vintage, 2008.
—— *La Matrice.* Paris: Le Livre de poche, 1966.
LEFRÈRE, Jean-Jacques. *Arthur Rimbaud,* Paris: Fayard, 2001.
MARÉCHAUX, Laurent. *Le Fils du dragon.* Paris: Le Dilettante, 2006.
MONFREID, Henri de. *Feu de Saint-Elme.* Paris: Robert Laffont, 1973.
POIVRE D'ARVOR, Olivier and Patrick. *Disparaître.* Folio. Paris: Gallimard, 2007.
STÉPHANE, Roger. *Portrait de l'aventurier: Lawrence, Malraux, Von Salomon.* Paris: Grasset, 2004.
TÉLÉRAMA hors-série, *Rimbaud, trafiquant d'âmes,* 2004
TONDEUR, Freddy. *Sur les traces d'Henri de Monfreid.* Fontenay-sous-Bois: Anako, 2004.

ILLEGALISTS, ANARCHISTS, AND REVOLUTIONARIES
AVRICH, Paul. *The Russian Anarchists.* AK Press, 2006.
BAKUNIN, Mikhail. *God and the State.* Cosimo Inc., 2009.
BLANDIN, Philippe. *Eugène Dieudonné.* Paris: Éditions du Monde libertaire, 2001.
BOUDARD, Alphonse. *Les Grands Criminels.* Paris: Le Pré aux Clercs, 1989.
CACUCCI, Pino. *Without a Glimmer of Remorse: The Remarkable Story of Sir Arthur Conan Doyle's Chauffeur.* Hastings: Christie Books, 2006.
CARUCHET, William. *Ils ont tué Bonnot.* Paris: Calmann-Lévy, 1990.
CHALANDON, Sorj. *Mon traître.* Paris: Grasset, 2007.
COLLECTIVE, *Durruti (1896-1936).* Montreuil-sous-Bois: L'Insomniaque, 2006.

COLOMER, André. *À nous deux, Patrie!*, Éditions de l'Insurgé, 1925.

DELACOURT, Frédéric. *L'Affaire bande à Bonnot*, collection "Procès de l'histoire". Paris: De Vecchi, 2000.

DEPAGNE, Rinaldo. *Le Martyre de Bobby Sands*, Edite, 2006

DEROUARD, Jacques. *Maurice Leblanc: Arsène Lupin malgré lui.* Paris: Séguier, 2001.

DEVI, Phoolan. *I, Phoolan Devi: the Autobiography of India's Bandit Queen.* New York: Time Warner Paperbacks, 1997.

FRAIN, Irène. *Devi.* Paris: Le Livre de poche, 1994.

GROGAN, Emmett. *Ringolevio: A Life Played for Keeps.* Boston: Little, Brown, 1972.

KAMINSKI, H.-E. *Bakounine: la vie d'un révolutionnaire*, La Petite Vermillon. Paris: La Table ronde, 2003.

LEBLANC, Maurice. *Arsène Lupin, Gentleman-Thief.* Penguin Classics. London: Penguin, 2007.

LEHNING, Arthur. *Michel Bakounine et les autres*, 10/18, 1976

LONDRES, Albert. *L'Homme qui s'évada.* Paris: Serpent à plumes, 1999.

MAITRON, Jean. *Ravachol et les anarchists.* Paris: Julliard, 1964.

MENZIES, Malcolm. *En exil chez les homes.* Paris: Rue des Cascades, 2007.

RUAUD, André-François. *Les Nombreuses Vies d'Arsène Lupin.* Paris: Les Moutons électriques, 2005.

SALOMON, Ernst von. *Les Réprouvés.* Paris: Bartillat, 2007.

—— *Les Cadets.* Paris: Le Livre de poche, 1966.

—— *Le Questionnaire.* Paris: Gallimard, 1953.

SANDS, Bobby. *One Day In My Life. Mercier Press, 2001.*

SERGE, Victor. *Memoirs of a Revolutionary.* London: Oxford University Press, 1963.

SERGENT, Alain. *Un anarchiste de la Belle Époque: Alexandre Marius Jacob.* Libertaires, 2005.

SKIRDA, Alexandre. *Nestor Makhno: Anarchy's Cossack.* AK Press, 2006.

STÉPHANE, Roger. *Portrait de l'aventurier: Lawrence, Malraux, Von Salomon.* Paris: Grasset, 2004.

THOMAS, Bernard. *La Belle Époque de la bande à Bonnot.* Paris: Fayard, 1989.

—— *La Bande à Bonnot.* Paris: Tchou, 1968.

—— *Ni dieu, ni maître: les anarchists.* Brussels: Sand, 2008.

WEISSMAN, Susan. *Dissident dans la révolution: Victor Serge, une biographie politique.* Paris: Syllepse, 2006.

CITY HOODLUMS AND URBAN GANGS

AUDA, Grégory. *Les Belles Années du milieu.* Paris: Michalon, 2002.

BORNICHE, Roger. *Le Gang.* Paris: Fayard, 1975.

BOUDARD, Alphonse. *Les Grands Criminels.* Paris: Le Pré aux Clercs, 1989.

DELAHOUSSE, Mathieu. *François Besse, la métamorphose d'un lieutenant de Mesrine.* Paris: Flammarion, 2006.

HISTORIA, "Le Hold-up du siècle: le train postal", 1968

HONDELATTE, Christophe. *Albert Spaggiari, le casse du siècle: "Ni armes, ni violence et sans haine".* Neuilly-sur-Seine Michel Lafon, 2007

MESRINE, Jacques. *L'Instinct de mort.* Paris: Flammarion, 2008.

NAIN, Jacques. *Mesrine, ennemi public numéro 1.* Paris: France Europe Éditions, 2006.

PERROUD, Frédéric. *Bonnie Parker et Clyde Barrow, les amants terrible.* Paris: Acropole, 1999.

READ, Piers Paul. *Le Trésor du Train postal.* Paris: Grasset, 1978.

SPAGGIARI, Albert. *Faut pas rire avec les barbares.* Paris: Robert Laffont, 1977.

—— *Les Égouts du paradis.* Paris: Albin Michel, 1992.

—— *Le Journal d'une truffe.* Paris: Albin Michel, 2000.

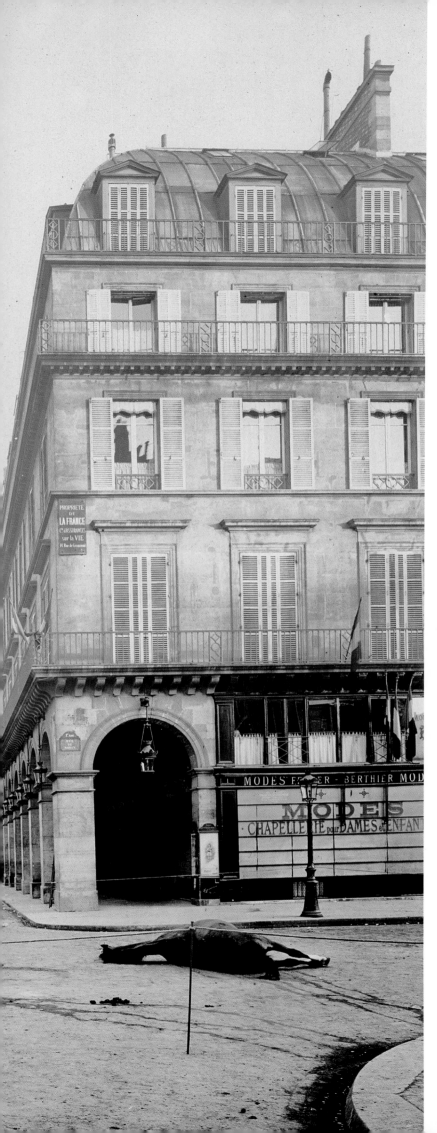

Page 232: A guerrilla, 20th century.
Facing page: La rue de Rivoli, Paris, following an attack, 19th century.

Translated from the French by Louise Lalaurie Rogers
Design: Delphine Delastre
Copyediting: Anne Korkeakivi
Typesetting: Barbara Kekus
Proofreading: Helen Woodhall
Color Separation: Reproscan, Orio al Serio
Printed in Spain by Grafos

Distributed in North America by Rizzoli International Publications, Inc.

Simultaneously published in French as *Hors la loi*
© Arthaud, Paris, 2009

English-language edition
© Flammarion S. A., Paris, 2009

87, quai Panhard et Levassor
75647 Paris Cedex 13

editions.flammarion.com

09 10 11 3 2 1

ISBN-13: 978-2-08-030107-9

Dépôt légal: 09/2009